MEXICAN MODERNITY

The MIT Press Cambridge, Massachusetts London, England

MEXICAN MODERNITY

The Avant-Garde and the Technological Revolution

Rubén Gallo

This book was set in Walbaum and Futura by Graphic Composition, Inc., and was printed and bound in Spain.

MIT Press books may be purchased at special quantity discounts for business or sales promotional use. For information, please email special_sales@mitpress.mit.edu or write to Special Sales Department, The MIT Press, 55 Hayward Street, Cambridge, MA 02142.

Library of Congress Cataloging-in-Publication Data

Gallo, Rubén.
 Mexican modernity : the avant-garde and the technological revolution / Rubén Gallo.
 p. cm.
 Includes bibliographical references and index.
 ISBN 0-262-07264-5
 1. Technology and the arts. 2. Technology in art. 3. Arts, Modern–Mexico–20th century. 4. Avant-garde (Aesthetics)–Mexico–History–20th century. 5. Mexico–Intellectual life–20th century. I. Title

NX180.T4G35 2005
701'.05'0972–dc22 2005045101

FOR MARÍA TERESA DEL CARMEN GODÍNEZ PRADO AND RUBÉN GALLO RUIZ

CONTENTS

Acknowledgments viii

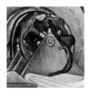

Introduction: **MEDIA AND MODERNITY IN MEXICO** 1

1

CAMERAS 31

2

TYPEWRITERS 67

3 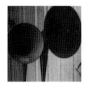 RADIO 117

4 CEMENT 169

5 STADIUMS 201

Epilogue: TEPITO IN THE EARLY MORNING 227

Notes 237

Bibliography 251

Index 260

Acknowledgments

This book owes much to the generosity of friends and colleagues who have shared their insights on media and technology.

Gustavo Pérez Firmat read an early version of the manuscript and offered countless suggestions and expert stylistic counsel. Jean Franco, a plotting woman and beloved friend, shared her encyclopedic knowledge of Mexican culture and literature. Hans Ulrich Gumbrecht taught me much about sports culture and the history of stadiums. Bruno Bosteels, Licia Fiol-Matta, Maarten van Delden, and Betsy Phillips made shrewd observations and helped me tighten the manuscript's weak points. Norris Pope, a fellow technology enthusiast, shared his insights on signal transmission.

Wireless gratitude goes to my fellow radio enthusiasts who came to Princeton in the spring of 2003 to exchange ideas about radio, literature, and the sound of modernity: Marjorie Perloff, a great inspiration on how to read poetry and have fun with it; Gregory Whitehead, true radiogenic artist; Thomas Y. Levin, who gave the conference's keynote address; and Allen Weiss, expert theoretician of disembodied transmissions. Esther Allen masterfully translated Kyn Taniya's radio poem for this book. I would also like to acknowledge the two anonymous readers who read the manuscript meticulously and offered invaluable suggestions for revision: my work benefited enormously from their rigor and intellectual generosity.

Telegraphic thanks to my colleagues in the Department of Spanish and Portuguese at Princeton, and to the chairman, Ángel Loureiro, for supporting my work and creating an intellectually stimulating academic environment. My discussion of Andrade's typewriter owes much to several conversations I had with Pedro Meira Monteiro, who graciously shared his expertise on Brazilian modernist poetry and the vicissitudes of writing machines.

I wish to express my gratitude to Princeton's University Committee on Research in the Humanities and Social Sciences for awarding me a grant to obtain images for this book, and to the Program in Latin American Studies, also at Princeton, for a faculty research grant that allowed me to travel to Mexico City's archives in the summer of 2004.

At the MIT Press, Roger Conover provided invaluable editorial advice, Paula Woolley and Matthew Abbate read the manuscript with eagle eyes, and Erin Hasley created the most stunning design I could have imagined for my work.

Elyse Kovalsky proofread the manuscript and prepared the index. Gabriela Núñez, from the Fototeca Nacional in Mexico City, worked hard to find many of the photographs in this book.

Thanks, as always, to Terence Gower, who listens, reads, and patiently indulges my mediatic obsessions.

MEXICAN MODERNITY

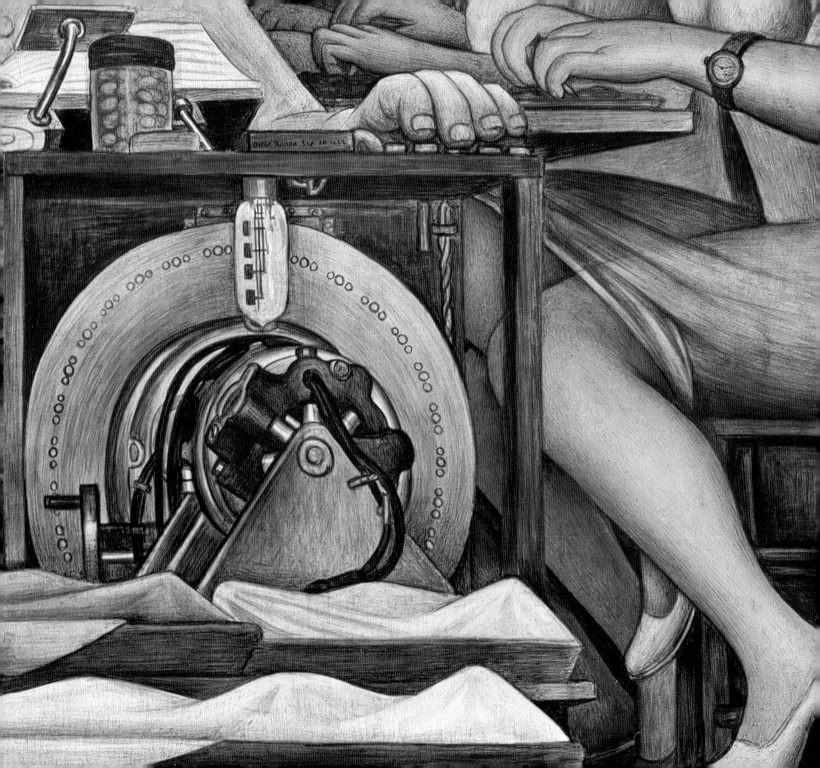

MEDIA AND MODERNITY IN MEXICO

This is a book about the other Mexican revolution: the cultural transformations triggered by new media in the years after the armed conflict of 1910 to 1920. The new revolutionaries were not soldiers or bandits but artists and writers; they did not fight with weapons but with cameras, typewriters, radios, and other mechanical instruments; and their goal was not to topple a dictator but to dethrone the nineteenth-century aesthetic ideals that continued to dominate art and literature in the early years of the new century. This was a struggle to set words and images in freedom, to synchronize cultural production to the vertiginous speed of an incipient modernity.

Like all revolutionary projects, it was utopian: these foot soldiers of technology were determined to change the world, to build a new society

inhabited by thoroughly modern subjects. It was also internationalist: technological revolutionaries rejected the nationalist obsession that had dominated the cultural scene in favor of a cosmopolitan avant-gardism that put them in dialogue with like-minded innovators in Moscow and New York, Paris and São Paulo.

But where to begin our analysis of Mexico's other revolution? There is no better starting point than Detroit, Michigan.

In 1932 the Mexican muralist Diego Rivera moved to Detroit in order to work on an ambitious mural cycle devoted to a subject that had become a constant preoccupation in his work: modern technology and its effects on society. The mural, *Detroit Industry,* was financed by Edsel Ford, a son of Henry Ford and then president of the Ford Motor Company, and it was to be painted on the walls around the central courtyard of the city's most important art museum, the Detroit Institute of Arts.

Rivera spent several months in Detroit, studying the Ford plant in River Rouge – at the time, the largest industrial complex in the world – and trying to understand how automobiles, those wondrous machines that had mechanized human movement, were made. Accompanied by Ford engineers and armed with a sketchbook, the painter toured the plant and carefully studied the func-

tions of assembly lines, stamping presses, furnaces, and open hearths – artifacts that eventually found their way into the mural.

When Rivera completed his project in 1933, the mural presented a detailed illustration of every step involved in the manufacture of an automobile. The north wall depicted the production of the inner parts, including the engine and transmission, while the south wall portrayed the stamping of exterior body parts and the final assembly of completed automobiles (figures 1 and 2). The entire process was documented so thoroughly and so accurately that even automotive experts marveled at Rivera's sophisticated understanding of Ford's assembly plant. "Edsel Ford," recounts William Valentiner, then director of the Detroit Institute of Arts, "was carried away by the accurate rendering of machinery in motion and by the cleanliness of the composition." And even Ford's managers marveled at Rivera's precision: "The function of the machinery was so well understood that when the engineers looked at the finished murals they found each part accurately designed."[1]

But *Detroit Industry* was more than a faithful depiction of the manufacturing process: it was a tribute to industry, a celebration of machinery, and a passionate homage to modern technology. The mural depicts a factory staffed by enthusiastic workers of all ages and races, all cooperating and

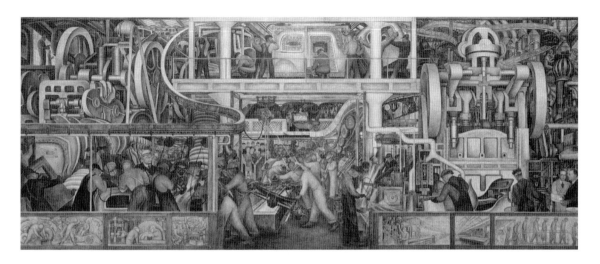

1. Diego Rivera, *Detroit Industry,* south wall (1932–1933). Gift of Edsel B. Ford. Photograph © 2001 The Detroit Institute of Arts.

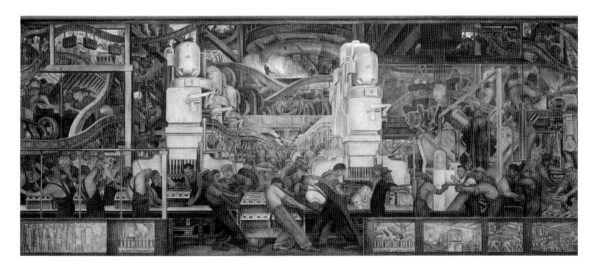

2. Diego Rivera, *Detroit Industry,* north wall (1932–1933). Gift of Edsel B. Ford. Photograph © 2001 The Detroit Institute of Arts.

joining forces for a common goal, the production of automobiles. Their lives are devoted to constructing machines, and they live in a mechanical world – engines and presses tower over them, surrounding them on all sides. Their existence has been entirely mechanized, and the effects of this all-encompassing industrialization could not be more positive: the workers live in perfect harmony with one another and with the machines, and their countenances reveal a seriousness of purpose and a complete engagement with their work. They are healthy and highly motivated, and they live together in a peaceful, mechanical world that does not exhibit the slightest hint of discord, labor tensions, or social strife. These workers inhabit a technological utopia – a new world that seems to confirm Rivera's belief, expressed eloquently in his memoirs, that machines would ultimately bring about humankind's "liberation from drudgery and poverty."[2]

Rivera's unbridled enthusiasm for machines and their effect on society was shared by many Mexican writers and artists of the postrevolutionary era. The 1920s and 1930s comprised a period of newly found peace and stability that came after nearly ten years of civil war, a new beginning marked by governmental efforts to catch up with the twentieth century by modernizing the country at a dizzying pace. During these years, an unprecedented number of intellectuals used their work to examine technology's impact on society and culture. While the presence of machines was not new – Porfirio Díaz had been an enthusiastic supporter of modern technology, and his regime sponsored the construction of railways, the import of automobiles, and the commercialization of typewriters and adding machines – what was a novelty in the postrevolutionary years was the sudden interest that writers and artists expressed in technological artifacts.

Though there had been plenty of machines during the Porfiriato, most intellectuals had treated them with disdain: they considered them telltale symptoms of a decadent society that had strayed away from the lofty ideals of *modernismo* – the dominant literary school in the nineteenth century – that included a passion for nature and classical antiquity and a desire to keep art on a marble pedestal, high above the problems and encumbrances of everyday life. In a statement that was symptomatic of his entire generation's view of machines, Manuel Gutiérrez Nájera, Mexico's best-known *modernista*, who often wrote under the pseudonym "El Duque Job," lamented that machines – those vulgar creations of modern society – were noisy pollutants that distracted writers from their divine mission. Life in Mexico, he wrote in 1881, had been spoiled by "the asthmatic

wheezing of locomotives, the irritating screeching of railways, and the whistling of factories"– irruptions of modernity that made it increasingly difficult for writers to focus on "the gardens of Academus, the celebrations of Aspasia, the tree of Piraeus, and the soft speech of poets."[3] For the *modernistas,* literature offered a flight from reality into the ideal world of classical antiquity, with its marble statues and peaceful gardens, and machines were annoying disturbances that interfered with the poets' lofty task. Octavio Paz has succinctly explained the *modernistas'* uncomfortable relation to an incipient modernity: "they are not fascinated by the machine, the essence of the modern world, but by *art nouveau.* For them modernity is not about industry but about luxury. Not the straight line but the arabesques of Aubrey Beardsley."[4]

The situation could not have been more different in the 1920s. Not only had machines and other manifestations of technological modernity – automobiles, airplanes, cameras, radios, and typewriters – become a common sight throughout the country, but suddenly these inventions sparked the imagination of a new generation of writers and artists. If Gutiérrez Nájera had dismissed machines as noisy distractions, Manuel Maples Arce praised them as a model for modern literature in his 1921 "Manifesto of Estridentismo," a document that exalted the stridencies of modern life – along with "the aristocracy of gasoline"– as crucial elements for the renewal of Mexican literature. And the young poet was not alone in his enthusiasm for the mechanisms of modernity: Luis Quintanilla published poetry collections devoted to airplanes and radios; Salvador Novo wrote countless texts about radio and automobiles and contributed to *El Chafirete,* a trade journal for auto drivers; Xavier Villaurrutia composed a poem to the phonograph and its mechanical reproduction of sound; Jaime Torres Bodet wrote experimental novels packed with typewriters, phonographs, cameras, and automobiles; the photographer Tina Modotti raced around the capital snapping photos of industrial complexes and the latest building projects commissioned by the administrations of Álvaro Obregón and Plutarco Elías Calles; and even conservative figures like José Vasconcelos, Obregón's Minister of Education, devoted his most famous work, *The Cosmic Race* (1925), to imagining a future society in which machines and technological artifacts would lead Latin America to triumph over the United States.

Along with these diverse figures, Diego Rivera had been carried away by the wave of enthusiasm for modern technology that had swept through Mexico in the 1920s and 1930s. His fascination with technology had begun well before his trip to Detroit in 1932. Rivera had celebrated the

machines of modern industry in most of his works, beginning with the murals he painted on the walls of Mexico's Ministry of Education, which link the rise of industry – represented by factories and smoking chimneys – with the triumph of the revolution in both Mexico and Russia. This technological utopianism appears most clearly in one of the panels of the Ministry's murals titled *The Arsenal* (1928), which shows Zapatista and Bolshevik revolutionaries joining forces in a landscape dominated by industrial machinery. This pairing was a recurrent theme in many of his murals: political and technological revolutions went hand-in-hand, and these two forces would eventually liberate mankind from oppression and suffering.

Rivera's interest in technology surged after his first projects in the United States. His *Allegory of California* (1931), painted on the walls of the Pacific Stock Exchange, celebrates technology as a powerful catalyst for the prosperity of California: the mural shows airplanes, engineers, industrial complexes, and towering structures coexisting harmoniously with idyllic agricultural landscapes. And in *The Making of a Fresco Showing the Construction of a City,* painted at the San Francisco Arts Institute in the same year, Rivera shows men of all races working together as they operate heavy machinery to build a modern city dominated by skyscrapers.

Rivera's passion for industrial machines was invigorated by his stay in Detroit, and it peaked in 1933, during the production of the ill-fated mural that was to have graced the walls of Rockefeller Center's RCA tower in New York City. As is well known, the mural (bearing the inordinately long title *Man at the Crossroads Looking with Hope and High Vision to the Choosing of a New and Better Future*) was destroyed in 1934 when Rivera insisted on including a portrait of Lenin; it was recreated in Mexico City the following year. The mural depicts a man as the technical controller of the universe: from his position at the center of the painting, this ur-engineer governs a completely mechanized universe populated by electrical transformers, microscopes and telescopes, an X-ray apparatus, plus numerous tanks, gears, and other such artifacts. Rivera's man has become one with the machines that surround him, an android who has gained complete control over the world.

As we can see from this brief overview of Rivera's murals, the artist had an almost religious faith in technological utopianism. He saw technology in all its modern manifestations – factories, industrial complexes, machinery, engineering, and scientific research – as a powerful force that would

lead humankind to a better future and would advance the goals of socialism by producing a kinder society where all men and women, regardless of race or creed, would live together in harmony and peace, united by the common goal of building a better world. And mural painting played a crucial role in the construction of the future technological utopia, since the purpose of Rivera's frescos was to enlighten the masses about the importance of technology for Mexican – and world – history.

But despite his enthusiasm for machines and for their beneficial effects on everything from agriculture to class consciousness, Rivera seemed to have little use for technology in his own art. At a time when artists in Mexico and the rest of the world were experimenting with the mechanization of artistic production through the use of photography, film, radio broadcast, gramophone recordings, and the adoption of collage and other techniques that deployed industrial processes like cutting and splicing, Rivera chose an art form – mural painting – that appears better suited for illustrating ancient biblical scenes than for extolling the virtues of twentieth-century machinery.

Rivera actually chose murals over more modern painting techniques, and this choice led him to privilege the art forms of the past. When the artist

returned to Mexico in 1921 after a prolonged stay in Europe during which he had experimented with cubism, Vasconcelos commissioned him to paint a historical cycle on the walls of the newly founded Ministry of Education in Mexico City and sent him to Italy to study the walls of churches and monasteries. Rivera liked what he saw and expressed no interest in modernizing the Italian fresco techniques, no desire to incorporate modern artistic procedures into his murals; on the contrary, he decided to delve even further into the past in search of the ideal painting technique. He was inspired not only by Renaissance art but by pre-Columbian wall painting: in an attempt to recreate the art form of the Aztecs, he spiked his paint mix with cactus juice. Rivera proudly asserted "that he was using the same process to decorate the walls of the Ministry of Education as the Aztecs had used at Tenochtitlán."[5]

By the time he went to Detroit, Rivera had long abandoned his use of cactus juice as paint binder. The experiment had proved to be a disaster when the mixture rotted and stained the murals, leaving them in the same ruined condition as the Aztec wall paintings the artist so admired. But he remained mired in the contradiction between his subject matter – modern technology and its positive effects on society – and his choice of artistic

technique – fresco painting, which was an art form of the past.

As Walter Benjamin argued in his "Work of Art" essay (written around the same time as Rivera completed his Detroit cycle), murals were one of the most aura-laden art forms. The German critic writes that mural painting was the antithesis of photography and other new media. If murals were unique, photography was infinitely reproducible; if murals inspired awe and distance, photography was accessible and down-to-earth; if murals were the art form of the past, photography was that of the future. Murals were fixed, while photography was movable and transportable, like airplanes, automobiles, and other machines of the modern era.[6]

Rivera's choice of mural painting over photography or other archetypically modern art forms like film or collage was quite an anomaly for an artist of his generation. By 1930, artists around the world – from the Mexican Estridentistas to the Brazilian *modernistas,* from the Spanish *ultraístas* to the Russian futurists – had written a considerable number of treatises, manifestos, and declarations about the relation between artistic technique and the mechanical processes that defined twentieth-century modernity. While their positions varied considerably, many of these figures believed that technology would inevitably transform not only artistic processes but life in general. The ques-

tion – as Leon Trotsky, Walter Benjamin, and Theodor Adorno argued – was not "Is technology a valid subject for artistic work?" but rather "How will technology transform art?"

One of the most articulate voices of the time, the Peruvian poet César Vallejo, argued that poets should not merely write about machines, but that they should instead explore how poetic techniques could be made to reflect the influence of mechanical processes. Technology had to be "assimilated" into poetic creation, and not merely named, a superficial act that would do little besides "filling our mouths with late-model words."[7]

Vallejo's call to assimilate technological influences into artistic technique was precisely what was missing in Rivera's murals. His creations brimmed with "late-model images" (and late-model Fords), but the artist seemed unaware that machines and mechanical processes could have a more profound effect on his work beyond appearing as subjects of representation.

But what would have been the alternative to Rivera's purely thematic treatment of technology? How could he have assimilated – to use Vallejo's term – mechanical processes into his artistic technique? What would a technologically inflected mural look like? Ironically, the answer to these questions can be found in Rivera's own work. One of the panels in *Detroit Industry* – the "vaccination" panel, which caused a scandal because its depiction

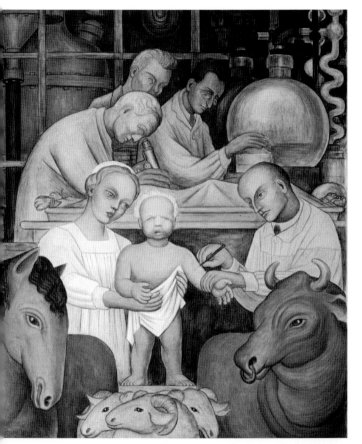

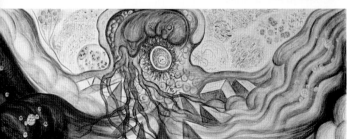

of a doctor and a nurse vaccinating a child was read as a modernized version of the holy family (figure 3)—shows a scientist looking into a microscope. A small panel directly below shows us what the doctor sees through his apparatus: sights that are normally invisible to the naked eye, a microscopic world of cells and embryos made visible by the optical advances of modern science. Technology, as the panel demonstrates, has transformed our visual understanding of the world.

In many of his murals, Rivera celebrates the new technologies of seeing brought about by modern science. In *Man at the Crossroads*, the controller of the universe is flanked by two giant elliptic lenses offering macroscopic and microscopic views of the world: the telescopic lens reveals planets and constellations of stars, while its microscopic counterpart shows cells, bacteria, and other microorganisms. Microscopes and telescopes (as well as the X-ray machine, another invention that makes frequent appearances in Rivera's murals) contribute to man's mastery of the world; these optical technologies make possible a new vision, more powerful, more complex, and more sophisticated than previous ways of seeing. Vision played a crucial role in Rivera's technological utopianism: machines would create a better world in part by introducing new modes of seeing that would guarantee a better understanding of the secrets of the universe, both macroscopic and microscopic.

3. Vaccination panel, detail from Diego Rivera, *Detroit Industry* (1932–1933). Gift of Edsel B. Ford. Photograph © 2001 The Detroit Institute of Arts.

Rivera was not alone in associating the rise of technology with an optical revolution: throughout the 1920s and 1930s, artists around the world exalted the new ways of seeing that had been made possible by technological advancements. In Germany, the Hungarian-born László Moholy-Nagy published a book announcing the emergence of a "new vision" in the arts; in the Soviet Union, Aleksandr Rodchenko urged artists to "revolutionize" their "visual reasoning"; and in Mexico, David Alfaro Siqueiros praised technology's potential to produce more "exact" portrayals of reality.[8] In a statement that echoes Rivera's passion for microscopes and telescopes, the critic Walter Benjamin argued that optical technologies, by making visible details that had been inaccessible to the naked eye, provided glimpses into an "optical unconscious" whose mysteries paralleled those of the psychic unconscious.

But unlike Rivera, these advocates of a new vision pointed to photography – rather than microscopes or telescopes – as the optical technology that would revolutionize our seeing. "Modern life is no longer thinkable without photography," wrote Albert Renger-Patzsch.[9] Rodchenko argued that the artifacts of modernity – skyscrapers, radio antennae, industrial towers – could only be appreciated in all their greatness through the mechanical

eye of the camera: the vast scale of modern inventions has "redirected . . . the normal psychology of visual perception," and "only the camera is capable of reflecting contemporary life."[10]

Advocates of the new vision shared Rivera's technological utopianism, but they took their enthusiasm for the optical revolution in another direction: they concluded that in the modern world photography would ultimately replace painting. The suggestion would appear a bit extreme, were it not for the fact that it came from artists who had traded the brush for the camera; Rodchenko dismissed painting as an outdated technique, incapable of representing the complexities of modern life,[11] and Moholy-Nagy was even more radical in his rejection of what he denounced as an outdated art form: "My conscience asks incessantly," he confessed, "is it right to become a painter in times of social revolution?"[12]

Rivera, on the other hand, was determined to stick to murals. He never seems to have considered that his passion for technology – for its utopian effects on society and its transformation of vision – made photography a more logical medium than fresco painting. Even as he celebrated microscopes, telescopes, and X-ray machines as optical technologies that had revolutionized our ability to see the world, the muralist never thought of exper-

imenting with a camera and revolutionizing his own vision. This fact is not surprising if one considers his technological record: despite his fascination with automobiles, his friendship with Edsel Ford, and his prolonged stay in the automotive capital of the world, Diego Rivera never learned how to drive a car (Edsel Ford gave him a car as a present, and one of the studio assistants doubled as a chauffeur).[13] The muralist failed to modernize either his vision or his locomotion; he loved technology, but preferred to keep it at arm's length. He celebrated the technological transformation of society, but was uninterested in opening his own experience to the transformative powers of technology.

But isn't the suggestion that Rivera should have embraced photography somewhat extreme? After all, the fact that a few painters traded their brushes for cameras does not mean that all artists had to follow suit. There were plenty of painters – in Mexico and elsewhere – who continued to work after the rise of photography, and many of them produced work that was undeniably modern. Isn't it excessive to claim that photography was the only medium capable of representing the modern era? Can't mural painting, despite its premodern origins, present a revolutionary vision of the world? Or are there aspects of the world that can only be seen through the mechanical eye of a camera?

It would indeed seem outrageous to suggest that the muralist should have learned to use a camera (and to drive a car), were it not for the following fact: Rivera painted many of the scenes in *Detroit Industry* from photographs of the Ford plant taken by Charles Sheeler in 1927 (the photographer had been hired to document the machines at the River Rouge plant for use in Ford's promotional materials), and thus the mural has a photographic foundation.[14] The muralist's working process confirms Rodchenko's assertion that the structures of modernity – skyscrapers, industrial plants, and towers – are best seen through the mechanical eye of a camera and not by the naked eye. In order to really "see" the heavy machinery at the Ford plant, Rivera relied on a photographic lens.

The reader might object that this interpretation makes too much of Rivera's use of Sheeler's photographs. After all, Rivera had seen the machines at the Ford plant with his own eyes, unmediated by any photographic apparatus, and perhaps he was merely using the photos – along with numerous handcrafted sketches – as mnemonic aids. And even if the muralist made use of photographic prints, wasn't he ultimately painting what he saw? What difference does it make if he used photos, sketches, or handwritten notes to reconstruct the mechanical sights that had been before his eyes?

But Rivera did not always paint what he saw with his own eyes. The stamping press that towers over the workers on the south wall of the mural, for example, is not the machine Rivera saw at the Ford plant in 1932, but a reproduction of an earlier model of the press that the painter had seen only in one of Sheeler's 1927 photographs. Rivera preferred the old press because its external appearance was more dramatic. As Linda Bank Downs explains in her book on *Detroit Industry,* the structure of the old press was "more apparent, making the machine more dramatically anthropomorphic" (see figures 4, 5, and 9).[15] Rivera's choice is significant because it reveals that he was less interested in technological efficiency (the new press was obviously more productive than the old one) than in surface appearance (the old press had a more mechanical look). And this is not the only example of the muralist's dependence on Sheeler's photographs. As Downs shows, "Rivera heavily relied on the use of photographs for many mural passages even when he had made many sketches of the same machines or workers."[16]

In many of the *Detroit Industry* scenes, Rivera painted not what he had seen, but what Sheeler had photographed. And in this translation from photograph to mural something was lost. One of the reasons that photographers from Modotti to Moholy-Nagy insisted on photography's superiority

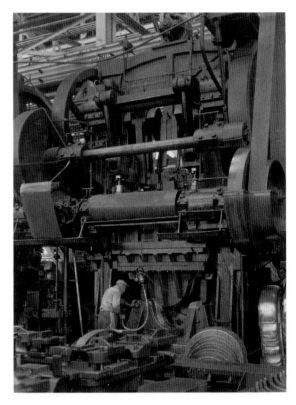

4. Charles Sheeler, *Stamping Press — Ford Plant* (1927). Photograph, silver gelatin print. © The Lane Collection. Courtesy Museum of Fine Arts, Boston.

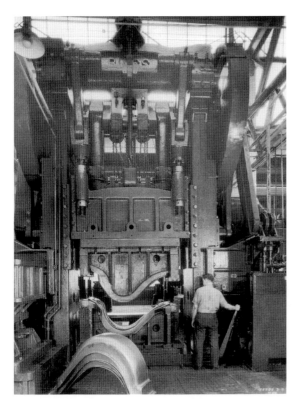

5. Photo of the stamping press at the Ford River Rouge plant in 1932. From the collections of the Henry Ford, Dearborn, Michigan.

over painting and on its political significance during "times of social revolution" was the medium's capacity to produce an accurate representation of reality: as long as photography was "straight"–unadulterated by retouching or other darkroom manipulations–it produced a photochemical, indexical imprint of the scene that stood before the camera's lens.[17] Many critics stressed the "veracity" and "unequivocalness" of the photographic medium, traits that made it a perfect tool for political activists from Mexico City to Berlin and from New York to Moscow. But it is precisely photography's indexicality that gets lost in Rivera's passage from photo to mural: the scenes in *Detroit Industry,* unlike Sheeler's photographs, are far from an accurate document of the Ford factory as it stood in 1932.

Whereas modernist photographers aspired to produce prints that accurately documented the real world, Rivera painted murals that skewed the reality of 1932 Detroit. His depiction of a stamping press that no longer existed when he visited the Ford plant is but one example; throughout the mural, Rivera altered what he had actually seen in order to embellish his portrait of the automotive factory and its political significance. If we compare Rivera's mural to photographs of the River Rouge plant in the 1930s, we discover the extent to which Rivera took liberties in depicting the lives

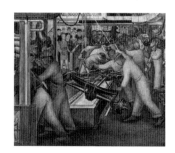

6. Detail of final assembly from Diego Rivera, *Detroit Industry,* north wall (1932–1933). Gift of Edsel B. Ford. Photograph © 2001 The Detroit Institute of Arts.

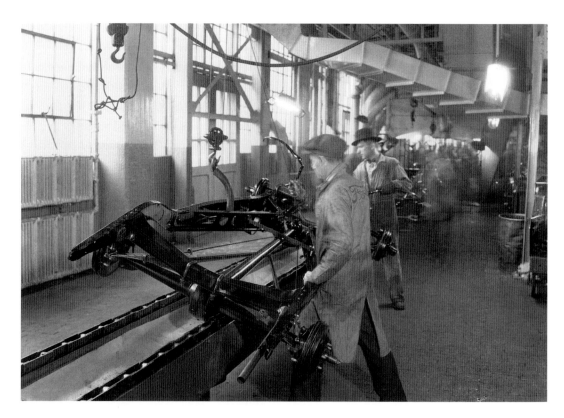

7. W. J. Stettler, photograph of final assembly, Ford River Rouge plant. Photo © 1932 The Detroit Institute of Arts.

of Detroit's auto workers. In figures 6 and 7, for example, we can see that Rivera's mural shows an assembly line teeming with workers, whereas a photograph taken by W. J. Stettler, a commercial photographer hired by Ford, reveals that only two men were assigned to the conveyor. The photo, a historical document, shows that even giant factories like Ford's had to cut jobs during the Great Depression: where a dozen had worked, only two remained. Rivera, in contrast, does not paint the grim reality that he witnessed at the River Rouge plant, but a utopian fantasy: a thriving workplace that goes on as if the depression had not decimated the number of men employed by the automobile industry.

Rivera also altered the workers' dress to make them conform to his vision of proletarians: Stettler's photo shows assembly line operators wearing simple frocks, but the mural presents them in overalls, which Rivera considered a more class-conscious apparel for factory workers.[18] But in addition to these minor details, Rivera's mural presents a grossly inaccurate view of the situation in Detroit's factories during the 1930s. While *Detroit Industry* portrays a harmonious world where men of all races work side by side to build a better and more modern society, 1932 Detroit was a city devastated by the Great Depression, troubled by organized crime, and often immobilized by street protests against the unfair labor practices of the Ford Motor Company. Though the city's strife was well documented in the press, which routinely published photographs of the workers' demonstrations, Rivera ignored the facts and painted the Ford plant as a technological utopia.

Desmond Rochfort has described the disjunction between Rivera's mural and the social conditions prevalent in 1930s Detroit:

By the standards and criteria of his own radical Marxist ideology, Rivera's view of Detroit's massive complex of capitalist production was not critical, but paradoxically celebratory. The sharp daily realities of the economic depression that had hit Detroit, as elsewhere in the United States, did not enter Rivera's vision at all. Detroit, in 1932, was in fact a city riddled with Mafia gangsterism, racism, and virulent anticommunism. There was considerable unemployment, and production at Ford was only a fifth of what it had been in 1929. Strikes, soup kitchens and bread lines were a daily reality, and the Ford Company's antagonism to organised labour had been well summed up in Henry Ford's famous dictum: "people are never so likely to be wrong as when they are organised."[19]

For all Rivera's enthusiasm about modern technology and its potential to revolutionize human experience, he seems to have been blind to the profound antitechnological impulse that

permeated *Detroit Industry*. In an age dominated by worldwide calls for artists to embrace a photographic "new vision," Rivera insisted on working in the entirely unmodern medium of fresco painting. But the muralist was not only resisting photography: by transforming photographs into embellished murals, Rivera was in fact subverting the properties – indexicality and mechanical reproducibility – that made photography both radically modern and politically revolutionary.

Despite Rivera's obsession with the future – and his paradoxical assertion that the mural was "the art form of the industrial society of the future"[20] – he was actually working backward by transforming a technological medium – photography – into a handcrafted one – mural painting. The mechanical aspects of photography vanish as the medium is put at the service of an artistic technique unearthed from the distant past. The stamping press featured in *Detroit Industry* clearly illustrates Rivera's process of working backward: the depiction of the press is based not only on Sheeler's 1927 photograph, but also on an image from a much more distant past – the stone statue of Coatlicue, the Aztec goddess of the earth (figure 8 and figure 9). Rivera saw the stamping press less as symbol of the technological future than as proof that the Aztec past lived on in the present. And had not the painter's experiments proved so disastrous during his work at the Ministry of Education, it is

entirely conceivable that his obsession with the pre-Columbian world would have inspired him to use cactus juices to paint the modern scenes he found in Ford's automotive plant; his is a vision of modernity seen not through the mechanical eye of the camera but through rose-tinted lenses.

Rivera's Detroit mural is a project riddled with contradictions: it celebrates the future while turning to the past, it promotes the new technologies of seeing while employing a traditional artistic medium, and it glorifies an industry that was mired in labor tensions. Critics have attempted to explain these incongruities in various ways: some, including Max Kozloff and Laurance Hurlburt, suggest that Rivera's glorified depiction of the Ford plant was at odds with his Marxist views and that he failed to highlight the exploitative nature of the industry under capitalist society; others argue that the disjunction between reality and representation was a political strategy on his part. Terry Smith, for instance, believes that Rivera was fully aware of the harsh labor conditions at the automotive plant, but that *Detroit Industry* deliberately presents a more humane model for organizing a factory, one in which workers and not profits occupy center stage.[21]

These critics focus on the thematic content of *Detroit Industry* and highlight the contradiction between the grim reality of Detroit and its idealized representation in the mural. But there is a key

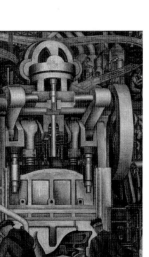

element that has been left out of this discussion: Rivera's use of media.

Rivera was fascinated not only by automobiles, factories, and microscopes, but also by the new media that constitute the focus of this book. Cameras, typewriters, radios, and cement structures appear prominently in his work. The "Pharmaceutics" panel in *Detroit Industry* (figure 10), for instance, features a man operating a series of modern machines: his right hand presses the keys of an adding/writing machine (set on top of a radio receiver) and is within reach of a black telephone. A microphone rises over his shoulder and there is a loudspeaker under his desk. He is an archetypal modern subject with prosthetic extensions of the senses at his disposal: he speaks, listens, writes, and communicates through modern devices.

Rivera's work celebrates the way in which these media have transformed our understanding of the world, but it does so – as I have tried to show in this introduction – from a purely thematic approach. The more pressing question of how these technological inventions have transformed the possibilities of artistic representation are conspicuously absent from his murals. Questions about media were a blind spot in Rivera's vision of technology.

It is precisely the muralist's blindness on these issues that this book seeks to elucidate. By

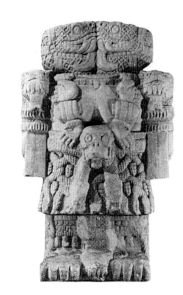

8. The Aztec goddess Coatlicue. Stone statue. Museum of Anthropology, Mexico City.

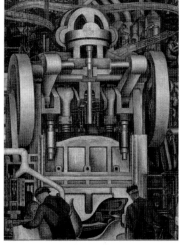

9. Stamping press, detail from Diego Rivera, *Detroit Industry,* south wall (1932–1933). Gift of Edsel B. Ford. Photograph © 2001 The Detroit Institute of Arts.

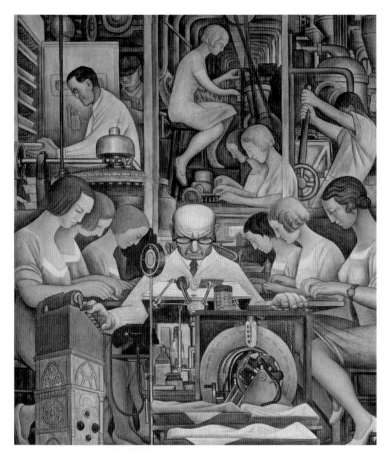

10. Diego Rivera, "Pharmaceutics," detail from *Detroit Industry* (1932–1933). Gift of Edsel B. Ford. Photograph © 2001 The Detroit Institute of Arts.

examining the technological transformation of media in postrevolutionary Mexico, I will address the many questions that Rivera left unanswered. My discussion will be concerned less with works like *Detroit Industry,* in which technology appears merely as a theme, than with works in which artists and writers explored the effects of modernity on artistic media.

As Friedrich Kittler has shown in his two influential studies, *Discourse Networks 1800/1900* and *Gramophone, Film, Typewriter,* the technological transformation of media in the early twentieth century was an extremely complex process with significant cultural and political repercussions. Before Kittler, most studies of aesthetic responses to modernization – think, for instance, of Leo Marx's *The Machine in the Garden* or Lily Litvak's *A Dream of Arcadia* – assumed that technology could enter literature only as a subject of representation, and their discussions focused on the simple question of whether a particular author depicted machines in a positive or negative light. Kittler, on the other hand, shifts the focus from thematic concerns to mediatic questions, and argues that regardless of subject matter, technologically inflected representations bear the traces of mechanization's impact on modern culture. It is the medium – and not the message – that deserves attention. Following Kittler and other media theo-

rists like Hans Ulrich Gumbrecht, my analysis will focus on three crucial characteristics of early media.

First, new technologies of representation introduced a radically new perception of reality. Not only does the world look different though the lens of a camera and sound different through a radio broadcast, but there are sights and sounds that can be perceived only with the aid of these machines. Beginning in the 1920s, media-savvy artists became interested in the modalities of perception that had been inaccessible before the invention of new technologies. In his writings on photography and film, Walter Benjamin argued that the camera renders visible aspects of reality that escape the naked eye. Extreme close-ups, slow motion, and other photographic techniques provide glimpses of what the German critic calls an "optical unconscious," an uncharted territory that, like its psychic counterpart, contains countless secrets that are inaccessible to the naked eye. In Tina Modotti's photograph of a piece of crumpled tinfoil (figure 11), for example, the camera captures minuscule attributes of the material that would escape the eye of viewers devoid of a mechanical apparatus. Modotti's photo reveals the elaborate geometric patterns formed by the crumples, the glittering of light and shade reflected in the creases. These visual characteristics exist in an

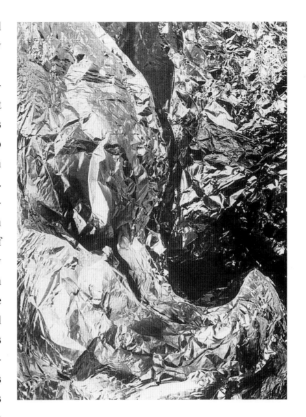

11. Tina Modotti, *Crumpled Tinfoil* (1926). SINAFO-Fototeca Nacional, Mexico City.

optically unconscious state, and it is only through the photographic lens that they can surface into visual consciousness. Like Modotti's camera, new media function as prosthetic instruments to probe the sensory unconscious of the world we inhabit.

Modotti's *Crumpled Tinfoil* is the perfect counterpart to Rivera's paintings of new techniques of seeing. Rivera was fascinated by microscopes, telescopes, and other artifacts that could see what remained inaccessible to the naked eye, but his paintings of cell life or astral worlds merely approximate the experience of discovering a new world through one of these lenses. In contrast, Modotti turns her camera into a microscope: confronted with her *Crumpled Tinfoil,* the viewer experiences the same revelation of an optical unconscious as the photographer. Photographer and viewer see eye to eye.

Machines played an important part in the exploration of modernity's optical unconscious. In Mexico, photographers Tina Modotti, Agustín Jiménez, and Manuel Álvarez Bravo discovered that the camera was especially well suited for "seeing" modern machinery. Extreme close-ups, sharp focus, and close cropping allowed photography to reveal visual details of machines that are imperceptible to the human eye. The best way to see mechanical artifacts, these photographers concluded, was through the mechanical eye of the camera, another machine. Diego Rivera reached a similar conclusion – he chose to see Ford's industrial complex through the lens of Sheeler's camera – but in the finished mural he disavowed his debt to photography.

Second: technological media are not mere tools at the service of representation; on the contrary, they shape, define, and determine the possibilities of representation. "Media," writes Kittler in *Gramophone, Film, Typewriter,* "determine our situation." He points to Nietzsche's experience with the typewriter as an example: when the German philosopher began to type, the machine altered his style of writing, leading him to abandon long treatises in favor of aphorisms composed in a short, telegraphic style.[22] "Our writing materials contribute their part to our thinking," mused Nietzsche in one of his typed letters, suggesting that the typewriter mechanizes writing not only by producing texts that look different from handwritten ones, but by forcing the operator to adapt his thinking and working process to the rhythms of a machine.[23] Theodor Adorno put it succinctly: "the transition from artisanal to industrial production transforms not only the technology of distribution but also that which is distributed."[24]

Kittler's assertion that media determine the possibilities of representation gives a new twist to the tensions between painting and photography

that Rivera elided during his work on *Detroit Industry:* regardless of its subject matter, a photograph will always bear the imprint of the mechanical processes of its creation. Just as a phonograph record has grooves – which are graphic traces of the mechanical inscription of sound – every mechanically produced representation registers the technological processes by which it was created. Thus, a photograph depicting an apparently nontechnological subject – for example, Modotti's close-up of tinfoil – provides a more compelling illustration of how mechanization has transformed representation than Rivera's murals, which despite their exaltation of technology are executed in a medium that is untouched by mechanical processes.

Third: media are historically determined. It is not mere coincidence that photographic, filmic, phonographic, and typewriting machines all appeared at the same point in history, in the last decades of the nineteenth century. The emergence of these new media went hand in hand with a discursive shift that Kittler has called "the discourse network of 1900." Technological innovations do not arise out of thin air; they are the culmination of historical and cultural processes. As an example, Kittler points to the repercussions of nineteenth-century political transformations on the aesthetic and technological spheres. Between 1800 and 1900, as Europe became increasingly industrialized, intellectuals moved away from the metaphysical themes of romanticism to the materialist aesthetics of modernism, and technologies of representation shifted from handcrafted to mechanized processes. "Around 1880," Kittler writes, "poetry turned into literature. Standardized letters were no longer to transmit Keller's blood or Hoffman's inner forms, but rather a new and elegant tautology of technicians."[25] Typewritten texts – and the literature of the machine age in general – were no longer suited for communicating metaphysical themes ("Keller's blood or Hoffman's inner forms"), and turned instead to representing the technical reality of the modern era. Together, these historical, cultural, and technological changes constitute the shift "from the symbol-based discourse network of 1800 to the technology-based discourse network of 1900."[26]

In his analysis of European culture, Kittler locates the major shift in discourse networks around 1900. A similar discursive shift occurred in Mexico, but the decisive date was 1920 – the year the Mexican Revolution came to an end, Álvaro Obregón became president, and the government embarked on an unprecedented modernizing campaign encompassing everything from education to urbanism. The Porfiriato's discourse network – governed by the antitechnological aesthetics of

modernismo – quickly ceded ground to a postrevolutionary discourse network, characterized in the political sphere by the country's rapid modernization and in the cultural realm by the embrace of new media and a widespread interest in machine aesthetics.

During the two decades following the end of the revolution in 1920, Mexico modernized at a dizzying speed. The government, under the leadership of presidents Álvaro Obregón and Plutarco Elías Calles, built roads – it planned a network of highways "traversing the nation from ocean to ocean and from border to border" – paved city streets, and set out to completely rebuild a nation devastated by a decade of civil war. In the capital, the city government published lavish spreads in *El Universal Ilustrado*, the most widely circulated illustrated weekly, advertising its endless modernizing projects: the demolition of slums, the ban of unhygienic open-air markets, the inauguration of a Ministry of Health (housed in a building that was photographed by Modotti), the widening of boulevards, the electrification of poor urban areas, the inauguration of tramway and bus services. Whereas Mexico City in 1920 was a sleepy town pockmarked by the repeated assaults of rifle-wielding caudillos, by 1940 it had become a bustling metropolis full of contrasts. Carleton Beals, the correspondent of *New Masses*, eloquently described the uneven process of modernization in Mexico City around 1931:

It is not a city of one texture, but a city of wide latitudes – from the hovels of Colonia Vallejo to the Hippodrome subdivision, as modern as Forest Hills; from the open-air markets, buzzing with Indian chatter, to tall department stores covering city blocks; from the lowly wayside shrine to the enormous cathedral, the largest church in the Western Hemisphere; from the loaded burro to the latest model limousines and the aeroplanes of Valbuena [*sic*]; from medicine women to Doctor Herrero, who has artificially created life in his laboratories; from the curb restaurant with its brick-colored stew to Sanborn's in the Palace of Tiles and the elegant Sylvaine's.[27]

Modernity and tradition, mechanical and manual labor coexisted – not always as harmoniously as Beals would have it – on the streets of Mexico City.

Mexico's uneven modernization brought with it hundreds of technological artifacts. The number of telephones installed in private homes grew exponentially after the revolution, and the Canadian-owned Compañía de Luz y Fuerza brought electricity to new neighborhoods every week. Ordinary people discovered photography and experienced the pleasures of both having their picture taken and snapping shots. The first radio stations began broadcasting in Mexico City in 1923, and

within a few months thousands of the city's inhabitants were tuning their newly acquired receptors to the latest news and musical programs. Typewriters – once the privilege of executives and their secretaries – could now be found in many homes, and modern writers, in sharp contrast to their Porfirian counterparts, celebrated the novelty of the writing machine in typewritten novels and poems. In 1924, the Ford Motor Company entered the Mexican market and soon after everyone dreamed of driving a brand-new car. Cementos Tolteca, which despite its autochthonous name was a British-owned firm, popularized the use of a radically new building material called Portland cement, and by the mid-twenties architects and engineers had erected entire neighborhoods, like Colonia Condesa, Mexico City's art deco district, entirely out of reinforced concrete structures.

In sharp contrast to Porfirian intellectuals' disdain of the modern, writers and artists of the 1920s and 1930s embraced the new technological media and wrote elegant accounts of their mechanical encounters. Tina Modotti used photography to depict the increased mechanization of everyday life; novelists from Mariano Azuela to Martín Luis Guzmán traded their pens for typewriters and created the first mechanically produced texts in the history of Mexican letters; the Estridentista poets Manuel Maples Arce and Kyn Taniya composed poems about radio and broadcast their voices over the airwaves; Juan O'Gorman and his fellow converts to functionalism embraced cement as the quintessentially modern building material and erected dozens of buildings – including a studio for Diego Rivera and Frida Kahlo in San Ángel – promoting the "aesthetics of cement"; and even José Vasconcelos, a conservative figure not usually associated with technophiles, closed his treatise on *The Cosmic Race* with a passionate tribute to the powers of modern technology. Not even the harmonious realm of music was safe from the technological madness: in 1926, the composer Carlos Chávez participated in a "mechanical ballet" scored for electric bells and airplane propellers, and a decade later he published a treatise calling for a "new music" inspired by electricity.[28]

In his writings on technology, Kittler associates four artifacts with the rise of the discourse network of 1900: the camera, the gramophone, the radio, and the typewriter. The German critic chose these four machines not only because they brought about the mechanization of visual, aural, and textual forms of representation, but because they inspired numerous literary texts, from Rilke's "Primal Sound" to Cocteau's play *The Typewriter*. The inventory of culturally significant artifacts was slightly different in Mexico, however, because modernization and intellectual responses to technology

evolved in a very different historical context there from that of European countries. The gramophone, for example, inspired comparatively little discussion among Mexican intellectuals, while other modern inventions that are largely absent from Kittler's studies, like cement, sparked intense literary and artistic debates.

My discussion of cultural responses to technological media in Mexico will focus on five artifacts: cameras, typewriters, radio, cement, and stadiums. Like Kittler's four machines, each of these new technological inventions contributed their part to the mechanization of cultural production: cameras mechanized vision and introduced new technologies for seeing the modern world; the typewriter mechanized writing and inspired a modern literary aesthetics that sought to break with the *modernista* models prevalent in the Porfirian era; radio mechanized the perception of sound and gave rise to a new aural art; cement mechanized architecture by replacing hand-crafted building materials with the industrially produced components of reinforced concrete; and stadiums – this study's most surprising finding – mechanized political spectacle by providing a stage for mass rallies and ceremonies in which the industrial processes of Fordism and Taylorism were applied to human bodies. The five chapters in this book examine the cultural repercussions of each of these artifacts in postrevolutionary Mexico:

Chapter 1 will discuss Tina Modotti's industrial photographs and their relation to contemporary debates on the role of photography in the modern era. With her depictions of oil tanks, telephone wires, and typewriters, Modotti was the first photographer in Mexico to explore photography's potential as a radically new technology of representation. In sharp contrast to Diego Rivera, Modotti portrayed machines and industrial scenes while also incorporating the latest technological developments into her medium of representation. At a time when most Mexican photographers made "artistic" prints that imitated the conventions of painting – soft-focus, hand-colored negatives featuring impressionistic, blurry scenes – Modotti favored techniques that were available only to the camera, including sharp focus, close-ups, and oblique angles. By using these novel strategies to capture industrial images, Modotti highlighted the kinship between photography and other technologies of the modern era. While artistic photographers attempted to disguise photography's mechanical underpinnings, she celebrated the fact that the camera, like the tanks and typewriters she photographed, was a product of the modern era.

The chapter on cameras will highlight a crucial aspect of Modotti's work that has gone unexamined: the history behind the technological artifacts depicted in her photographs. Modotti photographed some of the most important public projects built by Obregón and Calles, including the National Stadium and the Ministry of Health in Mexico City. These buildings, keystones of the government's modernizing campaign, were designed as powerful symbols of postrevolutionary ideology. Modotti's work suggests a kinship between photography and the postrevolutionary modernizing projects: revolutionizing vision went hand in hand with revolutionizing the country's infrastructure. Like the stadiums, schools, and office buildings erected in the 1920s, photography was a crucial component of the new Mexico envisioned by the administrations of Obregón and Calles.

If the camera mechanized vision, the typewriter mechanized literary production. Chapter 2 tells the story of typewriting authors in Mexico and of the machine's repercussions on literary aesthetics. Just as the camera sparked a debate between pictorialist and modernist photographers, between supporters and detractors of photography's mechanical underpinnings, the typewriter ignited a similar struggle between typewriting authors who embraced the machine aesthetics of modernity and writers who clung to antiquated

literary models even as they composed their works using a modern machine.

Ironically, the rise of the typewriter in Mexico coincided with the explosion of the revolution. The first author to acknowledge using a typewriter was Mariano Azuela, who composed *Los de abajo* using an Oliver writing machine. This archetypal novel of the Mexican Revolution reflects the condition of its mechanical production in an intriguing passage: after storming a northern town, a horse-riding band of illiterate revolutionaries loot a flashy Oliver and debate the uses of a typewriter in the midst of a civil war, thus suggesting that technological revolution does not always go along with political revolution. But Azuela was not the only typewriting author in revolutionary Mexico: Martín Luis Guzmán, the other novelist of the Mexican Revolution, was also mesmerized by the writing machine and devoted a short story, "Mi amiga la credulidad [My Friend, Credulity]," to the new invention. His text touches on a number of fascinating questions: What effect did typewriting have on literary form? Do typewritten texts register their own mechanical production, as Nietzsche suggested? How do mechanically written texts fit into the aesthetics of modern literature?

Chapter 3 explores the rise of radio broadcasting and its influence on avant-garde poetry. Among the first to experiment with the medium in Mexico

were the young poets belonging to the Estridentista movement, which was modeled loosely on F. T. Marinetti's futurist movement. Like Marinetti, the Estridentistas saw radio as the perfect model for a radically new poetic project: it was a medium characterized by the ability to transcend national boundaries, by the power to simultaneously broadcast a myriad of different programs, by the capacity to transmit the sounds of modernity, including interference and static, and by the potential to inspire a "wireless imagination" capable of revolutionizing literature.

This chapter will examine the Estridentistas' experiments with creating a "radiogenic" literature – a literature that would not merely take radio as a subject, but would use radical textual techniques to replicate the technological marvels of wireless broadcast. I will discuss the radio-inspired poems of two Estridentista writers, Manuel Maples Arce and Kyn Taniya, in relation to contemporaneous discussions about radio and literature by authors like Rudolf Arnheim and André Coeuroy.

While it might be easy to understand why cameras, typewriters, and radio are media – these technological artifacts are used for the communication of visual, textual, and aural messages – the mediatic nature of cement and stadiums, the topics of chapters 4 and 5, is less evident. But just like photography and radio, cement and stadiums were important devices for the transmission of messages. The Obregón and Calles administrations erected cement buildings in general and stadiums in particular as public structures designed to communicate a vision of postrevolutionary modernity to the inhabitants of Mexico City. As Beatriz Colomina has written, architecture is a medium and modern architecture shares more than a temporal overlap with the new media of the twentieth century.[29] Unlike the artifacts studied in the first three chapters, cement buildings and stadiums could also be inhabited – or at least temporarily occupied – thus literally incorporating the country's citizens into the technologies of representation. Like photographic, writing, and broadcasting devices, cement and stadiums mechanized the processes of representation. Cement was an industrially produced material, and it standardized architecture in the same way that the typewriter standardized writing; and the stadiums built in the 1920s were designed to stage spectacular formations in which human bodies were assembled as if they were products on an assembly line.

Chapter 4 explores "the aesthetics of cement" and traces the evolution of the material from a powerful literary symbol in the 1920s to a failed building technique in the 1940s. Forward-looking artists and writers hailed cement as a new technology with the potential to transform the world:

the "magic powder," as one enthusiast called it, was a mechanically produced building material that made possible a new form of architecture. Like modernist photography or radiogenic productions, the new cement architecture – known in Mexico as functionalism – made explicit both its mechanical underpinning and its kinship with other modern artifacts.

Cement and the new architecture it introduced became a powerful source of inspiration for artists and writers. If the Estridentistas celebrated "the wireless imagination," Federico Sánchez Fogarty and his followers extolled the "aesthetics of cement." The quest for a cement-inspired literature began with the publication of *Cement*, the best-selling socialist-realist novel by Fyodor Gladkov, translated into Spanish in 1929. Mexican intellectuals embraced the novel's suggestion that cement would provide a much-needed architectural and social cohesion to a country ravaged by years of civil war. Two magazines published during the 1920s and 1930s, *Cemento* and *Tolteca*, invited artists and writers to explore the powerful symbolism inherent in the new material, an effort that culminated in 1931 with *Tolteca* launching a competition for the best artistic representation of the eponymous cement factory.

Chapter 5 examines stadiums, the most unusual technological medium in postrevolutionary Mexico. In 1924, Vasconcelos erected the National Stadium, a vast open-air auditorium with a capacity of sixty thousand spectators (almost six percent of the population of Mexico City at the time), which he considered the first building in "Universópolis," the utopian city that would serve as the capital of "the cosmic race." After its inauguration, Vasconcelos deployed the stadium as a powerful medium – one that prefigures the Nazi mass events at Nuremberg – for transmitting his messages to the masses of spectators. Just as photography was a new means to disseminate images and radio was a new medium for broadcasting sounds, stadiums were a new technology for communicating political messages to a captive audience of several thousand spectators.

And what messages did Vasconcelos transmit from the stadium? An overview of the rallies held in the National Stadium reveals that modern technology is not always at the service of modernity. Vasconcelos used the stadium, a structure built using modern building techniques, to propagate his profoundly unmodern racial theories. Though Vasconcelos embraced technology and the scientific rationalism it represented, he simultaneously upheld irrational and metaphysical values like "race" and "spirit," the two pillars of his theory of the "cosmic race." Unaware that technology emerges from an intellectual tradition based on

Enlightenment values that is fundamentally incompatible with ultranationalist concerns, Vasconcelos sought to reconcile contradictory ideologies – machines and nationalism, industry and race – a perfect example of what Jeffrey Herf has called "reactionary modernism."

In the chapters that follow, we will find the answers to all the questions about technology that Diego Rivera left unanswered in his Detroit murals. We will see how the rise of new technological media sparked debates about the representation of technology, the technological transformations of representation, and the cultural repercussions of these processes. Taken together, the cultural histories of cameras, typewriters, radio, cement, and stadiums present a comprehensive account of Mexican postrevolutionary culture in the age of mechanical reproduction. As we will see, the discourse network that emerged in these years led to another insurrection in Mexico, an aesthetic revolution that was fought using the artifacts of modernity.

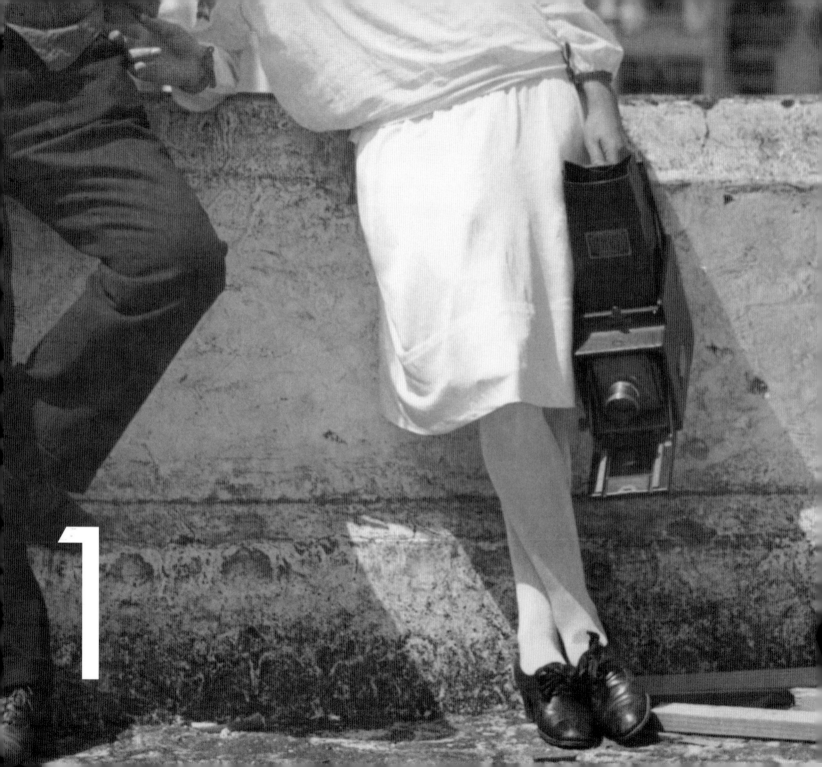

CAMERAS

New media change the way we experience the world, and nowhere has this transformation been more apparent than in photography. After the invention of the camera in the nineteenth century, the world began to look different as an optical unconscious surfaced into visual consciousness.

In Mexico, photography was embraced with open arms. Beginning in the Porfiriato, many "artists of the camera," as they were then known, set up studios in the capital. Many of them were foreign-born, including the Germans Hugo Brehme and Wilhelm Kahlo, and they combined portraiture with other commission work, including documenting buildings and historical monuments for the Mexican government. During the revolution, Brehme used his camera to capture striking scenes of the civil war, including the landscapes of devastation left behind by the fighting.

The photographic world in Mexico City was rather homogeneous, with most artists embracing a pictorialist aesthetic, until the arrival of two foreign photographers in 1923 caused a stir. They were Edward Weston and Tina Modotti, an American and an Italian, who used the camera in radically new ways and initiated a photographic revolution in Mexico. Photography had changed the way artists looked at the world, and the experiments of these two figures introduced yet another transformation: a new way of seeing postrevolutionary Mexico City that marked a momentous shift in the discourse network of visual culture.

Though Modotti started out as a disciple of Weston's, her photographic experiments in Mexico City were much more radical than those of the American photographer. During his time in the capital, Weston paid no attention to the products of postrevolutionary modernization – functionalist structures, industrial complexes, mechanized factories – that were being built all around him. Modotti, on the other hand, was fascinated by the country's rapid transformation and used her camera to document its passage into a modernity of sorts, albeit one where tradition often clashed with technology. In the pages that follow, we will see how Modotti, in the seven years she lived in the capital, introduced an alternative to the dominant photographic aesthetics she had found upon her arrival in Mexico City.

In a series of advertisements published in *El Universal Ilustrado* between 1923 and 1925, Kodak Mexicana promoted its photographic cameras as wondrous technological inventions. One of the ads (figure 12) shows an elegant couple aboard a late-model convertible, stopped by the side of the road to contemplate a picturesque scene: two boys – one wears his hat, the other clutches his cap respectfully against his stomach – hold up a long-legged hare, the trophy of the children's hunt, for the couple to admire and photograph. The man, one hand on the wheel of his car, smiles at them, while the woman, standing on the passenger side, points a bulky black camera toward the boys.

The photograph, which is in fact a photograph of the taking of a photograph, is accompanied by a caption promoting the technological virtues of the camera: "Todo lo que sus ojos ven, lo abarca el lente, y la anotación autográfica evita que se olviden datos importantes" [All your eyes can see is captured by the lens, and autographic recording keeps important events from being forgotten]. The caption exalts the camera as an extension not only of the eye – the lens captures everything that the eye sees – but also of human memory: its "autographic" function enhances mnemonic capacities by ensuring that "important events [will not be] forgotten." Unlike human memory, which is imperfect and prone to accidents, the camera's recollections – photographic prints – preserve every

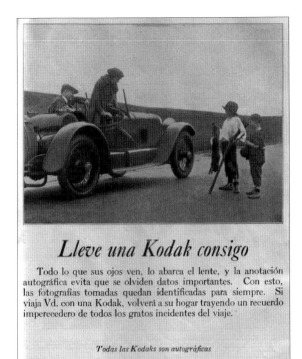

12. Kodak advertisement from *El Universal Ilustrado* 331 (13 September 1923): 57. Image courtesy of Hemeroteca Nacional, Mexico City.

detail against the corrosive effect of time: "Si viaja Vd. con una Kodak," concludes the ad, "volverá a su hogar trayendo un recuerdo imperecedero de todos los gratos incidentes del viaje."

The camera's ability to produce imperishable memories is guaranteed by its autographic capabilities: "Todas las Kodaks son autográficas," reads the slogan reproduced in every ad, using a neologism formed by the combination of the Greek roots αυτος and γραφειν, to mark or record. The camera is a machine capable of automatic recording: at the touch of a button, a series of mechanical operations instantly produces a faithful and imperishable record of all that the eye sees. The ad stresses the accuracy of the resulting photograph, and especially the automatic nature of its production. This autographic capability links the camera with the automobile and other inventions of the modern era characterized by a mechanical automatism. Like the convertible transporting the couple, the camera pointed at the young hunters is a sophisticated machine, a product of the technological advances of the twentieth century. Thoroughly modern, the man and woman depicted in the ad have automated both their movement and their recollection: they ride an automobile and photograph souvenirs with a camera. And the camera, since it also rides in the convertible, emerges as a doubly modern artifact: it is not only autographic but also automotive.

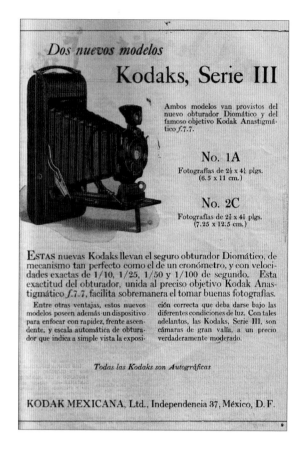

Dos nuevos modelos

Kodaks, Serie III

Ambos modelos van provistos del nuevo obturador Diomático y del famoso objetivo Kodak Anastigmático *f.7.7.*

No. 1A

Fotografías de 2½ x 4¼ plgs.
(6.5 x 11 cm.)

No. 2C

Fotografías de 2½ x 4¼ plgs.
(7.25 x 12.5 cm.)

ESTAS nuevas Kodaks llevan el seguro obturador Diomático, de mecanismo tan perfecto como el de un cronómetro, y con velocidades exactas de 1/10, 1/25, 1/50 y 1/100 de segundo. Esta exactitud del obturador, unida al preciso objetivo Kodak Anastigmático *f.7.7*, facilita sobremanera el tomar buenas fotografías.

Entre otras ventajas, estos nuevos modelos poseen, además un dispositivo para enfocar con rapidez, frente ascendente, y escala automática de obturador que indica a simple vista la exposición correcta que deba darse bajo las diferentes condiciones de luz. Con tales adelantos, las Kodaks, Serie III, son cámaras de gran valía, a un precio verdaderamente moderado.

Todas las Kodaks son Autográficas

KODAK MEXICANA, Ltd., Independencia 37, México, D. F.

13. Kodak advertisement from *El Universal Ilustrado* 436 (17 September 1925): 9. Image courtesy of Hemeroteca Nacional, Mexico City.

In announcing "Todas las Kodaks son autográficas," the ads claim by synecdoche that all cameras are autographic machines. While all cameras used the same mechanism and operated according to the same mechanical processes, not all photographers were happy to view their work instrument as a machine. In the 1920s there was considerable debate in Mexico and elsewhere about the role of mechanical processes in photography, and many photographers worked hard to prove that the camera was not a machine but a refined artistic tool.

Photographers' assumptions about their instrument – and about the characteristics of their profession – varied greatly during the 1920s, as we can see by comparing the portraits of Tina Modotti and Edward Weston with their cameras. Both portraits were taken in Mexico City in 1924, and both show photographers who made a living by photographing the people and places around them. The first photograph (figure 14) shows a stately Edward Weston posing beside his camera: he is smoking a pipe and holding a photographic plate in his left hand. The second image (figure 15) shows Tina Modotti holding her portable camera and talking to a friend as they both lean against a short brick wall on a rooftop terrace overlooking Mexico City.

Though the two cameras are the same – despite their varying dimensions, they use the

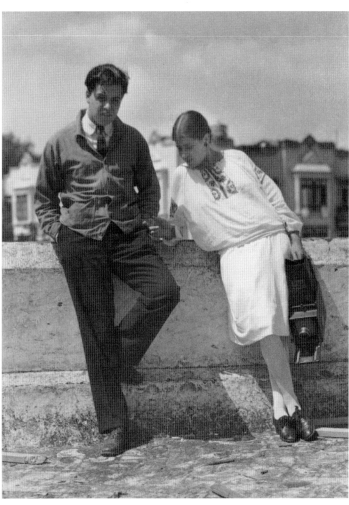

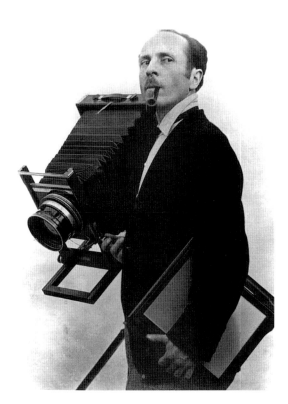

14. Tina Modotti, *Edward Weston with a Camera*
(1923–1924). SINAFO-Fototeca Nacional, Mexico City.

15. Edward Weston, *Tina Modotti and Miguel Covarrubias*
(1924). © 1981 Center for Creative Photography, Arizona
Board of Regents.

35

same photographic mechanism – the photographers' demeanor toward their instrument could not be more different. Weston is poised tall and proud next to his camera, holding one of its levers with his right hand and clutching the photographic plate in his left. He is formally dressed: he wears a jacket and tie, as if attending an important function, and stands next to his camera as a man would stand next to his wife for a family portrait. Weston's pose – staged for another camera – follows the conventions of artists' portraits that abound in European painting: the photographer appears next to his instrument with the same pride and earnestness that a painter would exude standing by his easel.

Modotti, on the other hand, holds her camera casually. It merely dangles from her left hand as she talks. If Weston was dressed up, she is dressed down, wearing simple white cotton street clothes. Weston appears alone with his instrument, evoking the romantic ideal of the solitary artist alone with his creation; Modotti, on the other hand, holds her camera during a public rendezvous. Modotti's camera, unlike Weston's, is not central to the image of the portrait but is merely an accessory to the focal act of socializing (engrossed in conversation, she forgets to look at the camera as the picture is taken). Weston's camera demands solitude and the artist's undivided attention; Mo-

dotti's is an ordinary object that does not prevent her from engaging in social activities. Weston's camera was a large, unwieldy contraption whose weight and dimensions forced it to remain stationed inside the photographer's studio; Modotti's was portable and easily maneuverable (in a letter to Manuel Álvarez Bravo, she wrote of her preference for small cameras): it could easily be taken outdoors – as the photo demonstrates – lifted, lowered, swung around, and even – were the conversation to take an unpleasant turn – hurled against her interlocutor.[1] ("Photography as Weapon" was, after all, the title of one of Modotti's texts on the camera's political function.)[2]

Weston looks at his camera as an artistic instrument – he stands next to it as a painter would stand next to his easel – while Modotti treats hers like a work tool, an ordinary object. Modotti, in fact, did not see herself as an artist, and she did not believe that cameras should be used to make art. "Always," she once wrote, "when the words 'art' and 'artistic' are applied to my work, I am disagreeably affected. I consider myself a photographer, nothing more."[3]

There is of course a certain irony to these two portraits: It was Weston who took the photo of Modotti with her portable camera and it was Modotti who photographed Weston in his stately pose. The couple had extremely diverging

approaches to photography, and these portraits allowed each of them to stage a playful caricature of the other's posture. Modotti, who would become a radical political activist, presents Weston as an old-fashioned bourgeois artist. And Weston, the high modernist, portrays Modotti as more of a talker than a photographer. In their exaggeration, these caricatures reveal strikingly different views about photography's role in society.

Can a camera be at once an autographic machine – as the Kodak ads would have it – and an artistic tool – as Weston would have it? Unlike the Kodak ad, Weston's pose links his instrument not to automobiles and other automatic inventions, but to the old-fashioned conventions of easel painting. And though his strict pose and serious demeanor were probably tongue-in-cheek, he was still worlds away from Modotti's vision of photography as a form of political activism. The attitude that Modotti attributes to Weston was in fact fairly common in Mexico: though cameras were incessantly advertised in Mexican newspapers as modern, autographic machines, most photographers in the 1920s did not view their instrument as a mechanical apparatus but as an artistic tool closely related to the brushes and pencils of traditional artists.

In a 1926 article titled "Conversaciones sobre el arte en fotografía" (Conversations on the Art of Photography) and published in *El Universal Ilustrado,* a writer using the English pseudonym "Snapshot" argues that photography's mechanical and artistic concerns are mutually exclusive. Even though photography depends on mechanical procedures, he argues, good photographers must rise above the medium's vulgar "automatism" in order to create artistic photographs. "Artistic photography," he writes, "is the exact opposite of documentary automatism."[4]

Unlike the Kodak advertisements, Snapshot sees the camera's automatism – its autographic function – not as a technical marvel but as an obstacle to artistic creation:

Hay que distinguir, pues, en la fotografía, sus dos grandes aspectos, esencialmente distintos, y que comprenden por un lado la parte mecánica . . . y por otro, la artística, que pone en juego . . . los conocimientos estéticos, imprimiéndole al cuadro la personalidad que transforma sus condiciones primitivas, hasta elevarla por el camino de la sensibilidad a una verdadera emoción estética.[5]

[In photography one has to distinguish between two very different components: on the one hand there is the mechanical aspect . . . on the other, the artistic process which requires an aesthetic training in order to imprint the work with the personality . . . that can elevate it into a true aesthetic phenomenon.]

In Snapshot's view, the camera's mechanical procedures were only capable of producing a barren and "primitive" work that had to be "transformed" and "elevated" to the level of art by a photographer endowed with "sensibility" and "aesthetic knowledge."

The Mexican critic's declarations correspond, almost verbatim, to the manifesto "Pictorial Photography" that the North American photographer Alfred Stieglitz had published in 1899. Stieglitz, preoccupied by the fact that at the turn of the century photography was "looked down upon as the bastard of science and art," outlined the requirements for photographs to attain the status of true "art." Above all, he explained, photographers must distance themselves from mechanical processes: "In the infancy of photography . . . it was generally supposed that after the selection of the subjects, the posing, lighting, exposure, development, every succeeding step was purely mechanical, requiring little or no thought. The result of this was the inevitable one of stamping on every picture thus produced the brand of mechanism, the crude stiffness and vulgarity of chromos and other like productions."[6]

Stieglitz considered the automatism that characterized mechanical processes as "vulgar" and "crude," and he attempted to minimize the photographer's dependence on the machine. In opposition to the mechanical, he praises the creative procedures that established photography as the successor to the earlier media of painting, drawing, and engraving. "Pictorial photography," writes Stieglitz, "evolved itself . . . by those who loved art and sought some medium other than brush or pencil through which to give expression to their ideas."[7] The photographer, he stresses, is bound by the same aesthetic standards as the painter or the draftsman: "The maker [of photographs] must be as familiar with the laws of composition as is the landscape or portrait painter."[8] And "the photographer, like the painter, has to depend upon his observation of and feeling for nature in the production of a picture."[9]

Stieglitz's view of the camera could not be more different from that advanced in Kodak's Mexican advertisements: he did not see the camera as an autographic instrument but as a merely graphic one. Automatism – "vulgar" and "crude" – was to be avoided at all costs, and the photographer should treat his camera in the same way that the painter handled his brush and the draftsman his pencil: as a tool for artistic expression.

But despite Snapshot's rejection, following Stieglitz, of the camera's status as an autographic machine and his protestations that photography is as much of an art as painting and drawing, we might be tempted to believe that these opinions, in

the end, did not alter the final product: a photographic print was, after all, produced by the same series of mechanical procedures regardless of whether the photographer considered his trade an art or a mechanical process.

This, however, was not always the case. Influenced by Stieglitz's pictorialist precepts, Mexican photographers in the 1920s interfered with the camera's mechanical processes to make their prints more artistic. Consider, for example, the case of Gustavo Silva, a portrait photographer with a thriving business in downtown Mexico City and a man whose work was emblematic of the photographic aesthetics prevalent in Mexico City when Modotti arrived on the scene. Silva was a frequent contributor to *El Universal Ilustrado,* and in the pages of this journal he was praised as "ese artista genial de la cámara oscura" (that brilliant artist of the camera obscura) and "el brujo del lente" (a sorcerer of the lens).[10] Like other pictorialists, Silva retouched his prints to make them more artistic, embellishing the black-and-white images with hand-painted colors and textures. An article published in *El Universal Ilustrado* (figure 16) describes Silva's retouching procedure in great detail:

Obtenida la positiva, Silva, como un alquimista de la edad media, echa mano a frascos y redomas de diversos tamaños y contenidos. Vacía un poco de rojo, de amarillo, de azul, negro. . . . Mejor que la más experta artista de un 'Beauty Parlor', su mano sabe hacer el 'maquillage'. El 'rouge' se esfuma sobre las mejillas, repartiéndose sabiamente mientras cae el 'kohl' sobre los párpados, alargándolos y avivando el fuego de los ojos. Luego la pátina del tiempo – otro de los secretos de Silva – da al conjunto el carácter de un cuadro viejo de un maestro antiguo.[11]

[After obtaining the positive, Silva, like a medieval alchemist, makes use of bottles of different sizes and various contents. He pours a bit of red, some yellow, a dash of black. . . . His hand can apply the makeup better than the most expert technician from some "Beauty Parlor." The rouge goes on the [portrait's] cheeks, while the kohl goes on the eyelids, making them appear longer and increasing the eye's fiery look. And then the sheen of time – another one of Silva's secrets – makes the whole feel like an early work by an old master.]

After developing the mechanically produced print ("la positiva"), Silva proceeds to embellish the image by applying a painterly makeup: he paints over the photograph using bright pigments resembling feminine cosmetics.

This process could not be more antithetical to the nature of photography. As the Kodak ads vaunted, the camera is primarily a mechanical instrument. Silva's retouching, in contrast, is entirely

16. "Silva, el brujo del lente," from
El Universal Ilustrado 541 (21 September
1927): 21.

17. Gustavo Silva's portrait and obituary
from *El Universal Ilustrado* 674 (10 April
1930): 10.

handcrafted: he painstakingly applies the pigments manually, using – like the painters and draftsmen of the past – brushes and pencils to embellish the image. But the minute his brush touches the print, Silva effectively undoes photography's most fascinating attribute, its indexical automatism. The resulting images are no longer autographic; they are no longer produced indexically by a machine but created by the manual skills associated with painting and drawing. As *El Universal Ilustrado*'s reporter perceptively remarks, the resulting print has the appearance of an "early work by an old master." It was such simulacra that led Walter Benjamin to refer to retouched negatives as "the bad painter's revenge on photography" and to describe hand-coloring as a strategy designed to "simulate aura."[12]

This process of retouching the photographic image by hand coloring was used not only by Silva, but by most of the pictorialist photographers active in Mexico during the 1920s. Hugo Brehme used this retouching procedure, as did many of the other photographers – including Smarth, Rafael Carrillo, Rafael García, Luis Márquez, and Ricardo Mantel – featured regularly in *El Universal Ilustrado*. Brehme's *Hombre con sombrero* of 1920 (figure 18) is characteristic of hand-retouched prints. To create this work, the artist had taken a black-and-white photographic print and treated it as if it were a canvas, using brushes and pencils to

18. Hugo Brehme, *Hombre con sombrero* (1920). Courtesy of Throckmorton Fine Art, New York

color the image. The end result is a painting that has a photographic imprint as its material support.

In addition to exemplifying the results of hand-retouching, *Hombre con sombrero* points to another characteristic of Mexican pictorialist photography. Pictorialist photographers invariably depicted traditional subjects: portraits of peasants in native dress, quaint village landscapes, and other similar scenes whose outlook is aptly summed up in the title of Hugo Brehme's 1923 book of prints, *México pintoresco*, picturesque Mexico. Though many of these images were created while Mexico was experiencing one of the most rapid and intense modernizing booms, modernity is conspicuously absent from these representations. The cameras, stadiums, typewriters, radios, and cement constructions that fascinated avant-garde figures in the first decades of the twentieth century are nowhere to be found in these idyllic photographs. Following the same impulse that led them to conceal photography's automatism under the guise of hand-painting, pictorialists like Silva and Brehme banished all references to the postrevolutionary discourse network from their photos.

In their transformation of the automatic into the handcrafted, pictorialist photographs like Brehme's *Hombre con sombrero* evoke the paradoxes considered in our analysis of Diego Rivera's *Detroit Industry*. Like Rivera, pictorialist photographers create representations that collapse the

technological and the antitechnological. But in the case of pictorialist photographs, the process is exactly the opposite of what we found in *Detroit Industry*. Rivera used a premodern medium, fresco painting, to represent highly modern subject matter – an automotive factory – while photographers like Brehme relied on a highly modern medium – photography – to represent premodern themes – painterly portraits of peasants. If Rivera sought to transform the antiquated medium of fresco painting into the art form of the future, pictorialists attempted to assimilate the technological medium of photography into the art forms of the past. And if Rivera's mural depicts a world that was more modern than the reality of Detroit in 1932, pictorialist photographs present a country that is less modern – and thus more "picturesque"– than the Mexico of the 1920s. Given these parallels, it comes as no surprise that Rivera had a pictorialist vision of photography. In one of his few texts on photography, the muralist played down the medium's mechanical underpinnings and compared photography to painting: "the camera and the manipulations of the photographic work are a TECHNIQUE, just as oil, pencil or water-color," he wrote.[15]

Like Rivera's mural, pictorialist photography was riddled with paradoxes: its practitioners relied on the camera, a recent technological invention, but their objective was creating pictures reminiscent of work by the old masters; their working instrument was automatic, but they sabotaged the medium's autographic process by manually retouching the prints. As if they were ashamed of the camera's status as a technological artifact, pictorialists worked hard to present mechanical prints as handcrafted creations.

Ultimately, photographers like Silva and Brehme disavowed their medium's status as an advanced technology of representation, employing painstaking procedures to transform it into a manual craft. It is significant that there are no portraits of pictorialist photographers posing with their cameras, like Weston and Modotti. Pictorialists were not proud of their work instrument, and they probably would have concealed it – as they concealed the print's autographic genesis – from public view, opting instead to pose for a portrait holding the brushes, palettes, and easels they used for retouching.

Even if pictorialism dominated the photographic scene in 1920s Mexico, not everyone agreed with the view that photography had to imitate painting, that the camera's autographic work should be disguised by handcrafted retouching. Ironically, one of the most assertive voices of dissent came from a painter: in a 1925 review of an exhibition of photographs by Weston and Modotti held in Guadalajara, the muralist David Alfaro Siqueiros chastises photographers who retouch their work to make it more artistic: "The immense

majority of photographers (I especially want to refer to the ones who want to be called 'serious photographers' or 'artistic photographers') actually waste those elements, that is, the physical factors which are innate to photography itself: they sacrifice them searching for 'pictorial' character: they assume that photographs can follow the same needs as painting, and they dedicate themselves to making falsifications of primitive Italians, of decadent portraitists, of aristocratic European women, of impressionist painters, and of poor painters from the last fifty years."[14] Siqueiros was probably thinking of Silva and Brehme when he wrote this text. In it, he reminds pictorialists that painting and photography are two different media (they don't respond to "the same needs"), and that photographers who imitate painters will only produce "falsifications." He stresses the degree to which pictorialist strategies were retrograde: photographers imitated not only painting but the antiquated paintings of "primitive Italians" and "decadent portraitists." For Siqueiros, all this amounts to a "waste" and a "sacrifice" of "the physical factors which are innate to photography itself."

Siqueiros's review goes on to describe an alternative to this pictorialist waste: modernist photography. He points to the work of Weston and Modotti – two photographers who rejected the precepts of pictorialism in favor of a modernist aesthetics – as a striking exaltation of these "physical factors" inherent in the photographic medium:

With the same photographic elements, or perhaps with less than most photographers use to lie and to deceive the others and themselves with "artistic" TRICKS, Weston and Modotti create TRUE PHOTOGRAPHIC BEAUTY. Material qualities of things and objects that they portray could not be more EXACT: what is rough is rough; what is smooth is smooth; what is flesh, alive; what is stone, hard. . . . In the feeling of REALITY that the works of these two great masters impose on the viewer, it is necessary to seek . . . [a] PHOTOGRAPHIC AESTHETIC – which is not only different from [a] PICTORIAL AESTHETIC by its very naturalness, but is diametrically opposite to it. One of the important values of photography is the organic perfection of details, a value that with the exception of the painters of the most detestable epoch, has not concerned any painter of the good schools. In one word the BEAUTY that surrounds the works of [these] photographers . . . is simply PHOTOGRAPHIC BEAUTY; beauty which is absolutely modern and which is destined to have a surprising development in the future.[15]

In his eloquent rejection of pictorialist "tricks," Siqueiros celebrates one of the properties that make photography a modern, mechanical medium: its indexicality, or – to use the language of Kodak's advertising campaigns – its ability to write

autographically. He praises Weston and Modotti for producing "exact" representations of reality: "what is rough" in reality "is rough" in the print; "what is smooth is smooth; what is flesh, alive." This simple fact renders their photographs "absolutely modern," the antithesis of pictorialist deception.

The photographic aesthetics that Siqueiros praises in the work of Weston and Modotti represents a return to the camera's autographic character. By avoiding the pictorialist retouching of prints, their photographs emerge as indexical representations produced through mechanical processes. Neither the hand nor the brush of the artist obscure the vivid and detailed representation captured by the camera. In addition, these photographs are no longer handcrafted works but are mechanically produced objects: and unlike hand-retouched prints, which aspire to the uniqueness and authenticity of painting, these photographs are mechanically reproduced from a single negative. This is what, in Siqueiros's view, makes these photographs "modern." Siqueiros also points out the kinship between photography and industrial technology: "I firmly believe," he writes, "that the understanding and observation of industrial photography ... especially admirable industrial photographs of machinery – was useful to the photographers Weston and Modotti in order for them to find the exact route of photography as a GRAPHIC AND AUTONOMOUS MANIFESTATION."[16]

Tina Modotti shared both Siqueiros's distaste for pictorialism and his passionate embrace of "straight," unadulterated photography. In her 1929 essay "On Photography" published in *Mexican Folkways,* she wrote: "If my photographs differ from that which is usually done in this field [of photography], it is precisely because I try to produce not art but honest photographs, without distortions or manipulations. The majority of photographers still seek 'artistic' effects, imitating other mediums of graphic expression. The result is a hybrid product that does not succeed in giving the work ... photographic quality."[17] Like Siqueiros, Modotti considers "art" and "photography" to be mutually exclusive terms. She too balks at photographers who "seek 'artistic' effects" by "imitating other mediums of graphic expression," and considers these endeavors contrary to "photographic quality." And – like Siqueiros – Modotti sees photographic quality as synonymous with maintaining the indexical traits of the medium by producing "honest photographs": the photographer in search of this type of quality must not interfere in any way with the medium's autographic process.

Modotti expressed her distaste for pictorialists more overtly in a letter to Edward Weston dated September 18, 1928, in which she recounted her

Cameras

reluctant participation in Mexico City's National Exhibit of Photography. For this exhibition, Modotti's prints were shown alongside works by Hugo Brehme, Smarth, Rafael García, Antonio Garduño, Roberto Turnbull, Ricardo Mantel, and a very young Manuel Álvarez Bravo. In the letter, Modotti complained about being lumped with Mexico's pictorialists:

had I told you that an exhibit of Photography took place here? Gee, I wish you had seen it; it surely was a mess! I also exhibited; I first had refused, but nice people like [Antonio] Garduño insisted so and I could see that they interpreted my refusal to snobbery, so I accepted and got a prize thereby. But don't get excited, it was just the fifth part of a first prize, since they had five first prizes; a delicious way of pleasing several at one time, and of not showing partialities, don't you think so? . . . [One of the photos showed] a head of an old man with a long beard, a terrible thing, the sort of thing Jane Reece might have done and called "Son of Man." [Of this] a would-be art critic said, "The technique with which the beard is rendered makes one feel the brushstrokes of Cezanne." Enough said, don't you think, Edward?[18]

Enough said, indeed!

The "terrible" work Modotti described was actually the grand-prize winner, a photograph of a venerable old man by the pictorialist photographer Antonio Garduño, which was reproduced in a spread in the weekly *Revista de Revistas*. Modotti's letter not only ridicules the antiquated subject matter – bearded old men representing wisdom and tradition – favored by pictorialists like Jane Reece; she is especially critical of those who – like the critic who saw "Cezanne's brushstrokes" in Garduño's photograph – resort to the vocabulary of painting to judge the quality of photographs. On the one hand, Modotti speaks against those who use photography to represent old-fashioned subjects; on the other, she criticizes those who seek to assimilate photography into the aesthetics of painting, thus disavowing photography's status as a mechanical medium.

The differences between Modotti's view of photography and that of the local pictorialists could not be greater. While these photographers worked hard – and by hand – to conceal the medium's automatism, Modotti insisted that the camera's autographic process remain undisguised by manual retouching. Unfortunately, in Mexico, unlike in other countries, these fundamental disagreements about photographic aesthetics did not unfold into an intellectual debate carried out in the pages of journals devoted to photography. But the differences between pictorialist and straight photographers did lead to a symbolically violent confrontation. In 1924, during Weston's exhibit at the Aztecland Gallery, Tina Modotti

witnessed the rage that these straight photographs provoked in a Mexican pictorialist. Inflamed by an uncontrollable wrath, Gustavo Silva walked up to one of Weston's modernist prints depicting a female torso and proceeded to vandalize it. Modotti described the incident in a letter, now lost, which Weston summarized in his daybook:

October 22 [1924] That mad Mexican photographer [Gustavo Silva] came yesterday, tells Tina, and after raving and waving and tearing his hair, went up to a certain "Torso," exclaiming "Ah this is mine – it was made for me – I could" – and with that he clawed the print from top to bottom with his nails, utterly ruining it ... the mount had been signed "Propiedad de Silva" [property of Silva].[19]

This small act of vandalism reveals the horror with which pictorialists viewed Weston's straight photographs. As an artist, Silva was deeply disturbed – "raving and waving and tearing his hair" – upon coming face to face at an art gallery with photographs that were entirely machine-made, and that made no effort to disguise the autographic condition of their production through hand retouching. Ironically, Silva's attack was a violent strategy to transform Weston's *Torso* into a pictorialist work: the mechanical had to be rendered artistic though manual procedures, and by

clawing the print from top to bottom, Silva effectively retouched it using his bare hands. In the end, the clawing produced the same effect as the procedures favored by pictorialist photographers: it gave the print a diffused, blurry quality. To underscore his transformation of Weston's "raw," mechanical *Torso* into an original artistic masterpiece, Silva signed the frame "Propiedad de Silva."

Just as the pictorialist ambition to make photography more artistic translated into concrete strategies like the manual retouching favored by Silva and Brehme, the straight photographers' search for a photographic aesthetics that was both independent from painting and thoroughly modern led them to devise novel photographic techniques. If Brehme's *Hombre con sombrero* embodied many of the ideals of pictorialist photography – the representation of traditional, untechnological Mexican scenes using the conventions of portrait painting – Modotti's 1925 *Telephone Wires, Mexico* (figure 19) exemplifies the photographic aesthetics favored by straight photographers.

Though both *Hombre con sombrero* and *Telephone Wires* were taken in Mexico during the 1920s, the photographs are so different that they would appear to represent not only different countries but also different historical periods. Nothing in Brehme's photograph suggests that it was taken in a country where the rapid technological development

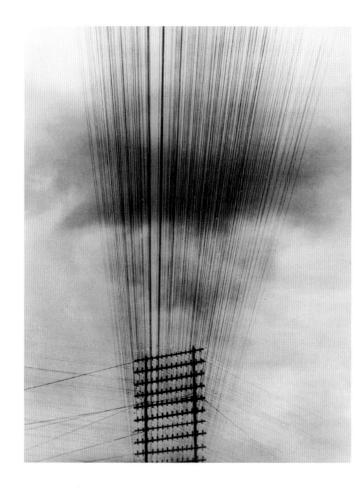

19. Tina Modotti, *Telephone Wires, Mexico* (1925). Fondo
Tina Modotti, SINAFO-Fototeca Nacional, Mexico City.

unleashed by governmental modernizing projects had begun to transform everyday life. It is a photograph of a villager in traditional dress representing – like the vast majority of Brehme's photographs – a traditional Mexico that seemed to have changed little since the early days of the colony. On the other hand, Modotti's photo, depicting a pole and a mesh of telephone wires flying high above the ground, is a portrait of one of the many new technologies that by 1920 had begun to alter the country's landscape. Unlike other photographers, including Edward Weston, who considered Mexican technological artifacts unsuitable subjects for photography, Modotti devoted a good number of works to representing the modernization of Mexico City in the 1920s. She photographed telephone and telegraph wires, industrial complexes (*Tank No. 1*, 1927; figure 26), governmental construction projects (*Stadium* [figure 23] and *Labor 2*, 1927), and modern machines (*La técnica*, 1928; figure 27).

Take, for instance, the image known as *Building, Mexico City* (figure 20), a photograph of one of the Ministry of Health buildings. Public health was one of the top priorities of the postrevolutionary government, so much so that an entire ministry was devoted to solving the country's many problems in this area, from eradicating tropical infections to lowering the alarmingly high infant

mortality rate. The building was designed by the architect Carlos Obregón Santacilia as an architectural metaphor of the new regime's hygienic ideals: it was shaped like a human body, with two wings that opened like arms onto a bucolic garden. Equipped with modern laboratories, the building's walls were decorated by Diego Rivera, who painted murals of red blood cells and other microorganisms engaged in heroic battles. In these works, class struggle gives way to germ warfare.

By photographing this particular building, inaugurated in 1929, Modotti used her camera to celebrate the postrevolutionary discourse network ushered in by the new regime. Modotti photographed several other important public projects in this era, notably the National Stadium commissioned by José Vasconcelos (to be discussed in chapter 5). All of these choices constituted a radical departure from the subjects that had been favored by Mexican photographers in the past.

Modotti's interest in documenting Mexico's modernity contrasts sharply with Weston's more traditional view of the country. Before arriving in Mexico, Weston had photographed industrial sites in the United States like the steel plant captured in *Armco Steel* (1922)—a photo that was reproduced in *Irradiador* 3, the Estridentista broadside, in 1923. After his arrival in Mexico, however, Weston

20. Tina Modotti, *Building, Mexico City,* also known as *Secretaría de Salud* (ca. 1928). Fondo Tina Modotti, SINAFO-Fototeca Nacional, Mexico City.

refused to photograph scenes relating to Mexico's modernization, which he blamed for "spoiling" the country. Various entries in his daybooks suggest that Weston made a conscious choice not to photograph technological scenes in Mexico, opting instead for the type of traditional landscapes and portraits favored by pictorialist photographers. "I should be photographing more steel mills or paper factories," he wrote at one point, "but here I am in Romantic Mexico, and willy-nilly, one is influenced by the surroundings . . . and there are sunlit walls and fascinating surface textures – there are clouds!"[20] Weston distanced himself from pictorialists in terms of technique, but not in terms of subject matter, since he favored quaint and "unspoiled" scenes of Mexican life just like Silva or Garduño. In contrast, Tina Modotti rejected both pictorialist technique *and* subject matter.

Pictorialists most certainly would have balked at the idea of photographing a government building, not to mention a tangle of telephone wires. They would perhaps have considered such contraptions entirely vulgar and antiaesthetic – visual pollution marring the pristine beauty of Mexican landscapes – and, as we saw, they worked hard to exclude such technological intrusions from their photographs. Modotti, on the other hand, not only shoots the telephone wires but finds what Si-queiros had termed "photographic beauty" in this unlikely scene. Depicting the wires from an unusual angle and cropping the image closely, she turns the telephonic tangle into an orderly, abstract composition of parallel lines.

Even more significantly, the photographic aesthetics deployed in *Telephone Wires* revolves around its innovative use of perspective. The perspective used by Brehme in *Hombre con sombrero* merely follows the conventions of painting, and it thus uses the same point of view – a frontal one centered on the man's chest – found in painted portraits. In contrast, Modotti employs an unusual perspective: she took the photograph looking straight up from the ground at the wires. Modotti produced a number of other images taken from varied and unusual angles. The photographs *Workers' Parade* (1926; figure 21) and *Campesinos Reading "El Machete"* (1929; figure 22) are taken from the opposite perspective of *Telephone Wires;* in these images, Modotti looks straight down from above, an effect that distorts the human figures, reducing them to the abstract geometric patterns formed by their hats.

Though Modotti never wrote about her experiments with perspective, her use of oblique angles recalls the work of another photographer who did write extensively on the subject, the Soviet constructivist Aleksandr Rodchenko. For example,

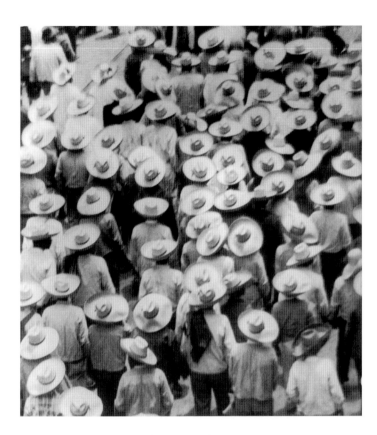

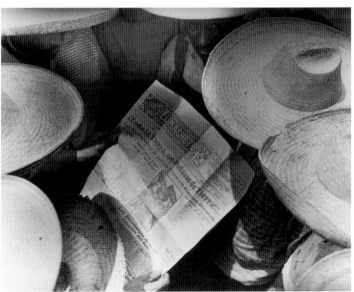

21. Tina Modotti, *Workers' Parade* (1926). Fondo Tina
Modotti, SINAFO-Fototeca Nacional, Mexico City.

22. Tina Modotti, *Campesinos Reading "El Machete"* (1929).
Fondo Tina Modotti, SINAFO-Fototeca Nacional, Mexico City.

25. Tina Modotti, *Stadium* (1927). Fondo Tina Modotti, SINAFO-Fototeca Nacional, Mexico City.

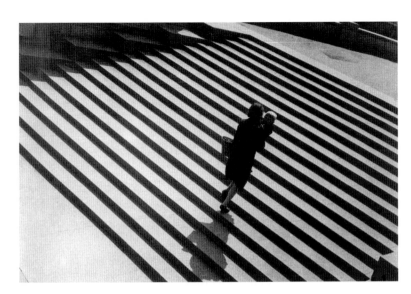

24. Aleksandr Rodchenko, *Steps* (1930). A. Rodchenko and V. Stepanova Archive, Moscow.

her *Stadium* (1927) depicts the tiers in a stadium from an oblique lateral angle (figure 23). This photograph is similar to Rodchenko's *Steps* (1930), which also uses an oblique perspective to highlight the geometrical patterns formed by concrete steps (figure 24). Modotti began experimenting with perspective roughly around the same time – and using many of the same techniques – as Rodchenko, and, although there is no evidence that either photographer was aware of the other's existence, the similarities between their procedures are striking. Modotti's *Workers' Parade*, to take another example, follows the exact same strategy as Rodchenko's *Assembling for a Demonstration* (1928–1930): both photographs are taken looking down on a street manifestation, and they both use an exaggerated vertical perspective that distorts and defamiliarizes the human figures. In both Modotti's *Campesinos Reading "El Machete"* and Rodchenko's *At the Telephone* (1928), the vertical perspective gives us an oblique view of an object – a telephone or a newspaper – but conceals the traits of the human figures in the image.

In a text from 1928, Rodchenko argues that the oblique perspectives used in photos like *Telephone Wires* are a form of rebellion against painting. "All paintings," Rodchenko writes, "have been painted either from the belly-button level or from

53

the eye level."[21] Rodchenko humorously refers to the type of frontal, centered perspective used in traditional portraits like Brehme's *Hombre con sombrero* as "the point of view of the belly-button"–an allusion to the way early cameras hung from the operator's neck and rested on the stomach–and claims that this point of view is antiquated and should be discarded by photographers. New art forms, he suggests, should find equally novel ways of seeing.

Urging photographers to experiment with unusual points of view, especially with oblique angles, he writes: "The most interesting viewpoints for modern photography are from above down and from below up, and any other, rather than the belly-button level."[22] Since oblique perspectives can be produced only with the camera, he agues that they constitute an implicit rejection of the conventions of painting: any photographer who used them "has moved a bit farther away from painting."[23]

Rodchenko further argues that traditional pictorial perspectives were "out of step with modern times"–they conveyed an outdated view of the world–while the distorted perspectives he champions were attuned to the twentieth century. "The modern city," he writes, "with its multi-story buildings, the specially designed factories and plants, the two- and the three-story store windows,

the streetcars, automobiles, illuminated signs and billboards, the oceanliners and airplanes–all these things . . . have redirected . . . the normal psychology of visual perceptions. . . . It would seem that only the camera is capable of reflecting contemporary life."[24] The technological developments of the twentieth century–the "modern city," factories, automobiles and billboards–called for new ways of looking. "We must revolutionize our visual reasoning," Rodchenko declares–a revolution that only the camera, another technological invention, could fulfill.

Rodchenko closes his call for a new way of looking with a curious example. If one were to photograph the Eiffel tower–that monument to industrial aesthetics–using traditional pictorial perspective, the results would be comically disastrous: "The belly-button view gives you just the sweet kind of blob that you see reproduced on all the postcards ad nauseam."[25] Only an oblique perspective, taken from the top down or from the bottom up, could capture the power and imposing effect of the structure's vast proportions.

The oblique angle in Modotti's *Telephone Wires* produces all the effects that Rodchenko attributed to distorted perspectives. It distances the work from painting and especially–to use one of Rodchenko's terms–from the pictorialist "photography à la painting"; it features a perspective that

could be captured only with the camera, an example of the photographic aesthetics urged by Siqueiros; and, more significantly, it highlights the camera's shared parentage with the telephone and other modern media.

The link between the camera and other technological artifacts is made even more explicit in Modotti's *Telegraph Wires* (1925; figure 25). To produce this image, Modotti used an autographic mechanism – the camera – to represent a telegraphic device. The camera and the telegraph are two inventions that revolutionized the graphic recording of information: the telegraph extended writing over long distances and the camera introduced a way to write automatically (photography means, literally, to "write with light"). The autographic representation of telegraph wires demonstrates the complex strategies that Modotti introduced into her work; she used a technological device – the camera – to represent another technological artifact – the telegraph – by means of a technologically informed perspective – the oblique angle: three products of the modern era condensed into one photograph. In *Telegraph Wires* – and in her other shots of Mexico's modernity – Modotti avoided the contradictions that plagued Diego Rivera. Unlike the mural painter, whose modern subject matter clashed with the premodern medium used for its depiction, Modotti found a

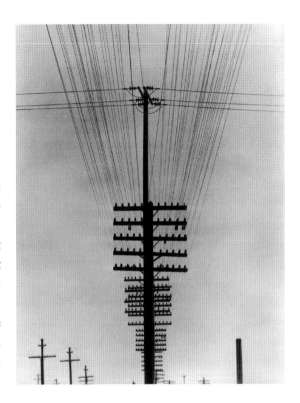

25. Tina Modotti, *Telegraph Wires* (1925). Fondo Tina Modotti, SINAFO-Fototeca Nacional, Mexico City.

means of representation that was as modern as the subjects it represented. Like her camera, her way of looking was as much a product of the modern era as the artifacts she photographed.

In addition to the visual strategies deployed in images with an explicit technological referent like *Telegraph Wires,* Tina Modotti used other techniques to highlight photography's status as a new technology of representation. Several of her works comment on the degree to which photography revolutionized the relationship between texts and images.

Between 1926 and 1930, Modotti submitted the photograph now known as *Workers' Parade* to various publications around the world. Performing what today would be called a photo-conceptual experiment, she neglected to include titles or accompanying captions with her submission, thus leaving the textual component of the image entirely to the discretion of the journal editors. The photo was first published in 1926 as "Workers' Parade" in *Mexican Folkways,* a journal devoted to "art, archaeology, legends, festivals, and songs," and a few months later it was reproduced, though this time untitled, in the pages of *Horizonte,* the Estridentista journal. In 1928, *New Masses,* a leftist publication based in New York, printed the same image as "May Day in Mexico,"

and the following year *Creative Art,* the New York fine arts journal, gave it the title "A Peasant's Manifestation"—the photo remains the same, but the workers were now transformed into peasants.

The photograph continued to parade around the globe, and in 1930 it appeared in the pages of *BIFUR,* the Parisian journal that was the literary home of French surrealists and other avant-garde figures. This time it was simply called "Mexique," thus sacrificing the occupational specificity of the photographed subjects to an exoticizing anonymity that turned them into a synecdoche of the entire Mexican nation. Modotti's image even found its way to *transition*—the prestigious avant-garde journal edited by Eugène Jolas whose regular contributors included James Joyce and Virginia Woolf—where it was labeled "Strike Scene." The editor, it seems, decided that these were workers, not peasants, and that as workers they should be striking, not parading.[26]

But how does this dizzying naming and renaming of images relate to the technological condition of photography? Modotti's experiment points to a curious attribute of photographic images: the visual information they convey cannot be translated easily into a textual description. When faced with the task of writing a few words to accompany the image, the editors of these various journals came up with contradictory captions: one

described the men in the picture as "peasants," while another identified them as "workers"; one believed they were parading, while yet another claimed they were striking. The image remains the same, but these captions offer disparate and contradictory textual translations.

The textual adventures of *Workers' Parade* become all the more suggestive when we compare them to another series of photographs produced by Modotti in the 1920s depicting various types of text, from a painted sign identifying an industrial tank as "No. 1" to a freshly written paragraph on a typewriter. Images like *Tank No. 1* (figure 26), *La técnica, Worker Reading "El Machete,"* and *Campesinos Reading "El Machete"* work in the opposite direction from *Workers' Parade.* Whereas an untitled picture submitted to various journals challenged editors to translate a photographic image into a textual caption, these photographs of tanks and newspapers translate texts into photographic images. As Carleton Beals remarked, Modotti preferred to place texts inside rather than outside her photographs.[27]

There is, however, an important difference between these two acts of translation. As we saw in the journalistic itinerary of *Workers' Parade*, the passage from images to textual captions produced contradictory captions. In contrast, Modotti's rendering of texts as photographic images was clear and unambiguous: the words "No. 1" that we see in *Tank No. 1* are as intelligible as those painted on the real tank, and reading the text on the photograph is no different from reading the text on the actual tank. Unlike the passage from image to text, that from text to photo does not introduce ambiguities.

Curiously, the translation of photographic images into textual captions was advocated by Walter Benjamin, who feared that photographs unaccompanied by texts could be misread by viewers. In his essay "The Work of Art in the Age of Its Technological Reproducibility," Benjamin writes that "illustrated magazines" put up "signposts for" the reader: "For the first time, captions become obligatory. And it is clear that they have a character altogether different from the titles of paintings."[28] Benjamin considered captions as "signposts" or "directives" that would guide the viewer to the correct – he was concerned with *political* correctness – reading of the photograph. "Will not the caption become the most important part of the photograph?" he asks,[29] suggesting that more important than the photographic image was its textual translation, a "signpost" orienting the viewer toward a correct political interpretation.[30]

In Benjamin's view, only captions could invest a photographic image with revolutionary value. As Eduardo Cadava has written, the German critic

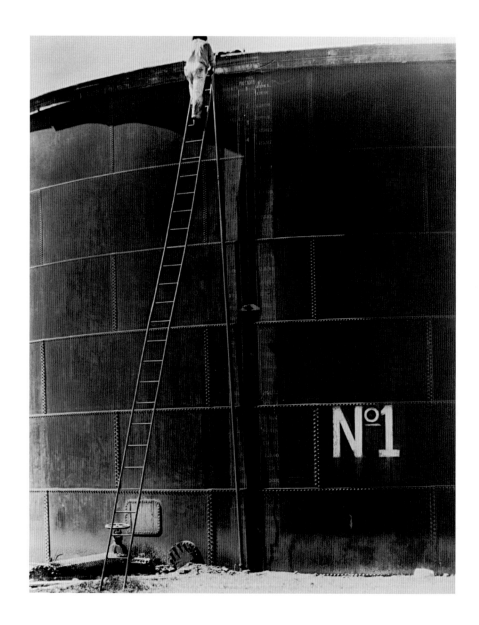

26. Tina Modotti, *Tank No. 1* (1927). Fondo Tina Modotti, SINAFO-Fototeca Nacional, Mexico City.

considered the value of the photograph contingent on the crucial "link between photograph and writing, between photography and the prevalence of an inscription."[31] Benjamin's views were shared by other social-minded critics, as Leah Ollman has shown: "Worker photographers and especially the editors of the *AIZ* [Worker-Illustrated Journal] recognized the malleability and ambiguity of photographs and the subsequent need to direct their meaning through photo-sequences and photo-text combinations."[32] Bertolt Brecht and Willi Munzenberger had similar misgivings. According to Ollman, Munzenberger advocated "the ultimate political effect produced by a combination of several pictures with their captions and accompanying texts.... In this way a skillful editor can reverse the significance of any photograph and influence a reader who lacks political sophistication in any direction he chooses." Brecht feared that, unaccompanied by text, photographic images could present untruths: "The camera can lie," he wrote, "just like the typesetting machine."[33]

Modotti, on the other hand, had no interest in providing the textual "signposts" favored by Benjamin. As we saw in the trajectory of *Workers' Parade*, she considered captions neither "obligatory" nor "the most important part of the photograph," and was quite happy to dispense with them. In fact, her view of the relation between photo and text was the exact opposite of Benjamin's. "Nothing is more convincing and eloquent," she wrote in 1932, "as what the eye can see. However accurately words may describe an armed police raid on a worker's demonstration, a worker's body mangled by mounted police, or a negro lynched by brutal henchmen, no report or written form will be quite as convincing as . . . a photograph [which] will be understood in all countries and by all nations just like moving pictures, regardless of the language of the legend or titles appended."[34] Whereas Benjamin argues that the caption is the most significant part of the photograph, Modotti upholds the visual image as the most striking component of photography. Photographic images are more accurate, more convincing, more eloquent, and more universal – since they will be understood "by all nations" – than words or supplementary textual elements.

Though photographs are not always understood as easily and as universally as Modotti claims – indeed, the disparate textual interpretations of *Workers' Parade* attest to the contrary – her brief essay does point to a crucial fact that Benjamin seems to have overlooked: photographs and captions, visual images and texts, represent two completely different systems of signs, each endowed with a distinct set of attributes. Modotti distinguishes between "words," which can be convincing

Cameras

and eloquent, and "photographs," which possess a representational fidelity that texts could never aspire to: "A photographer is the most objective of all graphic artists. He will record only that which presents itself to his lens at the moment of exposure," she writes.[35]

Modotti's observation that the camera "objectively" records only whatever happens to be in front of the lens corresponds to the ideas advanced by critics from Rosalind Krauss to Denis Hollier who have written about photography as an indexical medium. According to the philosopher C. S. Peirce, an index – a special class within his theory of signs – is a type of sign that is itself a physical trace of the referent or, as Denis Hollier has put it, "less the representation of an object than the effect of an event."[36] Examples of indices include fingerprints, footprints left on the sand, plaster casts, and even shadows. In all of these cases, it is a trace that points back to the referent, a physical mark that grounds the process of signification.

As Rosalind Krauss has shown, photographs are indices: "Every photograph is the result of a physical imprint transferred by light reflections onto a sensitive surface. The photograph is thus a type of . . . visual likeness, which bears an indexical relationship to its object."[37] And it is the photograph's indexicality that distinguishes it from other forms of visual representation like paintings or drawings, which belong to a second class of signs that Peirce called icons. Icons present a likeness of an object's external appearance, but, unlike indices, they have no physical connection to the referent. Though a painting might realistically depict a tank, it differs significantly from a photograph, such as Modotti's *Tank No. 1*, which is itself a photochemical imprint of a real tank. "It is the order of the natural world," Krauss writes, "that imprints itself on the photographic emulsion and subsequently on the photographic print. This quality of transfer or trace gives to the photograph its documentary status, its undeniable veracity."[38]

Like Benjamin, Krauss and Hollier are chiefly concerned with the differences between painting and photography, between iconic and indexical representations. There is, however, a third type of sign in Peircean semiotics – one that seems to have been left out from most discussions of the index: the class of signs that Peirce called symbols. A symbol, explains the philosopher in his essay "Theory of Signs," is a sign "whose interpretation depends on . . . abstract intellectual processes." Unlike icons or indices, a symbol is not connected to its referent by likeness or physical contact, but merely by a mental process of association, "by virtue of the idea of the . . . mind, without which no such connection would exist."[39] Spoken words and written texts are examples of symbols, since

they produce meaning through the abstract intellectual process of linguistic signification. If Modotti's *Tank No. 1* is an index and a painting of a tank is an icon, then the words "Tank No. 1," both on the real tank and inside the photograph, constitute a symbol.

All captions and all texts are symbols, and Modotti's photographs reveal important differences between symbolic and indexical signs. As the bizarre publishing itinerary of *Workers' Parade* shows, photographic images cannot be translated easily into textual symbols; the wealth of visual detail captured photochemically by the camera could never be exhausted by words – not even by a thousand words. Furthermore, an index, by definition, presents an accurate depiction of reality – an "undeniable veracity," as Krauss calls it – while nothing prevents a symbol from making a false claim or even an illogical statement. The captions assigned by the editors to Modotti's photo may err when they assure us that we are looking at a "workers' parade," a "peasants' manifestation," or a "strike scene," but in every one of these publications the photographic image undeniably presents us the same visual details that appeared before Modotti's camera in Mexico in 1926. Indices, as the adventures of *Workers' Parade* demonstrate, cannot be translated into symbols, or even into icons, without sacrificing the "undeniable verac-

ity" that characterizes photographs and other indexical representations.

These problems do not occur when the translation moves in the opposite direction. As Modotti's *Tank No. 1* and other photographs of texts suggest, symbols can successfully be translated into indices without compromising the accuracy of signification. The "No. 1" painted on the tank in Modotti's photograph is every bit as readable as it was in the real tank, just as the headlines in *Worker Reading "El Machete"* are as intelligible in Modotti's photo as they were in that day's issue of the proletarian newspaper. Thus, while the symbolic translation of indices often fails, the indexical reproduction of texts is invariably successful.

Though Walter Benjamin spent a great deal of effort to show that the mechanical processes of photography function according to procedures entirely different from those of painting – in other words, that indexical reproduction differs from iconic rendition – he seems to have overlooked the fact that photographs and texts are also two distinct classes of signs. Urging the translation of photographic images into textual "signposts" goes against his own theories, since the age of mechanical reproduction has transformed the status not only of iconic painting, as Benjamin showed, but also of textual symbols, as Modotti's work demonstrates. In the modern era, photography has turned

representation into an automated, indexical process that allows for the speedy and accurate reproduction of printed text.

In addition to their conceptual play with different kinds of signs, from symbols to indices, Modotti's experiments with the relationship between text and photograph point to another important fact: photography's indexicality is closely related to its status as a new technology. As we saw in the Kodak advertisements, cameras were hailed as autographic machines, as mechanisms capable of automatic recording. "Todo lo que sus ojos ven, lo abarca el lente, y la anotación autográfica evita que se olviden datos importantes" [All that your eyes see is grasped by the lens, and autographic recording prevents important facts from being forgotten], the ad claims, relating the camera's automatism to its production of indexical – or autographical – recordings.

And it was precisely the photograph's indexicality that was undone by pictorialist photographers who sought to conceal the automatism that characterized their medium. A retouched print, like Brehme's *Hombre con sombrero*, is no longer an index but an icon. The minute a brush or a pencil touches its surface, the photograph loses its indexical character; it ceases to be a pure photochemical trace of the referent and becomes – like paintings and drawings – a mere visual likeness of the object it represents.

In contrast to these pictorialist de-indexations of photographs, works like *Tank No. 1* highlight not only photography's functioning as an indexical medium but the index's origin in modern technology. Indexical representation is closely related to both mechanical reproduction and industrial processes, especially to the mass production of objects serially stamped out from single molds. Like photographs, the mass-produced commodities that abound in the modern era are mechanically reproduced indexical imprints.

The index's central place in the workings of modern media is made explicit in *La técnica* (1928; figure 27). The typewriter is a machine for writing (in Spanish it is called *máquina de escribir*), and its working procedure is indexical, like the camera's. As the keys are tapped, the metal types depicted in Modotti's photograph strike against the ink ribbon, imprinting the mark of each metal letter on the paper. When writing is thus mechanized, it evolves from a symbolic to an indexical process.

By turning its lens toward texts, the camera, like the typewriter, can become a writing machine. Modotti's photograph of Julio Antonio Mella's typewriter – which I will discuss at length in the next chapter – uses photochemical processes not only to "write" the letters and numbers printed on the keys but also to rewrite the typed text on the sheet of paper emerging from

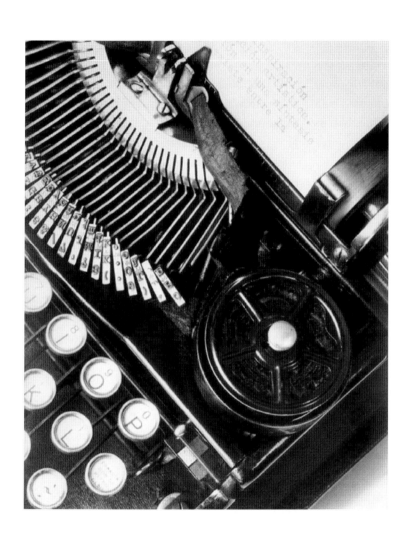

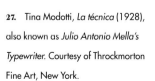

27. Tina Modotti, *La técnica* (1928),
also known as *Julio Antonio Mella's
Typewriter*. Courtesy of Throckmorton
Fine Art, New York.

the carriage. The text appearing on the photographic print was written mechanically – it was typed – and then rewritten, mechanically and also autographically, by Modotti's camera. Both the typewriter and the camera can write, but, as *La técnica* proves, the camera is more technologically advanced than the typewriter: the typewriter writes mechanically, but only the camera can write automatically. When used for reproducing texts, as in *Tank No. 1* and *La técnica,* the camera becomes a sort of automatic typewriter, copying entire texts at the click of a button.

We can now see why Modotti preferred to include texts inside her photographs as indexical reproductions of symbols and not outside them as captions. Captions are texts that must be written out by the hand of an editor who struggles to translate the photographic image into a few words, whereas texts inside photographs are autographically recorded by the pressing of a button. Captions must be manually composed, and their handcrafted nature – like pictorialist hand-retouching – clashes against the camera's automatism, whereas texts inside photographs attest to the camera's power as an automatic writing machine.

Though all cameras are autographic machines, as the Kodak advertisement proclaims, not all photographers looked at their instrument in the same way. Ashamed of the automatism that characterized their medium, pictorialists like Silva and Brehme attempted to make handcrafted paintings out of photographs, while straight photographers like Tina Modotti emphasized the camera's kinship with other modern technologies. Through the triple strategy of photographing technological artifacts, deploying oblique perspectives, and highlighting the indexicality of the photographic medium, Tina Modotti's work shows that the camera, like the typewriters, telegraphs, and telephonic artifacts it depicts, partakes in the automatism that characterized the modern era.

It is no coincidence that Modotti's politics were radically different from those of pictorialist photographers like Silva and Brehme. Pictorialists were entirely apolitical, although the case of Brehme is especially paradoxical, since he photographed countless battles and other scenes of the Mexican Revolution, but always in an entirely aestheticized manner that elided their historical and political context. Overall, pictorialists produced nothing but scenes of "Picturesque Mexico," whereas Modotti was a committed revolutionary. In 1930 she was expelled from Mexico because her political activism was deemed too threatening to the postrevolutionary government, and she devoted the rest of her life to working for the International Red Aid.

Modotti insisted on treating photography as a technology precisely because she realized the revolutionary potential inherent in its mechani-

cal processes. Mechanical reproducibility opened the door for mass production and mass dissemination of information – a sharp contrast to previous handcrafted artistic techniques that produced a single aura-laden original accessible only to a limited number of spectators. Unlike painting, photography had the potential to reach millions of viewers and readers (this was one of the benefits of destroying the aura of artworks, according to Walter Benjamin). Thus Modotti had little interest in showing her work in museums or galleries – she only had one gallery exhibit in Mexico – but instead chose to circulate her photographs as reproductions in journals, newspapers, and magazines.

Modotti considered photography as a tool for political activism, much in the same way that Rivera (and his patron Vasconcelos) saw muralism: as an efficient medium for disseminating political messages. But as we saw in our discussion of Rivera, despite the widespread enthusiasm generated by his project, murals are still bound by the limitations of an auratic medium. Photography, on the other hand, is revolutionary both because it teaches viewers how to see the world in new ways and because it has the potential to reach the masses. (In fact, *New Masses* was the title of one of the leftist journals to which Modotti regularly contributed.)

If we now return to the Kodak ads considered at the beginning of this chapter, we see that even if all cameras were autographic, photographers had radically different opinions about the nature of their work instrument. Pictorialists and modernists engaged in debates about the nature of the medium, exchanges that were as intense as those that unfolded in Europe among figures like Walter Benjamin, Siegfried Kracauer, and Georges Duhamel. Among the photographers and visual artists working in Mexico in the 1920s, Tina Modotti exhibited the most sophisticated understanding of photography as a revolutionary medium attuned to the age of mechanical reproduction.

If the camera sparked intense discussions that ultimately culminated in acts of vandalism like Silva's destruction of Weston's print, the typewriter ignited even more impassioned debates about the relation between modernity and representation, between art and machines, as we will see in the next chapter.

2

TYPEWRITERS

Chapter 1 discussed how Modotti's *La técnica* brought to light the similarities between the camera and the typewriter, two artifacts designed for mechanizing representation. In this chapter I will examine how the typewriter's mechanization of writing closely paralleled the camera's transformation of visual representation. Just as the camera inspired Modotti and other photographers to experiment with new ways of seeing, the typewriter led writers to launch new literary techniques attuned to an era dominated by modern innovations. Technology had changed the way writers worked, and nowhere was this change more apparent than in the rise of typewriter culture. Writing was no longer a handcrafted, manual exercise that required penning characters on paper; it had become a mechanized procedure requiring the tapping of keys, the pulling of levers, and the pushing of buttons—

a process not unlike the operation of industrial machinery in factories and plants.

The impact of the typewriter on literature was bound to be subtler and less apparent than that of the camera on visual representation; photographs look different from paintings, but published texts have the same appearance whether they are printed from a manuscript or a typescript. Nonetheless, the writing machine would revolutionize writing in postrevolutionary Mexico.

Typewriters were invented in the early 1870s and by the 1890s their use had become widespread in the business world. These machines, along with stock tickers, Dictaphones, and adding machines, could be found in every modern office, from Chicago to New York, from Mexico City to Buenos Aires. Writers, however, did not immediately embrace the typewriter as a tool that would simplify their task: they approached the "writing machine," as it was called at one point (and as it is still called in Spanish) with suspicion and skepticism. As Friedrich Kittler explains, "As far as one can reconstruct the unwritten literary history of the typewriter, only journalists and reporters such as Mark Twain and Paul Landau threw away their pens in the pioneering days of 1880."[1]

Once writers began to use typewriters, their reactions were mixed. Mark Twain bought a typewriter in 1874, liked it, and became the first author to submit a typewritten manuscript, his *Life on the Mississippi*, to a publisher.[2] Nietzsche was less enthusiastic: in 1882 he tried an early model of the typewriter to compose a few aphorisms, but soon abandoned it, complaining that it was bulky, unreliable, and that "typewriting [was] initially more exhausting than any kind of writing."[3] Henry James, in contrast, had a good experience; around the turn of the century he purchased a Remington, hired a secretary to type, and dictated entire novels as he paced around his study, inspired by the machine's rhythmic tapping.[4] T. S. Eliot featured a typist as one of the disembodied voices in *The Waste Land* (though it is hard to say whether the author meant this passage as a tribute or a jab). And in his seminar on Parmenides, Heidegger sounded a pessimistic note, denouncing the typewriter as a machine that "tears writing from the essential realm of the hand," and is symptomatic of the "increasing destruction of the word."[5]

In contrast to these vocal supporters and detractors of the typewriter, nineteenth-century Latin American writers left no written testimony of their first encounter with the writing machine. There is a logical explanation for their silence: the typewriter arrived in Latin America in the last two decades of the nineteenth century, a period dominated by the aesthetics of *modernismo*, a literary movement that saw all machines as modern

intruders into a literary world modeled on the pastoral ideals of the classical world. Though the poets of *modernismo* did not write specifically about the typewriter, we can extrapolate what their views might have been from their overwhelmingly negative reactions to machines in general. When Manuel Gutiérrez Nájera complained that the industrial artifacts of the modern era distracted poets from the sources of inspiration found in "the gardens of Academus," he could have had the typewriter in mind.[6] Preoccupied as they were with the great themes of sublime nature, romantic love, and artistic genius, the poets of *modernismo* snubbed the "writing machine" as unworthy of even a single line in their essays and literary disquisitions. For the *modernistas,* the typewriter was one more noisy machine, like railroads and automobiles, threatening to perturb their literary idyll.

The typewriter did not enter Mexican literature until after the revolution of 1910, when social upheaval made poetic dreams of Academus and Aspasia untenable. After 1917 Mexican novelists would devote several texts to examining the cultural implications of the writing machine. And, as we will see in the pages that follow, these literary elaborations were specific enough to differentiate among three kinds of typewriters: Olivers, Remingtons, and Underwoods.

The Oliver

The first significant mention of typewriters in Mexican literature appears in Mariano Azuela's *Los de abajo* (The Underdogs, 1915), the most famous novel of the Mexican Revolution. The writing machine makes an appearance in one of the many scenes depicting the civil war as a chaotic free-for-all. At one point in the novel a band of revolutionaries led by Demetrio Macías storms a town, pillages its houses, and loots, among other luxuries, a brand-new Oliver typewriter that soon proves too heavy to carry on horseback:

¿Quién me merca esta maquinaria?–pregonaba uno [de los revolucionarios], enrojecido y fatigado de llevar la carga de su "avance".

Era una máquina de escribir nueva, que a todos atrajo con los deslumbrantes reflejos del niquelado. La "Oliver", en una sola mañana, había tenido cinco propietarios, comenzando por valer diez pesos, depreciándose uno o dos a cada cambio de dueño . . . pesaba demasiado y nadie podía soportarla más de media hora.

["Who wants to buy this machine?" asked one [of the revolutionaries], overheated and fatigued from carrying his loot.

It was a new typewriter whose shimmering nickel finish fascinated all of them. In the course of only one morning, the Oliver had already had five owners. Its

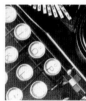

Typewriters

price started at ten pesos but depreciated by one or two pesos with each change of hands. It was too heavy and no one could stand to carry it for more than half an hour.]

Another rebel buys the machine from him, but soon decides that such a heavy apparatus has no use on the battlefield:

Doy peseta por ella – ofreció la Codorniz.

Es tuya – respondió el dueño dándosela prontamente y con temores ostensibles de que aquél se arrepintiera.

La Codorniz, por veinticinco centavos, tuvo el gusto de tomarla en sus manos y de arrojarla luego contra las piedras, donde se rompió ruidosamente.

["I'll give you a quarter for it," offered Codorniz.

"It's yours," responded the owner, giving it to him promptly, evidently fearful that he would change his mind.

For twenty-five cents, Codorniz had the pleasure of taking it in his hands and then hurling it against the stones, where it broke up with a great clatter.]

The destruction of the Oliver inspires the other rebels to smash all other useless objects, and a holocaust of riches ensues:

Fue como una señal: todos los que llevaban objetos pesados o molestos comenzaron a deshacerse de ellos, estrellándolos contra las rocas. Volaron los aparatos de cristal y porcelana; gruesos espejos, candelabros de latón, finas estatuillas, tibores y todo lo redundante del "avance" de la jornada quedó hecho añicos por el camino.

[It was like a signal: all who were carrying heavy, burdensome objects started to get rid of them, hurling them against the rocks. Pieces of crystal and porcelain, heavy mirrors, brass candelabra, fine statuettes, fancy china, and all the loot accumulated during the campaign went crashing against the rocks and shattered by the side of the road.][7]

This scene marks the entrance of the typewriter into Mexican literature, though its literary presence was doomed to be tragically brief: a dozen lines after its debut, the machine is smashed against the rocks, banishing it from the novel for good. Despite the typewriter's unhappy fate, the narrator describes it as a wondrous invention, emphasizing the fascination it exerted on the rebels: the Oliver "attracts everyone," mesmerizing the revolutionaries with the "shimmering of its nickel plating." One of the men describes the Oliver as "esta maquinaria," using a term usually reserved for industrial machinery, thus suggesting that the revolutionaries considered the Oliver a mechanical spectacle of sorts. The machine's appeal is so intense that Demetrio's men are not content with

merely looking or touching: they yearn to be the proprietors of such an exotic invention, and they go through great trouble to purchase the machine so they can have it all to themselves.

The typewriter changes hands six times in a single day, thus becoming the most frequently exchanged commodity in the novel. And even though the Oliver's price plunges at a precipitous rate, the typewriter continues to enthrall the revolutionaries, who keep trading it until they are physically unable to bear its weight. Even as it loses exchange value, the machine retains its symbolic value as a prized possession.

Ironically, despite their fascination with the typewriter as a glittering piece of modern machinery, the revolutionaries are unable to operate it. Demetrio's men are uneducated country folk who cannot write, let alone type, and thus they have no use whatsoever for a writing machine. And even if they could write, they would be hard pressed to find a function for the typewriter in the chaotic revolutionary world of battles, occupations, and retreats. The typewriter might be a useful tool in Mexico City's offices and businesses, but it is entirely useless (or "redundant," as the narrator states) in the rural world of Azuela's novel.

But the Oliver is not only useless: the bandits describe it as a burden – "una carga." In spite of the typewriter's powers of fascination, its function

28. The Oliver No. 5 (1907). SINAFO-Fototeca Nacional, Mexico City.

has been upturned. Machines are supposed to simplify and expedite labor-intensive tasks, but in the novel the typewriter brings about the opposite effect: rather than easing the revolutionaries' task of conquering towns and villages, the unwieldy machine burdens them, slowing their journey and unnecessarily complicating their job.

The Oliver is thus a textbook example of commodity fetishism gone awry; it is desirable but useless, a sought-after commodity that is also a cumbersome burden. Though the machine is entirely devoid of use value, it seems to abound in exchange value. To underscore the Oliver's status as a useless but precious commodity, the narrator describes its tragic end, followed by the destruction of other looted items that include crystal and porcelain wares, mirrors and candelabra, statuettes and other tchotchkes that the revolutionaries dump to lighten their load. All that these objects have in common is their lack of functionality – they are decorations that serve no purpose at all, useless to most people but especially to a band of nomadic revolutionaries.

The typewriter's first appearance in Mexican letters leaves us with a perplexing message: *Los de abajo* seems to present the writing machine as a useless technology, one that captivates the revolutionaries solely on the merits of it shiny appearance. Ironically, in the novel, the writing machine is never used to write anything. We don't know if Azuela's Oliver types well or badly, or even if it types at all, because the machine is never put to use. The machine could well be broken, a dysfunctionality that would further underscore the absurdity of the revolutionaries' obsession with the Oliver.

This characterization of the typewriter as a machine that is superficially seductive but fundamentally useless appears elsewhere in Azuela's novels. Azuela had a long-standing fascination with typewriters in general and with Olivers in particular, and he often made references to these machines in his novels. The first of Azuela's Olivers appears in *Sin amor* [Loveless], an early novel published in 1912, during Madero's short-lived presidency. Here the typewriter appears as the sidekick of the novel's protagonist, a provincial writer named Escolástica Pérez. Unlike the ill-fated Oliver of *Los de abajo,* the typewriter featured in *Sin amor* does type, and it types very well indeed:

La flamante Oliver galopaba vertiginosamente sobre una blanca hoja de papel. Escolástica, absorta sobre los brillantes signos del teclado, no oía las fuertes llamadas en el zaguán, ensordecida por el ruido de las barras subiendo y bajando, el tintín periódico del timbre y el rumor de moscardón del carro retrocediendo para caer sobre una nueva línea.[8]

[The late-model Oliver ran swiftly over a blank sheet of paper. Escolática, absorbed by the keyboard and its shiny symbols, did not hear the loud knocks at her door: she was deafened by the noise of striking type-bars, the rhythmic ringing of the bell, and the roar of the carriage returning to a new line.]

As in *Los de abajo*, the Oliver exerts its powers of fascination on both the character and the narrator. If the revolutionaries were mesmerized by the machine's shiny appearance, Escolástica is enthralled by the Oliver's sounds, a mechanical cacophony full of rising bars, clinking keys, ringing bells, and whooshing carriages. But Escolástica's engagement with the Oliver goes beyond fascination: she is absorbed – even hypnotized – by the machine to the point that she loses touch with the external world and cannot hear the loud knocks on her door.

Despite the narrator's apparent enthusiasm for the typewriter, and despite the fact that Escolástica's Oliver appears to be a useful machine, a closer reading of *Sin amor* reveals that this Oliver is not much different from the machine in *Los de abajo:* it is another example of a writing machine whose superficial appeal contrasts with its lack of function. Far from helping Escolástica to write more efficiently, the Oliver detracts from her writerly obligations. The narrator suggests that

writing recedes into the background as the operator revels in the typewriter's mechanical spectacle. Escolástica's enthusiastic tapping is not an efficient use of the writing machine, but an indulgent example of typing for typing's sake.

The plot of *Sin amor* portrays Escolástica as an impractical woman who is out of touch with reality, and her Oliver typewriter serves to underscore the absurdity of her situation. Azuela wrote the novel as a sarcastic indictment of the intellectual pretensions of the small-town Mexican bourgeoisie. As her name suggests, Escolástica is the ultimate caricature of the provincial intellectual. She is a housewife who edits a literary journal called *Paginitas de oro* (Little Golden Pages), and types her essays, reviews, and opinion pieces on the Oliver typewriter.[9] In a passage meant to illustrate the absurdity of Escolástica's literary endeavors, the narrator tells us that her next article is to be a proposal addressed to the central government, recommending strategies "to elevate the cultural life of the proletarian masses to a more decorous level," a pitch that leads another character in the novel to exclaim, "You know Escolástica: she's mad about everything that has to do with education and culture!"[10]

Of all the details given by the narrator to paint Escolástica as a caricature of provincial cultural life, none is as eloquent as her typewriter. The

Oliver was an industrial machine designed for the bustling, industrial world of large cities (the writing machine was a piece of heavy machinery or "maquinaria," as the revolutionaries in *Los de abajo* point out), and it is laughably out of place in the sleepy Mexican town of Azuela's novel. Escolástica needs an Oliver to type her articles as much as a provincial writer today would need a supercomputer to write an occasional poem. Like the looted typewriter in *Los de abajo*, Escolástica's Oliver is redundant. It is a machine whose complexity (notice the bulky, industrial look of the Oliver typewriter shown in figure 28) far exceeds the needs of its operator. The typewriter is overqualified for the simple job of writing bourgeois criticism for a corny, provincial journal, and it serves as a caricature of petty bourgeois pretensions.

Azuela's Olivers always seem out of place, invariably appearing in settings that have no use for a writing machine, like the countryside or provincial villages. In these remote locations, the typewriter becomes a strange and defamiliarized object: the characters find it exotic, fascinating, and alluring, but they cannot conceive of a practical use for it. In Azuela's novels the typewriter is never functional, it is never used to make the process of writing more efficient; it is always a dysfunctional machine, a technological spectacle that hinders the characters from completing their tasks.

But how do these unflattering representations relate to Azuela's own experience with the typewriter? Did the author share his characters' prejudices against the writing machine? Did he see the typewriter as an elaborate mechanical spectacle? Did he believe that typewriters were out of place in twentieth-century Mexico? To answer these questions, we will now turn to Azuela's real-life encounter with the typewriter – an encounter that, as we will see, was extremely significant.

Like his characters, Azuela was fascinated by typewriters, in part because it was a writing machine that allowed him to finish *Los de abajo*. Azuela began writing the novel in 1914, after he joined a group of Villista revolutionaries as a volunteer doctor and accompanied them through northern Mexico. Azuela was hard pressed to write anything in the midst of the chaotic succession of battles, occupations and retreats, and what little he wrote, he wrote by hand. In 1915, when he took leave of the insurgents and crossed the border into the safety of Texas, he had produced only "a bundle of handwritten papers" that he had been carrying well concealed under his cotton shirt.[11] When he arrived in El Paso, the editor of *El Paso del Norte*, an anti-Huerta, Spanish-language newspaper, put a typewriter at his disposal and enticed him to finish the novel by offering to publish it in his newspaper. Equipped with a writing machine,

Azuela typed away, and in a few weeks he completed the novel. The entire third part of *Los de abajo* was composed on a typewriter in the print shop of *El Paso del Norte*.[12]

El Paso del Norte was supported in part by advertising revenue from a local distributor of Oliver typewriters (see the advertisement reproduced in figure 29), and thus it is likely that Azuela typed the last section of *Los de abajo* on the keyboard of a shiny Oliver such as the one shown in figure 28. His time in El Paso gave the budding novelist a firsthand experience of the machine and transformed his writing method: from that point on he became a typewriting author, as he once told an interviewer.[13]

But Azuela, like his characters, had mixed feelings about typewriters. On the one hand, as his descriptions make clear, he was fascinated by the sophisticated technology of the writing machine; at the same time, his novels invariably cast the Oliver as an apparatus that is conspicuously out of place, a curious technical wonder that is at odds with the bare-bones reality of Mexican life during the 1910s.

An advertisement for the Oliver typewriter that appeared in the pages of *El Paso del Norte* (figure 29) might help elucidate Azuela's misgivings about the typewriter. The ad promotes the "Typewriter & Office Supply Co.," an authorized retailer of Oliver typewriters for northern Mexico. The ad copy then enumerates other artifacts, in addition to typewriters, distributed by the company – fireproof iron safes and filing cabinets, among others – and closes by announcing that the business also "rents, sells, and reconstructs all kinds of typewriters." As this ad reveals, in the 1910s typewriters were considered first and foremost as office equipment. They were sold by stores like the Typewriter and Office Supply Company that specialized in filing cabinets and other equally prosaic items. The main users and purchasers of writing machines were not writers or intellectuals, but businesses and other commercial establishments. Ironically, typewriter merchants like the Typewriter and Office Supply Company treated typewriters no differently than the bandits of *Los de abajo:* they used the machines not to

Typewriters

29. Advertisement for the Oliver typewriter in *El Paso del Norte* (1915). From Stanley R. Robe, *Azuela and the Mexican Underdogs* (Berkeley: University of California Press, 1979), 90.

write, but merely as commodities to be bought and sold for profit. In addition to buying and selling, companies like the one featured in the ad also "reconstructed" damaged typewriters, a line of business that would have allowed the company to turn a profit by rebuilding and reselling the Oliver shattered by the revolutionaries in *Los de abajo.*

Reconstructing damaged typewriters actually became a lucrative business. One typewriter historian explains that "by the 1920s, a major industry had developed for the rebuilding of typewriters . . . [so that] companies all over the country stripped second-hand machines down to their individual pieces – all 2,000 to 4,000 of them – soaked them in acid to get them completely clean, replaced worn parts with new ones, renickeled the bright parts, and repainted the frames their original black and trimmed them with decals of the original design. At least one rebuilder claimed its product 'better than new,' because it did not require a breaking-in period."[14]

As he made abundantly clear in many of his novels, Azuela considered the world of commerce represented by the Typewriter and Office Supply Company extremely vulgar. For him the modern obsession with trading, exchanging, and turning a profit was as unseemly as the revolutionaries' plunder denounced in his novels. In *La luciérnaga* [The Firefly], a novel published in 1932, he in-

cludes a scornful description of the many businesses that had filled downtown Mexico City since the Porfiriato, crowding the central square with offices, commuters, and noisy secretaries who spent all day at their Oliver typewriters. Azuela laments the transformation of the capital into "ese mundo bullicioso femenino que impone su ambiente vital en trenes, coches, camiones y peatones convergentes y divergentes del Zócalo, a la hora de los clarines de Palacio: *el mundo de la Oliver*" [that noisy feminine world that imposes its atmosphere on trains, automobiles, buses, converging and diverging pedestrians in the central square, as city hall sounds its trumpets: the world of the Oliver].[15] Evoking the prejudices of *modernistas* like Gutiérrez Nájera, Azuela considers the Oliver typewriter a symbol of the strident atmosphere, polluted by cars, buses, fast-paced secretaries, and other by-products of commerce that he found so antithetical to the peace and serenity needed by writers. The boisterous "world of the Oliver," as he calls it, was profoundly incompatible with the necessities of his literary profession.

There is a second, more compelling reason for Azuela's contempt for the Oliver. Not only was this typewriter a symbol of the vulgar world of commerce, but it was also associated with an extremely unsavory episode in Mexican politics: the reign of Porfirio Díaz and its aftermath. The his-

tory of Oliver typewriters coincides, temporally as well as conceptually, with the presidency of Díaz. The first Oliver typewriter – the "Oliver No. 1" – was introduced in Chicago in 1896, while Díaz was serving his second term as president (he had been president from 1877 to 1880, and ruled again from 1884 until he was forced to resign in 1911). The Oliver was invented by Thomas Oliver, "a minister who grew weary of writing his sermons in longhand," and the No. 1 was soon followed by new, improved models, including the No. 2 (1897) and the No. 5 (1906), the best-selling Oliver of all time.[16]

The Oliver No. 5 was made of cast iron and weighed over thirty pounds – giving credence to the revolutionaries' complaint that the machine was a "burden." It was described by one historian as "probably the closest to an indestructible typewriter ever made," a fortitude that makes the bandits' obliteration of the Oliver in *Los de abajo* even more astonishing. The machine proved to be immensely popular: over one million Olivers were sold before the company began to lose market share in the 1910s and went bankrupt in the 1920s.[17]

The Oliver was introduced to Mexico in the 1890s, at a time when Porfirio Díaz had consolidated his "iron-fist" rule, and the machine became an instant hit. It is not difficult to imagine that Díaz, who spent the last two decades of his presidency courting foreign investment and acquiring modern technology, would have applauded the typewriter as a symbol of the modernization he desired for Mexico. Díaz would even have admired the Oliver's origins: it came from Chicago, like the postgraduate degrees of the positivist Científicos that he had installed in his cabinet, and the machine had ties to the church (its inventor was a minister), an institution that had proved a bulwark of support for his government. Alongside railways and streetcars, telephones and electricity, the typewriter was another striking symbol of the technological "order and progress" that Díaz bestowed on Mexico during the last years of his regime.

A photograph from the Casasola archive illustrates the popularity of Oliver typewriters during the Porfiriato. Figure 30 shows a typing school in downtown Mexico City in which dozens of young women sit blindfolded at the keyboards of shiny new Olivers. This uncanny scene tells us a great deal about life under Díaz. Business was booming in the capital, in part due to the hundreds of European and American companies that had been lured into the city by the president, creating thousands of openings for typists and other trained workers including, for the first time, women. But many Mexicans were also blinded –

30. "The World of the Oliver": a typing school in Mexico City during the Porfiriato, ca. 1910. Fondo Casasola. SINAFO-Fototeca Nacional, Mexico City.

like the women in the photo – to the complex reality of their country: the capital appeared to be wealthy and prosperous, but the rest of the country languished in the most abject poverty. It was this blindness, linked to what Azuela called "the world of the Oliver," that led to the explosion of the Revolution in 1910.

It thus comes as no surprise that Azuela, a supporter of Madero's Revolution, would feel ambivalent toward a machine that in many ways symbolized the foreign-inspired modernity that had become a personal obsession for Porfirio Díaz. The Oliver was a thoroughly Porfirian machine, a fact that helps explain the ill treatment it invariably suffers in Azuela's novels.

In addition to the typewriter's associations with the vulgar world of commerce and with the hated regime of Díaz, there is a third explanation

for Azuela's misgivings about the Oliver. The type-writer was an eloquent symbol for the modern literature that emerged in the 1910s and 1920s, a new writing shaped by the industrial era and attuned to the bustling rhythms of the modern world – a literary revolution that the conservative Azuela opposed.

Modern novelists saw the typewriter as a striking symbol of the new narrative procedures inaugurated by the modern era. In the same way that the typewriter had mechanized the writing process, the technological innovations of the modern world had inspired new narrative procedures. Progressive writers seeking new narrative techniques attuned to the technological era they inhabited used the equally modern typewriter when they wrote. Old-fashioned novels, in contrast, were written out by hand and followed traditional narrative conventions. Most writers who used the typewriter were also engaged in the modernist experimentation with new writing techniques. Among the typewriting and typewriter-loving authors of this era, Kittler mentions Paul Landau, Blaise Cendrars, and T. S. Eliot – the same figures who launched the literary revolutions of modernism.[18]

Though Azuela typed, he typed reluctantly, feeling guilty about his dependence on a modern business machine. And unlike Cendrars, Eliot, and other forward-looking typewriting authors, Azuela was a traditionalist who derided all attempts to bring narrative techniques in line with the modern world. In his memoirs, he describes himself as a realist writer committed to nineteenth-century literary models, and he repeatedly points to Zola and Balzac as the most significant influences on his work.[19] Though he came of age as a writer in the 1910s and 1920s, when the ambition to create a new, modern literature obsessed authors from Mexico to Moscow, Azuela continued to look to the past for inspiration, and he showed nothing but contempt for those who sought to create experimental forms of writing.

In his memoirs, Azuela lashes out against modern writers, attacking "the fashionable literary movements of today," accusing them of "degeneracy," and concluding that they are nothing more than "rotting latrines."[20] He was especially suspicious of Mexican writers like the Contemporáneos poets who attempted any kind of literary experimentation, chastising them as "clumsy imitators of European avant-garde literature."[21] His appraisal of modern writing techniques – a vague category of which he never provides examples – was equally vicious: "Today's modern technique . . . consists in twisting words and phrases, and in obscuring concepts and expressions in order to create the effect of novelty."[22] Azuela

considered modern literature a "novelty," an exotic approach that had some appeal – he even tried his hand at it[25] – but which he ultimately rejected in favor of old-fashioned realism. Despite the initial seduction of its bells and whistles, he dismissed modern literature as having no place in Mexican intellectual life.

The treatment of the typewriter in Azuela's novel is thus a striking allegory of the author's prejudices against the modern narrative techniques he encountered in the 1920s. Like the typewriters in *Los de abajo* and *Sin amor*, modern literature is for him a "novelty" that seduces writers with the mechanical complexity of its operations. Like the typewriter, modern writing conceals a lack of purpose behind the gleaming appearance of its technical spectacle; and like the typewriter, modernism is ultimately dismissed as a mechanically inspired invention that is conspicuously out of place in postrevolutionary Mexico. Given the violence that characterized his attacks against forward-looking writers, Azuela would probably have chosen to dispose of modern literature in the same way that the revolutionaries rid themselves of their Oliver typewriter: by hurling it against the rocks of the Mexican landscape.

The story of Azuela and the Oliver leads us to a paradoxical conclusion: although Azuela was the first Mexican author to write about typewriters, he never explored the numerous ways in which mechanization could transform writing. He never asked the fundamental question of how typed texts might differ – in style, content, and technique – from handwritten ones. All of Azuela's descriptions focus on the external aspects of the typewriter, on its glimmering appearance and its spectacular sounds, and they never examine the *output* of the writing machine. Either Azuela's Olivers do not type, as in *Los de abajo*, or if they do, as in *Sin amor*, their output remains hidden from the reader. Like his characters, Azuela was ultimately too distracted by the machine's impressive exterior to focus on the particularities of mechanized writing.

The Remington No. 1: Musical Typewriting

Azuela was not the only Mexican writer to develop an interest in the writing machine during the years of the revolution. While Azuela was typing the final chapters of *Los de abajo* in Texas, Martín Luis Guzmán, another budding novelist who wrote extensively about the revolutionary years, was discovering the wonders of the writing machine, although this time around the machine in question was not an Oliver but a Remington.

Though Guzmán did not cast typewriters as characters in his novels, his encounter with the writing machine was to leave a more significant

mark on his literary production. Unlike Azuela, who merely sprinkled his novels with quirky references to the Oliver, Guzmán devoted an entire essay to his Remington, a machine he had purchased in 1917 during his self-imposed exile in New York City. The essay, "Mi amiga la credulidad" (My Friend, Credulity), first published in New York in 1918 and later included in the volume *A orillas del Hudson* (On the Banks of the Hudson), recounts the author's bizarre infatuation with the typewriter.[24]

In this brief text, Guzmán tells the story of his obsession with the Remington. Soon after his arrival in New York, he stumbled upon a biography of Henry James that described how the American novelist had become addicted to the clicking sounds made by his Remington typewriter. Guzmán mentions the anecdote only in passing, but the story is told in detail by Theodora Bosanquet, James's biographer and one-time secretary. Apparently James became so dependent on the clicking of his Remington for inspiration that he found it difficult to concentrate whenever circumstances forced him to use another machine. Once, while the Remington was being repaired, he had to make do with an Oliver typewriter, a substitution he found quite traumatic. As Bosanquet describes, James "dictated to [the] Oliver typewriter with evident discomfort, and he found it almost impossi-

bly disconcerting to speak to something that made no responsive sound at all."[25]

Driven by a great admiration for Henry James, Guzmán decided to trade in his typewriter, which he describes as an "old" and antiquated Underwood, for a new Remington similar to the one that had occasioned James's addiction: "Not wanting to be left behind, I resolved to get rid of my old and loyal Underwood, which I exchanged for a brand new Remington with excellent sound." Guzmán installed the machine in his New York apartment, and soon discovered that the Remington's loud clicking mesmerized his entire family:

El advenimiento de la nueva máquina ha producido en mi hogar toda una revolución: ha transformado los métodos, ha cambiado las costumbres, ha modificado los caracteres. Como tanto mi mujer como mis hijos opinaron, después de la primera audición, que no existe instrumento superior a la Remington para evocar las ocultas armonías, hemos hecho a un lado la pianola y el fonógrafo, no nos acordamos de Beethoven ni de Caruso y sólo gustamos ahora de escuchar, a mañana y tarde, a los grandes maestros de la máquina de escribir. ¡Quién hubiera pensado nunca que es posible ejecutar – a una y a dos manos, en color rojo y en color azul – desde un canto de la Ilíada, hasta una proclama de Marinetti! ¡Música divina! Mucho, en verdad, depende de la interpretación.

[The arrival of the new machine has produced a revolution in my home: it has transformed our methods, altered our customs, and modified our characters. After the first audition, my wife and children acquiesced that there is no better instrument than the Remington for evoking hidden harmonies. We have put aside the player piano and the phonograph, forgotten Beethoven and Caruso, and our only pleasure is to listen, morning and night, to the great typewriter masters. Who would have ever thought it possible to play – with one or two hands, in red or blue ink – everything from a verse from the *Iliad* to a proclamation by Marinetti! Divine music! Though much, it is true, depends on the performance.]

Guzmán's typewriter performance even attracts listeners outside his own home:

Entonces confirmo también el interés con que los vecinos de la casa toman mis conciertos nocturnos y me explico que los más entusiastas entre ellos, y los más atrevidos, abran las ventanas fronteras a la mía a pesar del crudo invierno, y me lancen a voz en cuello bravos que yo apenas distingo en mi enarbolamiento musical. El ticli-ticlá de mi Remington enardece a unos tanto como las mejores arias de la Galli-Curci y sume a otros en esa contemplación interior que sólo provocan el violín, el órgano y la orquesta.

[I then notice the great interest with which my neighbors listen to my nocturnal concerts. The most enthusiastic and daring among them open their windows, ignore the bitter winter, and shower me with "bravos" I can hardly make out in my musical trance. My Remington's ticli-ticla pleases some as much as the best arias by Galli-Curci and plunges others into that state of inner contemplation usually reserved for violins, organs, and orchestras.][26]

Guzmán makes a radically unorthodox use of his Remington – the typewriter has replaced not the pen, as we might expect, but the piano – and he seems less interested in the machine's textual output than in its acoustic performance. And though he uses the machine to write – he copies previously published literary masterpieces – writing fades into the background as he celebrates the typewriter's extratextual capabilities. He even lauds the Remington's therapeutic effects in treating his infant son's crying fits: "Cuando el pequeñuelo enfurece ... corro a donde está la máquina, la destapo apresuradamente y tecleo de memoria algún trozo de lo más clásico (*The Sacred Fount*, por ejemplo, que es mi predilecta). Y ... antes [del] segundo párrafo, mi hijo se apacigua y se acerca, indeciso ente la risa y las lágrimas." [When my little one starts crying ... I run to the typewriter, I uncover it as fast as I can, and I type by heart a passage from a classical work (*The Sacred Fount*, for example, which is one of my favorites). And ...

before I start the second paragraph, my son is already calm and quiet.][27]

Even more striking than the obsession with the Remington's acoustics is Guzmán's association of the late-model Remington with nineteenth-century artifacts. The machine's "ticli-ticlá" brings to his mind not the noise of the modern world but the romantic music of Beethoven, the operatic arias sung by the Italian diva Amelita Galli-Curci, and the novels of Henry James. Guzmán seems blind (or deaf) to the fact that the clicking he describes is a mechanical sound that has more in common with the cacophony of modern industry than with the harmonious, preindustrial world of "violins, organs, and orchestras" and the "inner contemplations" they inspire.[28]

The choice of James's *Sacred Fount* is significant. Though this novel appeared in the first years of the twentieth century (it was published in 1901), its main theme – that love and artistic inspiration stem from an inner "sacred fount" that is in constant danger of drying up – is a perfect example of the romantic ideals that Kittler considered incompatible with the age of the writing machine.

Contrary to Guzmán's romantic associations, his writing machine was manufactured by a company whose history underscores the typewriter's filiation with other industrial products: the factory of E. Remington and Sons, based in Ilion, New York, had originated as a weapons manufacturer (it had been an important provider of rifles during the American Civil War) and later branched out into the production of sewing machines. As figure 31 shows, E. Remington and Sons advertised its business as an "Armory, Sewing Machine and Type-Writer Factory," thus underscoring the technological continuity linking weapons, sewing machines, and writing machines. The Remington's militaristic origins led Kittler to call the typewriter a "discursive machine-gun," and to compare typing to shooting a firearm: "A technology whose basic action not coincidentally consists of strikes and triggers proceeds in automatic and discrete steps, as does ammunitions transport in a revolver and a machine gun."[29]

31. The factory of E. Remington & Sons as depicted in a catalogue. From Frank T. Masi, *The Typewriter Legend* (Secaucus: Matsushita Electric Corporation of America, 1985), figure 11.

But Guzmán is not only blind to the typewriter's industrial origins; he also seems unfamiliar with the differences among various typewriter models. He did not realize, for example, that by 1917 the "old" Underwood he originally owned was actually a more advanced machine than the Remington with which he replaced it. The Underwood was the first "visible" typewriter (before its introduction in 1897, typists could not see what they had written until they pulled the sheet from the platen), and this innovation quickly eroded the competing typewriters' market share, including the Remington's.[30] As historians of typewriters have emphasized, the Underwood "became the pattern to which all successful first-class typewriters conformed,"[31] and it quickly "became the best-selling typewriter in the world, at one time operating the world's largest typewriter factory."[32]

The Remington resisted visible typewriting for many years, but it finally gave way and introduced a visible machine modeled after the best-selling Underwood. Introduced in 1908, the Remington No. 10 had shortcomings that led one typewriter historian to observe that "for all the extra time they took to enter the field, Remington . . . produced retrograde machines. They were very, very good, but by the standards of the nineteenth century, not the twentieth [century]."[33] Since Guzmán bought his Remington in 1916 or 1917, there is a strong possibility that his machine was a Remington No. 10, the most recent model available in those years. By trading his Underwood for a Remington, Guzmán had in fact downgraded from an original to an imitation, from a modern machine to a retrograde one.[34]

But this was not Guzmán's only blindness to the history of typewriters. While he was busy singing the praises of his Remington's "ticli-ticlá," typewriter manufacturers were working to make their machines quieter, a trend that culminated with the introduction of the Remington Noiseless in the 1920s (figure 32), a machine that Guzmán probably would have disliked since it no longer sounded like James's turn-of-the-century typewriter. By the time Guzmán wrote his text in 1917, the Remington's "ticli-ticlá" had become a conspicuous sign of its obsolescence.

Guzmán's many blindnesses – his inability to recognize the typewriter as a mechanical apparatus and his ignorance of the technical differences between Underwoods and Remingtons – prevented him from seeing the writing machine's importance as a technological invention with the potential to revolutionize writing. For all his enthusiasm about the Remington, he made the same mistake as Azuela and failed to examine the crucial link between the mechanization of writing and the production of new narrative techniques. Uninterested

in the typewriter's impact on literature, he devotes his entire text to securing the Remington a respectable place in the pantheon of nineteenth-century high art.

Coincidentally, in the same year that Guzmán was attempting to conceal the typewriter's industrial origins under the guise of musical respectability in New York, Erik Satie was busy trying to achieve the opposite effect in Paris. In that year he composed *Parade,* a musical work scored for a typewriter, among other unorthodox and unmusical instruments. But Satie's perception of the typewriter and its relation to music was the exact opposite of Guzmán's. Whereas the Mexican writer strove to present the Remington as a euphonic instrument whose melodies could harmonize with the arias of the most famous Italian opera singers, Satie conceived the typewriter as a cacophonic machine that, like the sirens, airplane propellers, telegraph tickers, and lottery wheels featured in his composition, brought the noises of the modern world into the concert hall. Satie was drawn to the typewriter's "ticli-ticlá" not because it was musical, but because its stridencies were antithetical to traditional notions of harmony. If Guzmán strived to sublimate the Remington so it could stand alongside tenors and sopranos in the pantheon of high art, Satie used the typewriter to desublimate music, plunging it into the abyss of industrial noise.[35]

32. Advertisement for the Remington Noiseless in *El Universal Ilustrado* 695 (28 April 1928): 57.

Guzman's preference for nineteenth-century aesthetics is not only at odds with the Remington's industrial origins: it is also conspicuously out of place in New York, the capital of the twentieth century. Surprisingly, the New York described in Guzman's text is not a bustling city of automobiles, skyscrapers, and office towers, but a tranquil town inhabited by refined and appreciative music lovers who open their windows to applaud operatic typewriter concerts. His New York is not the energetic, modern city of Dos Passos or Langston Hughes, but a tranquil imaginary space haunted by the phantasmatic presence of nineteenth-century figures like Chopin and Beethoven. Even though the author owns a modern typewriter and lives in the most modern of cities, he remains blind to the mechanical underpinnings of the world that surrounds him.

But why does Guzmán seem so impervious to the modernity that envelops him? Why his insistence on situating himself and his Remington in the nineteenth century? In the last section of his essay, Guzmán makes explicit his strong antimechanical prejudices as he attempts to find an appropriate name for his typewriter exercises: "¿[Este ejercicio] es un cubismo o un vorticismo de la literatura? ¿Sería eufónico llamarla *remingtonismo*? *Mecanicismo*, sin duda, es el título que debiera ponérsele, si no fuera por las asociaciones deplorables que esa palabra puede despertar." [Should this literary exercise be considered cubist or vorticist? Would it be euphonic to call it *remingtonism*? *Mechanicism* would certainly be the most appropriate term, were it not for the deplorable associations awakened by this word.][36] Guzmán's assessment of machines as full of deplorable associations explains why he was unable to come to terms with his Remington's mechanical origins. "Mechanical" and "mechanistic" are terms he rejects as laden with vulgar connotations. But what is so frightening about mechanisms, especially if, like the Remington, they are designed to write? Guzmán gives us the answer in another text written during his exile in New York, in which he argues that "cultivated souls are by necessity static and enemies of progress."[37] The author counted himself among the ranks of cultivated individuals who opposed progress and all its manifestations – industry, machines, and new media like the typewriter and the phonograph – in the name of high culture.

Guzmán was fascinated by the Remington, but since he considered all mechanisms "deplorable," he disavowed the typewriter's mechanical origins and sought to disguise it as a nineteenth-century musical instrument. This rejection of the modern informs both the author's description of the Remington and his own writing technique: the lan-

guorous prose in which Guzmán describes his musical performances clashes with the fast-paced tempo of the modern world he inhabited in real life. Though he lived in New York and used a typewriter, his writing evokes the rhythms of nineteenth-century music, and as an author he is closer to Henry James than to James Joyce.

Guzmán's paradoxical encounter with the typewriter recalls the reluctance with which pictorialist photographers used the camera. Guzmán was as ambivalent as Brehme, Silva, and the other pictorialist figures discussed in chapter 1: he, too, employed a mechanical apparatus but was suspicious of its technological origins; he too attempted to disavow the mechanical underpinning of his instrument. If pictorialist photographers sought to elevate photography to the level of "true art" by creating photographs that mimicked the conventions of painting, Guzmán aspired to make his typing indistinguishable from piano playing by producing texts that read like nineteenth-century musical compositions. Guzmán repeated the pictorialist prejudice: his distaste for "mechanicism" prevented him from exploring the machine's potential for creating radically new forms of representation.

Though Guzmán opens his text by announcing that the Remington had created a revolution ("El advenimiento de la nueva máquina ha pro-

ducido en mi hogar toda una revolución"), his text narrates less a revolution than a regression, a romantic vision of literature dominated by concerns like inspiration and musicality. Ironically, the mechanization of writing brought by the typewriter was a modernizing force that would eventually stamp out all traces of romanticism from literature. As Kittler writes, the "technologically implemented materiality of writing" introduced by typewriters "no longer lends itself to metaphysical soul building." There was no longer room for romantic themes in an increasingly mechanized age in which "standardized letters were no longer to transmit Keller's blood or Hoffman's inner forms, but rather a new and elegant tautology of technicians."[38] Against the grain of the technological spirit of the times, Guzmán uses his Remington for precisely the kind of "metaphysical soul building"–the perpetuation of romantic ideals–that the typewriter would ultimately eliminate. In the end, Guzmán's infatuation with the Remington constituted another missed encounter with modernity.

Backspace: The Postcolonial Remington

There is another reason Guzmán's choice of a Remington typewriter strikes the reader as odd. Despite being a writer who took part in the Mexican

Revolution, became a politically engaged intellectual, and continued to play an active part in the country's postrevolutionary governments, he chose a machine that was politically conservative, even reactionary.

Like the company that made the Oliver, the Remington Typewriter Company was one of the foreign businesses that came to Mexico City during the Porfiriato. The Oliver had been the most popular machine in Mexican offices during the 1890s, but its place was eventually usurped by the Remington in the first years of the twentieth century. The Remington Typewriter Company prospered as it sold thousands of typewriters to corporations as well as to the Mexican government. But, as was the case with many of the foreign firms lured by President Díaz, the company's policies were not always in the best interest of the country or its citizens.

In 1907 the company began publishing *Remington Notes,* a little magazine that carried news items about its operations around the world. Business was booming, and Remington had offices in India (where it manufactured typewriters with Hindi scripts) and Africa, as well as Mexico. The company's Mexican headquarters were in Mexico City on San Juan de Letrán, between the Postal Palace and the Palace of Fine Arts, two of the grandest building projects commissioned by President Díaz in the years before the revolution. In

one of its articles about the Mexico City office, the magazine showcased its less than enlightened views on the country and its people, who were clearly split between the types and the type-nots. The article, called "The Express Wagons of Mexico City," was accompanied by a photograph showing several dozen humble porters carrying Remington typewriters on their heads (figure 33). The text describes a collision between foreign technology and local traditions, between the culture of the writing machine and the customs of rural Mexico. The government had just ordered fifty new typewriters from the Remington Typewriter Company to use in state schools, and the Mexico City office proceeded to deliver them by the most common means of transport: hiring the services of poor porters, who loaded parcels on their head and ran to their destination. These are the "express wagons" alluded to in the title.

This by itself would be a striking image of how the Remington Typewriter Company became a burden on poor Mexicans, but consider the language used in the article. The author begins by referring to the group of porters as "tattered objects" and makes a mock lament upon the quality of their service: "the term 'express' as describing the speed of their service may do all right as a euphemism but it will not stand any sterner test. But such as they are, they are all that Mexico offers as a substitute for the local express services of other countries,

Remington Notes

Volume 1 New York Number 2

REMINGTON TYPEWRITER COMPANY

The Express Wagons of Mexico City.

THE tattered objects in the foreground of the above picture have been described as the express wagons of Mexico City.

The description is accurate enough save in two unimportant particulars. They are not wagons and the term "express" as describing the speed of their service may do all right as a euphemism but it will not stand any sterner test. But such as they are, they are all that Mexico offers as a substitute for the local express services of other countries, and as such we must perforce accept them as they are.

After all, they are not so bad. They are not as clean as they might be, but the like may be found in other callings elsewhere. These peons, or licensed porters of Mexico, are really remarkable in many of their feats of strength and endurance. Heavy loads never seem to trouble them. One of the things which first impresses a stranger landing at Vera Cruz is the sight of these porters easily shouldering the heaviest trunks and carrying them through sand ankle deep, often for long distances without apparent fatigue.

The scene in the above picture can hardly be described as typical. On the contrary, it attracted considerable attention from the newspapers of the

33. Article from *Remington Notes* 1, no. 2 (November 1907).

and as such we must perforce accept them as they are." But it is not only their lack of speed that bothers the author, who appears rather uneasy about the porters' hygiene: "After all, they are not so bad. They are not as clean as they might be, but the like may be found in other callings elsewhere." In a later passage the author worries that the porters' unorthodox means of transportation could wreck the Remington's sophisticated mechanisms: "Typewriters intended for export to Mexico are always equipped with baseboards. The reason is not far to seek. The picture supplies it. The habit of the peons, a habit shared by the peasants of all Latin countries, of carrying all things possible on their heads, might easily work devastation to the inner vitals of a writing machine."[39]

Like the Oliver, the Remington typewriter was a burden – a very literal one – on the backs of these poor Mexicans. And judging from the exploitative tone of the company's newsletter, we can only guess that these porters would have been more than happy to follow the example of Azuela's bandits and free themselves of their loads by hurling the typewriters against the pavement. Perhaps the scene of mechanical destruction in *Los de abajo* was a fictional fulfillment of a repressed revolutionary wish harbored by poor laborers who were forced to bear the load of the Remington's imperialist policies.

In fact, once the Mexican Revolution broke out, the masses directed their rage at the two typewriter manufacturers that had been associated with the Porfiriato. The June 1914 issue of *Typewriter Topics* notes that "the Remington Typewriter Co.'s branch office in Mexico City, Mexico was looted by Mexicans" and that "the office of William A. Parker, agent for the Oliver Typewriter Co. in Mexico City, was also ransacked and looted by natives."[40] The peons, after all, did manage to "work devastation" on the typewriters, just as the columnist for *Remington Notes* had feared. Revolutions turn the world upside down, and one can easily imagine the exhilarated peons standing victoriously over the mechanical remains of the typewriters that they had carried on their heads for so many years. Poetic – or at least mechanical – justice.

The Remington No. 2: Mechanical Writing in the Tropics

After examining Guzmán's musical typing, we should ask whether there could have been a different encounter with the writing machine, one that celebrated its mechanical origins and inspired a literature that made explicit the industrial traces of its production. We know that there was an alternative to pictorialist photography advanced by

modernists like Tina Modotti and Edward Weston, who celebrated the camera's status as a machine and explored the revolutionary potential offered by the mechanization of visual representation. But was there a similar, forward-looking approach to typewriting, a literary movement that celebrated and explored the transformations of writing in the age of mechanical reproduction? Who would be the Westons and Modottis of typewriter literature?

This question of "typewriter literature" was addressed by Manuel Maples Arce in his 1921 "Manifesto of Estridentismo," which praises the typewriter as a symbol of the new writing proclaimed by the futurist-inspired movement. Maples Arce was another author whose vision was shaped by the experience of the Mexican Revolution, although unlike Azuela and Guzmán he was too young to have taken an active role in the struggle. In contrast to the novelists of the Mexican Revolution, whose narrative texts take the revolution as a literary subject, Maples Arce wanted to bring the revolution into the realm of Mexican letters, and he plotted a creative insurrection designed to jolt the literary world from its slumber by overthrowing the ancien régime of litterateurs whose despotic rule had kept literature in the dark ages of nineteenth-century aesthetics. In "Manifesto of Estridentismo," Maples Arce celebrates the typewriter as a symbol of the literary revolution he

hoped to unleash: "'Un automóvil en movimiento es más bello que la Victoria de Samotracia.' A esta eclactante afirmación del vanguardista italiano Marinetti . . . yuxtapongo mi apasionamiento decisivo por las máquinas de escribir y mi amor efusivísimo por la literatura de los avisos económicos." ["A moving racecar is more beautiful than the Nike of Samothrace." To this explosive affirmation by the Italian avant-gardist Marinetti, . . . I add my decisive passion for typewriters and my effusive love for the literature of classified ads.][41] Here Maples Arce points to two products of the modern world, typewriters and classified ads, as models for the literature of the modern era he aspired to create.

In contrast to Guzmán's efforts to distance his Remington from the vulgar world of machines, Maples Arce celebrates the typewriter as a symbol of the new literature precisely because of its industrial origins. The poet links the writing machine not only to automobiles (the "moving race car" lauded by Marinetti in his "Manifesto of Futurism") but also to the industrial noise of the twentieth century. As the name "Estridentismo" suggests, the young poet was eager to introduce the strident noises of modernity into Mexican letters, a strategy that Marinetti had already demanded in his futurist manifesto. Maples Arce is drawn to the typewriter's cacophonic

"ticli-ticlá" for the same reasons that Erik Satie had included the writing machine in *Parade*. ("It is necessary to sing," Maples Arce writes in the same manifesto, "the actualist beauty of machines in the most strident tones of our propagandist music.") In contrast to Guzmán's euphonic sensibility, Maples Arce celebrates the typewriter's noise as antithetical to a musical tradition he sees as outmoded and lifeless, and whose pernicious influence on Mexican letters he decries as "esos organillerismos pseudo-líricos y bonbones melódicos" [those pseudo-lyrical organ players and melodic marshmallows]. In a later passage of the manifesto he would be even more brazen about his belief that literature should stay clear of nineteenth-century musical forms: "¡Chopin a la silla eléctrica!" [Chopin to the electric chair!], he demanded in a tone that would certainly have horrified Guzmán's melodious sensibilities.[42]

The Estridentista "literature of typewriters and classifieds" was to be noisy, irreverent, and firmly grounded in the modern era–a literature, in short, that was the very opposite of Guzmán's languorous prose. The "Manifesto of Estridentismo" itself was an example of this new aesthetics: although it was not typed, it was mechanically generated, mass-produced in a printing shop, and postered around the streets of Mexico City by Maples Arce–a desublimatory gesture that brought literature down from its pedestal and onto the streets. In his manifesto the young poet links the typewriter to another textual artifact of the modern era, the mass-produced classified ads that appeared in daily newspapers. For Maples Arce, these ads are antithetical to outdated notions of high art: like typewritten texts, classifieds were machine-made, printed in newspapers with runs of hundreds of thousands, and mass-produced like industrial objects. In contrast to the romantic vision of literature as springing from a sacred fount of individual inspiration, the writing in classified ads serves the purely utilitarian function of announcing an object for sale. The "Manifesto of Estridentismo" is ultimately a classified ad of sorts, since it serves to advertise Maples Arce's product – a new literary movement – to the Mexican masses.

Maples Arce never followed through on his own call for producing a literature of typewriters. Despite the urgency of his own proclamations, he never wrote about typewriters in any of his poetry collections, and his poems, which remained bound to conventional forms and themes, in no way speak of the mechanical transformation of literature. Maples Arce was thus a theoretician who never put his ideas into practice. The "literature of typewriters" would have to wait one more year, for another author, in another Latin American country, who would devote a truly revolutionary poem to his writing machine: the Brazilian poet Mário de Andrade, who knew the Mexican Estridentistas

and developed an epistolary relationship with several members of the group.

Like Maples Arce, Andrade was a young writer inspired by the European avant-garde who aspired to launch a literary revolution in the Americas. And like Maples Arce, he identified the typewriter as an eloquent symbol of the new literature. In 1922 Andrade devoted a poem – "Máquina de escrever" (Typewriter), later included in *Losango caqui* (1924) – to the typewriter, creating a poetic homage to his Remington. The theme of "Máquina de escrever" is the same as that of Guzmán's "Mi amiga la credulidad," but the two texts could not be more different. A detailed discussion of Andrade's poem will solve the mystery of what the "literature of typewriters" imagined by Maples Arce might look like, and will allow us to pinpoint all that was sorely missing in the texts that Azuela and Guzmán devoted to the typewriter.

To understand the difference in tone and style between Andrade's poem and the texts by Azuela and Guzmán, consider the abrupt opening of "Máquina de escrever":

B D G Z, Reminton
Pra todas as cartas da gente.
Éco mecânico
De sentimentos rapidos batidos.[43]

[B D G Z, Reminton [*sic*]

For all the letters we type
Mechanical echo
of swiftly typed passions.]

These lines constitute one of the most radically unorthodox opening stanzas in the history of Latin American poetry; an old-fashioned writer like Guzmán might have compared this beginning to the opening thumps of Beethoven's Fifth Symphony, but I will refrain from such musical comparisons because what we have at hand is not a symphonic overture but a mechanical cacophony. The opening verse of Andrade's poem does not even contain words, but consists merely of marks left by the type bars after an anonymous operator has pressed several keys at random. There is no meaning in the characters "B D G Z": they are not Peircean symbols but traces of a mechanical event, indexical marks left behind by the moving parts of a machine.

With this opening stanza, Andrade makes clear his interest in the Remington as a machine. Not only does he refer to the sounds made by the typewriter as a "mechanical echo," but his opening characters – "B D G Z," pronounced "beh deh jeh zeh" in Portuguese – are onomatopoeic transcriptions of industrial clatter. The poet thus puts into practice both the futurist call for introducing noise into literature and the Estridentista project for a writing punctuated by antiaesthetic stridencies.

And this inaugural industrial banging is only the first step in a complex poetic project that reflects – and is shaped by – the typewriter's mechanical underpinnings.

The opening verse, "B D G Z Reminton," eloquently demonstrates how the typewriter transformed writing. Few of Andrade's readers have realized that the Remington in the first line is misspelled: it is not a Remington but a "Reminton," an illustration of the typographical errors that were commonly made by typists, and which conservative writers in the early years of the twentieth century often took as troubling symptoms of the degradation of writing brought about by machines. Andrade's "Reminton" is not just a typo but a demonstration of how machines can alter writing (and a refutation of Blaise Cendrars's assertion that "Never has a typewriter made a . . . spelling mistake").[44]

In "Reminton" the brand name lacks the letter *g*, a letter that seems to have been purloined from the illustrious name of the American arms manufacturer. There is no *g* in "Reminton," but there is a *G* in "B D G Z," the sequence of letters immediately preceding the word "Reminton." The letter *g*, it turns out, is not missing; it has merely been displaced from its expected location between the *n* in "Remin" and the *t* in "ton" to a more enigmatic site.

The tale of the misplaced *g* illustrates one of the ways in which the use of a machine can transform writing. In contrast to the flow of handwriting, typing requires the operator to break words into individual letters, and to press the corresponding keys one at a time. In the modern era, words must be assembled serially out of discrete letters, like objects on an assembly line. As Kittler has written, the typewriter transforms letters into "selections from a countable, spatialized supply," and the writing process becomes "manipulations of permutations and combination."[45]

Many conservative writers looked with horror at the serialization that characterized typewriting, a process that treated words like mass-produced industrial commodities. One such critic was the philosopher Martin Heidegger, who in a seminar admonished his students that the typewriter not only "tears writing from the essential realm of the hand" but ultimately "degrades the word."[46] Besides separating writing from the human hand, the typewriter also disassembles words into individual letters that must be typed serially. Like pictorialist photographers, Heidegger considered handcrafted creations as superior to their mechanical counterparts.

Andrade, however, had no misgivings about treating words like industrial objects on an assembly line; on the contrary, he was quite amused

by the process. The verse "B D G Z Reminton" demonstrates how the typewriter breaks words into individual letters and imprints them serially on the paper, and it also achieves a light-hearted effect: it tropicalizes the Anglo-Saxon and – at least for Portuguese speakers – unpronounceable "Remington" into a Latin-seeming and transculturated "Reminton." The *g*-less *Reminton* is a Remington parading in Brazilian drag, a machine that has broken free from the reactionary politics of the typewriter company.

Andrade's poem goes on to show another way in which the typewriter has transformed writing: the machine standardizes texts, depriving them of the subjective marks associated with handwriting. Heidegger lamented that "the typewriter makes everyone look the same,"[47] but Andrade finds much to celebrate in the uniformity of mechanically produced typescripts:

Igualdade maquinal,
Amor odio, tristeza
E os sorrisos de ironia
Pra todas as cartas de gente . . .
Os malevolos e os presidentes da Republica
Escrevendo com a mesma letra
 Igualdade
 Liberdade
Fraternité, point
Unificação de todas as mãos.[48]

[Mechanical equality,
Love hate sadness
And ironical smiles
For all the letters of the world
Hoodlums and presidents
All write using the same typeface . . .
 Equality
 Freedom
Fraternité, point
Unification of all hands]

In Andrade's poem, the standardization of writing is not, as Heidegger had suspected, a symptom of the degradation of human nature in the industrial age, but, on the contrary, a "mechanical equality" fraught with revolutionary potential. The uniformity of typescript banishes all traces of the writer's social class and exerts a democratic influence on texts, making a president's letter indistinguishable from one written by a hoodlum. The typewriter has the potential to spark a revolution in the republic of letters by ensuring "liberty, equality, and fraternity" for all letter writers – a radical proposition that would culminate with the "unification of all hands." Andrade's poem becomes a manifesto proclaiming the internationalization not of labor but of typing, and it invites the reader to participate in the socialist battle cry of mechanical writing: typists of the world, unite!

Andrade demonstrates that the typewriter has transformed not only the layout and appearance of letters, but the essence of writing itself. His poem proclaims a standardization of literature that abolishes all differences between high and low culture, between poetry and popular textual practices. The next section of the poem incorporates random lines taken from various form letters whose themes vary from expressions of sympathy to requests for money – subjects as disconnected and as random as the four letters that open the poem:

"Pesames"

"Situação difícil
Querido amigo . . . (E os 50 milreis)
 Subscrevo-me
 admro
 obgo."
E a assinatura manuscrita.[49]

["Condolences"

"Difficult situation
Dear friend . . . (and 50 dollars)
 Yours truly
 Sincly
 Obliged."
And add a handwritten signature.]

As Andrade's poem devolves into a collage of found texts (clichéd expressions of sympathy, evasive requests for money, formulaic greetings and salutations), the poet assumes the role of a bricoleur who uses the typewriter to recycle the textual refuse of industrial society.

We have come a long way from Martín Luis Guzmán's romantic notions of literary genius and from his assertion that "cultivated spirits are by necessity opposed to progress." Andrade celebrates the typewriter's potential to liberate writing from the bounds of tradition, desublimating poetry and making it indistinguishable from popular forms of writing. "Máquina de escrever" is the perfect example of the "literature of typewriters and classified ads" that Maples Arce envisioned in his manifesto: the poem was composed on a typewriter, and it is made up of fragmented form letters that – like classifieds – serve a purely utilitarian function, such as asking for money or conveying condolences. As Flora Süssekind has argued, Andrade's poem enacts the destruction of literary aura to the point where "all that is left of the lyrical subject is 'the handwritten signature.'"[50]

To further explain the radical thrust of Andrade's poem, it might be helpful to introduce a distinction between two different approaches to mechanical writing. In the first approach, exemplified by Azuela and Guzmán, the typewriter

enters the text merely as the subject of representation and has no impact on the form of the text. Guzmán celebrates the typewriter, but the machine appears in his prose merely as a theme; the celebration of the machine in his writing fails to modernize the author's Victorian style and technique. We might call this first approach, in which the interest in the typewriter is purely thematic, mechanographic writing.[51]

But there is a second, more interesting approach to incorporating the typewriter into a text, in which the author, inspired by the origins of the writing machine, goes beyond mere description and actually alters the structure of his text to expose the genesis of its mechanical production. These types of texts, of which Andrade's poem is a prime example, explore the special effects that can be created only with a typewriter and were thus unavailable to handwriting authors, underscoring the originality afforded by their mechanical production. This approach can be termed mechanogenic writing.

When Andrade begins his poem by typing "B D G Z," he has given us a mechanogenic opening verse: this line could be the product only of a typewriter – since it consists of the indexical imprints of the type bars on the paper – and would make absolutely no sense if we encountered it in a handwritten poem. But the most interesting aspect of this verse is that it does not describe; it transcribes. The line is not an evocation of typing but the trace left by a mechanical event – the random pressing of the typewriter's keys. As Flora Süssekind writes, "In this poem, the mediation of the machine . . . is not only the subject of the poem but also what shapes it."[52]

To understand the originality of Andrade's mechanogenic opening verse, consider another poem dealing with exactly the same subject, but using a purely mechanographic approach. The poem, Pedro Salinas's "Underwood Girls" (1931), also describes the operator's capricious pressing of the typewriter keys (which he calls the "Underwood girls"), but its effect could not be more different from Andrade's poem. Here is Salinas's poem:

Quietas, dormidas están,
las treinta, redondas, blancas.
Entre todas
sostienen el mundo.
Míralas, aquí en su sueño,
como nubes,
redondas, blancas
· · · · · · · · · · ·
Despiértalas,
con contactos saltarines
con dedos rápidos, leves,

Typewriters

97

como a músicas antiguas.
Ellas suenan a otra música:
fantasías de metal
valses duros, al dictado.
Que se alcen
.
Que se crean que es la carta,
la fórmula, como siempre.
Tú alócate
bien los dedos, y las
raptas y las lanzas,
a las treinta, eternas ninfas
contra el gran mundo vacío,
blanco en blanco.
Por fin a la hazaña pura,
sin palabras, sin sentido,
ese, zeda, jota, i . . .[55]

[Quietly they sleep
thirty of them, round and white,
carrying the world on their shoulders.
Look at them, sleeping
like clouds,
round and white
.
To wake them,
touch them
with frantic and delicate fingers
as if they were ancient notes.
They sound like a different music:
metal fantasies

hard waltzes after dictation.
Let them rise
.
Let them think it's a letter
a form letter as usual.
Go crazy
with your fingers
grab them
those thirty eternal nymphs
and hurl them
into the great empty world
white on white.
Finally the purest deed
speechless, senseless
es, zee, jay, i . . .]

There is a mechanical world of difference be-
tween Salinas' "ese, zeda, jota, i . . ." and Andrade's
"B D G Z." Salinas merely describes the pressing of
the keys in a way that could very well have been
written by hand. He spells out the name of every
letter in Spanish instead of letting his Underwood
do the work: he could have typed "S Z J I" to con-
clude his poem, thus saving time and ink and also
producing a verse that would go beyond descrip-
tion to become an actual typing sample. But Salinas
decided to write "ese, zeda, jota, i," a traditional,
mechanographic line that is a pale evocation of the
typing process. Despite its subject matter, Salinas's
poem contains nothing that betrays its mechanical

origins or marks it as a text composed on a typewriter. It is as if the author were afraid to let the indexical traces of mechanical writing enter his poem; instead, he decides to remain on the safe ground of mechanographic writing, where the machine is always at one remove from the text.

Andrade's poem, in contrast, abounds in examples of mechanogenic writing – mechanical effects that could have been produced only on a typewriter, thus emphasizing the fact that the poem was not handcrafted but mechanically produced. In addition to the mechanical indexicality of the opening verse, there are several other mechanogenic passages. The section featuring the collage of condolence letters and requests for money, for instance, includes two mysterious abbreviations: "admro" and "obgo." Neither of these abbreviations is standard in Portuguese, though we can easily guess their meaning: "admro" appears to be a short form of *admirador* (admirer), a word customarily used in the formal closing of a letter, and "obgo" is a contraction for *obrigado* ("thank you"), though the standard abbreviation would be "obrgo." There is a clear mechanogenic explanation for this unorthodox lexical foreshortening: the Remington typewriter included keys with two superscript letters – "o" and "r" – commonly used in abbreviations. For example, "o" is often used to abbreviate ordinal numbers in Por-

tuguese (as in "1o," "2o," "4o"), and "r" is normally placed after an "S" to form "Sr," the contraction of *Senhor*.

Inspired by the discovery of these two superscript letters on the keyboard of his Remington, Andrade incorporates them into his poem, using them to type new words that stand out for their originality. The invention of these abbreviations is entirely determined by the typewriter keys: "obgo" and "admro" were neologisms (or neomechanisms) created only to take advantage of the two superscript keys. The invention of these contractions is a mechanogenic strategy that exposes the poem as a collage of typewriter strokes.

Before returning to Mexico and the Revolution, I would like to consider one last example of Andrade's awareness of the typewriter's potential to create a new form of writing. The last section of the poem contains a series of enigmatic verses:

Trique . . . Estrago!
E na letra O.
· · · · · · · ·
Não poder contar meu extase
Diante dos teus cabelos fogaréu!

A interjeição saiu com o ponto fora de lugar!
Minha comoção
Se esqueceu de bater o retrocesso.
Ficou um fio

Tal e qual uma lagrima que cai
E o ponto final depois da lagrima.

Porém não tive lagrimas, fiz "Oh!"
Diante dos teus cabellos fogaréu.
A máquina mentiu!
Sabes que sou muito alegre
E gosto de beijar teus olhos matinais.
Até quarta, heim, ll.

Bato dois LL minusculos.
E a assinatura manuscrita.

[Tap . . . an accident!
It's the letter O.

· · · · · · · ·

I can't describe my fascination
Before your fiery red hair!

The exclamation came out with the period in the
 wrong place!
What a commotion
I forgot to backspace.
The result was a line
Exactly like a falling tear
And a period after the tear.

But I didn't shed any tears, I said "O!"
Before your fiery red hair.
The typewriter lied!
You know I'm cheerful
and like to kiss your bedroom eyes.
See you on Wednesday, ll.

I type two lowercase LLs
And add a handwritten signature]

In addition to describing various aspects inherent in the experience of typing—like pressing the wrong key ("It's the letter O," laments the narrator as he describes the unexpected intrusion of a typo) and having to type two lowercase *l*s because his Remington lacked a key to type the double slash ("//") traditionally used to mark the place reserved for the signature in Brazilian correspondence—the author makes a more mysterious allusion to the typewriter keyboard. After writing "I can't describe my fascination / Before your fiery red hair!" Andrade continues with a series of enigmatic lines. "The exclamation came out with the period in the wrong place!" he laments, explaining that he

forgot to backspace
The result was a line
Exactly like a falling tear
And a period after the tear.

These descriptions are bewildering: to what tear is the author referring? Where is the misplaced period that sparks the "commotion"?

Andrade is in fact describing another peculiarity of his Remington keyboard. The machine—

probably the Remington portable, a four-bank machine introduced in 1920 – did not have a key for typing an exclamation mark. Instead, operators were required to assemble this character by typing an apostrophe, then backspacing, and finally typing a period so that it would fall directly under the apostrophe to create a composite exclamation mark (this process can be represented by the following equation: ' + . = !). The "commotion" ensues because Andrade "forgot to backspace," and thus ended up with two individual, sequential characters: an apostrophe followed by a period (' .). The result is a dangling apostrophe resembling "a falling tear" (a mechanical tear, since the author acknowledges that he had "shed no tears") and "a period after the tear."[55]

This curious procedure demonstrates that the typewriter required the operator both to assemble words out of individual letters and to piece together characters out of the existing keys – a true Taylorization of language that would have horrified Heidegger, since the chopping of words that he associated with the typewriter has now extended to the characters themselves. Andrade, however, has no qualms about using his Remington for such a lighthearted, mechanical dismemberment.

These strategies from the inclusion of indexical typestrokes to the mechanogenic passages celebrating the discovery of new typewriter keys –

produce a desublimatory effect on writing. Andrade's poem could not be further away from the nineteenth-century ideals of high art praised by Guzmán: "Máquina de escrever" is not a masterwork written by a "cultivated spirit" and inspired by a "sacred fount" of creativity, but a mechanical assemblage of found texts, ready-made phrases, and random indexical keystrokes. In his preface to *Losango cáqui*, Andrade stresses that his texts are not poems but "brincadeiras" (textual games): "raro tive a inteção," he writes, "de poema quando escrevi os versos sem titulo dêste livro" [rarely did I have the intention of making a poem when I wrote the untitled verses in this book].[56] Andrade's text is an eloquent example of the desublimated "literature of typewriters and classifieds" that Maples Arce had called for in his manifesto.

Andrade was not alone in identifying the typewriter as an instrument of desublimation: one of Marcel Duchamp's more mysterious readymades is a black typewriter case with the word "Underwood" embossed on its side. The meaning of Duchamp's *Underwood* (1916) becomes clear when it is compared to the artist's other readymades: a urinal, a bicycle wheel, a postcard of the *Mona Lisa*. All of these are desublimated objects that are antithetical to the ideals of high art. Like the urinal in *Fountain*, the typewriter was a lowly object

that shocked viewers when it was introduced into the sublimated space of an art exhibit.

If we now return to postrevolutionary Mexico, we realize the degree to which writers like Azuela and Guzmán missed the point about the typewriter. Their antitechnological prejudices – especially their refusal to accept the typewriter as a machine – prevented them from exploring the critical impact of mechanical writing on literature. Despite their fascination with Olivers and Remingtons, the novelists of the Mexican Revolution were unable to write texts that reflected the industrial underpinnings of their production. In contrast to Andrade, whose mechanogenic explorations yielded a new form of poetry attuned to the seriality and mechanicism of the postrevolutionary discourse network, Azuela and Guzmán remained in the safe territory of mechanographic writing, where thematic references to typewriters coexist with an antiquated prose that was more attuned to nineteenth-century waltzes than to twentieth-century machines.

In their misapprehension of the typewriter, Azuela and Guzmán expose one of the least studied characteristics of the novel of the Mexican Revolution: its formal traditionalism. Though Azuela and Guzmán wrote in an era marked by attempts to create literary revolutions – of which Maples Arce's call for a "literature of typewriters and classifieds" was but one example – they remained firmly entrenched in nineteenth-century narrative forms. These writers rejected new narrative techniques for the same reasons that they rebuffed machines: because they deemed any association with the mechanization of the modern era "deplorable" and unworthy of serious literature. The novelists of the Mexican Revolution thus ended up in a paradoxical position; just as they celebrated the typewriter but rejected mechanical influences in their own literary production, so they embraced revolution as a subject but refused to allow the revolutionary spirit to transform their narrative.

Backspace: Mechanical Love Objects

Kittler would have approved of Mário de Andrade's poetry as an eloquent literary product of the era of writing machines, because the poet avoids the romantic themes of love and passion in favor of more mundane subjects like his typewriter experiments. But Andrade had a most unusual relationship to his writing machine. He was so attached to his Remington that he baptized it Manuela (in honor of his best friend, the writer Manuel Bandeira) and began to treat it as an erotic object. "She gives me the impression," Andrade told Bandeira in a letter, "that I have next to me a big volup-

tuous woman, so big that she's Titianesque, and Titianesquely fine as well."[57]

Andrade's infatuation with Manuela went on for a long time, as he told an interviewer: "I'm very affectionate and I tend to fall in love with the things that surround me. My Remington, for example. Her name is Manuela, a name that condenses the love I feel for both the typewriter and my best friend, who is named Manuel. . . . I have to confess that like a true lover, her way of being, her defects and her qualities, have provided me with a number of useful ideas. I've even dedicated a poem to her." But Andrade's relationship to Manuela was not merely Platonic. He acted out his mechanical desires: "When I write . . . I sometimes pause to lean my head on the typewriter's metal head and I feel its cold touch. Other times, when I've been writing slowly, I pat the typewriter with my right hand, like someone who caresses a horse to tame it."[58]

Now we can see why Andrade could write so eloquently about the Remington in "Máquina de escrever": he had taken the typewriter as a love object. And the relationship between poet and writing machine is fraught with unusual tendencies: it is voyeuristic (he spends hours looking at Manuela), fetishistic (he fixates on the machine's metal parts), and logophilic (he is attracted to its letters and keys). Andrade was a mechanical per-

vert – a pathology that makes him the perfect twentieth-century subject, for he modernized both his writing and his object choice. Nietzsche believed that "our writing instruments contribute their part to our thinking." Andrade might have added that "our writing materials contribute their part to our loving."[59]

The Underwood

Though I have focused almost exclusively on literary representations of typewriters, the first decades of the twentieth century saw the production of countless extraliterary depictions of typewriters, including cartoons, drawings, photographs, films, sculptures, and even – thanks to Satie – musical compositions. Among visual artists, photographers were especially well equipped to perceive the cultural significance of mechanical writing, since their own work relied on the mechanization of visual representation, and they were familiar with the resistance encountered by attempts to introduce technology into traditionally manual processes. Inspired by the similarities between the camera and the typewriter, many photographers in the 1920s created works about the writing machine: Ralph Steiner produced the photograph *Typewriter Keys* (1921); the Russian constructivist El Lissitzky photographed a human

hand typing on a Remington; and Tina Modotti, as we saw in chapter 1, photographed a typewriter belonging to her lover, the Cuban revolutionary Julio Antonio Mella.

I would now like to return to Modotti's *La técnica* and ask how this photographic depiction of the writing machine differs from the textual elaborations, both mechanographic and mechanogenic, examined in this chapter. Can the camera "see" anything in the typewriter that escapes textual representations? How does the typewriter's mechanization of writing relate to the camera's mechanization of vision? Can photographic representations of typewriters be divided like their textual counterparts into mechanographic and mechanogenic creations?

But before embarking on a discussion of *La técnica* and its relation to the "literature of typewriters," we should ask a simple question: what kind of typewriter did Modotti photograph? None of Modotti's critics have addressed this important question, even though, as we have seen, there was a world of difference between Olivers, Remingtons, and other brands: each brand had come to represent important attributes, from visibility to noiselessness, developed in the history of typewriting.

The typewriter represented in *La técnica* is neither an Oliver nor a Remington but an Underwood. It is also a kind of typewriter that we have not yet encountered: a portable machine, lighter and more transportable than the desktop models favored by Azuela and Guzmán. As we can see from comparing figures 34 and 35, Modotti's typewriter was an Underwood Portable Typewriter, a three-bank model (meaning that it had three instead of four rows of typewriter keys) introduced in 1919 and manufactured until 1929.[60] Modotti had a good reason to choose an Underwood for this photograph. We have already seen how after its revolutionary introduction of visible writing, the Underwood had secured a reputation as the most advanced and best-selling typewriter. Even more importantly, by the 1920s the Underwood brand had become synonymous with speed. The company claimed its typewriters were the fastest in the world, and to prove this assertion it began sponsoring typewriting races that were invariably won by typists using Underwood machines. Describing the company's edge over its competitors in these races, Bruce Bliven writes, "In 1915 Underwood typists were still winning, to the growing pique of other firms, and to Underwood's unconcealed delight. It was the long Underwood dominance of the championship, more than anything, that finally killed the sport, for finally no other company wanted to play."[61]

In addition to speed, the Underwood photographed by Modotti had another modern advantage over competing typewriters – portability. Ads for the machine present it as the perfect gadget for

UNDERWOOD
STANDARD PORTABLE
TYPEWRITER

RESPONDING to the call of the traveling business man, the news writer and the field worker, demanding a practical and strong, nonfolding PORTABLE TYPEWRITER the Underwood Typewriter Company takes pride in offering to the public a machine combining all of the stated qualifications.

In the manufacture of this new machine, in the careful selection of materials, in excellence of workmanship, all the skill, ability and experience of the Underwood Typewriter Company have been employed.

LATEST EQUIPMENT DEVICES

Line Space Lever. Line Space Change. Left and Right Margin Stops. Capital and Figure Shift-Keys. Capital and Figure Shift-Key Lock. Paper Release. Carriage Release. Margin Release. Backspacer. Two-Color Ribbon Attachment. Stencil-Cutting Device. Full-Size Ribbons, on Standard Underwood Ribbon Spools. Weight, including Carrying Case, 8¾ pounds. And it callitypes!

34. Tina Modotti, *La técnica* (1928), also known as *Julio Antonio Mella's Typewriter*. (Courtesy of Throckmorton Fine Art, New York).

35. Illustration from *Underwood Standard Portable Typewriter* (1919).

the twentieth century: traveling executives could take it along and use the portable device aboard automobiles, trains, and even airplanes. A promotional photograph from 1926 (figure 36) shows the winner of one of the typing competitions celebrating her victory by riding in the sidecar of a motorcycle along with her portable Underwood – a strategy that closely parallels the Kodak advertisements discussed in chapter 1 that portrayed cameras aboard automobiles. Like the photographers in the camera ads, the modern typist has mechanized both her means of representation and her means of transportation. The Underwood portable was thus not only the most desirable commodity in the world of typewriters, but also the machine most attuned to the speed of the modern era.

Besides choosing the most modern of typewriters, Modotti also photographed it using a number of strategies that underscore the machine's parentage with other industrial products. Unlike Azuela or Guzmán, who were afraid to look beyond the shimmering surface of their instruments, Modotti directs her eye and her camera's lens toward the Underwood's industrial core, zeroing in on the typewriter's mechanical components: the keyboard, the type bars, the ribbon, and the platen – four distinct sets of mechanical parts whose synchronized functions allow the machine to type.[62] The contiguity of these four sets of elements (each occupying a distinct section of the photograph) invites the reader to conceive of typing as an operation that, like Taylorized industrial processes, depends on the serialized combination of discrete tasks: pressing a key, driving a type bar to strike the ribbon, advancing the platen.

Modotti's framing reveals a small cross section of the Underwood's typing mechanism – dozens of buttons, type bars, steel levers, metal screws, and other movable parts – and emphasizes its technical complexity. Unlike the novelists of the Mexican Revolution, the photographer underscores the fact that typewriters contained between two and four thousand moving parts, a feature that placed them among the most sophisticated of machines in the early years of the twentieth century.[63] Confronted with the mechanical inventory presented in *La técnica*, no sensible viewer could mistake the Underwood keys for quaint "Underwood girls" or harmonious piano keys; the photograph makes it abundantly clear that typewriter parts have more in common, visually and functionally, with factory machines and industrial mechanisms than with musical instruments.

Modotti's photograph also stresses the relation between typewriters and industrial machines by revealing the geometrical figures inherent in the typewriter parts: keys and ribbon reel form perfect circles, while the type bars draw scores of parallel lines. Here Modotti was adapting the modernist strategy of revealing geometrical shapes hidden in

everyday objects; Edward Weston, for example, had photographed the interior of the house he shared with Modotti in Mexico City to produce *Sink* (1925) and *Toilet* (1925), two photographs that highlight the pristine geometrical shapes inherent in the design of ordinary lavatory fixtures. But if Weston was drawn to the geometry of his

56. Stella Willins, 1926 Amateur Champion of Typing Competitions, riding on the sidecar of a motorcycle. From Bruce Bliven Jr., *The Wonderful Writing Machine* (London: George Allen & Unwin, 1973), 120.

Mexican bathroom (an apolitical space cut off from the postrevolutionary struggles of 1920s Mexico), Modotti preferred the geometrical precision found in the most prominent symbols of the postrevolutionary discourse network. Her photographs reveal the geometrical order structuring steel beams, telephone wires, industrial tanks, and typewriters, artifacts that played a crucial role in the modernizing projects launched by the Obregón and Calles administrations.

In photographing the Underwood's keys, type bars, and platen, Modotti not only exposes the typing mechanism that others had concealed, but she also conceals what others invariably showed in their accounts of the writing machine: the typing hand. Whereas Heidegger lamented that "the typewriter tears writing from the essential realm of the hand," Modotti appears to celebrate such a severance. Her photograph shows every mechanical part needed for typing, including the end result – a typed text on the platen – but it omits the single nonmechanical element needed to operate the machine: the human hand. If Andrade's poem predicted a typewriter-inspired unification of all hands, Modotti's photo counters with an amputation of all hands, a severance that leaves the viewer with the eerie impression that the automation of the writing process has dangerous consequences for the human body.

We know, of course, that the typewriter does not do away entirely with the human hand: it requires the agency of human fingers to press its keys and activate the complex mechanisms of its levers and type bars, and thus *someone* must have written the text on the Underwood's platen. The text in question was actually written twice: first by an absent typist, then again by Modotti's camera (it was "written with light"), which produced a photographic facsimile of the typed original. Initially the text was written mechanically by the anonymous typist, but then the camera rewrites it automatically, without the intervention of typing fingers or human hands. As we saw in chapter 1, once the shutter is released, the "writing" of the image occurs instantaneously, through an indexical photochemical process that imprints the image on the negative. By photographing a typed text, Modotti has in effect transformed the camera into a writing machine (thus anticipating the invention of the photocopier by several decades), and one that has an undisputed advantage over the Underwood, because though the Underwood writes mechanically, only the camera can write automatically.

By transforming the camera into a writing machine, Modotti reveals a keen awareness of technology's impact on traditional forms of representation. She understands that technology was not merely another theme to be investigated in artistic works, but a powerful force capable of radically transforming art. Whereas Azuela and Guzmán merely *describe* the typewriter, writing texts about Olivers or Remingtons, Modotti *emulates* the typewriter's function by converting her camera into a writing machine capable of producing photographic facsimiles of written texts. This is not only a photograph of a typewriter; it is also one of the most original examples of automatic writing.

Readers familiar with the history of "automatic writing" might protest that Modotti's experiments with cameras and typewriters have nothing to do with the surrealist concept of *écriture automatique*, a psychic process that has more in common with free association than with writing machines. Perhaps a clarification is in order: André Breton coined the term "automatic writing" to describe a surrealist exercise that sought to recreate textually the process of free association. Even though most of these exercises were done with pen and paper and involved no machines, Breton unequivocally described them as automatic (he famously defined "surrealism" as a "psychic automatism"), and his 1924 *Manifesto of Surrealism* explains the link between surrealist writing and mechanical automatism: "Nous sommes les modestes appareils enregistreurs qui ne s'hypnotisent pas sur le dessin qu'ils tracent, nous servons peut-être à une plus noble cause." [We are modest

recording devices that are not hypnotized by the drawing they produce and thus we can serve a nobler cause.][64] In Breton's view, automatic writing was automatic not because it relied on machines, but because it sought to transform the writing subject into a writing machine – a "recording device" – that would exert no authorial claims on his or her textual production. Practitioners of automatic writing take as their model the tape recorder, the typewriter, and the camera: mechanical "recording devices" whose sole function is transcribing that which is put before them. Breton's writing hand was, like the typewriter photographed by Modotti, a mere instrument for the transcription of texts. Determined to passively transcribe the workings of the unconscious, the surrealist poet effectively became a writing machine.

Automatic writing has one more connection to the typewriter: like the writing machine, it produces desublimated texts. Once automatized, the author is no longer an inspired spirit capable of writing great works, but merely a transcribing machine that generates random texts. In his first manifesto, Breton gives one example of such desublimated, automatic writing resulting in an assemblage of newspaper texts that is strikingly similar to Andrade's collage of typewritten texts in "Máquina de escrever": "Il est même possible d'intituler poème ce qu'on obtient par l'assemblage aussi gratuit que possible . . . de titres et de fragments de titres découpés dans des journaux." [It is even possible to consider a poem the result of an assemblage, as random as possible, . . . of headlines and fragments of headlines cut out from newspapers]. The automatic poem described by Breton – a composition produced through the random assemblage of newspaper headlines – reads exactly like Andrade's "brincadeira," a desublimated collage of texts whose arbitrary, lowly subjects challenged antiquated notions of high art. Thus, although typing and automatic writing are two distinct activities, they ultimately produce the same results: they mechanize the writing subject, stripping him of all authorial claims, and effectively desublimate his output.

Modotti shares Breton's – as well as Andrade's – interest in the desublimatory powers of automatic writing, and her photograph, like Breton's manifesto and Andrade's poem, transforms writing into a series of random textual fragments. *La técnica* shows a typed text on the platen, but Modotti has cropped the image so that the edge of the photograph cuts across the page, slashing through sentences and words to leave only a series of unintelligible textual debris. The only visible characters – "nspiración / ción artística / ón en una síntesis / existe entre la" – form a disjointed

assemblage of broken words that reads like one of Breton's experiments in automatic writing. The words are fragmented twice: first by the typewriter, which divides them into letters, and then by the camera, whose cropping of the field of vision leaves us with dangling textual fragments. While conservative critics lamented the fragmentation and division of language produced by the writing machine, Modotti seems to revel in it, compounding the typewriter's division of words into discrete letters with the camera's cropping of the typed passage. Cutting and cropping, she seems to suggest, are quintessentially modern procedures that go hand in hand with the mechanical functions of typewriters and cameras.

There is an important difference, however, between Breton's and Modotti's approaches to automatism. Breton linked *écriture automatique* to unconscious processes, while Modotti related her experiments with automatic writing to political activism. The word fragments in *La técnica* were not typed at random, but were selected from Leon Trotsky's writings on revolutionary art. The original passage – which Modotti, despite her reticence about accompanying photos with texts, had reproduced on the invitation to her only exhibition in Mexico City – reads as follows: "La técnica se convirtiera en una inspiración mucho más poderosa de la producción artística: más tarde encontrará su solución en una síntesis más elevada el contraste que existe entre la técnica y la naturaleza."[66] [Technique (or technology) will become a more powerful inspiration for artistic work, and later on the contradiction itself between technique (or technology) and nature will be solved in a higher synthesis].[67] The text is an excerpt from "Revolutionary and Socialist Art," the eighth and final chapter of Trotsky's *Literature and Revolution*, which had been translated into Spanish in 1923. Like our inquiry into the history of typewriters in postrevolutionary Mexico, the passage hinges on the question of technology and its impact on artistic representation.

Trotsky raises two important points here that relate to Modotti's depiction of the typewriter in *La técnica*. First, the Russian thinker chastises those who question whether technology is a subject worthy of artistic representation, since they naively assume that it is merely another theme – like flowers or forests – to be treated by artists. Technology, he argues, is not a mere theme of representation but a powerful force capable of driving history forward and destined to transform all aspects of human experience, including art. All art – like life itself – is destined to become increasingly mechanized, and those who attempt to shelter their work from the forces of technology are fools who don't understand the logic of history. Antici-

pating Walter Benjamin's theories by over a decade, Trotsky concludes that artists should not ask whether technology is a worthy subject for their work; they should instead examine how the forces of technology will inevitably transform their craft.

Literature and Revolution contains a second idea that relates to Modotti's photograph. Besides following Marx's conception of technology as a positive force that would propel history forward, Trotsky also believed that technological forces would transform art by making it more useful to society. "Technology," he writes in the passage quoted by Modotti, "will become a more powerful inspiration for artistic work," meaning that in the future art will be inspired by the usefulness that characterizes technological artifacts. Technology will invest art with a purpose, liberating it from the purely ornamental and decorative functions it traditionally served in bourgeois society. Anticipating Kittler's ideas, Trotsky argues that technology will eventually do away with mysticism, romanticism, and other outdated artistic models that he dismisses as "useless": "The Revolution cannot live together with romanticism. . . . Our age cannot have a shy and portable mysticism, something like a pet that is carried along 'with the rest.' Our age wields an ax."[68] An ax to chop the hands off typists, Modotti could have added!

In *La técnica*, Modotti presents a visual elaboration of these two crucial Trotskyite ideas: that mechanization is part of a larger historical force and that technology will alter the function of art. Her depiction of the Underwood suggests that the advent of typewriters was not an isolated phenomenon, but rather one of the numerous manifestations of mechanized media in the modern era. *La técnica* is an image of a typewriter photographed by a camera, a strategy that suggests a parallel between the mechanization of writing brought about by the writing machine and the mechanization of vision introduced by the camera. Modotti thus demonstrates that in 1927 Trotsky's predictions about the inevitable technologization of the world were already a reality, since two of the most fundamental acts of communication – writing and seeing – were already routinely mechanized: people now wrote using machines and looked at the world through photographs mechanically reproduced in journals and newspapers. And, as the photograph suggests by placing his text at the center of the image, Trotsky himself was an example of a modern intellectual who had integrated technology into his creative process.

As visitors to Trotsky's house in Mexico City (now the Museo Casa León Trotsky) can appreciate, the Russian revolutionary was an avid user of the latest technologies of communication; his

study (figure 37) – left as it was the day he was murdered – is crowded with the Dictaphones, phonographs, and typewriters that he relied on for the composition of his books. Trotsky's acts of communication – speaking, listening, reading, and writing – were mediated through machines. And as we can see in the photo, Trotsky's typewriter was, like Modotti's, an Underwood. Not only was the Underwood modern, portable, and vertiginously fast, but it was also the machine of choice for revolutionary intellectuals.

Like Trotsky, Modotti considered the mechanization of communications as part of a much larger historical process through which technology would transform the world. *La técnica* is not an isolated image, but part of a series of photographs depicting various aspects of the modernization of Mexico propelled by the Obregón and Calles administrations in the 1920s. Considered as a group, these works demonstrate that the mechanization of writing was but one of the numerous transformations – like the electrification of neighborhoods and the building of highways – brought about by the postrevolutionary programs designed to catapult Mexico into the modern era.

Even more significantly, *La técnica* elaborates on Trotsky's assertion that technology would transform art by making it "purposeful." The visual and textual processes of representation de-

picted in the photograph are not only mechanized but also designed to serve a simple purpose: Trotsky's text serves to promote political and aesthetic revolutions, and the typewriter serves to reproduce and distribute his message, as does the camera used to photograph it. More than a mere representation, *La técnica* emerges as an efficient apparatus for the dissemination of Trotskyite ideas, because every print of the photograph can be thought of as a mechanically reproduced facsimile of Trotsky's text designed to propagate his revolutionary ideas. Of course what is being reproduced and disseminated is not so much Trotsky's actual writing – which, as we saw, has been fragmented and turned into nonsense by the camera – but a photographic image that demonstrates with numerous examples the complex process of cultural mechanization described in *Literature and Revolution.* Coupled with the camera, the typewriter becomes an apparatus of political propaganda and places mechanical reproduction at the service of revolution.

Modotti's depiction of the Underwood as an apparatus of revolutionary propaganda takes the desublimatory powers ascribed to the typewriter by Breton and Andrade one step further: the writing machine desublimates literature by turning texts into political treatises. Mechanized writing is not only attuned to the industrial realities of modern

37. Leon Trotsky's office in Coyoacán, Mexico City, with a view of his Dictaphone, gramophone, and Underwood typewriter. Photo: Rubén Gallo.

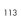

life, but it is also a tool of political activism. Modotti stated that the Underwood she photographed belonged to Julio Antonio Mella, a radical revolutionary who was in Mexico plotting the overthrow of the Cuban dictator Gerardo Machado, thus hinting at a connection between Mella's revolutionary political ideas and his mechanized writing. (Mella was murdered in Mexico City in 1929, apparently by Machado's agents; Modotti was detained as a suspect in the murder and later forced to leave the country.) The typewriter, like the camera, was a weapon – an *automatic* weapon to fight revolutionary struggles.

The passage of these Olivers, Remingtons, and Underwoods through Mexican culture between 1915 and 1928 illustrates the contradictory attitudes with which writers responded to the typewriter and its introduction of mechanicism into literature. The first authors in Mexico to write about typewriters, Azuela and Guzmán, embraced the writing machine as a subject of representation, but they did not explore its role in shaping a new discourse network. Tormented by the idea that machines were "vulgar," they failed to understand that mechanization was an inevitable effect of modernity that would ultimately transform not only the actual process of handwriting but – more significantly – its relation to the world and its function in society. Ironically, the first Mexican authors to use typewriters declined to explore the effects of

mechanization on their trade. Impervious to the aesthetic revolutions exploding around them, they clung to outdated literary models that harked back to a preindustrial world. In the end, their flirtation with the typewriter culminated in a missed encounter with modernity.

Antimechanical prejudices kept the novelists of the Mexican Revolution from experimenting with the new literary strategy that Maples Arce proclaimed in his call for "a literature of typewriters" and that Mário de Andrade deployed in his "Máquina de escrever:" mechanogenic writing, a form of writing that was not merely *about* typewriters but *shaped* by the machine, thus realizing Trotsky's prediction that technology would become "an inspiration for artistic work." Andrade demonstrated how the use of the typewriter would bring about a desublimation of writing practices: writing in the modern era had to be brought down from the pedestal of high art and forced to reflect the everyday, mechanized reality of the twentieth century. Mechanogenic writing was by necessity a desublimatory exercise.

The figure who best understood the radical effects of mechanization on literature was Tina Modotti. Her main contribution to the "literature of typewriters" was to demonstrate that the mechanization of writing went hand in hand with photography's mechanization of vision and with the growing industrialization of the world. She under-

stood that the technologization of culture would require us to rethink and expand our conception of literature. The invention of mechanical reproduction meant that literature could no longer be seen as a purely textual practice isolated from other mechanized forms of representation like photography or phonography. In the modern era, all types of signs – textual, visual, and auditory – could be reproduced mechanically by typewriters, cameras, or phonographs, and modern literature had to find creative ways to incorporate these extratextual, machine-made signs. *La técnica* is the most radical example of such an expanded mechanogenic text: it demonstrates Trotsky's theory of the inevitable technologization of the world through the use of mechanically reproduced textual and visual signs.

Typewriters

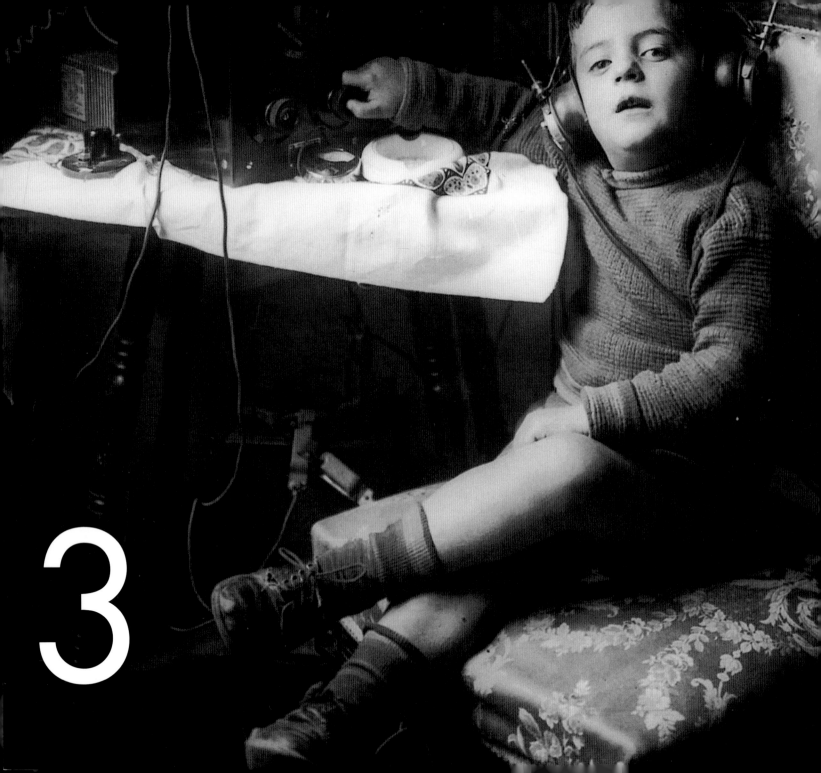

3

RADIO

If cameras revolutionized vision and typewriters mechanized writing in the modern era, radio electrified the aural world by transforming sounds into a series of electromagnetic impulses. As radio enthusiasts listened to early announcers, they experienced the uncanny sensation of hearing a voice that sounded human but was actually the product of a complex series of technical processes. Radio was a more mysterious medium than either photography or mechanical writing: it broadcast eerie, disembodied voices from unknown sources; it sent messages wirelessly — magically, it appeared — across countries and continents; it made listeners temporarily blind, forcing them to rely on purely acoustic information to recreate sights, smells, and other sensations; and it transmitted words and music through electrically charged waves that were invisible to the human eye. As a machine, the radio receiver was infinitely more complex than cameras or typewriters. The average person could learn

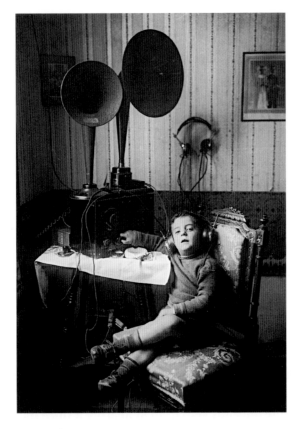

38. Boy with earphones, Mexico City, ca. 1920. SINAFO-Fototeca Nacional, Mexico City.

to take photographs or type letters, but operating a radio receiver was the exclusive privilege of sophisticated techies who were well versed in the intricacies of Hertzian theories.

A photograph of a Mexican boy listening to a radio apparatus in the 1920s (figure 38) captures the uncanny qualities of the medium: it shows a five-year-old wearing a pair of earphones, sitting on a chair, and tuning a radio. The child looks like he has become one with the receiver: his body is caught in the tangle of wires connecting the receiver's various parts, and the oversize earphones give his head a technical aura, as if it were an extended part of the apparatus. The boy has become an android: his body is wired, his head capped with bulky devices, and even his little hand looks like it is plugged into the radio. The *punctum* of the photograph is the boy's lost gaze: he looks away from the radio as his hand moves the tuning knob – an entirely realistic depiction, since sight plays no role in tuning a radio. Perhaps this photograph is so haunting because this child, who otherwise appears so healthy and wholesome that he might as well be a poster boy for postrevolutionary Mexican children, is made to look blind. He stares into space – into the invisible airwaves – as his hand fidgets with the knob outside his field of vision. But in fact this young radio enthusiast is not staring into space: he is looking intently at the photog-

rapher's camera, probably marveling at the technical complexity – or at least at the sheer bulk – of a machine that is pointed at him. This boy is an archetypal modern subject, framed by acoustic and visual technologies: his hearing has been electrified, his sight photographed.

In its early days, radio was altogether different from the modern medium we know today. Before 1921 there were no radio stations with regular broadcasts, and most transmissions were launched into the airwaves by a handful of enthusiasts scattered around the world. Equipped with bulky, custom-made receivers and transmitters (radio systems were not sold in stores until the 1920s), they spent countless hours exploring the waves, wired to a receiver, and sifting through the crackling of static with the hope of eventually tuning into a message sent from far away by another amateur. Rudolf Arnheim, one of the first theorists of radio, called this activity "fishing the waves," suggesting that tuning into an actual broadcast was as unpredictable and as difficult as angling: one never knew what the day's catch might bring.[1]

Like the typewriter, radio was invented in the last decades of the nineteenth century. And if the typewriter evolved from the sewing machine, radio developed from two inventions that allowed the transmission of signs over long distances: the telegraph and the telephone. In the 1890s the Italian inventor Guglielmo Marconi found a way to send telegraphic messages wirelessly over short distances by using radio waves (also called Hertzian waves in honor of Heinrich Hertz). Marconi's invention functioned exactly like a telegraph, since it could send and receive only messages in Morse code, and it became known as the radiotelegraph or wireless telegraph. In 1899 the inventor successfully radioed a message across the English Channel, thus inaugurating the era of long-distance wireless telegraphy.

In the first years of the twentieth century, radiotelegraphic communications boomed. Hundreds of radiotelegraphy stations were built around the world, including one atop the Eiffel Tower in 1903, and entrepreneurs discovered myriad uses for this early form of wireless communication. The new technology was used to communicate with ships at sea, to broadcast time signals from observatories – a development that made possible the synchronization of clocks around the world to the second – and to transmit military orders to officers fighting in areas devoid of telegraph wires. Radiotelegraphy played an important role in the American invasion of Mexico in 1914, and it became the most important means of communication among European leaders during World War I. Stephen Kern has even argued that it

was the instantaneous and impersonal nature of radiotelegraphic messages, which left "no time for reflection or consultation," that precipitated the outbreak of war in the summer of 1914.[2]

But Marconi had grander ambitions for radio, and eventually he found a way to transmit sounds – and not merely telegraphic messages – over the waves. This new invention was as much of an advancement over the radiotelegraph as the telephone had been an improvement over the telegraph, and it became known as the radiotelephone or wireless telephone. In 1915 the Italian inventor sent the first wireless voice message across the Atlantic, an event that inaugurated the era of transcontinental radiophony.

During the late 1910s and early 1920s, hundreds of amateurs around the world built radio receivers and transmitters that they used to communicate with one another. Operators would spend hours surfing the waves, hoping to pick up the voice of a fellow radio enthusiast located in another corner of the world. They experienced the thrill of communicating with the unknown, since one never knew who – or what – would speak through the radio, and there was always the haunting impression of listening to voices that had come out of nowhere.

At first radiophony was used for exactly the same purposes as the wireless telegraph – to broadcast the time signal, communicate with ships, and send military orders – but eventually the institution that we now know as the radio station, offering regular broadcasts at scheduled times, was born. The first radio station to go on the air was KDKA in Pittsburgh, with a broadcast of the results of the Harding-Cox election on November 2, 1920. Over the next few years the entire world was seized by a radio frenzy: hundreds of radio stations appeared on the map from Moscow to Buenos Aires, and by 1930 there were millions of radio listeners around the world. Illustrated magazines from this period often carried advertisements for radio service depicting what was surely an ideal for many middle-class consumers: a prosperous family gathered in the living room around the radio receiver, enjoying a musical program that came into their home from a distant station.

Because of its mystery, radio caught the attention of poets around the world. Young writers from Paris to Mexico City embraced the new medium as a powerful symbol of modernity and sought to create a new literature infused with the power and cosmopolitanism of radio. And nowhere was this literary infatuation with radio as fertile as in Mexico, where avant-garde poets were directly involved in the first radio stations and inflected the history of Mexican broadcasting with a distinctly avant-garde twist.

Surprisingly, the invention of radio sparked far more serious and intense debates among writers than the introduction of the typewriter, even though the latter related much more directly to the literary profession. Every writer in the 1920s and 1930s had something to say about radiophony. Conservative critics warned that radio was a cheap form of entertainment that broadcast everything from Wagnerian operas to the time signal without rhyme or reason, and that it would ultimately lead to the decline of serious culture. In contrast, avant-garde poets saw radio and its technological wonders as a catalyst for a poetic revolution that would awaken literature from its nineteenth-century slumber. The avant-garde's love affair with radio began with F. T. Marinetti, the first poet to suggest that radio could function as a poetic model. In one of his futurist manifestos, Marinetti urged young poets to develop a "wireless imagination," a new form of writing inspired by the wonders of radio broadcast. Syntax, he argued, formed the "wires" of literature, and it had to be destroyed so that authors, in the spirit of the times, could communicate "wirelessly" with their readers. The poet called this new form of writing, which was fragmented and disjointed like radiotelegraphic messages, "words in freedom."[3]

Marinetti's wireless imagination – *imaginazione senza fili* – was a pun on the Italian term for radiotelegraphy, *telegrafia senza fili*. One of Marinetti's best-known examples of "words in freedom," his 1914 *Zang Tumb Tuuum* (figure 39), includes the first literary depiction of radio transmission: a calligramic representation of a radio apparatus broadcasting news about the war from atop a hot air balloon floating over the battlefield. The words "vibbbrrrrrrrarrre" and "TSF——" (the acronym for *telegrafia senza fili*) represent the radio waves sent into the air by the transmitter.

Marinetti's radio calligram marked the beginning of a prolonged literary fascination with radio. A long line of poets that included Blaise Cendrars, Guillaume Apollinaire, and Vicente Huidobro wrote texts celebrating the wonders of radio broadcast. In Spain, the avant-garde poet Juan Larrea Celayeta published a poem called "Nocturno TSH" (1919) that included a verse in Morse code, and in the same year the Catalan Joan Salvat Papasseit named his first book *Poemes en ondes hertzianes* (Poems in Hertzian Waves) as a tribute to the new medium. In Russia, the futurist poet Velimir Khlebnikov devoted his 1921 "Radio of the Future" to extolling the endless potential of wireless broadcast. "Even smells," he predicted, "will be obedient to the will of the Radio. In the middle of winter the honeyed smell of lime, mixed with the smell of snow, will be the Radio's real gift to the country."[4] And in Czechoslovakia, Jaroslav

39. F. T. Marinetti, radio calligram in *Zang Tumb Tuuum* (Milan: Edizioni Futuriste, 1914).

Seifert published a collection of poems titled *Na vlnách TSF* [On the Waves of the Wireless Telegraph] in 1925.

This brief overview does not even include radio plays, a new genre that one announcer called "the theater of the ears," and which prospered during the 1920s and 1930s, when figures as diverse as Walter Benjamin, Bertolt Brecht, Walter Ruttman, Orson Welles, and even Ezra Pound experimented with writing for broadcasting.

But nowhere in the world was the literary fascination with radio as deep and as fruitful as in postrevolutionary Mexico. Radio came to Mexico in the early 1920s, a time of unbridled enthusiasm for the future: the civil war had just recently come to an end, and Mexicans placed great hopes on the revolutionary government and its promises to catapult the country into a new era of prosperity and modernity. The 1920s were a utopian period, and radio was received with open arms. There are many radios in Mexican literature of the time, and none of them ever share the sad fate of Azuela's Oliver at the hand of the revolutionary bandits. In sharp contrast to the typewriter, radio inspired nothing but praise and admiration, especially from writers and artists.

The origins of radio broadcasting in Mexico were intertwined with the birth of a postrevolutionary avant-garde. The first radio station in Mexico City was launched by a literary magazine, *El Universal Ilustrado*, a weekly publication edited by Carlos Noriega Hope that routinely published the work of the most experimental writers and artists of the 1920s, from Tina Modotti to Manuel Maples Arce, from Diego Rivera to Salvador Novo. When the magazine's radio station first went on the air on May 8, 1923, its inaugural program featured Manuel Maples Arce, the founder of the Estridentista movement, reading a futurist poem about radio. The poem was called "TSH," the Spanish acronym for "telefonía sin hilos," or wireless telephony, and it included a verse celebrating radio as the "nuthouse of Hertz, Marconi, and Edison."[5] Radio stations in other countries had devoted their inaugural broadcasts to political elections, news reports, live concerts, even sporting events, but only in Mexico were the precious seconds of the first historical broadcast turned over to a twenty-three-year-old futurist poet.

The broadcast of "TSH" was merely the beginning of a long collaboration between the Estridentistas and Mexican radio stations. The poets also played an active role in the second station to go on the air in Mexico City, which operated under the name CYB and was owned not by a literary magazine but by a cigar factory called El Buen Tono. Besides taking part in Mexico's first radio broadcasts, the Estridentistas also wrote extensively

about radio and its cultural effects. In addition to "TSH," the group produced many more texts inspired by the wireless. Radio gave its name to the first Estridentista journal, *Irradiador*, and it figures prominently in many of the group's books, including Germán List Arzubide's *El movimiento Estridentista*. Luis Quintanilla devoted an entire book of poems to the medium (he called it *Radio: Poema inalámbrico en trece mensajes* [Radio: Wireless Poem in Thirteen Messages]), and the artist Ramón Alva de la Canal designed a futurist building that was to serve as the central radio station for Estridentópolis, the movement's capital city. The station was to be "animated by the spirit of the times, which was that of radiophony,"[6] and it actually came close to being built in 1926 (a sketch of the building, showing its futurist style and towering antennas, was published in *El movimiento Estridentista* and is reproduced in figure 40). In the end, Estridentismo became so identified with radio that Carlos Noriega Hope once wrote in *El Universal Ilustrado* that "Estridentismo and radiophony are twin figures: they are both avant-garde creations!"[7]

The Estridentistas were not alone in their love of radio. Other young writers who were not associated with the movement also embraced broadcasting with open arms. The poets centered around the journal *Contemporáneos*—who for the most part had no use for technology and were more interested in the high modernist aesthetics of Proust and Joyce than in the mechanical stridencies of Marinetti and the futurists—also went on the air and wrote numerous texts about radio. One of the Contemporáneos, Francisco Monterde García Icazbalceta, became the editor of the journal

p. de Germán Cueto, y es en cada mañana una

40. Design for the Estridentópolis radio station by Ramón Alva de la Canal. From Germán List Arzubide, *El movimiento Estridentista* (Jalapa: Ediciones de Horizonte, 1927), 97.

Antena, launched in 1924 by El Buen Tono's radio station, and he invited other members of the group, including Salvador Novo and Xavier Villaurrutia, to take part in the radio-literary venture. Novo composed several texts about the wonders of broadcasting–including a "Radio Lecture on Radio" and a bizarre 1938 discussion of the radiophonic "unconscious"–and for some time he hosted his own radio show. Even Alfonso Reyes, a more traditional writer who was more interested in Hellenism than in futurism, spoke on the radio and wrote an enthusiastic piece called "Radio: An instrument for *paideia*" that celebrated the medium's parentage with the arts of classical oratory.[8]

The novelists of the Mexican Revolution also played a role in early broadcasting. Martín Luis Guzmán, who during Obregón's presidency served as the editor of *El Mundo,* got his newspaper to follow the modern example of *El Universal Ilustrado* by opening its own radio station. The inaugural broadcast, on August 15, 1923, featured a lecture by Education Minister José Vasconcelos on the important role that radio could play in educating the Mexican masses. For the benefit of those who could not afford a radio receiver, *El Mundo* set up a loudspeaker outside its offices, a ploy that was so successful that it caused a mob scene: "A dense and expecting crowd gathered on Calle Gante, at the doorstep of our advertising offices, where a large receiver broadcast the radiophonic vibrations to the four winds. . . . The crowds spilled onto the street, blocking traffic, and feverishly applauded the eminent artists and intellectuals [who took part in the inaugural broadcast]."[9]

One reason that radio was infinitely more popular than the typewriter among Mexican writers had to do with one of the gravest problems afflicting postrevolutionary Mexico: illiteracy. The revolutionary bandits in Azuela's novel had no use for the typewriter because they could not read or write; for them the writing machine was merely a shiny but useless piece of technology. Over half of the Mexican population in 1920 would probably have shared the bandits' view; for the illiterate masses, typewriters were an exotic form of technology that could play no role in their lives.

Radio, in contrast, was the perfect medium for a country with a high illiteracy rate. Everyone – literate or illiterate – could listen to the radio. Peasants in distant regions who had never been able to read a newspaper could now tune into the news, hear the latest reports from the capital, and even enjoy music from other parts of the world – all without leaving their village. Postrevolutionary governments soon realized that radio was the perfect medium to educate the masses, and in 1924 the Ministry of Education launched its own radio

Radio

station, CYE. The inaugural program featured a conference by Bernardo Gastélum, the new minister, echoing Vasconcelos's theories as he extolled radio as the most powerful weapon in the country's battle against illiteracy. Benedict Anderson has argued that in many countries, newspapers and printed media were crucial in shaping nationalist feeling; but in a highly illiterate country like Mexico, it was not newspapers but radio that allowed citizens to identify with the new state that emerged from the revolution.[10]

But as we have seen in previous chapters, the true cultural impact of a new medium cannot be measured by the number of citations it receives in print. The typewriter's cultural repercussions, for example, had less to do with making the machine a familiar fixture in novels and poems than with inspiring a radically new type of literature attuned to the serialized and mechanical character of modern life – the "literature of typewriters and classifieds," as Maples Arce called it. Radio's impact on literature is a bit more difficult to grasp: one can see how a text like Andrade's "Máquina de escrever" reflects the mechanical conditions of its production, but how could a text bear the traces of the radiophonic revolution? Unlike the typewriter, radio is not used to write texts, only to broadcast them once they have been written. Did broadcasting inspire a "literature of radio" that was as rad-

ical in its experimentation as the "literature of typewriters" discussed in the previous chapter? To answer these questions, we should take a closer look at the radio-inspired works created by the Mexican avant-garde in the 1920s.

Reverse Audions

Maples Arce's "TSH" was the first effort to "write" radio in Mexican letters, and the poet was the perfect figure to undertake such a task. Besides having launched the Estridentista movement in 1921 by plastering the streets with a bombastic manifesto praising modern technology, he had composed poems to jazz, automobiles, skyscrapers, and other fixtures of twentieth-century life. The idea to write a poem about radiophony, however, came not from Maples Arce but from his editor. As the day of *El Universal Ilustrado*'s inaugural broadcast drew nearer, Carlos Noriega Hope approached the poet and asked him to compose a text on radio.

Maples Arce agreed, but with a caveat: despite his enthusiasm for modern machines, he had never heard – or even laid eyes on – a radio apparatus. Determined to carry out his assignment, he paid a visit to a friend who owned a receiver and asked to be initiated into the mysteries of wireless reception. The poet put on a pair of earphones, sat

in front of the bulky apparatus and proceeded, like the little boy in the photo, to spend several hours turning knobs and attempting to tune in. There was mostly static, but after many efforts some faint voices and a crackling piece of music became audible. "They left a deep impression on me," Maples Arce later told an interviewer, "those noises and those songs that jumped from one wave to another and caused a certain amount of confusion." Eventually he went home and, "still under the effects of that audition," he wrote "TSH."[11]

The poem conveys the mixture of excitement and confusion that Maples Arce experienced while listening to the radio for the first time:

Stars launch their programs
at nighttime, over silent cliffs.
Words,
forgotten,
are now lost
in the reverie of a reverse audion.
 Wireless Telephony
 like footsteps
 imprinted
 on an empty, dark garden.

The clock,
like a mercury crescent,
has barked the time to the four horizons.
 Solitude

is a balcony
 open onto night.
Where is the nest
of this mechanical song?
Memory
picks up wireless messages
and one or two frayed farewells.
through sleepless antennas.

 Shipwrecked women
lost on the Atlantic
their cries for help
explode like flowers,
on the wires of international pentagrams.
My heart
drowns in the distance.
And now a "Jazz-Band"
from New York;
vice blossoms
and engines thrust
in synchronic seaports
Nuthouse of Hertz, Marconi, and Edison!
A phonetic brain shuffles
the perspectival accidents
of language.
Hallo!
 A golden star
 has fallen into the sea.[12]

Radio

127

Unlike Marinetti's *Zang Tumb Tuuum* or other early texts about radio, Maples Arce's "TSH" focuses not on radiotelegraphy but on radiophony, an invention that was no more than a few years old in 1923. The poem recreates the experience of listening to an early broadcast, recording many of the impressions Maples Arce felt during his first use of a receiver. When, after hours of surfing the airwaves, the poet finally managed to tune in, he must have wondered where the elusive broadcasts were coming from. He could hear a crackling voice, a random piece of music, but he had no way of knowing who had sent them into the air or where they came from. The transmission could have come from another district in Mexico City, from a nearby town, or from another country. It must have been especially eerie for him to hear disembodied voices, words severed from the speaker by technology. The source, the origin of the broadcasts was a great unknown, and Maples Arce highlights this mystery in "TSH" by asking, "Where is the nest / of this mechanical song?"—a question destined to remain unanswered.

Maples Arce could never know the source of the "mechanical song" because radio is an invisible medium. The listener cannot see who is speaking nor who is operating the transmitter at the other end; neither can he see the Hertzian waves that carried the voice and music messages across the world. The poet was fascinated by the idea of a night sky (the poem opens "at nighttime, over silent cliffs") brimming with radio waves containing everything from jazz music to sos calls. Several verses in the poem attempt to visualize these waves through synesthetic images: in one passage, the poet imagines that waves, as they travel from one country to another and back again, draw "international pentagrams" on the night sky.

Fernando Bolaños Cacho, the artist who illustrated Maples Arce's "TSH" when it was published in *El Universal Ilustrado*'s special issue on radio, also attempted to visualize the indiscernible radio waves (figure 41). He depicted them as lightning bolts emerging from three heads floating in the night sky—a visual representation of the disembodied character of broadcasting. Like radio voices, these heads have been severed from their human bodies.

So much was unknown about radio—at least to operators like Maples Arce, who were not well versed in the intricacies of electromagnetic theory—that broadcasting seemed to work through a series of unfathomable mysteries. In "TSH" Maples Arce alludes to this technical puzzle by calling radio the "nuthouse of Hertz, Marconi, and Edison." The poet understood that the medium was born out of three scientific breakthroughs—Edison's development of the elecron tube, Hertz's

41. Manuel Maples Arce's poem "TSH" illustrated with a print by Fernando Bolaños Cacho, *El Universal Ilustrado* 308 (5 April 1923): 19. Photo courtesy Hemeroteca Nacional, Mexico City.

experiments with electromagnetic waves, and Marconi's invention of wireless transmission – but, as a layman, he could not fully understand the workings of radio. Compared to other artifacts of the modern era, receivers remained inscrutable. One could peek inside an automobile, a camera, a typewriter, and get a glimpse of the mechanisms that made it work – there were levers and buttons and gears – but radios contained no moving parts. Nothing turned or throbbed inside a radio; there were only vacuum tubes that stayed put and offered none of the mechanical spectacle of other devices.

Maples Arce considered radio a "nuthouse" because even the most basic principles of the medium were difficult for the layman to grasp. The world of broadcasting was like a vast insane asylum: operators, who spent hours crowned by bulky headphones and wired into their receivers, must have looked like madmen to those unaccustomed to the paraphernalia of modern technology. And there was something slightly borderline about spending entire days fishing the waves, angling for random bits of broadcast from unknown sources. Even the sounds he picked up from the airwaves seem to have issued from a psychotic subject: there are "cries for help" and "accidents of language." Marconi and his predecessors, Maples Arce concluded, had created a giant nuthouse, a planet inhabited by radio freaks.

Aside from these more general musings about the mysteries of radiophony, "TSH" offers an inventory of the types of broadcasts that the poet heard on that fateful night. There are "cries for help," a reference to radio's crucial role in communicating with ships and receiving SOS signals (the most famous broadcast of an SOS had taken place eleven years earlier, when the *Titanic* sent a wireless distress signal from its Marconi room, although the message was sent by radiotelegraphy and not by radiophony). Jazz was another symbol of modernity, and it is not surprising to find "a 'Jazz-Band' / from New York" among the sounds mentioned in the poem: the most modern music broadcast from the most modern city using the most modern technology. Lastly, "TSH" records the poet's amazement at hearing voices in all sorts of foreign tongues: radio "shuffles" languages, turning the airspace into an electromagnetic Babel, and Maples Arce picks up music from New York, as well as a Germanic-sounding "Hallo!"

But perhaps the most original element in "TSH" is the poet's attempt to incorporate the language of radiophony into his poem. "Words, / forgotten, / are now lost / in the reverie of a reverse audion," the poet writes in a verse that most certainly marks the first literary use of "audion," a vacuum tube that functioned as a primitive amplifier and had revolutionized radio technology after its invention by Lee De Forest in 1906. Maples

Arce makes a similar poetic use of a highly technical term in the verse that describes "synchronic seaports" as brimming with noise. "Synchronic" is an adjective used to describe frequencies, and only a technological enthusiast like Maples Arce would use the word to qualify seaports. The line can be read as an allusion to one of radio's first uses, to broadcast a time signal that allowed ships to synchronize their clocks to the second with the mainland.

In "TSH" Maples Arce not only elaborates three major characteristics of radio – its mystery, its invisibility, its cosmopolitanism – but also attempts to write a new type of poetry based on the technical language of radiophony. Curiously, there was no equivalent of this effort in the literature about typewriters that we surveyed in the previous chapter: none of the stories or poems incorporated words like "platen," "type bar," or even "keys." Pedro Salinas's poem comes close: it is a poem about typewriter keys, but, instead of using the word "keys," it anthropomorphizes these machine parts and turns them into "Underwood Girls."

Unlike the language of typewriters, the vocabulary of radio was so novel, so strange-sounding, that many poets had the same idea as Maples Arce and decided to compose texts using radiophony's technical jargon. In some cases, these experiments led to a curious form of technological fetishism. At least two poetry collections published in the 1920s feature radio terminology in their titles, even though not a single one of the poems deals with wireless broadcast: Joan Salvat Papasseit's Catalan *Poemes en ondes hertzianes* (1919) and Jaroslav Seifert's Czech *Na vlnách TSF* (1925).

Peppering poetry with technical radio terms became such an obsession that the Peruvian poet César Vallejo wrote an article in 1926 censuring this trend. "New poetry," he wrote, "is what they call poems whose lexicon is made up of the words 'radio,' 'jazz band,' 'wireless telegraphy.'" Since Vallejo was a fierce critic of Maples Arce's work, which he mentions in the same article, it is not improbable that he had "TSH" in mind as he wrote this piece. The Peruvian poet believed that the influence of modern technology on poetry had to be much more profound than merely using new words. "The wireless telegraph," he argued, "should not merely lead us to say 'wireless telegraph' but it should awaken new experiences... amplifying our life and understanding." Poets had the obligation to write about new technologies in a way that reflected their impact on human experience. Otherwise, Vallejo warned, poets were merely "filling our mouths with late-model words."[15]

And Vallejo was right: though Maples Arce's "TSH" might have been the first composition in Mexico to incorporate radio terms, and it must be credited with providing an accurate impression

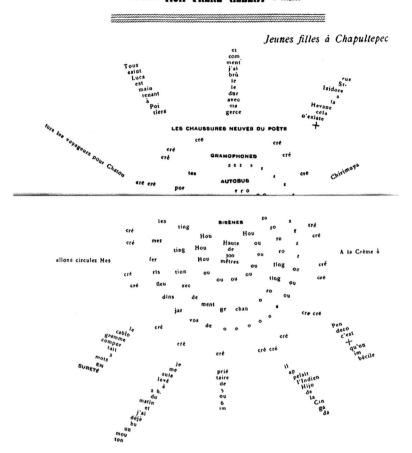

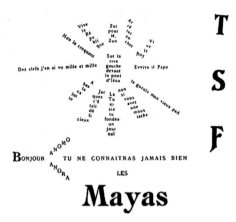

42. Guillaume Apollinaire, "Lettre-Océan," *Les Soirées de Paris* (15 June 1914).

of the mixture of disorientation and wonder that early radio listeners experienced, the poem's form and structure are entirely conventional – especially when compared to a truly revolutionary radio text like Marinetti's *Zang Tumb Tuuum*. There is not much "wireless imagination" at work in Maples Arce's text. Aside from the use of "late-model" words like "audion" and "synchronous," "TSH" is indistinguishable from late-nineteenth-century Mexican poetry, obsessed with night skies, love messages, and other romantic imagery that Kittler considered out of place in the discourse network of the new century. Ultimately, "TSH" is to radio what Pedro Salinas's "Underwood Girls" is to the typewriter: a text devoted to a modern machine but written in the most traditional form.

But how could a poet write about radio in a more audacious manner?

Ocean Letters

Despite its bombastic reception in Mexico City, Maples Arce's "TSH" was not the first poem about Mexican radio. Nine years earlier another poet had written an electrifying ode to Mexico and radio broadcasting. That poet was none other than Guillaume Apollinaire, and his work was the well-known calligram "Lettre-Océan" (figure 42).

First published in *Les Soirées de Paris* in 1914, "Lettre-Océan" might be one of Apollinaire's more famous poems, but few readers realize this is a poem about the vicissitudes of radio broadcast in Mexico. It is not that hard to see why readers might miss the main theme of this text: the poem features a disarray of words, letters, and bits of sentences; an assortment of typefaces is scattered throughout the page; and the reader's overall impression is one of chaos. Approaching the text for the first time, one might even have trouble figuring out where to begin reading. One of the most radical experiments in modernist poetry, the text moves in all directions, from top to bottom, left to right; in some areas (given its spatial dimensions, it seems more appropriate to speak of "areas" than of "parts"), the poem even spins out of control into centrifugal spirals.

"Lettre-Océan" is full of references to Mexico. The name of the country appears in Spanish several times (in the phrases "REPUBLICA MEXICANA" and "Correos Mexico"), and the poem also includes the names of Mexican cities, like Coatzacoalcos and Veracruz. A few phrases provide glimpses of everyday life in Mexico: "Jeune filles à Chapultepec" evokes a common sight in the Porfirian city: young ladies strolling through Mexico City's Chapultepec Park. A misspelled phrase, "il appelait l'Indien Hijo de la Cingada," paints a scene of

racial discrimination: an aggressive man insults an Indian by calling him "Hijo de la Chingada," the worst possible taunt in Mexican Spanish, a vulgar and aggressive epithet which has been the object of a lengthy psychoanalytic study by Octavio Paz. But "Chingada" is not the only dirty word in the poem: another fragment (also misspelled) informs us laconically that "pendeco [*sic*] c'est + qu'un imbécile." *Pendejo* means "asshole," and in English this phrase would read something along the lines of "Pendejo is more than a jerk."

The first page of the calligram ends with a mysterious admonishment to the reader: "Tu ne connaîtras jamais bien les Mayas," which translates as "You will never know the Maya well." The Mexican poet Octavio Paz was so intrigued by this statement – and by the fact that a French symbolist would write an avant-garde poem full of insults in Mexican slang – that in 1973 he wrote a response to Apollinaire, in a text called "Circulatory Poem (for the Disorientation of All)" written for the Museum of Modern Art's exhibition *The Art of Surrealism*. The poem includes the following apostrophe to Apollinaire:

> (Guillaume
> you never knew the Maya
> ((Lettre-Océan))
> Chapultepec girls

> hijo de la çingada
> (Cravan inside the belly of sharks in the Gulf of
> Mexico)[14]

Reading "Lettre-Océan" as a surrealist poem, Paz decided to top off Apollinaire's random list of Mexican impressions with an even more surreal event: the dadaist Arthur Cravan's disappearance off the coast of Mexico in 1918 and the rumors that he had been eaten by sharks. In Paz's reading, Apollinaire's poem seems to anticipate by two decades Breton's famous dictum that Mexico was the most surrealist country in the world.

But "Lettre-Océan" is not only a poem about Mexico; it is also a text about radio and its effects on language. The letters "TSF" – the French acronym for *télégraphie sans fil*, or wireless telegraphy – appear on the poem's first page in oversize bold type and seem to float, like radiotelegraphic waves, on the blank space between the two textual spirals that anchor the poem. Each of these two spirals contains an ingenious depiction of radio broadcast: the first features various bits of text ("Long live the Pope," "Long live the Republic") darting in all directions from a central point, while in the second equally disjointed phrases irradiate from a textual center. As Marjorie Perloff has pointed out, each of these spirals is a calligramic depiction of an antenna seen from above as it sends radio

waves into the air (an idea which Apollinaire seems to have borrowed from Marinetti, who had devised a similar textual spiral to depict radio broadcasts in *Zang Tumb Tuuum*).[15]

While writing "Lettre-Océan," Apollinaire had a specifc antenna in mind – the Eiffel Tower, which in 1903 had become France's most famous wireless tower. Each of the spirals revolves around a central text that describes an attribute of the Eiffel Tower: first its location ("On the left bank, facing the Iéna bridge"), then its height ("300 meters tall"). The Eiffel Tower's broadcasting of invisible radio messages into the Parisian sky was an image that fascinated many avant-garde figures from Robert Delaunay to Vicente Huidobro, and Apollinaire's poem is one of its most ingenious representations. This calligramic depiction of radio broadcast is so accurate that it even includes the crackling and howling of interference, represented by the onomatopoeic "cré cré cré" and "hou hou hou" that oscillate from the second spiral. Radio imagery features so prominently in Apollinaire's calligram that Paz refers to it as "((Lettre-Océan))," a notation that effectively encloses Apollinaire's original title in typographic radio waves: (()).

But why did Apollinaire write a poem focusing on both Mexico and radio? Is the poem merely a surrealist juxtaposition of the modern and the primitive, France and Mexico, the Eiffel Tower and the Maya? Was Octavio Paz right in suggesting that "Lettre-Océan" was written "for the disorientation of all"? Or is there something more complex in Apollinaire's rapprochement of Mexico and wireless telegraphy? We can find an answer to these questions in another one of the poem's many enigmatic lines: the greeting "Bonjour mon frère Albert à Mexico" (Hello, my brother Albert in Mexico City) which towers in boldface over the second page.

Apollinaire himself never went to Mexico, but his brother Albert did. Albert de Kostrowitzky (the poet's real family name) was a bank employee with a passion for traveling who had spent time working in Russia and England before embarking for Mexico in early 1913. On February 9 his ship docked at Veracruz (thus the mention of this port in "Lettre-Océan"), and the next day he continued by land to the capital. Albert could not have picked a worse moment to arrive in Mexico City: February 10, 1913, was the beginning of the *decena trágica*, the ten tragic days that plunged the capital into one of the bloodiest episodes of the Mexican Revolution. The wave of violence began with a coup d'état against President Francisco Madero, the liberal and levelheaded intellectual who had defeated Porfirio Díaz at the polls in 1910. A drunken thug named Victoriano Huerta, with the

Radio

135

support of the United States ambassador, imprisoned and eventually assassinated Madero and other members of his cabinet before installing himself as the new president of Mexico. During those ten days, Mexico City was the site of ruthless clashes between rival factions that killed hundreds of innocent bystanders and left many of the city's buildings in ruins. A photograph from the Casasola archive (figure 43) shows a street lined with crumbling buildings and gives us a good idea of what Albert de Kostrowitzky might have seen in his early days in Mexico.

Immediately after his arrival in the capital, Albert went into hiding at a fellow Frenchman's house. He wrote to his brother Guillaume every other day during the *decena trágica*, assuring him that he was safe. Albert's postcards give us a glimpse of what it must have been like for an unsuspecting foreigner to find himself suddenly in the midst of the revolution. "Today I was woken up by the firing squad," he wrote to Apollinaire the day of his arrival. "I am safe in a French house.... They are carrying the bodies of rebels and loyalist soldiers." Two days later: "Still safe. Businesses are closed and everyone staying in. Many dead and wounded." And on February 19, the last of the tragic days: "Fighting stopped yesterday. No more cannon fire. We were getting used to it. Machine guns would fire 40 or 50 shots without a break. On

my first day here I saw people being pulled from the windows of the house where I'm staying."[16]

Albert survived the ten tragic days, stayed on in Mexico for several years, and continued to write to his brother regularly. His letters reveal a curious inability to grasp the complexities of the political situation or even the subtleties of Mexican life. In a letter dated July 12, 1914, a few months after the American invasion of Veracruz, Albert laments that life in Mexico City is not as lively as in the bohemian neighborhoods of Paris: "There is no popular literature in Mexico," he tells his brother, "no singers to be seen on the city streets. Indians don't know how to read or write and they sleep on mats on the ground, on the bare soil sometimes.... There are no amusements, except for military music and the cinema, where they show mostly French and Italian films." In the same letter, Albert laments the vicissitudes of mail service in times of revolution. "I never received your book *La fin de Babylone*," he tells Apollinaire. "It must have gotten lost around Tenbladeras, near Vera Cruz, where they left many bags of mail. The delivery of mail from Europe has been interrupted three times already since the American invasion." Not even letters were safe from the violence of the revolution: Albert reports rumors that entire bags of mail were burnt![17]

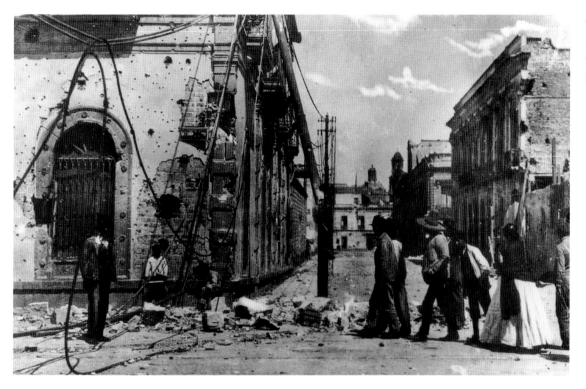

43. Damaged houses during the *decena trágica*, Mexico City, 1913. Casasola Archive. SINAFO-Fototeca Nacional, Mexico City.

Radio

As it turns out, the fragments of text that make up "Lettre-Océan" are not so random after all. Many of them are taken directly from the descriptions of life in Mexico that Albert included in his letters or from text printed on the postcards he sent. The phrases "REPUBLICA MEXICANA / TARJETA POSTAL," for example, are transcribed from the back of one of Albert's Mexican postcards reproduced in the *Album Apollinaire*. The phrase "Jeunes filles à Chapultepec" comes from another postcard sent during the *decena trágica* that shows an image of Chapultepec Castle, one of the landmarks in Mexico City (which, incidentally, was later chosen as the site of Mexico's tallest radio antenna).[18] And one of the textual fragments that appears near the top of the first page of "Lettre-Océan"–

Les voyageurs de *l'Espagne* devant faire
le voyage de Coatzacoalcos pour s'embarquer
je t'envoie cette carte aujourd'hui au lieu
de profiter du courrier de Vera Cruz qui n'est pas sûr

[Since the passengers of *L'Espagne*
have to travel to Coatzacoalcos to board the ship
I'm sending you this postcard today instead
of using the Veracruz mail which is not safe]

– paraphrases Albert's complaints about the bags of mail at Veracruz as well as the closing words of one of his letters: "I'm sending this letter with a Spaniard who leaves tomorrow. In this way it will reach you for sure. There are rumors that *L'Espagne* did not sail yesterday."[19]

But "Lettre-Océan," as the title indicates, is also a poem about the difficulties of communicating between Mexico and France. Albert's letters had to traverse the Atlantic to reach his brother, a journey that was painfully slow even in peaceful times. We can only imagine how anguished Apollinaire must have been when he read the news about the *decena trágica,* especially since the reassuring postcards sent by Albert would not reach him until many weeks later. "Your voice," the poet tells his brother in the second line of "Lettre-Océan," "reaches me despite the enormous distance." But this was merely an episode of wishful thinking: in 1913 radio technology was not advanced enough to broadcast voice messages. At the time, the radiotelegraph was the only reliable method for getting messages across the ocean.

A phrase in "Lettre-Océan" reveals that the brothers' correspondence was not limited to postcards and letters. One of the textual fragments irradiating from the second spiral reads "le cablo gramme compor tait 2 mots EN SURETÉ" [the radio-telegram consisted of two words: in safety]. Upon arriving in Mexico City, Albert wanted to let his family know that he was safe, and the only fast, reliable method for sending his message was through radiotelegraphy. Messages had to be short and to the point, so he wrote only two words – "en sureté" – to let his brother know that he had not fallen victim to the revolutionary mobs. Apollinaire was so taken with the message (which, unfortunately, has not survived) that he wrote an entire poem to the radiotelegram, celebrating it as a modern "letter" that was able to traverse the ocean almost instantly, even in times of revolutionary turmoil.

To send his radiotelegram to France, Albert must have visited a radiotelegraphic office in Mexico City like the one shown in figure 44. The photo demonstrates the complex procedures through which telegrams were received: an operator wearing a pair of earphones listened to the Morse signals (which were also recorded on ticker tape for

later reference) and typed every letter of the message as it came in. Speed was crucial, as evinced by the operator's hands: his frantic movements were too fast for the camera and came out as a blur. The receiving room was an assembly line of language: words and sentences—like Albert's "en sureté"—were put together one letter at a time by workers who were caught between two machines, the radio receiver and the typewriter. As he picked up Albert's missive, Apollinaire must have been deeply impressed by the transformation of language—the medium of his work—into a serialized product. It

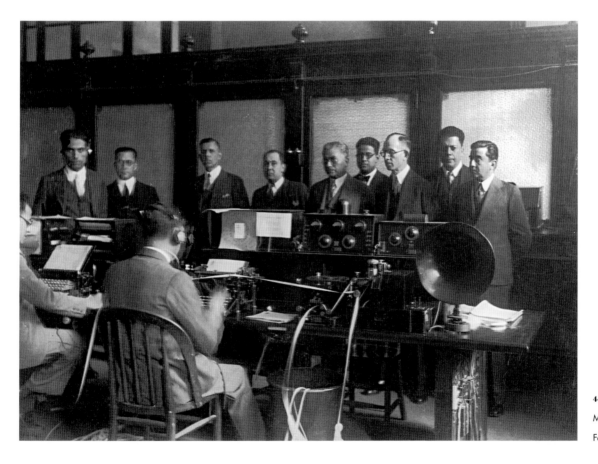

44. Radiotelegraphic station in Mexico City, ca. 1920. SINAFO-Fototeca Nacional, Mexico City.

is no coincidence that the poet started experimenting with calligramic writing around the time he received his brother's radiotelegram.

Apollinaire did not invent the term "Lettre-Océan"; it appears to have been a common name for radiotelegrams sent to or from ships. In 1924 Blaise Cendrars published a little prose poem with the same title, describing his marvel at sending and receiving "ocean letters" as he sailed to South America:

The ocean letter is not a new poetic genre
It's a useful message with an adjustable fee and a lot
 cheaper than a radio
. .
The ocean letter was not invented for writing poetry
But when you travel when you do business when you're
 on board when you send ocean letters
It's poetry.[20]

Apollinaire's "Lettre-Océan" is poetry indeed, but of a new kind. It is a poem about Mexico and radio, about the revolution and the wireless telegraph.[21] Curiously, "Lettre-Océan" demonstrates that radio transmission and revolutions have similar effects on language: Albert complained that the ongoing fighting meant that entire sacks of mail were destroyed, and postal communications were haphazard and fragmentary. Likewise, the constraints of radiotelegraphy force writers to adopt a fragmentary style. Instead of writing "Je suis en sureté" in his radiotelegram, for example, Albert had to make do with an abbreviated version consisting of the last two words of this phrase, as Apollinaire points out in his calligram. And if the revolution turned the streets of Mexico City into a chaotic battlefield strewn with corpses, Apollinaire creates a similar textual disarray on the page of his calligram. Like revolutionary mobs – or radio waves – the words on the page are animated by an anarchic energy that makes them run in all directions: from top to bottom ("TSF"), from left to right, and in multidirectional spirals.

Like Maples Arce's "TSH," "Lettre-Océan" is a poem about radio, but the two texts could not be more different. Maples Arce praises radio in a poem that is virtually indistinguishable from nineteenth-century models, while Apollinaire writes in a chaotic, fragmentary, and lawless prose that is attuned to an era marked by revolutionary chaos and radiotelegraphic fragmentation. Apollinaire not only writes about radiotelegraphy; his very language is shaped by the medium's strict economy. "Lettre-Océan" is one of the clearest examples of Marinetti's theory of a radio-inspired revolutionary writing. To describe revolution, Marinetti wrote in one of his early manifestos, "one has to destroy syntax" and write telegraphi-

cally, "with the economy and speed that the telegraph imposes on reporters and correspondents in their superficial dispatches."[22] In his first manifesto, Maples Arce reached a similar conclusion and wrote that in the modern era it is "telegraphically urgent to employ a [writing] method that is radicalist and efficient."[23] "Lettre-Océan" is not only telegraphic; it is radiotelegraphic.

Like the typewriter, radio provides a desublimatory effect on literature. A poem that is truly radio-inspired, like "Lettre-Océan," abandons the transcendental themes of literature in favor of simple, everyday occurrences, such as saying hello to one's brother or transcribing Mexican slang. The poet shows that texts written in the era of broadcasting have no room for the type of romantic imagery that Kittler derided as "Keller's blood or Hoffman's inner forms." Apollinaire's calligram, with its medley of random phrases, is extremely close in spirit to Andrade's "Máquina de escrever," which also includes various fraternal musings ("they filched my brother's typewriter"). If Andrade's poem is an example of "the literature of typewriters and classified ads," Apollinaire's composition is a compelling example of what we might call "the literature of radio." Apollinaire may never have understood the Maya, but he certainly understood the wireless!

Radio Smoke

Though Albert de Kostrowitzky survived the *decena trágica*, his luck did not last for very long: he died under mysterious circumstances in Mexico City in 1919. A year later, the revolution would come to an end and a new chapter in Mexican history was to begin – an era marked by peace, reconstruction efforts, and a technological frenzy that one writer called "the madness of radio."[24]

The invention of radio inspired writers around the world to imagine futuristic scenarios, but in Mexico the poets were not the only ones fantasizing about the utopian possibilities of radio. Engineers, editors, journalists, and even entrepreneurs exercised a wireless imagination without restraint, giving rise to a number of true stories that would be more at home in a science-fiction novel than in a country recovering from a decade of civil war.

The madness began in 1923 with Mexico's first radio fair. For several years, a group of entrepreneurs who formed a "radio league" had been pressuring President Obregón to sign legislation authorizing regular radio broadcasts. On June 16, 1923, they launched a spectacular public relations offensive: an elaborate radio fair held at the elegant Palace of Mines (the current site of the Annual Book Fair in downtown Mexico City) designed

to initiate the president and the general public into the mysteries of wireless broadcasting. There were stands sponsored by La Casa del Radio (a large store owned by Raúl Azcárraga, whose descendants would later found the media giant Televisa and dominate Latin American broadcasting), by *El Universal Ilustrado* (which owned the city's only functional radio station), and by entrepreneurs who planned to build their own radio stations in the near future.

Few people in 1923 had actually seen a radio, so the organizers of the fair set up a transmitter and a receiver and proceeded to demonstrate, to the astonishment of visitors, how voices and sounds could travel wirelessly from one end of the room to another. For those traditionalists who considered these experimental broadcasts too abstract and removed from their lives, the fair featured a number of exhibits designed to show how radio was destined to transform the life of every person.

For the duration of the fair, the graceful Palace of Mines was transformed into a futurist stage: the décor, the stands, and the products were designed to give visitors a hint of what it might be like to live in the future. An article about the fair in the newspaper *El Universal* describes a curious strategy devised by the owners of La Casa del Radio to lure customers to their booth (and to their radio station): "The Azcárraga brothers regaled their clients and friends with bottles of 'Radio' soda and starting today their station will broadcast the most important events at the fair."[25] Perhaps not all visitors to the fair were eager to wear a pair of earphones and let the radio waves penetrate into their ears, but most would be willing to ingest a Radio soda. The way to clients' ears, Azcárraga probably reasoned, was through their stomachs!

As it turns out, Mexico was to have other radio-inspired drinks. In 1926, when the madness of radio was in full swing, Cervecería Moctezuma, one of the country's largest breweries (named after the renowned Aztec emperor but owned by a French company), launched XX, a radiophonic beer. The new brand was promoted in a series of advertisements published in *El Universal Ilustrado* (see figure 45) showing two enormous beer bottles towering over Mexico City and functioning like wireless antennas, broadcasting myriad miniature double Xs that evoke Apollinaire's depictions of radio interference in "Lettre-Océan." The tagline, "What one hears everywhere," revealed the brewers' wish that their product, like radio waves, could be everywhere at once. Looking at these ads, we are reminded of Vallejo's reproach against poets who attempted to be modern by simply including the word "radio" in their compositions. In this case it is not a poet but a brewery named after an Aztec emperor that attempts to jump onto

the bandwagon of modernity by using the word "radio" as a magic wand.

Back at the radio fair, visitors were surprised by the Radio soda, but they were even more surprised by the stand belonging to El Buen Tono, a tobacco factory that was about to open Mexico City's second broadcasting station and that launched one of the most spectacular episodes in radio history anywhere in the world, as we will see.

El Buen Tono had been founded in 1899 by Ernest Pugibet, a Frenchman who had become one of the country's most successful industrialists – so much so that visiting dignitaries were often taken on a tour of his factory by Mexican presidents. Obsessed with all things modern, Pugibet had bought airplanes, blimps, and hot air balloons during the Pofiriato and had them fly over Mexico City to promote his cigars. His plan to build Mexico's most powerful radio station on the grounds of his factory was not as scatterbrained as it now sounds: the exact use of radio was still undetermined (was it to be an extension of the newspapers? a high-tech telephone? an educational tool?), and Pugibet had the brilliant idea that it might also serve as a new medium for advertising.

Ironically, El Buen Tono was named after an old fashioned expression, immensely popular during the Porfiriato, that is best translated as "good upbringing" and was used to refer to the impec-

Radio

45. Advertisement for Moctezuma's XX as a radiophonic beer. *El Universal Ilustrado* 478 (8 July 1926): 6.

cable manners and flawless social etiquette that was expected of "good families" in prerevolutionary Mexico. *Tono* can also mean "tone," as in musical tone, and perhaps by acquiring a radio station the cigar company was hoping to jump, along with the rest of the country, on the bandwagon of postrevolutionary modernity: its name would no longer

Anuncio Estridentista de "El Buen Tono".

46. Advertisement designed by the Estridentistas for El Buen Tono. From Germán List Arzubide, *El movimiento Estridentista* (Jalapa: Ediciones de Horizonte, 1927), 77.

refer to the good manners of yore but to the good radio sounds of the future.

While *El Universal Ilustrado* lured visitors to its booth at the radio fair by offering sips of Radio soda, El Buen Tono was even more ingenious: it launched a new brand of cigarettes – called Radio, of course – and handed out free boxes to hundreds of eager smokers at the fair. But unlike the Radio soda and the radiophonic beer, which were entirely ordinary drinks graced with a technological name, Radio cigarettes were modern through and through. The manufacturer engaged the services of the Estridentistas to design a futuristic ad campaign for the cigarettes (see figure 46), and the avant-gardists obliged, depicting the new brand of cigarettes in a futuristic world filled with skyscrapers, neon lights, and machines. The ad copy promoted Radio as "the cigarettes of the epoch."

A photograph of El Buen Tono's stand at the radio fair (figure 47) shows a proud Pugibet standing in front of an enormous radio receiver and surrounded by banners urging visitors to "Smoke 'Radio.'" To give visitors a taste of the future, the women who tended the booth wore radio antennas on their heads and carried baskets full of Radio cigarettes. The booth was a futuristic space inhabited by walking radio receivers, androids whose attires merely exaggerated the defamiliarizing effects that earphones, wires,

47. El Buen Tono's stand at the radio fair, Mexico City, June 1923. SINAFO-Fototeca Nacional, Mexico City.

and other technological paraphernalia produced on the human body. And while these radio hats were not sophisticated enough to catch radio programs, the women-antennas were extremely successful at catching potential customers for El Buen Tono, at least if we are to judge from the crowds gathered in the company's stand.

El Buen Tono's radio adventure continued well after the radio fair, and so did the company's collaboration with young poets. The campaign for Radio cigarettes was so successful that El Buen Tono continued to commission advertisements from the Estridentistas and effectively became their corporate patron. *Irradiador,* the Estridentista journal that published three issues in 1923 (figure 48), was financed in part by the advertising revenue from the tobacco company, and the back cover of every issue featured an elaborate, avant-garde ad for El Buen Tono's cigarettes. Ironically, the Estridentistas were much more daring and experimental in their ads than in their own poetry. Maples Arce's "TSH" might read as a fairly traditional com-

48. Cover of *Irradiador* 1 (1923). Photo courtesy Jean Charlot Archive, University of Hawaii.

49. Estridentista advertisement for El Buen Tono. Back cover of *Irradiador* 1 (1923). Photo courtesy Jean Charlot Archive, University of Hawaii.

position, but the cigarette ad featured in the first issue of *Irradiador* reads like Apollinaire's calligram: the composition is fragmented and chaotic, and bits of phrases ("buen … tono … mejores … cigarros") follow the concentric patterns of radio waves (figure 49). Blaise Cendrars once called advertising "the flower of contemporary life," and the Estridentistas, like the Russian constructivists and the French simultaneists, turned ads into a new form of avant-garde experimentation.[26]

Despite these avant-garde ad campaigns, El Buen Tono was faced with a thorny problem: only a handful of people in Mexico City owned radio receivers, so the company's elaborate plans to "turn every smoker into a radio listener" would fall on deaf ears. It was easy to get people to drink Radio sodas and smoke Radio cigarettes, but how could the company get them to buy an actual radio? El Buen Tono came up with an ingenious plan. A new ad, published in *El Universal Ilustrado* and *Antena* (figure 50), offered to exchange empty cigarette boxes for the parts needed to assemble a radio apparatus: three boxes for a battery; five boxes for a wire antenna; fourteen for a set of earphones; and twenty for a fully functional radio receiver.[27] Like workers at a factory, smokers were encouraged to build a radio by assembling its various parts and following the methods of Taylorized

production. El Buen Tono was on a mission to make every smoker into a thoroughly modern subject who consumed industrialized tobacco, listened to the radio, and assembled receivers.

A text distributed by El Buen Tono at the radio fair (and published the next day in *El Universal*), reveals the company's futuristic plans for transforming every smoker into a radio subject:

50. Advertisement for El Buen Tono's radio giveaway in *Antena* 2 (1924).

Radio

147

In a short time El Buen Tono will begin operating a broadcasting station for the delectation of its consumers. Every day, at previously announced times, every smoker of El Buen Tono cigarettes will be able to sit comfortably in his bedroom, enjoying a luscious cigarette and contemplating the fanciful figures drawn by the aromatic smoke in front of him, while he hears a human voice narrating everything that unfolds in the metropolis. All events of public interest, no matter how slight, will be broadcast by this powerful station from the svelte towers that will soon rise from our building on Plaza San Juan [de Letrán].[28]

The tale of a cigarette company seeking to take over its consumers' bodies by filling their lungs with aromatic smoke and their ears with radio broadcasts sounds like an episode from Khlebnikov's "Radio of the Future" or Apollinaire's "Le roi Lune." But the story of El Buen Tono and its radiophonic adventures gets even more uncanny: three years after the inauguration of its broadcasting station, the tobacco producer found itself involved in a bizarre saga that involved a Scandinavian explorer, an expedition to the North Pole, and the power of radio signals to put Mexico at the top of the world.

Short Wave: The Great Unknown

At this point the cultural history of Mexican radio takes an unexpected detour to ... the North Pole.

But before continuing our cultural history of broadcasting, we need to recount a fantastic affair that was the talk of the town in Mexico City during the summer of 1926.

In the first days of May 1926, the Norwegian explorer Roald Amundsen (figure 51), a seasoned adventurer who had been the first man to reach the South Pole, set out on an ambitious expedition to the North Pole. This time he did not board a ship or fly an airplane, as he had done on previous journeys, but settled for a means of transportation that was as implausible as his itinerary: an enormous

51. Roald Amundsen, ca. 1920. © Bettman/Corbis.

zeppelin, almost 350 feet long, which he patrioti-
cally called the *Norge* (figure 52). His choice raised
a few eyebrows, but Amundsen explained that a
dirigible has many advantages over an airplane.
"An airship," he wrote in an account of his expe-
dition, "floats in the air even if all the motors
should fail." The prospect of an engine failure in
midair and above a frigid no-man's-land did not

scare the explorer, who coolly remarked that in
such a situation – which did arise during the
course of his trip – "considerable repairs can be in
part effected while the airship continues to be
driven by the remaining motors."[29]

Equipped with a large crew that included me-
chanics, radiotelegraphists, and weather ob-
servers, the *Norge* embarked from Spitsbergen in

52. The *Norge*. From *Air Pio-
neering in the Arctic: The Two
Polar Flights of Roald Amundsen
and Lincoln Ellsworth* (New York:
National Americana Society,
1929).

northern Norway on a route that was to take it across the Polar Sea, over the North Pole ("the top of the world," as the explorer called it in his journals), and down the other side of the globe to Alaska. The logistics of the trip were extraordinarily complex. Since there were no dirigible repair facilities in the Arctic, Amundsen took the precaution of shipping elaborate kits, composed of hundreds of spare parts, to every scheduled stop along his route. And to keep in touch with the world below, he had a powerful radio apparatus installed aboard the blimp, a floating station capable of sending and receiving meteorological forecasts, travel details, and the time signal. "A considerable amount of attention," the explorer explained later, "was paid to the radio equipment. From the Marconi company in England complete information had been obtained relating to the radio apparatus with which the *Norge* was equipped."[50]

Amundsen wrote an in-depth account of his hair-raising trip, including details about everyday life in a zeppelin floating over the polar ice. There were, for example, strict rules governing the crew's behavior: "The most important point was not to throw anything overboard which might get into the propellers and smash them. It was also forbidden to go on the gangway in the keel with shoes or boots without rubber soles, lest the metal in non-rubber soles should strike sparks against the steel in the gangway and thus ignite the gasoline vapors or the hydrogen."[51] A terrifying prospect indeed!

Against all odds, Amundsen's journey was a success. He reached the North Pole on May 12, 1926, and, to mark his triumph, he dropped two flags (one for Norway and one for the United States), especially designed so that "on reaching the ice [they] would stand perpendicularly" on the land below. "We are sure that all our readers will understand the feelings of our crew of the *Norge*," he later wrote, "when we saw the . . . flags waving under us with the background of snow-covered ice." Immediately after lowering the flags, Amundsen ran to the *Norge*'s Marconi room and sent a radiotelegram announcing the good news. The message, written in the rapid, telegraphic style that fascinated avant-garde poets from Marinetti to Apollinaire, conveys the excitement felt by the explorer: "WHEN NORGE OVER NORTH POLE WAS GREATEST OF ALL EVENTS THIS FLIGHT." It even offers a brief but compelling description of the polar landscape: "ICY WASTES WHOSE EDGES GLEAMED LIKE GOLD IN THE PALE SUNLIGHT BREAKING THROUGH FOG WHICH SURROUNDED US STOP." This abbreviated, run-on message reads so much like an example of Marinetti's "words in freedom" that the *New York Times*'s editors felt compelled to fill in the missing syntactical elements, which they wrote by hand on the telegram, as we can see in figure 53.

53. Roald Amundsen's radiotelegram sent from the North Pole. From *Air Pioneering in the Arctic: The Two Polar Flights of Roald Amundsen and Lincoln Ellsworth* (New York: National Americana Society, 1929).

The rest of the journey was even more terrifying, as the explorer had to traverse "the biggest unexplored area of the world" – a region that many cartographers had called "the great unknown" – to arrive in Alaska.[32] Amundsen's narrative captures the atmosphere of desolation in this uncharted region: "What were the secrets of this area? . . . Would we succeed in pulling aside a part of the veil that covered it? And if we succeeded, should we land safely, so we could tell the world what we had seen? These questions animated every man aboard the [air]ship in the first minutes after we had passed the Pole, but soon our duties again occupied us and the flight went on as before."[33] Amundsen did land safely in Alaska as scheduled (the landing of the dirigible, he reported, "scared the Eskimo dogs"),[34] and he instantly became a celebrity. Reports about his journey were broadcast by radio around the world, and photographs of him and his dirigible appeared on the front pages of every major newspaper from Moscow to Buenos Aires.

In Mexico City, accounts of the Norwegian's feat dominated the press throughout June 1926. Photos of Amundsen and his zeppelin appeared almost daily in the city's most important publications, from *Revista de Revistas* to *El Universal Ilustrado*. *Excélsior*, the country's most influential newspaper, serialized Amundsen's travel journal and proudly announced to its readers that the text had been sent wirelessly from the United States – where Amundsen was spending a few days before returning to Scandinavia – by "direct radiogram, exclusively for *Excélsior*."[35] The paper's New York correspondent even secured an exclusive interview with the explorer that appeared on the front page on July 4, 1926.

It is at this point that Mexican radio enters the story. According to several historians of broadcasting, part of the reason the Mexico City press was so interested in Amundsen had to do with a freak incident of radio transmission. As the explorer reached the North Pole, he tuned his onboard receiver and happened upon a program sent into the airwaves by El Buen Tono's station, which had recently acquired a powerful short-wave transmitter. The incident, reports radio historian Jorge Mejía Prieto, "became one of [the radio station's] greatest points of pride"[36] and inspired yet another ad campaign: an image of Amundsen on the North Pole, standing under his zeppelin and pointing to a box of Radio cigarettes (figure 54). He is pictured smoking a Buen Tono cigarette, and the ad copy – "Smoke 'Radio'" – urges readers to follow suit.

For El Buen Tono, the news about Amundsen's polar reception of their program was a dream come true. As is clear from its ad campaigns, the company was out to modernize Mexico one citizen

54. Advertisement for El Buen Tono's Radio cigarettes showing Roald Amundsen on the North Pole. *El Universal Ilustrado* 478 (8 July 1926): 7.

at a time, turning every smoker – and by extension every Mexican – into a radio listener fully attuned to the sounds of modernity. By smoking Radio and listening to our station, the ads seem to reason, every Mexican will become a modern subject. And could there be a more perfect model for this ideal than Roald Amundsen? The Norwegian was an archetypal modern man: he traveled in flying machines, crisscrossed the world with the ease of Hertzian waves, and he listened to the radio – not just to any radio, but to El Buen Tono's short-wave broadcasts. As the North Pole ads illustrate, the tobacco company hoped not only to turn every smoker into a radio listener, but to turn every Mexican into an Amundsen.

Curiously, though most radio histories point to Amundsen's polar reception as one of the highlights of Mexican broadcasting, none of the historians provides more details about the fantastic event: What exactly did Amundsen hear on the radio? How did he identify the source station? When did he contact El Buen Tono, and what did he tell the station? These questions point to significant lacunae in the history of Mexican radio, and since the answers were nowhere to be found in the scant publications on the subject, in August 2004 I embarked on an expedition to the Mexico City archives determined to uncover the entire story.

My first stop was El Buen Tono's radio station, which, surprisingly, is still on the air and operating on the same frequency as in the 1920s, XEB, although it is no longer owned by the tobacco company (El Buen Tono went bankrupt many years ago after it was bought by British American Tobacco). My inquiries at the offices of XEB about the North Pole broadcast and the Norwegian expedition were met with blank stares and a slight suspicion, not entirely unfounded, that I, too, was afflicted with the "madness of radio." No one there had ever heard about Amundsen, but the manager – a master of public relations, like her predecessors from the 1920s – thought it might help the station's rating to do an interview and invited me to tell the Norwegian's mad story on the air (and so I did!).

My next stop was the newspaper archive at UNAM, the National University, where I scoured past issues of *Excélsior* in search of more details. This time I had better luck, and I was able to find the puzzle's missing pieces and correct the record on the explorer's Mexican connection. Amundsen, it turns out, did not really hear Mexican radio on the North Pole. In mid-June 1926, after the news of Amundsen's expedition had been featured daily on *Excélsior*'s front page for weeks, El Buen Tono seized the occasion to promote its cigarettes. The company launched a new ad for Radio cigarettes showing Amundsen at the North Pole and an-

nouncing, "Amundsen has said it: the true conquerors of the North Pole are El Buen Tono's 'Radio' cigarettes. El Buen Tono, the company of worldwide fame."[37] These were the days before truth in advertising, and a week later the cigar manufacturer launched an even more daring ad featuring the same image of Amundsen smoking on the North Pole (figure 55): "The first thing Amundsen did as he flew over the North Pole was to smoke a 'Radio' cigarette: the cigarettes famous throughout the globe."[38] It appears that years later, when browsing through archival clippings, El Buen Tono's managers took the ad copy literally, and spread the word that the explorer had indeed said what the spreads claim he had said. The story of Amundsen's polar reception eventually found its way into Mejía Prieto's *History of Radio and Television in Mexico,* and his account was later repeated verbatim by other historians.

Though El Buen Tono's radio signal never reached the explorer, the Radio campaign effectively brought Amundsen to Mexico. Though in real life the explorer never visited, the ad campaign transported him to Mexico, at least symbolically, since his name and photograph were delivered to every Mexican family that subscribed to *Excélsior.*

These ads were so effective in bringing Amundsen to Mexico that he became something of a local celebrity. In July 1926 *Excélsior* reported that a

55. El Buen Tono's advertisement for Radio cigarettes, *Excélsior,* 25 June 1926, 8. Photo courtesy Hemeroteca Nacional, Mexico City.

group of local enthusiasts had invited the Norwegian to visit Mexico City and give a series of lectures about Arctic travel, but the explorer politely declined. He told a reporter that he was too exhausted from his polar trip and simply wanted to go back to Norway and get some rest. In any case, the newspaper concluded, "the explorer was very pleased to hear that he was well known in Mexico, and he expressed gratitude for the praiseworthy reports of their deeds published in *Excélsior*."[39] The explorer, it seems, was only drawn to icy corners of the planet – Antarctica, the North Pole, Norway – and had little use for a tropical country like Mexico.

The explorer's Mexican fans were not discouraged by this lack of interest, and they continued to celebrate his prowess until after his death. When Amundsen lost his life in 1928 (he vanished in the Arctic as he was flying to rescue a fellow explorer from a dirigible crash), two prestigious learned societies in Mexico City organized an elaborate homage to his life and deeds. The event took place on December 14, 1928, and was cosponsored by the Mexican Society of Geography and Statistics and the National Academy of History and Statistics. The proceedings were published in a booklet titled *Sesión solemne en homenaje al ilustre explorador de los polos Roald Amundsen*. The meeting was attended by over one hundred Mexican

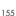

Radio

scientists, and featured a keynote speech on Amundsen's explorations by Agustín Aragón, who extolled the Norwegian as a "model citizen" and a "tireless lover of ice" and compared his heroic adventures to those of Don Quixote and the Spanish conquistadors. "May Roald Amundsen rest in peace," one of the orators concluded, "and may History write his name in characters that will be remembered for all eternity for his virtuous and generous deeds."[40]

The story of Amundsen tuning into Mexican radio over the North Pole turned out to be merely a clever advertising ploy devised by El Buen Tono, nothing more than a fantasy full of cigarette smoke and mirrors. But fantasies—as Freud demonstrated in his discussions of dreams, slips of the tongue, and other parapraxes—can tell us a great deal since they almost invariably represent the fulfillment of a wish. It is easy to see what wish was being fulfilled in El Buen Tono's fantasy about its radio station: that Mexico, a country that had become increasingly isolated and cut off from the rest of the world during the revolution, could finally take its place among the community of modern nations. The whole world was talking about Amundsen's feat, and the cigar manufacturer's claims allowed Mexico—and El Buen Tono—to share center stage with the Norwegian explorer. During a time marked by great expectations, the company's radiophonic fantasy propelled Mexico from the margins to the "top of the world."

El Buen Tono's claims might have been untrue, but their choice of radio as the medium that would help Mexico break free from its longtime isolation was apt. The "madness of radio" that seized the country in the 1920s was due in part to the hope that the wireless, with its ability to send messages across national borders, would remedy the country's geographical solitude and connect Mexico to the rest of the world. And this expectation was not entirely unfounded: in 1923, the same year that Mexico launched its radio fair and inaugurated its first broadcasting stations, the United States recognized the government of Álvaro Obregón, effectively ending the country's status as an international pariah.

Radio Lectures

Compared with El Buen Tono's fantastic radio adventures and Apollinaire's "Lettre-Océan," Maples Arce's "TSH" seems extremely conventional. One of the problems with this poem, as Vallejo points out, is that it merely incorporates technical terms without truly evoking radio's role in shaping a new discourse network. But we can better understand the poem's greatest shortcomings by referring to two concepts introduced by the French critic André Coeuroy, one of the early theorists of radio.

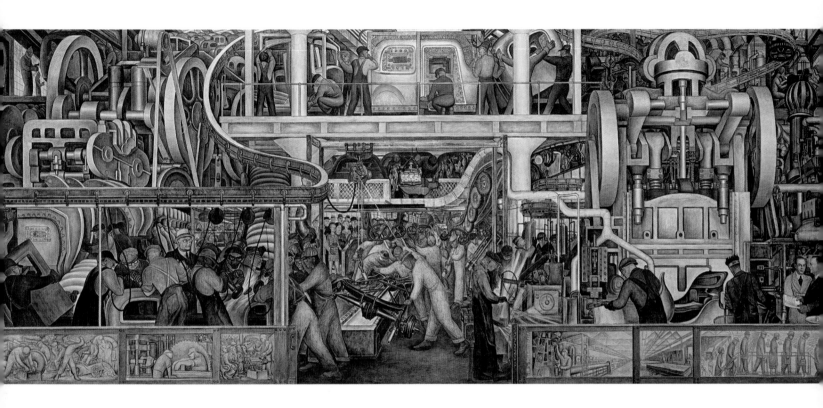

Plate 1. Diego Rivera, *Detroit Industry,* south wall (1932–1933). Gift of Edsel B. Ford. Photograph © 2001 The Detroit Institute of Arts.

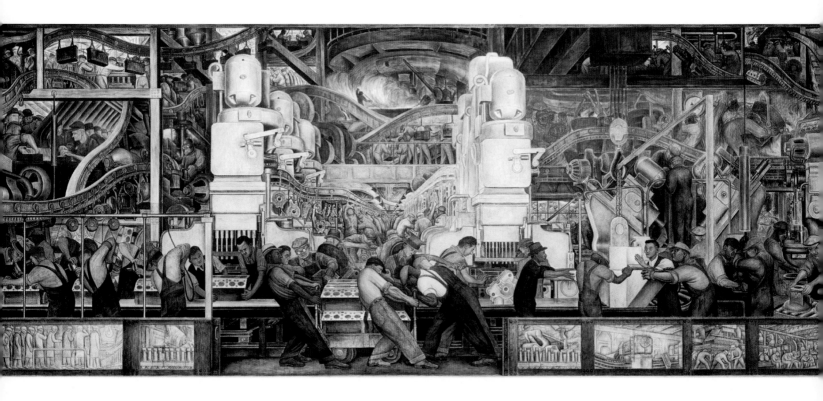

Plate 2. Diego Rivera, *Detroit Industry,* north wall (1932–1933). Gift of Edsel B. Ford. Photograph © 2001 The Detroit Institute of Arts.

Plate 3. Diego Rivera, "Pharmaceutics," detail from
Detroit Industry (1932–1933). Gift of Edsel B. Ford.
Photograph © 2001 The Detroit Institute of Arts.

Plate 4. Kyn Taniya [Luis Quintanilla], *Avión*
(Mexico City: Editorial Cultura, 1923). Photo courtesy
Biblioteca Nacional, Mexico City.

Plate 5. Manuel Maples Arce, *Urbe: Super-poema
bolchevique en 5 cantos* (Mexico City: Editorial Cultura,
1924). Photo courtesy Biblioteca Nacional, Mexico City.

Plate 6. Manuel Maples Arce, *Metropolis* (English translation by John Dos Passos of *Urbe*; New York, 1929). Photo courtesy Munal, Mexico City.

Plate 7. *Metropolis*, frontispiece by Fernando Leal. Photo courtesy Munal, Mexico City.

Plate 8. Hugo Brehme, *Hombre con sombrero* (1920). Courtesy of Throckmorton Fine Art, New York.

Plate 9. Cover of *Irradiador* 1 (1923). Photo courtesy Jean Charlot Archive, University of Hawaii.

Plate 10. Estridentista advertisement for El Buen Tono. Back cover of *Irradiador* 1 (1923). Photo courtesy Jean Charlot Archive, University of Hawaii.

IRRADIADOR

REVISTA DE VANGUARDIA. - PROYECTOR INTERNACIONAL DE NUEVA ESTETICA PUBLICADO BAJO LA DIRECCION DE MANUEL MAPLES ARCE & FERMIN REVUELTAS.

Nº 1

EL RESTORAN REVUELTAS

DEPOSITO GENERAL: - LIBRERIA DE CESAR CICERON. AV. MADERO 56 - MEXICO. D. F.

In his *Panorama de la radio* (1930), Coeuroy divides radio-inspired literature into two categories: "radiophonic" and "radiogenic." This distinction echoes my discussion of mechanographic and mechanogenic works in the last chapter, but with some important differences. Radiophonic works – like the mechanographic poems about the typewriter – treat radio as a subject, but their structure and language remain untouched by the medium. Radiogenic works, in contrast, are written for broadcast, and their style, structure, and even length are shaped by the possibilities and limitations of the radio. Coeuroy advises authors writing for radio to reflect on the characteristics of the medium – its complete reliance on acoustic detail, the blindness into which it forces the listener – and to avoid composing texts for broadcast as if they were writing for the stage or for publication.[41]

Maples Arce's "TSH" is a perfect example of a radiophonic poem. Even though it was designed to be read on the air, it could just as well have been written for publication. Nothing in the poem takes advantage of radio's features, and it even seems too long and complicated for a piece designed to be broadcast live. Many elements in the poem, including blank spaces and column alignments, could not have been perceived by radio audiences. Reading a printed version of "TSH" we get the sense that Maples Arce's listeners might have drifted away, their attention span taxed by a piece that was too hard to follow. The poet's radio broadcast was probably an illustration of what Coeuroy warns would happen when a piece written for print is read on the air: "a radiogenic address should in no case be written down and then read in front of the microphone" lest listeners fall asleep.[42]

In contrast, radiogenic texts keep the audience engaged because they are written specifically for a wireless listener and are entirely shaped by the possibilities of the medium. Like mechanogenic texts, they bear the imprint of the new technology that produced them. One of the best examples of this form of writing is "The Death of Paper," a radio play broadcast in 1937 by Radio Paris, the station perched atop the Eiffel Tower. Like "The War of the Worlds," another radiogenic experiment, this play begins with what sounds like a legitimate radio program, featuring music, advertisements, and news – a strategy that we might call *trompe l'oreille*. At one point, an apocryphal newscaster interrupts the broadcast to announce that a "destructive electrical current" is wreaking havoc around the world by obliterating everything made of paper: books, money, train tickets, grocery bags, even cigarette wrappers – an image that was surely El Buen Tono's worst nightmare of modernity gone awry.[43]

Radio

"The Death of Paper" is a perfect radiogenic text not only because the compelling plotline keeps listeners glued to their seats, but because this work could only exist as a radio play. As Denis Hollier points out, the apocryphal report about the death of paper is entirely believable when announced by radio, but implausible in print: "In a book, [the play's] message would be refuted by the material support. To announce the death of paper in a book would be mere fiction, whereas . . . [t]he existence of broadcast news is not affected by the death of paper. If the written press were to disappear, radio would take great pleasure in announcing its demise, and could do so, for example, during a newscast such as the one *La mort du papier* was apparently pretending to be."[44]

Though Maples Arce's "TSH" represents a missed encounter with radiogeny, other writers in Mexico would go on to write truly radiogenic texts. The first such experiment in Mexico took place in August 1924, a year after Maples Arce's broadcast, when El Buen Tono's radio station invited Salvador Novo, one of the members of the Contemporáneos group, to go on the air and talk about his work. Whereas Maples Arce used his time on the air to read a fairly traditional ode to radio, Novo seized the occasion to reflect on the characteristics of the new medium and to analyze the radical effects that it would have on culture and society. He delivered a "Radio Lecture on Radio," a talk that ex-amined the poet's own experience speaking on the air, in a typical avant-garde gesture of *mise en abîme.*

Novo's "Radio Lecture"– a transcript was published after the broadcast in *Antena* and *El Universal Ilustrado*– opened with an apostrophe to his listeners that captures the excitement and wonder felt by a young poet who had been given access to one of the most spectacular technologies of the modern era. "Ladies and Gentlemen who can hear me," Novo began, "I don't know how to describe the emotion that fills my throat when I consider that my voice, weak as it is, can be heard, through the magic of science, in the most remote corners. . . . We can [now] listen to the voice of our fellow men, not merely from the Rio Grande to the Suchiate River, but from one pole to the other, throughout the entire earth."[45] Novo thus opens his lecture with a radiogenic gesture, acknowledging that he is speaking to a wireless audience spread throughout the world. Like Apollinaire, Novo marvels at radio's power to take messages around the globe, connecting people and places no matter how isolated by geography they might be. If Apollinaire could hardly believe the radiotelegraph's ability to bring him news from his brother Albert in Mexico, Novo is amazed that his voice can be heard not only within Mexico's borders ("from the Rio Grande to the Suchiate River"), but "from one pole to the other." Even before Amundsen reached

the Arctic, radio enthusiasts were already celebrating the fact that Mexican radio could be heard at the North Pole!

Novo continues his address with a comment about one of the most salient features of radio: the wild heterogeneity that characterized most radio programming. In another radiogenic moment, the poet imagines the acoustic context in which his listeners might hear his words: "You have just listened to the All Nuts Jazz Band sextet and now you hear my words. In ten minutes you will be listening to Arditi's *Il baccio,* Nervo's "Guadalupe la Chinaca," or Massenet's *Manon* – all while you sit in your favorite position, wearing pajamas and slippers – something one could not do at the opera – smoking your second pipe or napping."[46] Novo's words, though tongue-in-cheek, give us a rather accurate description of the medley of styles that characterized radio programming in the 1920s. He describes a broadcast that opens with jazz music, continues with an Italian waltz, cuts to a recitation of "Guadalupe la Chinaca" (a poem by Amado Nervo, one of the corniest authors Mexico ever produced), and concludes with Jules Massenet's opera about a femme fatale. As we will see in the final section of this chapter, this wild heterogeneity became one of the most intensely debated aspects of the medium.

Operating a radio was an uncanny affair, and Novo peppers his radio lecture with lively descriptions of the bizarre rituals required by radiophony, like wearing earphones: "Earphones give whoever wears them the appearance of a policeman or a surgeon, or at least that of an obedient telephone operator who never manages to connect." Or turning the receiver's knob to tune in: "The act of searching for the wave is a superior gesture, like that of a sailor holding a compass between his thumb and his index finger."[47]

But perhaps Novo's most original observations concern the possible uses of radio technology. In a passage as fanciful as Khlebnikov's "Radio of the Future," the Mexican poet suggests several imaginative uses for radio in the home: "We no longer will waste time teaching parrots how to talk: special earphones will be built for that purpose. And the same goes for children, who already have them. In the education of our children, radio plays a more important role than the baby bottle or the wet nurse, and it is in any case more hygienic to handle. It governs, shapes, and sweetens the flight of infant ears, and inspires men, from an early age, to ignore what is said to them."[48] Using radio to train parrots and educate children might sound like a wacky idea, but it is no wackier than drinking radio sodas, smoking radio cigarettes, or assembling receivers from tobacco boxes. This was, after all, an era marked by the madness of radio, and some of Novo's ideas were actually common practice: an article published in *El Universal*

Ilustrado (appropriately called "The Madness of Radio") describes how certain hospitals experimented with radio's therapeutic properties by wiring newborn babies to radio receivers (figure 56).[49] Perhaps one of the reasons the little boy in figure 38 had such a lost gaze was that he had been wearing headphones since the day he was born!

Novo's radio lecture reads like an extremely concise manifesto on the wonders of the wireless. It highlights radio's ability to collapse distance, the heterogeneity of its programming, and its ability to inspire futuristic scenarios and fantastic applications. And while these observations could have

56. Wired newborns. From "La locura del radio," *El Universal Ilustrado* 263 (18 May 1922): 32.

been published in a text, the fact that they were aired through the same medium they were describing gives them a distinctly radiogenic character. Novo's listeners must have felt a rush of excitement upon realizing that they, too, played an important role – as receivers – in the wondrous medium described in the radio lecture.

In his discussion of radiogenic texts, Coeuroy advises authors who speak on the radio to improvise in order to keep the listener's attention. "Talking on the air," he writes, "should be a form of improvisation in which the personality of the speaker is grasped, in full action, by the invisible listener."[50] Reading the transcript of Novo's radio lecture, one can easily imagine his listeners completely enthralled by his words, charmed by the poet's wit and quirky personality. "Radio Lecture on Radio" was an ideal radiogenic experiment.

Interference

Coeuroy's theory of radiogenic writing is extremely useful for thinking about works written for broadcast, like Novo's radio lecture or Maples Arce's "TSH," but it does not do justice to the complexity of a text like Apollinaire's "Lettre-Océan," which, though it was not written for the air, is thoroughly shaped by broadcasting. To accommodate such texts, it might be useful to expand Coeuroy's definition of "radiogenic" to include works

that, although not written for broadcast, neverthe-less bear the imprint of the wireless medium in the same way that mechanogenic texts like An-drade's "Máquina de escrever" are marked by me-chanical writing. Using this expanded definition, Apollinaire's "Lettre-Océan" would be an arche-typal radiogenic poem. The fragmentation and dis-persion of its language, its telegraphic style, even its appearance on the page are indices of wireless broadcasting. Many of the phrases in the poem came to Apollinaire through his brother's cable-

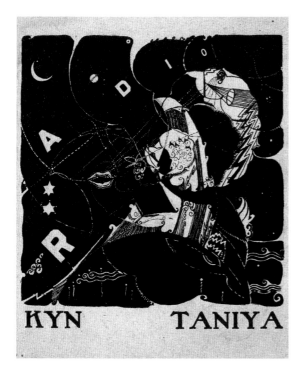

gram, and thus "Lettre-Océan" is literally medi-ated by radio transmissions.

But were there any radiogenic texts written in Mexico? So far we have discussed only one Mexi-can poem about radio: Maples Arce's "TSH," which, as we saw in the last section, was not radiogenic but simply radiophonic, and a good example of what Vallejo criticized as an uninteresting way to write about radio. But radio-inspired literature in 1920s Mexico was so abundant and diverse that finding a radiogenic text should not be too difficult.

Take, for example, the work of Luis Quin-tanilla, another Estridentista poet who signed his works using the orientalizing pseudonym Kyn Taniya. In 1924, the same year that Novo broadcast his radio lecture, Kyn Taniya published a collec-tion of poems called *Radio: Poema inalámbrico en trece mensajes* [Radio: Wireless Poem in Thirteen Messages]. The book's cover featured an illustra-tion by Roberto Montenegro (figure 57) depicting many of the themes discussed in this chapter. As Bolaños Cacho had done for "TSH," Montenegro depicts the universe of radio transmission as a vast nocturnal sky crisscrossed by stylized waves and letters (which spell out the word "RADIO," the title of the book). Floating on the ether are disembod-ied organs – a mouth and an ear – that represent the amputated character of radio voices. This dark soundscape is mysterious, eerie, and full of bizarre doodles – a visual representation of interference,

57. Cover of *Radio* (1924) by Kyn Taniya [Luis Quintanilla]. Photo courtesy Biblioteca Nacional, Mexico City.

those amorphous sounds that break the continuity of radio transmission.

Once we have made our way past the book cover, the collection's most original poem is "IU II-IUUU IU" (the title is an onomatopoeic representation of the high-pitched sounds heard while tuning a radio). Like Apollinaire's calligram, Kyn Taniya's text at first appears like a jumble of random texts:

. . . IU IIIUUU IU . . .

ÚLTIMOS SUSPIROS DE MARRANOS DEGOLLADOS EN CHICAGO ILLINOIS ESTRUENDO DE LAS CAÍDAS DEL NIÁGARA EN LA FRONTERA DE CANADÁ KREISLER REISLER D'ANNUNZIO FRANCE ETCÉTERA Y LOS JAZZ BANDS DE VIRGINIA Y TENESÍ LA ERUPCIÓN DEL POPOCATÉPETL SOBRE EL VALLE DE AMECAMECA ASÍ COMO LA ENTRADA DE LOS ACORAZADOS INGLESES A LOS DARDANELOS EL GEMIDO NOCTURNO DE LA ESFINGE EGIPCIA LLOYD GEORGE WILSON Y LENIN LOS BRAMIDOS DEL PLESIOSAURIO DIPLODOCUS QUE SE BAÑA TODAS LAS TARDES EN LOS PANTANOS PESTILENTES DE PATAGONIA LAS IMPRECACIONES DE GANDHI EN EL BAGDAD LA CACOFONÍA DE LOS CAMPOS DE BATALLA O DE LAS ASOLEADAS ARENAS DE SEVILLA QUE SE HARTAN DE TRIPAS Y DE SANGRE DE LAS BESTIAS Y DEL HOMBRE BABE RUTH JACK DEMPSEY Y LOS ALARIDOS DOLOROSOS DE LOS VALIENTES JUGADORES DE FÚTBOL QUE SE MATAN A PUNTAPIÉS POR UNA PELOTA

Todo esto no cuesta ya más que un dólar
Por cien centavos tendréis orejas eléctricas
y podréis pescar los sonidos que se mecen

en la hamaca kilométrica de las ondas

. . . IU IIIUUU IU . . .[51]

[. . . IU IIIIUUUU IU . . .

DYING SQUEALS OF HOGS SLAUGHTERED IN CHICAGO ILLINOIS ROAR OF NIAGARA FALLS ON THE CANADIAN BORDER KREISLER REISLER D'ANNUNZIO FRANCE ETCETERA JAZZ BANDS FROM VIRGINIA AND TENNESSEE ERUPTION OF POPOCATÉPETL OVER VALLEY OF AMECAMECA AND BRITISH BATTLESHIPS ENTERING THE DARDANELLES NOCTURNAL MOAN OF THE EGYPTIAN SPHYNX LLOYD GEORGE WILSON AND LENIN BELLOWS OF THE PLESIOSAUR DIPLODOCUS AS IT BATHES EACH AFTERNOON IN THE PESTILENT SWAMPS OF PATAGONIA GANDHI'S IMPRECATIONS IN BAGHDAD CACOPHONY OF BATTLEFIELDS AND OF SEVILLE'S SUN DRENCHED BULLRINGS GORGING ON THE GUTS AND BLOOD OF MAN AND BEAST BABE RUTH JACK DEMPSEY AND AGONIZED CRIES OF VALIANT SOCCER PLAYERS WHO KICK EACH OTHER TO DEATH FOR THE SAKE OF A BALL

All that is now just a dollar.
One hundred cents will buy you a pair of electric ears
And you can go fishing for sounds that rock
on the radio waves' kilometric hammock.

. . . IU IIIIUUUU . . .][52]

To paraphrase Octavio Paz, this sounds like a poem written "for the disorientation of all." There is, however, much logic to this textual madness:

the poem is a transcription of the sounds a hypo-
thetical listener would hear by tuning a radio re-
ceiver and pausing for a few seconds at every
available station. Like Maples Arce's "TSH," it at-
tempts to recreate the marvel of listening to the
radio in the early years of broadcasting, but it uses
a very different set of literary techniques. The
result is a medley that highlights the most salient
features of radio as an acoustic medium.

Like the reports about Amundsen's journey
published in the Mexican press, Kyn Taniya's
poem takes the reader through a dizzying journey
around the world. The poem opens with a news
announcement about slaughtered pigs in Chicago,
moves to Niagara Falls "on the Canadian border,"
continues with a two-word reference to Austria
and one of its most famous violinists, Fritz Kreisler
(whose name reverberates in the radio soundscape
as "Kreisler Reisler"), before heading to Italy and
France; it hops back to the American states of Vir-
ginia and Tennessee, jets to Mexico (identified by
its most famous volcano, the Popocatépetl), criss-
crosses the world three times – from the Darda-
nelles to Egypt, from Russia to Patagonia, from
Baghdad to Seville – before concluding with a re-
turn to the land of Babe Ruth and Jack Dempsey,
where my gentle reader is most likely reading
these pages.

Kyn Taniya's shuttling across countries and
continents evokes one of the most admired capa-
bilities of radio: its ability to send messages and
programs across national boundaries. When Novo
marveled at the fact that his voice was heard "from
one pole to the other" as he spoke on the radio, he
was elaborating on one of the medium's most se-
ductive features. Early theorists of radio enthused
at the fact that even simple people who would
never have the opportunity to travel or come into
contact with another culture could now tune into
foreign-language programs, listen to American
jazz music, and experience an instant connection
to other countries. As Rudolf Arnheim argued in
Radio (1936), the medium transformed every lis-
tener into an acoustically cosmopolitan subject.[53]

Besides shuttling across geographic regions,
"IU IIIUUU IU" also shuffles among different genres
of radio broadcasts. Kyn Taniya offers a smor-
gasbord of sound programming. His poem includes
news reports (English battleships entering the
Dardanelles), musical programs (jazz bands
in Virginia and Tennessee), sports broadcasts
(baseball star Babe Ruth and boxing champion
Jack Dempsey), as well as bizarre bits of trivia (*Di-
plodocus plesiosaurus* bathing every afternoon in
the Patagonian swamps). These random juxtaposi-
tions replicate the traditional structure of early
radio shows, which combined music, news, and

other announcements without much attention to creating a coherent program.

Amid all the sounds included in Kyn Taniya's poem, perhaps the most specifically radiophonic one is that of interference – the simultaneous and involuntary reception of more than one channel that gives rise to "noise." Interference had been part of radio communications ever since the days of wireless telegraphy, as we saw in Apollinaire's depiction of a circle of monosyllabic *cré cré cré crés* and *hou hou hou*s emanating from the Eiffel tower in "Lettre-Océan." In "ıu ıııuuu ıu," interference appears in the both the onomatopoeic title and in the acoustic jumble recorded in the poem. In contrast to the noise-free, well-tuned reception of one channel, the poem evokes a soundscape in which bits of programming from all channels make themselves heard simultaneously.

Interference was specific to the radio, and in its early years the entire project of radio broadcasting was seen – especially by conservative critics – as a form of interference. Its antagonists derided radio as a disorderly medium that shoved classical music into the same wavelength as news reports and vulgar advertisements. Even poets like Novo, who wrote enthusiastically about radio, evoked images of colliding radio waves, where an Italian waltz might clash with a jazz band to produce a completely anarchic soundscape.

Enemies of radio, like the conservative French critic Georges Duhamel – one of the technophobes lambasted by Walter Benjamin in his "Work of Art in the Age of Its Technological Reproducibility" – went even further, denouncing the heterogeneity of broadcasting as a threat to true learning. In his *Defense of Letters* (1937), Duhamel wrote: "The real radio lovers, those simple people who really need education, are beginning to prefer noise to books ... they absorb everything pell-mell: Wagner, jazz, politics, advertising, the time signal, music hall, and the howling of secondary waves.... We are in utter confusion ... today the man in the street is fed, morally as well as physically, on a mass of debris which has no resemblance to a nourishing diet. There is no method in this madness, which is the very negation of culture."[54] For Duhamel, all radio was a form of interference that disturbed the French intellectual's Cartesian mind with its irruption of unexpected and unwanted sounds. Duhamel's diatribe against radio condemns the same jumble that Kyn Taniya playfully recreates in his poem: a "mass of debris" consisting of bits of jazz, politics, advertising, music hall, and even "the howling of secondary waves." Unlike Duhamel, however, Kyn Taniya found this howling of interference interesting enough to turn it into the title of his poem, "ıu ıı-ıuuu ıu."

Kyn Taniya's radio medley in "ıu ıııuuu ıu" is much closer to the playful texts of radio enthusiasts like Apollinaire and Novo than to the alarming accusations of Duhamel. The poet enjoys his irreverent lumping together of the Italian poet D'Annunzio and Patagonian swamps, of Gandhi and soccer, of Mexican volcanoes and prehistoric dinosaurs. The poem concludes with an image that reveals the author's bemused embrace of the broadcasting jumble: listening to radio is like fishing the air waves: "And you can go fishing for sounds that rock / on the radio waves' kilometric hammock. / . . . ıu ıııuuuu . . ." Angling for sounds is fun and unpredictable: the day's catch might consist of anything from reports about bullfighting in Seville to "the howling of secondary waves." In the aural world of "ıu ıııuuu ıu," interference is a catch as legitimate as a music program or news reports. Interference makes possible a polyphony that is wilder and more exciting than the intellectual monophony preached by Duhamel: radio is polyphonically perverse, and its acoustic promiscuity excited adventurous thinkers while scandalizing aurally repressed listeners like Georges Duhamel.

Vallejo would certainly have approved of Kyn Taniya's literary treatment of radio. Not only does the poem evoke the most salient features of the medium – its cosmopolitanism, its susceptibility to interference, the heterogeneity of its program-

ming – but its very language is shaped by the requirements of radio transmission. Like "Lettre-Océan," Kyn Taniya's poem is made up of fragments of phrases. There is no punctuation, and the entire composition reads like a run-on (or runaway) sentence. The result is a perfect example of the "telegraphic style" that Marinetti urged poets to adopt in writing about the modern world: a truncated form of writing that does away with syntax in favor of speed.

If Apollinaire represented the heterogeneous, anarchic quality of radio broadcast by transforming the page into a jumbled calligram showing text running in all directions, Kyn Taniya does something similar by shaping his poem into a solid block of text that blends everything together. Faced with this textual monolith, the reader is hard pressed to figure out where one broadcast ends and the next begins. As in Vallejo's ideal poem, "ıu ıııuuu ıu" makes the reader experience the speed and disorientation that radio introduced into the world.

Radio Antennas

"Lettre-Océan" was born out of Apollinaire's fascination with the fact that a message from Mexico could cross the ocean, travel thousands of kilometers, and materialize in France in the form of a radiotelegram. In "ıu ıııuuu ıu" the object of

Radio

165

fascination is the same phenomenon, but the transmission moves in the opposite direction, with broadcasts coming from Europe to Mexico.

Kyn Taniya's poem demonstrates that broadcasting was the perfect antidote to Mexico's legendary isolation from the rest of the world. Radio transforms every listening station into the center of the universe, into the destination of news and messages from all five continents. In "IU IIIUUU IU" El Buen Tono's fantasy has come true: radio waves go around the earth, they even reach the North Pole, but more importantly, they bring the whole world to Mexico. And every listener is transformed into a thoroughly cosmopolitan subject, tuning into international broadcasts in all languages.

Whereas El Buen Tono aspired to turn every smoker into a radio listener, Kyn Taniya's poem transforms every reader into a thoroughly modern subject by using an ingenious calligramic strategy that Apollinaire would have applauded. The poet inscribed the frontispiece of his book (reproduced in figure 58) with an unusual figure that at first appears to be a Chinese ideogram – an extension of the orientalist tendencies at play in the pseudonym Kyn Taniya. The figure, however, is simply an amalgam of the poet's initials: the letter K is placed horizontally atop a vertical T, a combination that, in keeping with the title of the book, produces a svelte and elegant radio antenna. The poet was so fascinated by radio that he transformed himself – or at least the letters representing him on paper – into a radio apparatus. Or, to be more precise, into part of a radio apparatus, for as participants in El Buen Tono's promotions knew, an antenna needs to be attached to other devices, including a receiver and a pair of speakers, in order to receive broadcasts.

This onomastic antenna connects to *Radio*, Kyn Taniya's book, a textual apparatus designed to let the reader tune in. But there is one crucial part missing from this setup: a loudspeaker. A radio hooked up to an antenna might be able to tune into programs, but without a speaker – or at least a pair of earphones – these remain inaudible and inaccessible to human ears. But where is the loudspeaker in Kyn Taniya's *Radio*? The answer is simple and completes the poet's literary-technological game: the missing piece of equipment can be found in the reader.

If the poet functions as an antenna, catching broadcasts from the airwaves, and his poem is a broadcasting device, then the reader is the loudspeaker: it is only when someone reads "IU IIIUUU IU" out loud that the broadcast is complete and the sounds become audible. Kyn Taniya has thus constructed an elaborate textual machine: Hertzian waves travel from the poet-antenna to the radio-text

and are finally spoken by the reader-loudspeaker. Should the reader choose to be discreet and read silently to himself, he becomes a pair of earphones, a device allowing only one person to hear the radio sounds while preserving the silence around him. Loudspeaker or earphones? In any case, the poet and his readers have become thoroughly modern radio subjects, so modern that they are part machine—androids attuned to the "madness of radio" unleashed by Mexican modernity.

Earphones

If we now return to the photograph of the little boy listening to the radio, our point of departure for this chapter, we realize that there is one crucial question we did not ask of this image: What was this young radio enthusiast listening to on his headphones? The texts discussed in this chapter give us a clue: he was probably listening to jazz bands, radio lectures, sports broadcasts, foreign languages, opera, and the howling of secondary waves. All at once. And judging from the look on his face, it is not unlikely that this radio medley sounded something like IU IIIUUU IU!

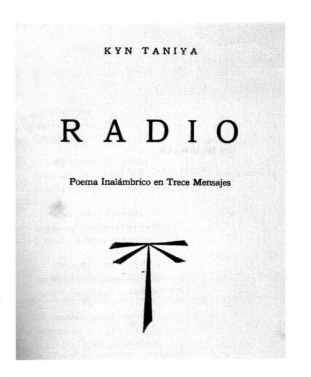

KYN TANIYA

RADIO

Poema Inalámbrico en Trece Mensajes

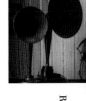

Radio

58. Kyn Taniya [Luis Quintanilla], frontispiece of *Radio* (1924). The letters *K* and *T* form an antenna. Photo courtesy Biblioteca Nacional, Mexico City.

CEMENT

"Se acerca el principio de la edad del concreto."

[A new age of concrete is approaching.]

Federico Sánchez Fogarty, "El polvo mágico" (1928)

"Los latinoamericanos de mi generación conocieron un raro destino que bastaría por sí solo para diferenciarlos de los hombres de Europa: nacieron, crecieron, maduraron en función del concreto armado."

[Latin Americans of my generation had an unusual destiny that would suffice, in and of itself, to distinguish them from Europeans: they were born, brought up, and they came of age in relation to reinforced concrete.]

Alejo Carpentier, "Conciencia e identidad de América" (1975)

If cameras, typewriters, and radio broadcasting introduced mechanical mediation into visual, textual, and aural representation, cement – or to be more precise, the new construction techniques using reinforced concrete – mechanized the language of architecture. Beatriz Colomina has argued that modern architecture was a mass medium that shared more than a temporal coincidence with other twentieth-century media, and as we will see in this chapter, cement was a medium of representation with a history that closely paralleled that of the three artifacts studied earlier.[1] Cement was another new technology – in this case a construction technology – that gained popularity in the postrevolutionary period. Like cameras and typewriters, reinforced concrete replaced the handcrafted methods favored in nineteenth-century architecture with industrially produced materials, sparking intense debates among Mexican architects and critics about the "artistic merit" of this new invention. Like radio, cement inspired architects to find new building techniques to exploit and make evident their use of this new product and their dependence on mechanical processes – the architectural equivalent of what Coeuroy called "radiogenic" writing.

The new cement architecture that flourished in this period is a literal demonstration of Kittler's assertion that "media determine our situation."

The situation of Mexico City's inhabitants – their living and work environments, as well as their ability to move around in space – was now dictated by the new buildings, roadways, and other public projects that radically transformed the cityscape. Cement constructions introduced a completely different spatial logic, and citizens had to learn to exist in the new spaces of modernity.

Unlike cameras, typewriters, and radio, which initially were confined to a small minority of intellectuals and technological aficionados, cement was the most visible of the new media. The construction boom of the 1920s filled Mexico City with brand-new buildings – ministries, schools, housing projects – that were also used to disseminate the new ideology, at once nationalist, revolutionary, and modern, of the postrevolutionary government. Just as Modotti had used her camera as a medium to communicate her revolutionary messages, the Obregón and Calles administrations used cement as a medium to disseminate their political ideas. In this chapter I will "read" cement architecture, following the same strategies we have used for interpreting photographic, typewritten, and radiophonic texts.

In the annals of the cultural responses to technology, cement stands out as an atypical case. Unlike cameras, typewriters, and radios, cement had a

more complicated passage through representation. Lacking the gleaming appearance of modern machines and the aura of futurism that enveloped other technological artifacts, cement was initially ignored by the Mexican intelligentsia. No poets composed odes to the new building material; no artists portrayed it as a symbol of future utopias; no essayists explored its cultural symbolism. Cement was deemed banal and uninteresting, and for many years it was excluded from aesthetic and cultural debates. Mexican cement makers were deeply concerned by the lack of cultural interest in their product, and they worked hard to ensure that cement eventually received its share of aesthetic attention. Perhaps, like other industrialists, they had come to expect that all new technologies would immediately inspire a literary revolution, as radio did for the Estridentistas. Perhaps they suspected that artistic representations of cement would translate into increased sales. Or perhaps they simply craved attention for their lowly material. Whatever their motivation, cement makers decided to end the cultural neglect of their product, and in 1925 they joined forces to form the Committee to Propagate the Use of Portland Cement, an organization devoted to propagating, among other things, the cultural use of cement. Cement thus became the only technological artifact in 1920s Mexico to have an entire committee

devoted to its aesthetization. And as I argue in this chapter, the aesthetization of cement was a slow, tortuous, and deeply paradoxical process.

Cement proper was not a new invention. The word "cement" refers simply to a binding material made of ground stones, and its use can be traced back to ancient Rome. In the nineteenth and early twentieth centuries, technological developments gave rise to an innovation that would revolutionize architecture: reinforced concrete, also called ferroconcrete. This new building technique, which combined the flexibility and versatility of cement with the strength of metal, consisted of pouring cement over a steel frame. The steel gave reinforced concrete increased strength and stability, including the capacity to withstand earthquakes.

In Mexico, the use of cement, and especially reinforced concrete, flourished in the 1920s. After nearly a decade of civil war, cement quickly emerged as the government's preferred building material for its projects, including schools, office buildings, factories, markets, stadiums, and even highways. The motivation was not only practical – concrete buildings could be erected rapidly and inexpensively – but ideological. Architects sought a building material to represent the new reality of postrevolutionary Mexico, one that enacted a clear break with the past and particularly with the architecture of the Porfiriato, which had been

dominated by turn-of-the-century steel-and-glass buildings like the Palacio de Bellas Artes and the Palacio de Correos. Besides looking different from Porfirian marble, cement had also been hailed as the most modern of building materials by architects from Le Corbusier to Walter Gropius, and by functionalists, constructivists, and other avant-garde groups. Inexpensive and modern, efficient and forward-looking, cement emerged as the perfect substance for building the new Mexico envisioned by the postrevolutionary government.

But despite the ever-increasing success of cement architecture, the Mexican intelligentsia was uninterested in the material, refusing to represent it or explore its cultural symbolism. In stepped the Committee to Propagate the Use of Portland Cement, which launched its proselytizing campaign with missionary zeal, publishing utopian advertisements like the one reproduced in figure 59. Central to the campaign to promote the aesthetic virtues of cement was Federico Sánchez Fogarty, an energetic young publicist who was one of the founding members of the committee (figure 60). Throughout the 1920s and 1930s, Sánchez Fogarty launched countless events designed to expand the public's awareness of cement as a cultural symbol. He organized competitions for the best uses of cement; he invited artists to paint and photograph cement structures; he composed dozens of slogans exalting the modernity of the material (for example, "El cemento es para siempre"; "El concreto es la letra, el verbo de la arquitectura contemporánea"). But his most important move was the creation of two journals devoted to exploring the cultural dimensions of cement: *Cemento*, which published thirty-eight issues between 1925 and 1930, and *Tolteca*, published between 1929 and 1932. In the pages of these journals, Sánchez Fogarty included photographs of the latest concrete buildings in Mexico, articles on the history and importance of cement, and even drawings by young artists, commissioned especially for the journal's cover. But the central mission of these two publications was to counteract Mexican intellectuals' indifference toward cement by creating and promoting an aesthetics of cement.

Federico Sánchez Fogarty first alluded to Mexican writers' lack of interest in cement in "El polvo mágico" (The Magic Powder), an essay published in the January 1928 issue of *Cemento* that opens with the following paragraph:

Hay un polvo gris que, si resucitara algún autor de 'Las Mil y Una Noches', se haría el tema de un cuento maravilloso. Este polvo es tan impalpable como el talco que usamos para la cara después de rasurarnos. Se mezcla con partículas de piedra y agua, y a la resultante masa, tan plástica como el barro con que modelan los escultores,

SUBSTANCIA
FORMA
COLOR

La Substancia es Concreto

La Forma se vacía en Concreto

El Color está en el Concreto

El Concreto es el Material Arquitectónico Completo

FEDERICO SANCHEZ FOGARTY

59. Advertisement for cement. *Cemento* 18 (October 1926).

60. Federico Sánchez Fogarty, from *The Architectural Record* (April 1937): 12.

puede dársele la forma de un bloque o de una cornisa o de lo que usted necesite o quiera imaginarse. A las tres horas aquello que era un polvo se ha transformado, como por obra de magia, en una roca.... Este polvo gris, este polvo mágico se llama Cemento Portland, y esa roca artificial, concreto.[2]

[If one of the authors of *The Arabian Nights* came back to life, he would surely write a fantastic story about this gray powder, as delicate as the talcum we apply on our cheeks after shaving. It can be combined with gravel and water to produce a substance that is as malleable as the clay used by sculptors, and it can take the shape of a block or a cornice or anything else you might need or imagine. Three hours later what was once powder has been transformed, as if by magic, into a rock.... This gray powder, this magic powder is called Portland cement, and that artificial rock, concrete.]

The essay's fanciful opening can be read as a lesson to Mexican writers and an indictment of their lack of interest in cement. Sánchez Fogarty conjures an imaginary author – a resurrected storyteller from the *Arabian Nights* – who will accomplish what the Mexican writers have failed to do: create a literature about cement. In truly didactic fashion, the rest of the essay explains exactly why cement would be the perfect subject for a work of fiction: it possesses "marvelous" attributes, like the capacity to metamorphose from powder ("as delicate as talcum") to clay and then to rock. Cement is a "magic powder" not only because of its malleability – it passes from solid to liquid and back to solid – but also because of its ability, like a character in a fairy tale, to assume any shape – a "block," a "cornice," or "anything else you would like to imagine."

Since cement was a powder whose properties verged on magical realism, and since writers were meant to write about what is magical, as the authors of the *Arabian Nights* did, it seemed unfathomable to Sánchez Fogarty that no poets or novelists had turned their attention to this wondrous building material. As the editor of *Cemento*, he would devote a great deal of energy to urging writers and artists to produce work about cement that explored its marvelous characteristics.

Ironically, when Sánchez Fogarty wrote "El polvo mágico" in 1928, a writer had recently devoted an entire novel to cement. Three years earlier, in 1925, the Soviet novelist Fyodor Gladkov had published *Cement*, a socialist-realist narrative recounting the fate of a cement factory in the newly created Soviet Union. A few months after the publication of "El polvo mágico" in 1928, Gladkov's novel was translated into Spanish by José Viana and published in Madrid and Santiago de Chile.[3] The novel had been an instant hit in Spain, where it became the fourth best-selling book at

Madrid's book fair of 1929 (after Isadora Duncan's biography and two war novels),[4] and it was extremely well received by the small minority of Communist sympathizers in Mexico; Baltasar Dromundo, a member of the Mexican Communist Party, gave it an enthusiastic review in *El Universal Ilustrado,* and Frances Toor, the editor of *Mexican Folkways* and a good friend of Tina Modotti, called it "a great novel."[5]

It seems strange that despite the popularity of Gladkov's *Cement* in the Spanish-speaking world, Sánchez Fogarty never mentioned it in the pages of his journal *Cemento.* Since the journal was published through November 1930, one wonders why the editor missed the opportunity to comment on the one real writer who had devoted an entire novel to cement.

Upon closer inspection, however, we see that Gladkov's novel had very little to do with Sánchez Fogarty's vision of cement. *Cement,* the Soviet novel, is the story of Gleb Chumalov, a worker who returns home after fighting in the Bolshevik Revolution and discovers his town's only industry, the cement factory, abandoned and in disrepair. "Damn these people!" exclaims Chumalov, "What a wonderful factory they have ruined, the wretches."[6] The factory, once a roaring monument to production and efficiency, is now "nothing more than a rubbish heap, and the workmen good-for-nothing loafers, or petty hagglers." To Gleb's dismay, entire sections of the factory are now used to keep animals: "there's goats in the factory ... and rats ... nothing but gnawing animals"; "the factory isn't a factory anymore but a cattle barn."[7]

Enraged by the apathy and indolence that have ruined his old workplace, Gleb vows to resurrect the factory. He spends the entire novel organizing the workers, fighting the bureaucracy, and obtaining government funds. In a section titled "Robos de manteca y judías en el restaurante comunal" [Filching of lard and beans in the communal kitchen], Gleb addresses a climactic, rousing speech to his fellow workers: "Comrades ... cement is a mighty binding material. With cement we're going to have a great building-up of the Republic. We are cement, comrades: the working class."[8]

Gleb invokes a bizarre metaphor in an attempt to motivate the workers to resurrect the factory: since cement serves to build foundations, they, as workers, are a type of cement. Proletarian cement – the workers – must bond with industrial cement – the factory – to build the new republic. Although Gleb must endure countless trials (including his wife's betrayal, a theme developed in a steamy romantic subplot) he finally succeeds. In the last scene of the novel, a victorious crowd of workers assembles under the roaring diesel

motors and pays tribute to Gleb, their proletarian hero. They celebrate "the re-starting of our factory, of the giant factory of the Republic." Turning toward his comrades, Gleb utters the closing lines of the novel: "We are building up socialism, Comrades, and our proletarian culture. On to victory, Comrades!"[9]

Gladkov's treatment of cement could not be more different from that of the legendary writer imagined by Sánchez Fogarty in "El polvo mágico." Gladkov did not write his novel to praise the "magical" qualities of cement, or to narrate its fantastical transformation from powder to clay to rock, but as a didactic aid for the construction of socialism and "proletarian culture." In fact *Cement* has almost nothing to do with cement as a modern building material. Although the entire novel revolves around a cement factory, the "magical powder" is mentioned only once. Surveying the ruined factory, Gleb Chumalov notices, forgotten in a corner of the warehouse, some old sacks of cement that "lying in damp sheds had long ago petrified into blocks hard as iron."[10]

Sánchez Fogarty would not have been impressed by such treatment of the substance he worked hard to promote. Not only are these petrified sacks of cement devoid of the magical malleability celebrated in "El polvo mágico," but they are ultimately useless, since nothing can ever be built out of them. Gladkov, it seems, did not really like cement. In fact his *Cement* never really set: in response to critics who found the romantic subplot too sappy and melodramatic, Gladkov rewrote his novel twice, first in 1934 and then again in 1941.[11] In contrast to the cement sacks in the warehouse that are ruined by an excess of solidity, the novel's plot suffers from a lack of firmness, since it could be altered at will. Nevertheless Anatoly Lunacharsky, the Soviet commissioner of culture, found *Cement* solid enough to proclaim, "on this cement foundation we can build further."[12]

Gladkov was never really interested in cement architecture. He uses cement merely as a metaphor for the type of society he hoped the newly created Soviet Union would become: solid, strong, indestructible. As critic Katerina Clark writes, "*Cement* is a novel about postwar reconstruction."[13] Like the bags of cement Gleb finds in the warehouse, the new Soviet society had to be rock-solid. When addressing the workers in the Spanish translation of the novel, Gleb emphasizes not cement but *cimiento,* the foundation of an edifice: "El cemento cimienta bien. Nuestro cemento es una buena base a la República. El cemento somos nosotros, camaradas, la clase obrera." [Cement builds good foundations. Our cement is a good base for the republic. Comrades we, the working classes, are cement.][14] The entire novel is about

building rock-solid foundations – social, economic, familial, and otherwise. The word play between "cement" and "foundation," between *cemento* and *cimiento,* prominent in the Russian original, suggests that Gleb himself is not only *cimiento* (the foundation of the new society, the new factory, and Gladkov's novel); he is also *cemento* (he tells the workers "we are cement") and ultimately a *semental* (in the romantic subplot, Gleb is a proletarian "stud" destined to impregnate Soviet women with revolutionary zeal).

Though Sánchez Fogarty might have been horrified at the depiction of cement as a wet, petrified, and unusable building material in Gladkov's novel, he would have applauded the novelist's elaboration of cement as a trope for strength and solidity. The Mexican publicist was also fascinated by the material's symbolic fortitude, and he authored numerous slogans – reproduced in the pages of *Cemento* and *Tolteca* – exalting cement as a trope for strength, stability, and durability: "Concrete is eternal"; "Concrete is forever"; "Concrete houses have the strength of an Iron Palace" (see figure 61).[15] In "El concreto es eterno" (Concrete Is Eternal), another essay published in *Cemento,* Sánchez Fogarty extolled the invincible solidity of concrete structures: "El concreto es eterno: mezclado con materiales adecuados en proporciones convenientes, resiste todas las fuerzas de destruc-

ción. Es más sólido que muchas de las rocas que se aglomeran en las montañas." [Concrete is eternal: when it is mixed with the right materials in the correct proportions, it resists all forces of destruction. It is more solid than many of the boulders found in mountains.][16] Concrete, Sánchez Fogarty would repeat in numerous essays and advertisements, is so solid that it is virtually indestructible.

Sánchez Fogarty liked cement for exactly the opposite reasons that the Estridentistas liked radio: whereas radio promised the dematerialization of events that could be transmitted through invisible airwaves, cement represented the concretization of ideals into solid structures. If the Estridentistas invented a wireless aesthetics, then Sánchez Fogarty, like Gladkov, promoted an igneous aesthetics: a celebration of all that is solid, strong, and durable (like the phallic chimney reproduced in figure 62).

It is not entirely coincidental that the igneous aesthetics favored by both Gladkov and Sánchez Fogarty were grounded in cement. They both lived in countries that had been fragmented and divided by prolonged civil war, and now aspired to unity and solidity. For both of them, cement became the antidote to all the evils of the old regime. As the architectural historian Enrique de Anda Alanís has written, many Mexican architects believed that cement would be a magical cure-all for all the ills

61. Advertisement for the Committee to Propagate the Use of Portland Cement. From *El Universal Ilustrado* 433 (27 August 1925): 9.

62. Advertisement for cement published in *El Universal Ilustrado* 435 (10 September 1925): 87.

of postrevolutionary society.[17] In contrast to the social ills that give rise to revolutions – social divisions, weak infrastructure, political instability – cement represents unity, strength, and stability. For broken countries, cement emerges as the perfect social glue, promising to extend its powers of cohesion and solidity beyond the architectural realm and into the social fabric, to replace the chaos of *conflicto armado* with the order of *concreto armado*.

Though both Gladkov and Sánchez Fogarty gravitated toward the igneous aesthetics of cement, their motivations could not have been more different. Sánchez Fogarty's job was to propagate the use of cement, while Gladkov was on a mission to propagandize the Soviet Revolution. Sánchez Fogarty was motivated by mercantilist concerns – the increased capitalization, cultural and otherwise, of cement – while Gladkov preached the communist ideal of building a fraternal, well-structured society. One was in the business of marketing cement; the other in the business of marketing revolutions.

It thus makes sense that Sánchez Fogarty, the capitalist, never mentioned Gladkov's *Cement*. As a marketer of cement, Sánchez Fogarty would have disapproved of Gladkov's treatment of the building material. The unflattering portrayal of cement in the Soviet novel as wet, petrified sacks in a dilapi-

dated warehouse would certainly turn away potential buyers. In fact, Gladkov's presentation of cement as an ugly, cold, and base material corresponds to the generalized stereotypes about cement that Sánchez Fogarty was working hard to counter. The lay public, it seems, was much slower than architects and engineers in discovering the virtues of the "magic powder." Most people, as Sánchez Fogarty laments in "El polvo mágico," still clung to the misconception that cement was merely "tierra molida" (a bunch of ground-up soil): "Pero no se crea (muchas personas así lo creen . . .), no se crea que el cemento Portland es tierra molida . . . el cemento Portland no es tierra molida. La fabricación de este artículo es compleja y costosa." [But you should not think (as many people seem to do . . .) that Portland cement is a bunch of ground-up soil. The production of this material is costly and complex.][18] To the publicist's dismay, most people did not see cement as a "polvo mágico" but as "tierra molida" – an extremely ugly material to be used only when budgetary constraints so required, and even then preferably disguised by a nobler substance.

A number of articles published in *Cemento* allude to the general prejudice against cement and make a point of countering the perception of cement as an antiaesthetic building material. In "Cenicienta" [Cinderella], an article published in

the July 1929 issue of *Cemento*, the author laments that cement had become the Cinderella of construction materials: a noble substance relegated to the demeaning role of a subaltern: "el papel que representa el concreto armado en los talleres de muchos arquitectos americanos [es] el de cenicienta: un auxiliar muy útil pero despreciado.... El concreto reforzado no solamente no puede exhibirse – sino que se le clasifica con [los materiales] innombrables." [In the workshops of many American engineers, reinforced concrete plays the role of a Cinderella: a very useful but disdained material.... They do not want to let the concrete show, and it is classified along with unspeakable materials.][19] The Cinderella analogy was not too far from reality. Many new buildings in postrevolutionary Mexico were erected with cement, but most architects attempted to disguise their use of the material. Either architects would cover cement with nobler materials, or, in the movement that became known as neocolonial revival, they would fashion cement to look like sandstone. In the mansion of architecture, cement was relegated to the basement, while visitors reveled at marble, sandstone, and the other superficial stepsisters that decorated facades and exteriors. Sánchez Fogarty was faced with the difficult task of aestheticizing cement, of convincing the Mexican public that cement – like Cinderella – was a lovely maiden and not a haggard wench, "polvo mágico" and not "tierra molida."

The debate about the aesthetic merits of cement, however, was more complicated than a simple opposition pitting advocates against detractors of concrete. As in the case of the other media discussed in this book, aesthetic practices would ultimately be transformed and reshaped by the advent of this new product. The introduction of cement would radically transform architecture, much as photography transformed art.

Faced with the sudden increase of concrete buildings in the 1920s, traditional Mexican architects raised their eyebrows at the prospect of edifying with cement. Most architects had trained during the Porfiriato, when the building materials of choice were Italian marble and Parisian iron. In contrast with these "noble" materials, they saw cement as a cheap, generic product incapable of constructing anything memorable or remarkable. Architecture was an art, and as such it called for refined materials. In their view, cement structures could be interesting and well built, but the baseness of their material kept them from rising to the level of architecture. The question they raised – Can cement ever build true architecture? – echoed the doubts raised by traditional painters, who doubted whether the mechanical process of photography could ever rise to the level of true art.

Like photography, cement was considered suspect because of its mechanical origin: it was a material produced by machines, generated by industrial processes that were antithetical to the handcrafted nature of artistic creation.

In a move reminiscent of the tactics used by photographers to defend their work, advocates of cement responded to the traditionalists' misgivings about cement architecture with two conflicting strategies. Some architects sought to prove the artistic merits of cement by demonstrating that concrete buildings could *look* exactly like nineteenth-century sandstone or marble buildings. Like pictorialist photographers who strove to make photographs that were indistinguishable from paintings, these architects erected buildings that mimicked the style of established architecture. To prove that cement could indeed be used to construct true works of art, they made concrete look like traditional materials. In *Cemento* 19 (November 1926), Sánchez Fogarty reproduces the photograph of an elegant house in Mexico City's Colonia Roma, built using deceitful concrete blocks that imitated the look of stone, a trompe l'œil that came to be known as *cantera artificial* [artificial sandstone]; and in *Cemento* 28 he reproduced the pseudocolonial facade of the Banco Nacional de México on Plaza Santo Domingo, a cement structure built in 1928 (figure 63). "Looking at this building for the first time," Sánchez Fogarty writes of the Colonia Roma house, "there was no doubt that the facade was made of stone.... I was astonished when the architect informed me that it was built of artificial stone."[20] Another, more extreme example of this effort to make cement respectable by using it to imitate the past can be found in the Nashville Parthenon (figure 64) – a true-to-life replica, in cement, of the famous Greek original – documented in *Cemento* 25 (August 1928).[21] One unsympathetic critic referred to these architectural experiments as a form of *pastelería* (cake decoration).[22]

But there was also a second group of cement advocates – mostly engineers – who sought to refute the traditionalists' distrust of modern materials by other means. Like the modernist photographers championed by Walter Benjamin, these builders argued that the question about cement's artistic merit was moot, since notions of art and architecture had been entirely transformed by the advent of mechanical processes. Cement, like photography, was mechanically produced, and Sánchez Fogarty stressed that "el cemento es una de las manufacturas más mecanizadas que existen." [Cement is one of the most mechanized products].[23] This second group of cement supporters believed that the question to ask was not "Are cement buildings true architecture?" but "How has cement

63. Cement building imitating the look of nineteenth-century architecture: "Banco Nacional de México, sucursal Santo Domingo." From *Cemento* 28 (March 1929), 12.

64. A cement Parthenon in Nashville. From *Cemento* 25 (August 1928).

transformed architecture?" And, in a move reminiscent of the modernist insistence on making photographs that expose the mechanical aspects of their production, these engineers erected buildings that flaunted their use of cement. The most famous and most successful of these structures was the Jalapa Stadium (figure 65) commissioned by Heriberto Jara during his tenure as governor of Veracruz. The stadium was built in 1925 by Modesto C. Rolland, a young engineer who loved all things modern (he was also a member of the Radio League and one of the organizers of the 1923 Radio Fair) and was profiled in the pages of *Cemento* as an "especialista en concreto" [concrete specialist].

In the Jalapa Stadium, whose unadorned surfaces make no efforts to conceal their concrete structures, cement does not mimic the look of other building materials. The stadium was in fact the first building in Mexico to take full advantage of the new possibilities offered by concrete construction. Rolland realized that reinforced concrete was a new technology that offered considerable advantages over previous building techniques, and he enthusiastically experimented with the new possibilities it afforded. The U-shaped roof, for example, is cantilevered over the entire stadium, supported only by a series of thin columns (figure 66). Technically the roof, the columns that

Estadio de JALAPA—arquitectura de la REVOLUCION FUERTE en lo material y en el afán ESPIRITUAL que lo ERIGIO

Fot. Casillas

65. The Jalapa Stadium. From *Horizonte* 8 (November 1926): 1.

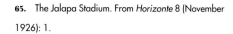

Cement

support its weight, and the steps form a single, seamless structure – an effect that could be achieved only with reinforced concrete. In an article in *Cemento* (signed by OZY, an anagram of the author's name: federicO sáncheZ fogartY), Sánchez Fogarty stressed that the stadium was one piece, like a vast stone carving: "El estadio de Jalapa, es, pues, de una sola pieza continua: cimientos, muros, graderías, columnas y techo: algo así como una colosal piedra de enorme dureza que hubiera sido esculpida por un artífice mitológico." [The Jalapa stadium is one continuous structure: foundations,

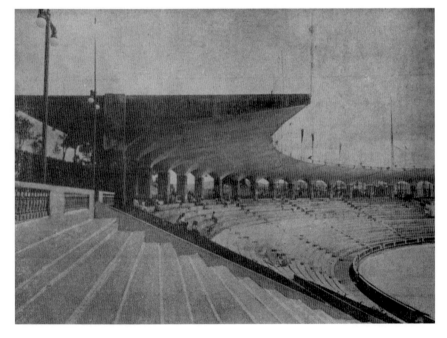

66. The Jalapa Stadium. From *Cemento* 10–11 (November 1925).

walls, steps, columns, and roof form something akin to a colossal stone of great solidity that could have been sculpted by a mythological artificer].[24]

We have thus seen two opposing strategies launched to defend cement against the attack of traditionalists who deemed it too base a material to be worthy of architecture. Though both of these groups championed the use of cement, their aesthetic goals could not be more different. One group sought to prove that cement was artistic by erecting concrete structures that mimicked the look of marble or sandstone, thus subjecting cement to a regressive form of trompe-l'œil. Meanwhile, the second group embraced an "aesthetics of cement" and cherished the fact that cement – including its physical appearance – was unlike any other building material. In the first case, cement was forced to imitate materials that were considered aesthetically pleasing, while in the second case, cement itself was presented as an aesthetically innovative material. Needless to say, Sánchez Fogarty belonged to the second group. He not only wanted to present cement as an attractive material, but he sought to demonstrate that cement possessed an inherent beauty, a progressive aesthetics.

The battle against cement's detractors had to be fought on the cultural front, and not only through the construction of buildings in the style of the Jalapa Stadium. As important as erecting cement

structures that exposed their concrete skeleton was the need to educate the Mexican public to appreciate the aesthetics of cement. But how could one promote the innovative aesthetics of cement? Sánchez Fogarty imagined a possible solution in "El polvo mágico": a writer could compose a work of literature exalting the magic of cement. But as we have seen, no Mexican writers took up the challenge. Not even the Estridentistas – a group of poets obsessed with modern artifacts, from airplanes to automobiles – expressed any interest in cement. *Cemento* even had a difficult time finding paid contributors to write about the product. Sánchez Fogarty had to compensate for this lack of writerly interest by becoming the bard of cement he had called for. *Cemento*'s most celebratory articles, including "El cemento es eterno" and "El polvo mágico," were written by the publicist himself. Given this shortage of local writers, *Cemento* eventually began to publish translations of foreign texts – usually, like "Cinderella," taken from American or European journals – that took up the challenge of aestheticizing cement by narrating its marvelous virtues.

These foreign texts used other strategies to promote cement. For example, "Desafío" – a short text by a certain C. A. Monroe, reprinted from an American or British construction magazine and translated into Spanish by Sánchez Fogarty under a pseudonym (Derisanty: feDERIco SANchez fogarTY) opened with a personification of cement, who apostrophizes the reader and flaunts its virtues:

Yo soy el cemento y desafío a comparaciones. . . . Soy universalmente indispensable. No solamente soy el más grande constructor, sino también el más grande civilizador. Soy el guía, el innovador de las ideas constructivas. Y pues construyo, soy el poderoso aliado de toda la humanidad.[25]

[I am cement and I defy comparisons. . . . I'm indispensable around the world. I'm not only the greatest builder; I'm also the greatest civilizer. I'm the guide, the innovator of constructive ideas. And since I construct, I'm the powerful ally of humankind.]

Though Monroe had the noble intention of establishing a respectable genealogy for cement ("my family tree reaches so far back into the past that Nero sat on me in the Coliseum in Rome," read one of his most memorable phrases), his essay did not quite accomplish Sánchez Fogarty's call to aestheticize cement. Monroe presented cement as a respectable material with an illustrious lineage and even as a "civilizing force," but he failed to address the problem of aesthetics. His essay does not debunk the perception of cement as an ugly powder resembling "tierra molida." Ultimately,

67. Frontispiece designed by Jorge González Camarena. From *Cemento* 25 (August 1928).

"Desafío" focused on the metaphysical properties rather than on the physical attributes of cement.

Sánchez Fogarty eventually gave up on writers and turned to artists in his quest to aestheticize cement. Perhaps visual artists, he reasoned, could produce alluring depictions of "the magic powder" to bolster its image. In 1928, he invited the painter Jorge González Camarena to design the frontispiece and front covers of *Cemento*. For every issue, the artist produced highly stylized compositions featuring cement bags (dry and useful, unlike those of Gladkov's warehouse) and workers and bricklayers erecting a modern metropolis out of the new material. The frontispiece of *Cemento* 25 (figure 67) shows a utopian scene that Gladkov would have applauded: on the left we see workers mixing cement and building walls with it; on the right, a gleaming city of skyscrapers, futuristic structures, and clear skies – a bright new world made of reinforced concrete. Besides presenting cement as a beautiful, desirable material, these images also link it to the stylistic innovations of the Soviet avant-garde.

Art proved more useful than literature for aestheticizing cement, and in 1931 Sánchez Fogarty masterminded an ambitious plan to incite Mexico's most important artists to celebrate the material. Cementos Tolteca had recently opened a new plant on the outskirts of Mexico City. Naturally, the factory was built of cement, and its tanks, ovens, and warehouses were sober, unadorned structures in the modern style that Mexican architects called "functionalist." Sánchez Fogarty, now working as Cementos Tolteca's publicist and editor of the jour-

nal *Tolteca*, seized the inauguration of the new plant as an opportunity to promulgate the aesthetic virtues of cement. What ensued was to be the most ambitious, most successful, and most spectacular campaign to aestheticize cement in Mexico.

On August 1931, *Tolteca* announced an upcoming competition for the best artistic representation of the company's new plant in Mexico City. Artists were asked to submit original paintings, drawings, and photographs that captured the plant's radically new architectural style and highlighted its innovative use of cement. Young artists were lured by substantial cash prizes, by the opportunity to have their work reviewed by Diego Rivera and other prestigious jurors,[26] and by Tolteca's promise to exhibit all submissions in the National Theater (now the Palace of Fine Arts), one of the most venerable institutions in Mexico City.[27] The competition was an instant success: it received almost five hundred entries, and the finalists included many artists who later rose to international fame: the painters Juan O'Gorman, Rufino Tamayo, Jorge González Camarena, and Carlos Tejeda; and the photographers Manuel Álvarez Bravo, Lola Álvarez Bravo, and Agustín Jiménez.[28]

The jury awarded first prizes to the works that most clearly highlighted the features of the new architectural style inaugurated by cement: solid, unbroken surfaces, simple structures evoking geometrical shapes and free of decorative elements. Manuel Álvarez Bravo's winning entry was a photograph of the plant's furnace titled *Tríptico Cemento – 2* (figure 68) that clearly portrays the "aesthetics of cement" envisioned by Sánchez Fogarty.[29] A heap of powdered cement lies at the foot of a towering concrete wall, thus suggesting through visual metonymy the material's uncanny ability to metamorphose from talcum-like powder to solid rock. (To be precise, the photo does not show a heap of Portland cement, the finished product, but of cement in an intermediate stage of its production when it is closer to rubble than to talcum powder.)[30] Álvarez Bravo's photograph not only serves a didactic purpose – illustrating the different stages of cement elaboration, from powder to monolithic structure – but it also captures the "magical" feature of the material exalted in "El polvo mágico": its marvelous ability to assume myriad different shapes and forms.

In addition to depicting the different stages and forms of concrete construction, Álvarez Bravo's photograph aestheticizes cement at at least two levels. First, it transforms the Tolteca plant into an abstract composition – a rectangular wall bisected by a triangular heap of cement – of the type favored by modernist photographers like Modotti. *Tríptico Cemento – 2* follows the same

68. Manuel Álvarez Bravo, *Tríptico Cemento – 2* (1932), also known as *La Tolteca*. Photo courtesy of Colette Álvarez Bravo Urbajtel.

strategy Álvarez Bravo deployed in *Instrumental* (figure 69) and other works: the camera is used to reveal geometrical patterns hidden in everyday objects. Discovering the geometric logic of life was one of the fundamental ambitions of modern art, and the sober disposition of simple shapes in *Tríptico Cemento – 2* is reminiscent of Rodchenko's orderly compositions and Albert Renger-Patzsch's photographic foregrounding of geometrical shapes in mass-produced objects.

In *La peinture moderne*, Le Corbusier and Amédée Ozenfant associated geometry with the order and stability of modernity. They praised the geometrical patterns of the modern city, "whose street plan – the houses in an almost uniform grid of windows, the neat stripes of the sidewalks, the alignment of trees with their identical circular grills, the regular punctuation of street lamps, the gleaming ribbons of tramway lines, the impeccable mosaic of paving stones – always and forever encloses us with geometry." Man, they concluded, "is a geometric animal."[51] By transforming the Tolteca plant into a geometrical composition, Álvarez Bravo's photograph highlights the material's relation to the avant-garde aesthetics of modern art.

On another level, Álvarez Bravo's photograph exalts the type of architecture that could be built only with cement. His image reveals the rustic

69. Manuel Álvarez Bravo, *Instrumental* (1931).
Photo courtesy of Colette Álvarez Bravo Urbajtel.

beauty of the furnace wall, an unadorned concrete structure that stands out as a monument to the new cement architecture. The wall is a masterful example of the elegance that can be achieved by reducing architecture to its barest elements and doing away with all extraneous elements. "Form follows function" was the fundamental precept of functionalism, and the wall's bare form follows the simplicity of its function as a supporting structure.

By juxtaposing the wall and the pile of cement, Álvarez Bravo evokes the link between modern architecture and concrete. The new architectural style called for clean, unbroken surfaces, an effect that is best achieved by cement. Cement can be poured into any type of mold – spherical, cylindrical, rectangular – and the resulting structure will always be a seamless, unbroken form. Other materials, like bricks or sandstone blocks, mar

the surface with unseemly lines and grids, but cement invariably produces pristine, "functional" structures.

In an essay titled "¿Por qué este primer premio?" [Why This First Prize?], published alongside Álvarez Bravo's photo in *Tolteca* 21, Sánchez Fogarty praised *Tríptico Cemento – 2* for linking the concrete wall with the tenets of functionalism. "This mineral wall," he wrote "reveals, in Álvarez Bravo's photograph, the subtle yet solid character of concrete, that human stone – gray, virile, defiant – that is eternal but also svelte."[32] The photograph could indeed serve as the poster image of modern architecture. It demonstrates that simple, unadorned structures built out of cement could be appealing, as well as "strong," "harmonious," "subtle," and "eternal."

It comes as no surprise that Sánchez Fogarty – particularly during his tenure as editor of *Tolteca* – became a champion of functionalist architecture, a movement that brought about an unprecedented aesthetization of cement. In a few years, cement rose from a lowly substance derided as antiaesthetic and cold to the material of choice for the architectural avant-garde. Sánchez Fogarty was so relentless in his promotion of the new architecture that Anita Brenner, a long-time Mexico City resident and author of the travel guide *Your Mexican Holiday* (1932), credited him with almost single-handedly turning Mexico City into one of the functionalist meccas of the world:

Born in the United States and nursed in France, Germany, and Holland, [functionalism] is nevertheless a novelty almost everywhere except in Mexico, where it is now so completely acclimated that it is taken for granted. It is worth recording, with a smile, how that happened. First, the Tolteca Cement Co. had concrete to sell and happened to command the services of an indefatigable and sophisticated advertising manager, Sr. Federico Sánchez Fogarty, who stormed the town with art contests, magazines, lectures, and all sorts of restless intelligent pro-modern propaganda. Act II, some young architects in official positions established a kind of dictatorship, requiring all government construction to be "functional." Next the vanguard among architects began to build homes in that manner, using their own funds, and selling the houses as rapidly as they were put up because – they were cheap, and buyers liked the trim light look of them. Finale, the conservatives capitulated, embraced the dogma, and now the great "cubist versus traditional" battle is finished history.[33]

The artistic competition organized by *Tolteca* was one of the most successful examples of the "pro-modern propaganda" launched by Sánchez Fogarty to publicize the virtues of the new architecture. With its exaltation of functionalist aesthetics, the *Tolteca* competition effectively put an end

to the perception of cement as "tierra molida." By sponsoring, exhibiting, and circulating works like Álvarez Bravo's *Tríptico Cemento – 2*, Sánchez Fogarty succeeded in aestheticizing cement, presenting it as an appealing material closely related to the aesthetics of avant-garde art and architecture. *Tolteca*, as he wrote some years later, effectively sparked an "aesthetic revolution."[34] The Cinderella story had come to a happy ending: cement, once an abject material, had been recognized as an avant-garde product, and what was once derided as "tierra molida" was now praised as "polvo mágico."

Ironically, in his messianic quest to aestheticize cement, Federico Sánchez Fogarty played a role not unlike that of Gladkov's protagonist. Like Gleb Chumalov, the proletarian hero in *Cement*, Sánchez Fogarty became obsessed with a cement factory and embarked on a mission to recruit supporters for his cause. Like the Soviet worker, Sánchez Fogarty traveled around town giving speeches and promoting his project, and also like Gleb, his success was ultimately applauded by "comrades" such as Anita Brenner. Whereas Gleb Chumalov renewed the Soviet factory's industrial output, Sánchez Fogarty inaugurated the Mexican factory's cultural production of cement.

Despite Sánchez Fogarty's success, the project of aestheticizing cement – like that of aestheticizing any technology – is riddled with paradoxes. As a medium, cement is designed to be useful and not necessarily beautiful. Cement was originally embraced by builders and architects not because of its aesthetic qualities, but because of its malleability, versatility, and endurance: in short, it was chosen for its functionality. But what happens when someone like Sánchez Fogarty focuses not on cement's usefulness but on its aesthetic attributes? Could there be something fundamentally problematic about this aesthetic shift? Could the project of aestheticizing cement detract from its functionality? How do Sánchez Fogarty's promotional activities relate to other efforts to aestheticize technology?

These questions are best answered by invoking two concepts that will prove useful in clarifying the relationship between technology and aesthetics: "use value" and "cult value."[35] "The utility of a thing," Marx wrote in *Capital*, "makes it a use value"; use value is, in other words, a measure of an object's functionality.[36] Objects that are generally useful to most people, like typewriters, radios, and cameras, are loaded with use value, while useless things, like the petrified sack of cement in Gladkov's novel, are devoid of this form of value. In contrast, cult value, a concept developed by Walter Benjamin in "The Work of Art in the Age of Its Technological Reproducibility," is a measure of aesthetic appeal. Natural landscapes, mural

paintings, and great works of art exert an immense fascination on viewers. Inciting viewers to draw nearer in order to contemplate and admire them, these objects attract and seduce, and are thus endowed with high cult value: they inspire viewers to form a "cult" around them. Cult value is closely related to Benjamin's concept of the "aura"– a measure of "authenticity," "originality," "distance," and "sublimity." Cult value decreases with mechanical reproduction, just as the aura of the artwork withers in the age of mass media.[37]

But what exactly is the relation between use value and cult value when it comes to technological artifacts like cement? It seems entirely plausible that an object might possess *both* use value and cult value. For example, the Jalapa Stadium was both an extremely useful construction (it could be used simultaneously by twenty thousand spectators) and an aesthetically appealing building (a true monument to the "aesthetics of cement" promoted by Sánchez Fogarty). But, as we will see, unlike the Jalapa stadium, most efforts to aestheticize technology – including the aesthetization of cement – fail to harmonize use value and cult value.

When it comes to technological artifacts, cult value is inversely proportional to use value. Think, for example, of the numerous displays at the Museum of Technology in Mexico City. Built in the 1970s by the public electric utility Compañía Fede-

ral de Electricidad, the museum houses numerous artifacts that once represented the wonders of modernity. Automobiles, railroad cars, and airplanes serve as silent witnesses of the government's success in modernizing the nation; gargantuan motors, turbines, and transformers are proudly displayed as monuments to the power and strength of modern industry. Radios and television sets are showcased like treasures inside velvet-lined vitrines, along with what were once the most modern of devices. But despite the appeal of the displays and the eloquence with which the didactic panels exalt the uses of every object, a great irony lurks behind the Museum of Technology: none of the artifacts – exhibited in the museum precisely for their efficiency and functionality – can be used. The airplanes and trains, radios and televisions, motors and turbines are in the museum merely for display purposes. And since they cannot be operated, they are entirely devoid of use value.

Ironically, these objects cannot be used precisely because they are on display: motors have been pulled from factories and trains have been lifted from their tracks so that visitors can admire them. The museum endows these artifacts with cult value by displaying them as appealing objects, but in so doing it strips them of their use value. They are exhibited because they are useful, yet by exhibiting them they are rendered useless. As

Denis Hollier writes, "objects enter a museum only after they have been detached from the context of their use value."[38]

Conversely, machines that are in use are seldom put on display. Motors and gears, when used in factories or other industrial settings, are usually kept from public view behind No Admittance and Do Not Enter signs, as if the eyes of curious viewers would somehow hamper their productivity. Part of the fascination exerted by technological artifacts in the 1920s and 1930s came from the fact that these useful machines were rarely seen in public. Everyone talked about the new inventions of the twentieth century, but few people had actually seen them: they were in use and thus off limits. At the peak of their efficiency, these devices were saturated with use value and entirely devoid of cult value.

At the Museum of Technology in Mexico City, use value and cult value are mutually exclusive attributes. A machine can either be useful and hidden from view, or it can be made visible and useless. And since technologies can either be in use or on display, but not both, the museum is ultimately a Museum of Useless Technology.

To return to cement, we should ask whether the campaign to aestheticize cement launched by Sánchez Fogarty is comparable to the aesthetiza-tion brought about by the Museum of Technology. What happened to cement's use value as – thanks to Sánchez Fogarty – it gained cult value? Does the aesthetization of cement diminish its usefulness? The answers to these questions can be found in the story of Heriberto Jara, one of the earliest converts of Sánchez Fogarty's campaign to aestheticize cement. A revolutionary general who served as governor of the state of Veracruz from 1924 to 1927, Jara became Mexico's first minister of the navy in 1941, and had the dubious honor of being awarded the Stalin Peace Prize. Jara was also one of the most energetic promoters of all things modern. A passionate admirer of the Estridentistas, he helped finance the movement by appointing Maples Arce and other writers to high-level positions in state government. Inspired by the young poets' worship of modern technology, in 1925 Jara commissioned the Jalapa Stadium as a monument to the new architecture made possible by cement. Apparently President Calles viewed the governor's enthusiasm for futurist poetry and modern architecture with such suspicion that during the inaugural ceremony of the Jalapa Stadium Jara deferentially explained that "in Veracruz our only futurism is to follow the programs of President Calles to make our great country even greater."[39] But despite his obsequious disclaimer, Jara would continue to launch controversial "futurist" projects.

Jara embarked in one of his most ambitious projects during the first years of his tenure as minister of the navy (1941–1946). Appointed to this newly created post at the height of World War II, he instantly dreamed of modernizing Mexico's navy to help the Allies win the war. The navy's overhaul, he decided, would be carried out with the help of cement, and Jara recruited Miguel Rebolledo, an engineer who had built many of the most accomplished modern buildings in Mexico City during the 1920s: the Polo Club, Edificio Gante, and the department stores El Puerto de Liverpool and El Palacio de Hierro, projects that had been celebrated in the pages of *Cemento* as examples of the new aesthetics of cement.

In 1942 Jara commissioned Rebolledo to revamp the port city of Veracruz, which had fallen into disrepair, and to oversee other reforms destined to revamp and modernize Mexico's tiny navy. Rebolledo was to carry out these projects using cement, as he had in his earlier urban constructions. Jara hoped to recreate the success of his most famous public project, the Jalapa Stadium; if cement had allowed him to build the state's most celebrated public project in the 1920s, the same material would allow him to construct a modern navy in the 1940s. Cement was to be put at the service of the fight against Nazism, as Jara explained in an interview published in *Excélsior*: "these public works will allow Mexico to con-

tribute to the world battle for freedom and justice, since the shipyards, docks, and warehouses under construction here in Veracruz can be used by democratic nations in their heroic fight against Nazism and fascism."[40] The war would be won by the Allies, and it would be won with Mexican cement.

Jara's naval project, though initially well received by the press and the general public, soon became the focus of harsh criticisms and sarcastic rebukes. In early 1944, *Excélsior* ignited a national scandal by ridiculing Jara's plans as ineffectual and wasteful. The newspaper's attacks zeroed in on the minister's infatuation with cement. Many of the articles were signed by Jorge Piño Sandoval, a member of the Communist Party who became one of Jara's fiercest critics.[41] Piño Sandoval rebuked Jara for hiring Miguel Rebolledo—a concrete engineer—to oversee the naval projects. "Ingeniero Miguel Rebolledo is recognized as an expert on concrete structures, but he has only worked on apartment buildings, which require a completely different technique from that used in shipyards … any person with a bit of common sense knows that building on land is not the same as building on water."[42]

Piño Sandoval's article goes on to attack both Jara and Rebolledo for fetishizing cement. He argues that they had chosen cement as the material for the Veracruz projects not because it was a useful material, but because the two men had devel-

oped an obsession with concrete. The reporter ridiculed the projects in Veracruz as ultimately useless, except as examples of the bizarre applications of cement. These projects included a plan to extend the Isla de Sacrificios, a tiny island off the port of Veracruz, by pouring tons of cement around it – a project Piño Sandoval mocks as a "science-fiction filling" made out of cement.[43] Piño Sandoval also lambasts a useless dock made entirely of reinforced concrete ("the material with which Mr. Rebolledo is given to experiment") and a flawed retaining wall, also made of cement, "Ingeniero Rebolledo's favorite material."[44]

But among these outlandish projects, there was one that stood out for its absurdity: a plan to build ships made of concrete – "bureaucratic ships," as an *Excélsior* columnist called them.[45] Cement, Jara reasoned, was a marvelous material, and if it had been good enough to build a stadium, it should be good enough to build a fleet. Since his appointment as minister of the navy in 1941, Jara began working with Rebolledo to develop "experimental" cement boats. In late 1943, before a large audience of government bureaucrats and curious onlookers, the two men launched the first Mexican-built cement vessel. In *Excélsior*, Piño Sandoval recounted with great irony the unfolding of this ill-fated event:

Como se sabe, el Señor Ingeniero ... Rebolledo es un devoto del concreto armado. Su larga experiencia en la materia lo ha inducido a rechazar cualquier otro material. Este amor al concreto lo llevó a idear un chalán todo de cemento. Aún puede verse la empalizada que se hizo para vaciar allí, no lejos del legendario astillero, el famoso chalán ... se vaciaron, para obtener el famoso chalán de una pieza, tantos costales de concreto como se pueden comprar con 40,000 pesos. Concluido el vaciado, fraguado el concreto – la brisa contribuyó gratuitamente a esta labor – llegó la fecha de botar el chalán.

Aquélla iba a ser la primera embarcación de concreto – toda una casa, como las que hace el Ing. Rebolledo en la metrópoli – iba a surcar hasta las aguas del golfo.

El chalán se deslizó hasta el agua y segundos después, ante la deslumbrada concurrencia que servía de testigo al notable hecho histórico, el mar levantó una inmensa burbuja.

Una burbuja que exclamó

–¡Bluff!

Y – oh triste final – el chalán se fue al fondo del mar.[46]

[As is well known, engineer Rebolledo is a devotee of reinforced concrete. His years of experience with this technique have led him to reject any other materials. His love of concrete led him to design a barge made entirely of cement. You can still see the wooden structure built, not too far away from the now legendary shipyard, to pour the concrete for the famous boat.... The construction of the barge required as many sacks of cement as can be bought with 40,000 pesos. Once the cement was poured

and the concrete had set – the gulf breeze contributed beautifully to this goal – it was time to launch the boat.

This was to be the first concrete ship – as big as the houses built by Mr. Rebolledo in Mexico City – and it was set to sail on the Gulf waters.

The barge was pushed into the water. A few seconds later, before the stunned congregation that had come to witness such a historical event, an enormous bubble appeared on the water.

And the bubble went

"Bluff!"

And – oh sad ending – the barge sank to the bottom of the Gulf.]

And so did Jara's dreams of a Mexican naval victory over the Nazis.

The project of building a cement ship was not as foolish as it first sounds. Ferroconcrete boats had been constructed in the past, and during the Great War they provided a popular, cheap form of naval transport.[47] Many factors contributed to the boat's sinking in Veracruz – the plans had been bought from Czechoslovakia (a landlocked nation with no navy of its own!) and subsequently altered by Jara's staff – but chief among them was Jara's obsession with cement. *Excélsior*'s articles make it clear that Jara was more interested in cement than in ships, and the entire venture became an experiment in concrete construction rather than one in naval engineering. As Piño Sandoval pointed out,

Jara's choice of Miguel Rebolledo, rather than an experienced naval engineer, was symptomatic of an obsessive fixation with cement.

The cement ship's theatrical failure made Jara the butt of countless jokes, and tarnished the general's reputation for life. In the annals of Mexican history, he would be remembered not for the successful construction of the Jalapa Stadium but for the spectacular sinking of the cement boat (and also for another equally mad project: his decision to build the country's navy yards in Las Lomas, the Beverly Hills of Mexico City). The specter of these failures would haunt Heriberto Jara until his death in 1968.[48]

Jara's experiment with the cement ships failed because it constituted a fetishization of technology. The general chose concrete not because it was practical or useful, but because it was spectacular – it was meant to impress the "astonished viewers" who gathered on the pier to witness the launching of the experimental boat. Jara's ship project was very similar to another famous case of technological fetishism that unfolded in the Soviet Union around the same time. At the outbreak of World War II, Stalin ordered the construction of a fleet of airplanes, but he chose not light, rapid aircraft – the fighters that could most efficiently defend the Soviet Union – but massive aircraft that would *look* impressive in military parades: bulky,

obsolete machines that proved to be completely useless for defending the country against Hitler's attacks. Despite their inefficiency in air defense, the planes caused a sensation in military parades because of their spectacular bulk.[49] Like Stalin's heavy bombers, Jara's cement ships were built not to be useful but to be impressive. And like the Soviet strongman, Jara fell prey to the spectacular powers of technology.

If we now return to the distinction between use value and cult value, we see that Jara's cement ship was a project endowed with cult value. The ship was put on display before a large audience that gaped at its spectacular attributes: the ship's size, its unadorned concrete surfaces, its monolithic solidity. The spectacle unfolded successfully until the ship had to be put to use. As *Excélsior*'s columnist sarcastically observed, since Jara's ship could not stay afloat, it was entirely devoid of use value. The experimental vessel was a great success as a cult object – a monolith to be marveled at – but a complete failure as a usable artifact: it was weighed down by its excess of aura.

In the end, Jara's ship was a monument to cement. Its function was not pragmatic – to float – but aesthetic – to impress the crowds with its use of what had become a fancy building material. In this respect, the cement ship was no different from the artifacts housed in Mexico City's Museum of Technology: it could be looked at, but it could not be used, and it was useless precisely because it had been designed to be exhibited. The ship, in fact, would have been a complete success if, instead of launching it, Jara had placed it in a museum as a monument to cement. Jara's tragic flaw was his inability to realize that monuments are not functional.

Despite its powerful effect on the crowds gathered to witness its launching, Jara's ship was ultimately no different from the cement bags in Gladkov's novel. Like Gladkov's cement, Jara's ship was rendered useless by an excess of water; and the ship, like the petrified sacks in the Soviet novel, was a telling symbol of an ambitious concrete project gone wrong. It is a great irony that Jara's passionate and irrational love of cement ("amor al concreto," as Piño Sandoval called it) would culminate with a sunken ship, an image as unappealing and antiaesthetic as the petrified cement sacks in Gladkov's novel. In both episodes, cement is stripped of both use value and cult value and turned into a damp rock.

Jara's cement ship represents the culmination of Sánchez Fogarty's efforts to aestheticize cement. Here was a man who took the publicist's injunction to promote cement's cult value to an extreme: to the point at which cement was so thoroughly aestheticized that it became pure technological spectacle.

By the time the cement ship sank in 1943, Mexican thinkers had come a long way from their Porfirian predecessor's mistrust of technology. Machines, technological artifacts, and new media were no longer considered, as they were for Manuel Gutiérrez Nájera, as vulgar distractions and symptoms of a debased world that had deviated from the aesthetic ideals of the nineteenth century; they were now almost universally embraced, passionately celebrated, and in many cases – including that of Heriberto Jara – obsessively fetishized. The technological revolution was a success: a new discourse network was firmly in place, and a protechnological ideology had replaced old-fashioned phobias and anxieties about Mexican modernity.

Ironically, Gutiérrez Nájera's rejection and Jara's embrace of new technologies have one thing in common: a disregard for the use value of new media. Caught up in a desire to live in "the gardens of Academus," Gutiérrez Nájera did not pause to consider that a typewriter might have increased his literary productivity and given him more time to sit in an idyllic pasture. Similarly, Jara became so obsessed with cement that he lost perspective on the goal at hand – to build a ship invested with enough use value to make it float – and failed to consider other, perhaps less modern materials that might have been more appropriate. Technophobes and technophiles can be equally blinded by their passions.

And where has the technological revolution led Mexico in the years since Jara's boat? To a modernity that is fast approaching postmodernity, as we will see in this book's epilogue. But before that, the next chapter will take us on a tour of one type of new building that took advantage of cement architecture: the stadium.

5

STADIUMS

In the preceding chapters, we discussed how four technological artifacts gave rise to new forms of representation marked by the mechanical conditions of their production: the camera opened the door to modernist photographic experiments; the typewriter led authors to mechanogenic writing; the wireless inaugurated radiogenic broadcasts; and reinforced concrete inspired functionalist architecture. In this final chapter we will examine how another technological invention of the modern era–the monumental stadium–gave rise to a most unusual form of representation: mass spectacles performed by thousands of bodies lined up in geometrical formations. Like photography, typewriting, broadcasting, and cement architecture, stadiums constituted a new medium that was extremely productive of culture in postrevolutionary Mexico.

Though stadiums had existed in antiquity, the early twentieth-century obsession with building massive complexes capable of housing tens or even

hundreds of thousands of spectators was a thoroughly modern phenomenon. The trend began in 1896, when the Olympic games were resurrected, with the construction of a vast stadium in Athens, and continued every four years, with host countries trying to outdo their predecessors by building structures that were larger, more modern, and more impressive than those that had come before: Stockholm inaugurated its Olympic stadium in 1912, Paris in 1924, Amsterdam in 1928, Los Angeles in 1932, and Berlin during the infamous Nazi Olympics of 1936.

There were several important differences between twentieth-century stadiums and their classical predecessors. The new structures were constructed with modern building materials like cement and steel and were designed to hold many more spectators; but above all what set them apart from the constructions of antiquity was their function. Modern stadiums were designed as showcases for host nations to exhibit their technical and cultural progress before the rest of the world. Countries spent years carefully planning the inaugural ceremonies for the stadiums as performances of modernity staged for the international community (in addition to the foreign Olympic delegations in attendance, photography, radio, and film made these events accessible to a worldwide audience). Like the pavilions for world's fairs, the

Olympic stadiums were constructions of extreme allegorical importance: they were designed to convey a carefully crafted image of the nation. Countries around the world built stadiums as monuments to progress, as evidence that they belonged to a select group of developed nations. Like the technological artifacts described in previous chapters, stadiums were modern in several ways: they were often built using the latest building techniques; they reflected the most avant-garde trends in architecture; and, above all, they were designed to accommodate the most visible and ubiquitous product of the modern era: the masses. As Hans Ulrich Gumbrecht has written, "Large crowds in modern stadiums and ever multiplying international events were... the scenario that shaped the history of modern sports between 1896 and the Berlin Olympics of 1936."[1] Built to seat thousands of spectators, stadiums served as stages for the performance of equally massive spectacles: military parades, acrobatic exercises, and elaborate geometrical formations in which human bodies functioned as the minuscule parts of a vast gymnastic display.

In the 1920s, Mexico also succumbed to the international obsession with building stadiums, and the country built not one but two massive stadiums: the National Stadium in Mexico City, finished in 1924, and the Jalapa Stadium in Vera-

cruz, completed the following year. Unlike other stadiums around the world, these Mexican constructions were not erected on the occasion of an Olympiad (Mexico would have to wait until 1968 to host the games), nor were they designed to impress the international community or to export a national image. Instead, Mexico's stadiums were built for a purely domestic cultural consumption: directed at Mexican audiences, they were symbols of a new postrevolutionary modernity, monuments to the progress made by the Obregón government since the revolution had come to an end in 1920.

A Tale of Two Stadiums

The National Stadium was the most ambitious, most expensive, and most controversial project undertaken by José Vasconcelos, one of the most influential thinkers of the postrevolutionary period, who served as Álvaro Obregón's minister of education from 1921 to 1924. During these four years, he commissioned an unprecedented number of buildings, including schools, athletic facilities, and the Ministry's headquarters on Calle Argentina in downtown Mexico City. In his memoirs, Vasconcelos describes how in these years he was driven by a veritable obsession with stadiums. He had built several smaller-scale stadiums – "modest" structures with capacities for between two and six thousand seats – but he dreamed of a monumental stadium for the city and for the country. Vasconcelos envisioned a vast construction that would serve as an open-air theater capable of housing sixty thousand spectators (almost six percent of the population of Mexico City in 1921).[2] The project was outrageously expensive – about one million pesos – and since it could not be financed with the Ministry's budget, Vasconcelos devised what he called a "democratic" solution: he announced that, unless someone raised an objection, every employee in the Ministry would forgo one day's salary to help pay for the stadium (no one objected). "The project will be grandiose," Vasconcelos proclaimed, "as well as indispensable for a capital like Mexico City."[3]

Vasconcelos found the perfect site for the stadium on the outskirts of Colonia Roma, the ritzy, Parisian-style neighborhood that had been built during the Porfiriato. The lot itself, however, was far from ritzy: it was an abandoned cemetery known as Panteón de La Piedad. He asked Obregón to expropriate the land, and commissioned a young architect, José Villagrán García, to design the building. Vasconcelos envisioned a Greek stadium made of stone; but much to his chagrin, he was told that the only affordable option consisted of two materials he considered vulgar precisely because they were modern: cast iron and cement.

70. Maquette of the National Stadium. Courtesy of the Archivo Histórico de la Secretaría de Educación Pública, Mexico City.

"I detest those constructions," he told the architect, "which like American skyscrapers have to be torn down after fifty years."[4] As Valerie Fraser has written, Vasconcelos saw the stadium's concrete construction "as a necessary evil [and] not as a symbol of modernity."[5] Just as the pictorialist photographers described in chapter 1 used a modern technology – the camera – to depict premodern scenes of peasants and quaint villages, Vasconcelos used modern materials like iron and concrete to recreate buildings from classical antiquity.

Modeled after the Athenian stadium erected for the 1896 Olympics, the National Stadium was shaped like a giant horseshoe. Though Vasconcelos wanted the stadium to have "the same style as those glories of art history, the grand stadiums that rose under the blue skies of Greece,"[6] the final project was a mishmash of styles. The curved facade featured murals by Diego Rivera, and the top part was decorated with a gallery of colonial-style arches, as we can see in figure 70.

The stadium was inaugurated on May 5, 1924, the anniversary of Mexico's defeat of the French army at the Battle of Puebla and only a few weeks before Obregón completed his term and Vasconcelos resigned his post. The minister designed the inaugural ceremony – attended by Obregón, his cabinet, and sixty thousand spectators – to showcase the cultural and educational achievements of

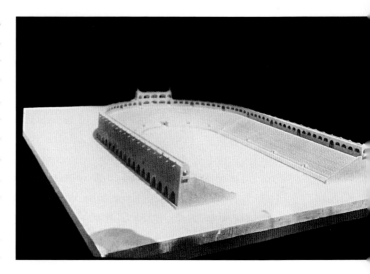

his four years in office. There were thousands of schoolchildren on display, marching in formation and performing the most elaborate dances. These were the children of the Mexican Revolution, educated in the schools that Vasconcelos had built. The inaugural ceremony was meant to prove that Mexico's educational reforms had succeeded in imposing order and structure among the dispossessed Mexican masses. The National Stadium was, above all, an imposing monument to the success of postrevolutionary education. "The stadium was the crown jewel," wrote Vasconcelos later, "of four years of working for the country's educational reform."[7]

But what makes the National Stadium unique, setting it apart from other governmental building projects, is its eventual role as a stage for the country's most important political ceremonies. It became the preferred location for the inauguration of new presidents – Calles received the presidential sash there in 1924, Emilio Portes Gil in 1928, Pascual Ortíz Rubio in 1930, and Lázaro Cárdenas in 1934 – as well as for receiving foreign dignitaries: there were official receptions at the stadium for Harry Truman, the first American president to visit Mexico in the twentieth century, and for Cuban president Carlos Prío Socarrás. In all these events, the stadium served as a stage where thousands of ordinary spectators could gather to watch political ceremonies.[8]

Despite its cost, its popularity, and its centrality to political life, the National Stadium had an extremely short life. A few months after its inauguration, the structure began to crack (the architect blamed Vasconcelos for interfering with the design,[9] while the minister blamed his successors for altering the original structure).[10] The building that Vasconcelos had envisioned as eternal stood for a mere twenty-six years: in 1950, during the presidency of Miguel Alemán, the stadium was demolished to make way for the Multifamiliar Presidente Juárez, Mexico's first Corbusier-inspired housing project, designed by the architect Mario

Pani. The new construction signaled a crucial shift in the direction of Mexican cultural politics: the demolition crews also dealt the final blows to the official nationalist architectural program, which was to be replaced by an internationalist modern style. (The Multifamiliar Juárez was as ill-fated as the stadium: large sections of the complex collapsed – along with several other buildings designed by Pani – in the 1985 earthquake, leaving an eerie plot of barren land that reminds visitors of the site's original function as a cemetery.)

Today, all that remains of Vasconcelos's National Stadium is a statue of a javelin thrower (figure 71) that stands, alone and out of context, on a corner across from the Multifamiliar Juárez. Almost no one remembers the stadium, and Colonia Roma's residents often wonder why the streets around the housing complex are shaped like a giant horseshoe.

The Jalapa Stadium

A few months after the inauguration of Vasconcelos's grand project, builders were already at work on a second large-scale stadium, this time in Jalapa, the capital of the state of Veracruz. The Jalapa Stadium – inaugurated on January 20, 1925, with a massive ceremony that rivaled the opening of Vasconcelos's project – was the brainchild of the

71. The only remaining trace of Mexico City's National Stadium: a statue of a javelin thrower outside the Multifamiliar Juárez. Photo: Rubén Gallo.

state governor, Heriberto Jara, whose cement fixation we discussed in chapter 4. Like Vasconcelos, Jara saw the stadium as the perfect platform to showcase the achievements of his government: the building itself would be an impressive structure that would attest to Jara's dynamism, and it could be used to stage spectacles that would transmit the government's cultural and political messages to thousands of spectators.

Though the Mexico City and Jalapa stadiums were constructed almost at the same time, the two projects were vastly different. Vasconcelos's inspiration came from antiquity; Jara's from modern architecture and the aesthetics of cement. Vasconcelos's project was nationalist; Jara's internationalist. Vasconcelos saw the National Stadium as a return to the past; Jara conceived his project as a bridge to the future. Vasconcelos recommended the use of stone and handcrafted materials; Jara embraced cement and reinforced concrete. The National Stadium was built using traditional building techniques; the Jalapa Stadium took advantage of innovative construction techniques, including the design of a cantilevered roof over the steps. Vasconcelos's stadium was demolished after two decades; Jara's still stands, gracefully, by the campus of the University of Jalapa.

Despite these numerous differences, both structures were products of the same early-

twentieth-century obsession with building stadiums. In the pages that follow, we will take Vasconcelos's National Stadium as a case study as we discuss the effects of this stadium frenzy on Mexican cultural history.

The National Stadium and the Cosmic Race

In the preceding chapters, we have seen how the invention of new media was often linked to larger ideological shifts: the introduction of the typewriter, for example, corresponded with the literary shift toward a literature of the modern era, capable of reflecting the increased mechanization of everyday life, and the use of cement was concomitant with the rise of modern architecture. In a similar way, the popularity of stadiums in postrevolutionary Mexico was another manifestation of the emergence of a postrevolutionary discourse network.

Besides being a crucial part of the building campaign that Vasconcelos launched during his tenure as minister of education, the National Stadium was also closely linked to the utopian project he outlined in two of his most important works, *La raza cósmica* (1925) and *Indología* (1926). Though most critics have treated Vasconcelos's public projects and his writings as completely separate enterprises, the National Stadium is one of the clearest illustrations that buildings and texts were complementary parts of the same cultural mission.

In *La raza cósmica,* a utopian treatise that reads at times like a work of science fiction, Vasconcelos lays out his vision for the future of Latin America. He envisions a slow evolution from barbarism to civilization that will take nations through three stages: first, there is the "material or warrior period," a primitive stage during which countries are governed by strongmen who rule by brute force; then comes a more advanced "intellectual or political period," marked by the developments of laws and institutions to safeguard the collective well-being; and the process culminates with "the spiritual or aesthetic period," a utopian state of pure bliss in which daily life is devoted to the pursuit of aesthetic ideals. Once this final stage is reached, people will no longer need rules or laws, since they will live in a state of harmony and "constant inspiration," and their lives will be entirely devoted to the pursuit of beauty and "aesthetic pathos."[11]

Vasconcelos describes life in the third stage as dominated by a "feeling for beauty and a love so intense that it could be confused with divine revelation."[12] Religion would be the main social force, and it would be experienced as "a sort of inebriating poetry."[13] This new civilization would be so advanced that Vasconcelos considers it "the

attainment of the Kingdom of God on earth."[14] During the third stage, Vasconcelos believed that the Americas would see the emergence of a "cosmic race," a superior ethnicity resulting from generations of intermarriage among all Latin American peoples. He also predicted a future clash of civilizations between the Anglo-Saxons and the new Latin race. Here the treatise approaches fantastic literature: the author envisions the future capital of Latin America as a bustling city towering over the Amazon and called "Universópolis." Threatened by the Latins' growth, he predicts, the North Americans will try to conquer this city and rename it "Anglotown."[15] Curiously, this third age would also be dominated by machines and military technology, though always at the service of aesthetic ideals. "If in the future the fifth race conquers the world," he writes, "then airplanes and armies will go around the world, educating all peoples for their entrance into the world of knowledge. A life based on love will give expression to all forms of beauty."[16]

Though there seems to be a world of difference between the curious teleology promulgated in *La raza cósmica* and the numerous construction projects undertaken during his tenure as minister of education, there is a common theme running through both: a vision of Mexican history as a painful evolution from barbarism toward a utopian civilization. Vasconcelos saw the Mexican Revolution as a regression into the most primitive stage of societal development, the rule of caudillos and the reign of brute force that he called the "age of the warrior."[17] He viewed Obregón as a savior who had managed to put an end to revolutionary bloodshed and helped propel the country toward the peace and stability that marked the second, "intellectual" stage of the 1920s. At that point, thanks to the numerous cultural programs carried out by his ministry, the nation was making rapid strides toward the final stage, the aesthetic utopia that would see the triumph of the cosmic race.

Vasconcelos saw his construction projects as catalysts for the country's advancement toward the utopian "third stage": public schools, gymnasiums, and the Ministry of Education building – even the murals of Diego Rivera which he commissioned for its walls – were all designed to solidify the nation's position in the "intellectual stage" and prevent it from sliding back into the barbarism of the "warrior stage." As Valerie Fraser has put it, Vasconcelos "saw education as the key to Mexico's progress towards the desired third stage."[18] But among all these projects, the National Stadium occupied a privileged place. If schools and government buildings belonged to the second stage of civilization, Vasconcelos saw the National Stadium as a more important project, one that anticipated the final, "aesthetic stage" and the advent of the cosmic race.

In a speech given at the stadium's inaugural ceremony, Vasconcelos stressed the building's links to the aesthetic ideals of the third stage. Introducing the thousands of schoolchildren who were about to perform a series of carefully choreographed nationalist dances, he announced: "In the stadium we can see the birth of a new race devoted to the highest aesthetic ideals: it sings in chorus, practices sports, and searches for beauty."[19] His description of the children at the stadium reads exactly like his evocation of the aesthetic age in *La raza cósmica:* in them he sees "the birth of a new race" devoted to the pursuit of beauty and to other equally aesthetic activities: singing, exercising, and searching for the good.

Recalling the stadium's inauguration in *Indología,* Vasconcelos stresses the aesthetic dimension of the ceremonies: "During the splendid opening ceremonies one could feel that we had created a collectivist national art. Or rather a pan-American art, since the spirit of all of Latin America palpitated in the building."[20] The opening ceremony signaled the historical advancement of not only the Mexican people but all Latin Americans. As in *La raza cósmica*'s third stage, he sees the continent's Latin nations coming together at the stadium's inauguration in the pursuit of an aesthetics that was thoroughly infused with "the spirit of Latin America."

Perhaps the clearest indication that Vasconcelos regarded the National Stadium as a catalyst for the "aesthetic period" can be found in the motto he composed for the stadium. Inscribed over the main entrance so that every spectator would walk under it upon entering the building, was the phrase "alegre, sana, fuerte, esplende: raza," which translates roughly as "race: shine in your joy, health, and strength." As if the final stage of civilization had already been achieved, the imposing building greeted the audience by announcing that they belonged to a race that was "joyous," "healthy," "strong," and "iridescent." Once seated, the sixty thousand spectators would constitute a living monument to the cosmic race.

Vasconcelos considered the National Stadium the first building of the future "aesthetic age," the cornerstone of Universópolis. In his initial proposal, Vasconcelos wrote of "that stadium which the entire city will see rising, like the hope of a new world,"[21] emphasizing the project's role in the building of a utopia. The stadium was designed to give Mexicans a glimpse of what the future had in store for their country if it managed to stay on track as it advanced toward the final stage of civilization. It was proof that his utopian vision of a powerful Latin American civilization – a cosmic race – was already becoming a reality.

Stadiogenic Events: Masses and Mass Ornament

In earlier chapters we discussed the various forms of media specificity inspired by new technologies: prints deploying distinctly photographic techniques, mechanogenic typescripts, radiogenic broadcasts, functionalist cement architecture. If stadiums, like photography or radio, constitute a new medium, we should now ask whether these structures generated new forms of representation that were specific to stadiums – events that could be performed only in this type of structure and that exploited the representational potential of the new medium. Is there such thing as a "stadiogenic" event? Or, to phrase the question in a different way, what made stadium events different from other staged performances, like theater, concerts, or public speeches?

The first and most important characteristic of stadium events was their capacity to deploy the masses. Unlike other public spaces that came before them, stadiums were designed to accommodate the masses, the most visible by-product of modernity. Not only could stadiums hold tens of thousands of spectators, but their spectacles often featured thousands of performers in strictly choreographed formations: mass events choreographed for a mass spectatorship. Like newspapers and radio, stadiums were designed to feed the masses' appetite for spectacular entertainment.

The inaugural ceremony for the National Stadium was an archetypal stadiogenic event. This ceremony was performed by and for the masses, as we can see in the front-page article in *El Universal* reproduced in figure 72. The stadium was a vast stage for the exhibition of the new postrevolutionary Mexico: the audience comprised a "multitude of 60,000 spectators," and the students performing the dances and athletic exercises also numbered in the thousands. A chorus of twelve thousand children sang Mexican and Spanish songs (Vasconcelos emphasized that no other melodies were allowed in the ceremony);[22] a group of one thousnd couples in national costume danced the *jarabe tapatío*; hundreds of gymnasts formed human pyramids; and a parade of military cadets spelled the word "MEXICO" with their perfectly aligned bodies.[23] The stadium's opening ceremony deployed the masses to demonstrate the extent to which the country had advanced since the bloodiest days of the Mexican Revolution. The masses performing in the stadium were a far cry from the barbarian mobs that executed rebels and pillaged towns during the armed conflict; these were civilized masses, educated in Vasconcelos's schools, who subjected their every movement to the strictest rules of order and reason.

Artists and writers were particularly receptive to the National Stadium's potential for representing the masses as orderly citizens. Unlike any other

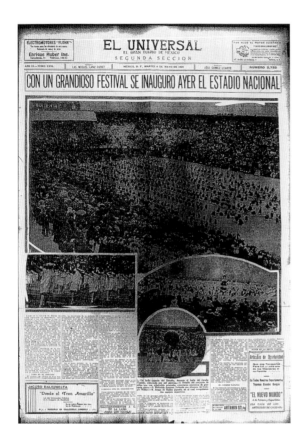

72. Front page of *El Universal* (6 May 1924), announcing the inauguration of the National Stadium.

building erected by the postrevolutionary government, the stadium became the subject of countless artistic representations, a trend that lent credence to the minister's conception of the building as a monument to the "aesthetic age." Kyn Taniya, the Estridentista poet whose radiophonic creations we discussed in chapter 3, composed a poem to the stadium. "Estadio," written in 1926 and dedicated to José Vasconcelos, celebrates the masses of spectators who come together to witness highly stylized events: "Hip ! Hip! / 80,000 people," writes the poet, exaggerating the building's capacity,

eighty thousand
with a single idea
with a single soul
covering them like a vast black marquee.[24]

Kyn Taniya portrays the masses as a manifestation of Vasconcelos's cosmic race: not only are these spectators orderly and composed (and thus entirely unlike the unruly mobs a visitor might encounter today in a Mexican stadium), but they also have the same "ideal" and share a common "soul." The poem (reproduced in figure 73) was published in *El Universal Ilustrado*, accompanied by a woodcut by Bolaños Cacho showing a muscular discus thrower standing before the stadium – a utopian image depicting one of the stadium's statues that

could have also served as an illustration for the new man described in *La raza cósmica*.

A year after Kyn Taniya wrote his celebratory poem, Tina Modotti photographed the National Stadium. *Stadium, Mexico City* (figure 74) is a close-up of the sloped steps where the sixty thousand spectators would normally sit (figure 75). The photograph is a portrait of the masses in absentia: the photo's close cropping makes the steps appear to extend endlessly in all directions, thus creating the illusion that the structure can hold an infinite number of spectators (like Kyn Taniya, Modotti seems to exaggerate the building's actual capacity: perhaps a sign of the artist's excessive enthusiasm for the stadium). Although Modotti and Vasconcelos had very different political views and were not on good terms, Modotti's portrayal of the stadium as a symbol of stability, order, and harmony is entirely in agreement with Vasconcelos's vision of the project. In her photo, the steps form a series of parallel lines and rectangular volumes, with the overall effect of perfect geometrical harmony. In its effort to highlight order, the photo gives the impression that the stadium was a functionalist building—a sober structure of minimalist elegance—whereas in real life the stadium was a hodgepodge of architectural styles that included everything from neoclassical steps to colonial arches (see, for example, the view of the National Stadium in figure 70).

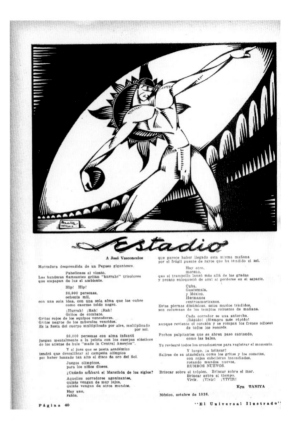

75. "Estadio" by Kyn Taniya [Luis Quintanilla],
illustrated with a woodcut by Fernando Bolaños Cacho.
From *El Universal Ilustrado* 494 (28 October 1926): 40.

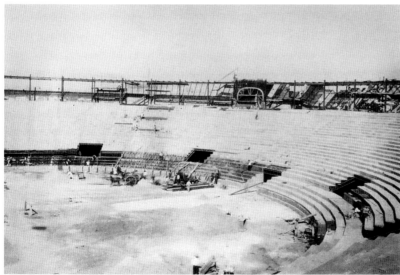

74. Tina Modotti, *Stadium, Mexico City* (1927). Fondo Tina Modotti, SINAFO-Fototeca Nacional, Mexico City.

75. National Stadium, Mexico City, ca. 1924. Detail: steps. Photo courtesy of Archivo Histórico de la Secretaría de Educación Pública, Mexico City.

Stadiums

213

A few years after Modotti took this photograph, the writer and choreographer Nellie Campobello staged a spectacle, designed specifically for the National Stadium, that provided the clearest illustration of its design as a site for the postrevolutionary masses. Campobello's *30-30*, billed as a "ballet de masas" and a "ballet proletario," was performed at the National Stadium on November 22, 1931. It was named after the rifle that had become the weapon of choice during the revolution: the *carabina 30-30,* an outdated, nineteenth-century Mauser. The ballet, consisting of three scenes – "Revolution," "Sowing," and "Liberation" – was a highly stylized representation of the Mexican Revolution as a popular peasant uprising leading to a happy ending in which the life of *campesinos* has been radically improved. Like other events held at the National Stadium, the ballet was performed by masses of singers and dancers moving in carefully choreographed scenes: there were over one thousand performers, including four hundred women dressed in red, two hundred plow women, two hundred peasants, and two hundred workers.[25]

Besides being a stadiogenic event, Campobello's *30-30* was the most direct and most eloquent representation of Vasconcelos's historical vision to be staged at the stadium since its inauguration. The ballet's message was that the nation had come a long way since the revolutionary days of chaos and disorder and that the new Mexico was now inhabited by orderly masses who no longer fought or killed, but went to public schools, danced ballet, and attended events at the National Stadium. The last scene in *30-30* reads like a staging of Vasconcelos's description of the triumph of the cosmic race: after fighting the revolution, the performing peasants put down their arms and devote their lives to building rural schools, cultivating the land, and setting up industrial workshops. Had Campobello enjoyed the metareferential games of modernism, she might have added a fourth project to her utopian coda, and closed her ballet by having the dancing protagonists erect a national stadium.

In addition to their deployment of the masses, stadiogenic events have another characteristic that sets them apart from other spectacles: the staging of carefully choreographed formations of performers that, seen from above by spectators in the stands, form geometrical figures and even words. Many events at the National Stadium featured these highly ordered choreographies, illustrated in figure 76 and figure 77, which Vasconcelos considered one more proof that revolutionary mayhem had been replaced by postrevolutionary order.

But these geometric performances were not Vasconcelos's invention – they formed part of nearly every stadium spectacle around the world,

from Los Angeles to Berlin – and neither were they universally applauded. In 1927 the German critic Siegfried Kracauer noted with concern that "performances of the same geometric precision are taking place in what is always the same packed stadium, be it in Australia or India, not to mention America."[26] Kracauer coined the term "mass ornament" to describe performances in which human bodies are used to form rigid geometrical patterns. "The ornament," he wrote, transforms thousands of bodies into "lines and circles like those found in the textbooks of Euclidean geometry, and also incorporates the elementary components of physics, such as waves and spirals." And this geometrical ordering extends to the spectators as well, since the human patterns are "cheered by the masses, themselves arranged by the stands in tier upon ordered tier."[27]

While Vasconcelos saw geometrical patterns as representing social order, Kracauer considered them a symptom of the dehumanization of modern times. "The patterns seen in the stadiums," he wrote, "are composed of elements that are mere building blocks and nothing more." By participating in these events, performers lose their individuality, since "only as part of a mass, not as individuals . . . do people become fractions of a figure."[28] Participants in mass ornaments are treated not as humans, but as mere fragments of a figure, as accumulations of corporeal bits and

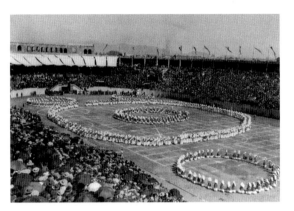

76. Mass ornament at the National Stadium, Mexico City, ca. 1920s. SINAFO-Fototeca Nacional, Mexico City.

77. Mass ornament at the National Stadium, Mexico City, ca. 1920s. SINAFO-Fototeca Nacional, Mexico City.

pieces: "arms, thighs, and other segments are the smallest . . . parts of the composition."[29] Kyn Taniya seems to have arrived at a similar, though less critical conclusion; his poem celebrates the figures formed by the disjointed bodies of performers at the National Stadium: "Estas piernas dinámicas, estos muslos tendidos, / son columnas de los templos robustos de mañana" [Those dynamic legs, those tense calves / are the columns of tomorrow's robust temples].[30]

Kracauer considered the fragmentation of the human body in these spectacles as a symptom of modern society's treatment of individual bodies as expendable materials: "The structure of the mass ornament reflects the principle of capitalist production." Not only are these spectacles alienating experiences ("community and personality perish when what is demanded is calculability"), but they replicate the logic of industrial production. Kracauer compares the performers in mass ornaments to workers in a factory – "everyone does his or her task on the conveyor belt, performing a partial function without grasping the totality" – and concludes that the hands of the factory workers serve the same disjointed function as the limbs of participants in mass ornaments.[31] Stadiogenic performances thus extend the processes of Taylorization to the human body.

Whereas Vasconcelos hailed stadium events as examples of aesthetic order and political maturity, Kracauer denounced them as symptoms of political passivity. Stadiogenic performances required masses of sheeplike individuals, who renounced their individuality for the sake of forming decorative figures. These events, wrote Kracauer, "expropriate people's energy, while the production and mindless consumption of the ornamental patterns divert from the imperative to change the reigning order."[32] Like religion, stadium performances are the opium of the people, a powerful anesthetic that numbs the masses' critical judgment.

Fascism

Vasconcelos and Kracauer thus arrive at two completely contradictory assessments of stadium events. Vasconcelos's view would have us believe that these elaborate performances are signs of civilization, the cultural productions of an enlightened and ordered people – so ordered that the bodies were turned into writing, as we can see in one of the mass ornaments documented in figure 78, which shows athletes lining up to form the letters *E* and *N*, the Spanish initials of the National Stadium. The German critic, on the other hand, denounces these ornaments as morally repugnant

spectacles that contribute to the capitalist exploitation of the masses. Whom should we believe? Were stadium events the work of heroes or villains?

The answer lies in a third characteristic – in addition to the masses and their ornaments – that distinguishes stadium events from other types of performances: fascist ideology. Elias Canetti has shown that despots need the masses as a specular reflection of their inflated ego, and the modern stadium became the privileged site for the concentration of adoring crowds.[33] Stadiums were the favored medium used by fascist leaders to stage their vision of the new society they were trying to create. Both Hitler and Mussolini built stadiums and staged elaborate spectacles whose mass appeal contributed to the rise of Nazism and fascism. Hitler's obsession with stadiums makes a perfect case study of how modern stadiums were a perfect medium for fascist spectacle.

Soon after his rise to power in 1933, Hitler began to dream of a giant stadium: Berlin was to host the 1936 Olympics, and the city needed a vast stage to showcase the achievements of National Socialism before the world. He commissioned architect Otto March to design the largest stadium in the world, an oval structure with the capacity for 110,000 spectators (thus surpassing the 1932 Los

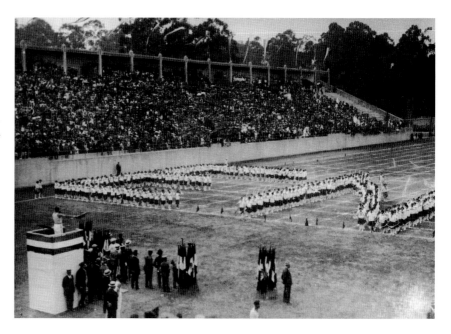

78. Mass ornament at the National Stadium, Mexico City, ca. 1920s. The bodies spell the letters *E* and *N* (for *Estadio Nacional*). SINAFO-Fototeca Nacional, Mexico City.

Angeles Olympic stadium, built to accommodate 104,000).[34] But when the Führer went to inspect the building, he was so disappointed that he threatened to cancel the Olympic games, because the stadium was too small and unimpressive.[35] Hitler eventually decided the stadium could be fixed. He enlisted Albert Speer, who would later become his official architect, to devise a few last-minute improvements to the building, such as cladding the facade in stone (he shared Vasconcelos's distaste for cement), and in the end the games went ahead as planned.

The opening ceremony was a textbook example of the mass ornaments analyzed by Kracauer. The events included a parade of Hitler Youth who, on cue, let out 200,000 doves; a chorus of 3,000 voices; and a crowd of flagbearers from every participating nation. Leni Riefenstahl captured the vast scale of these mass ornaments in *Olympia*, a film that includes shots of thousands of people forming parallel lines outside the Olympic stadium (figure 79) and a grid of athletes doing pushups (figure 80).

After the Olympics, Hitler commissioned Speer to build an even grander stadium as part of the party rally grounds in Nuremberg. Hitler envisioned a building whose vast scale and seating capacity – it would hold 400,000 spectators – were unprecedented in the history of architecture. This was to be a mammoth project, as Speer makes clear in his memoirs: "The pyramid of Cheops, with a base of 756 feet and a height of 481 feet, measured 3,277,300 cubic yards. The Nuremberg stadium would have been 1815 feet long and 1518 wide and could have enclosed a volume of 11,100,000 cubic yards, some three times more than the pyramid of Cheops. The stadium was to be by far the largest structure on the tract and one of the hugest in history. Calculations showed that in order to hold the required number of spectators the stands would have to be over 300 feet high."[36] When Speer advised Hitler that such a vast project would cost as much as 250 million marks, the latter replied: "That is less than two battleships of the *Bismarck* class. How quickly a warship can be destroyed, and if not, it is scrap-iron anyhow in ten years. But this building will stand for centuries." And when Speer warned him that the Nuremberg stadium would not meet the prescribed Olympic proportions, Hitler responded that it did not matter, since in the future Germany would rule the world and the games would take place in Nuremberg "for all time to come, in this stadium. And then we will determine the measurements of the athletic field." Speer observed that Hitler's obsession with the Nuremberg stadium was one of the clearest symptoms of his political megalomania: "He wanted the biggest of everything to glorify his

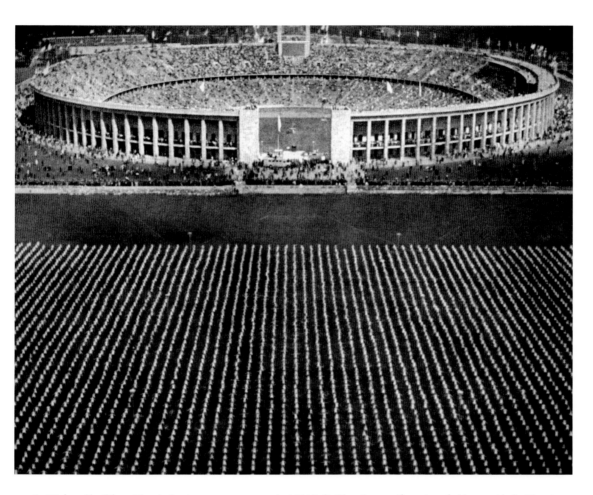

79. Leni Riefenstahl, still from *Olympia* showing mass ornaments at the 1936 Berlin Olympic games (formations of athletes outside the Olympic stadium). Reproduced in *Schönheit im Olympischen Kampf* (Berlin: Im Deutschen Verlag, 1937).

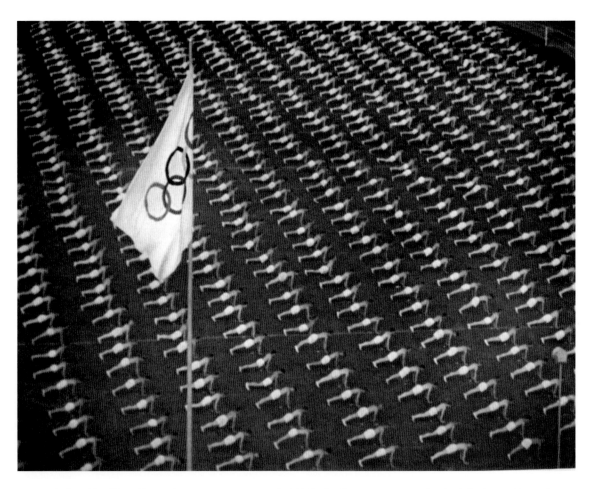

80. Leni Riefenstahl, still from *Olympia* showing mass ornaments at the 1936 Berlin Olympic games. Reproduced in *Schönheit im Olympischen Kampf* (Berlin: Im Deutschen Verlag, 1937).

works and magnify his pride. These monuments were an assertion of his claim to world dominion before he dared to voice any such intention to his closest associates."[37]

"This is the greatest day of your life," Hitler told Speer as he laid the cornerstone for the Nuremberg stadium on September 9, 1937. But the war interrupted the construction project, and the giant stadium, scheduled for completion in 1945, was never finished.

The similarities between Vasconcelos's and Hitler's projects are striking. The architectural critic Antonio Méndez Vigatá has suggested that Vasconcelos's design of the National Stadium as a political stage "anticipated Speer's Zeppelinfeld of 1934 as a political architectural artifact,"[38] but the parallels between the two projects go even further. Both Vasconcelos's National Stadium and Hitler's stadium plans reveal a typically fascist megalomania: both men demanded stadiums that were larger and grander than any existing building in their nations; both budgeted exorbitant sums – one million pesos for the National Stadium and two hundred million marks for the Nuremberg stadium; both planned their buildings for eternity (Vasconcelos wrote, "I admire nations that know how to build for eternity,"[39] and Hitler reportedly said, "This building will stand for centuries").[40] Both saw stadiums as showcases for mass orna-

ments representing the triumph of physical education, and both presented their projects as monuments to race (as noted earlier, Vasconcelos's motto for the National Stadium was "alegre, sana, fuerte, esplende: raza"; Hitler's entire Nuremberg complex was a shrine to the German *Volk*).

In yet another parallel, both Vasconcelos and Hitler had their stadiums filmed. While Hitler's Olympic stadium was captured in Riefenstahl's *Olympia*, Vasconcelos had a film made of the National Stadium's inaugural ceremony.[41] The resulting movie was sent abroad as evidence of the great strides achieved by the postrevolutionary government. "In the future," wrote Vasconcelos in his memoirs, "every time the Mexican government needs to showcase its public works in Mexico or abroad, the first thing it has to do is to exhibit the film of the National Stadium's inauguration."[42] Compensating for the lack of a Mexican Olympics, this film ensured that the National Stadium received as much attention as other international stadiums: if other countries could not come to see the Mexican stadium, then the stadium would travel through the cinematic medium to foreign spectators around the world.

In the end, both the Mexico City and the Nuremberg stadiums were catastrophic failures: one had to be demolished after two decades; the other was left unfinished when World War II broke out.

Hitler es la escoba de Dios que está barriendo de la superficie de la Tierra todo lo malo que se había acumulado durante siglos, pero sobre todo, la concepción judaica del mundo de aprovechar a la humanidad diezmando sus legítimas riquezas mediante la usura y la creación de valores ficticios.

¿No son robos en gran escala los famosos "columpios" provocados artificialmente en las Bolsas por los "príncipes" de la Banca Internacional, que hacen bajar los valores despojando a media humanidad para después comprar esas mismas acciones a precios irrisorios, volviéndoselos a vender a los incautos una vez pasado el pánico, a precios diez veces más altos?

La guerra actual es una lucha del trabajo honrado en contra del poder abusivo del dinero, una lucha entre el verdadero socialismo y los ídolos y parásitos a quienes trata de derrumbar de su altivo pedestal, desde donde siguen chupando la sangre roja de hombres, mujeres y niños.

Si Hitler ha lastimado a ciertos pueblos lo ha hecho en contra de su voluntad, y por la sencilla razón que no puede cumplir la misión que le ha encomendado el Creador en una forma menos enérgica y severa. Jesu-

HITLER

Para Labrar su Moisés, Miguel Angel Tuvo que Usar su Cincel a Golpe de Martillo

cristo también arrojó a latigazos a los mercaderes que profanaban el templo. Hasta un buen padre en ciertas ocasiones se ve obligado a lastimar a sus hijos con tal de evitarles mayores males en el futuro.

Como el marinero trepado en el mástil grita lleno de entusiasmo: —Tierra—, al ver a lo lejos la costa entre la bruma, dándoles la grata nueva a todos los demás tripulantes del barco, así yo grito con fuerza: —Optimismo—, y os doy la grata nueva que el porvenir de la humanidad encierra en su seno las más grandes esperanzas que puede concebir el cerebro del hombre.

La repartición más justa de la riqueza proporcionará a cada ser humano la oportunidad de vivir desahogadamente, los inventos mecánicos puestos a disposición de todos acor-

tarán las horas de trabajo, dejándo a cada individuo más tiempo para estudio y la meditación, para el d envolvimiento espiritual y el cult del alma. El enorme desarrollo de aviación tenderá a borrar fronter y linderos, creando una cultura mún y superior, que será puesta disposición de todos, aun de los m humildes.

Todo hombre trabajará en bien su patria y de toda la humanidad, que se enriquezca indebidame aprovechando su puesto o posici será declarado traidor a la patria. C da nación fijará su meta y todos hijos, sin excepción, harán causa mún y procurarán realizar lo plan do. Aunque habrá orden y discipli cada hombre disfrutará de suficien libertad para forjarse su propia fi sofía, siempre y cuando ésta no est en contradicción con el bien de tod

Hitler ha sido duro y severo, pe con guantes de seda ningún esculto ha podido esculpir su obra sobre granito, para labrar su Moisés, M guel Angel tuvo que usar su cinc a duro golpe de martillo.

Para juzgar la obra de Hitler ha que remontarse a las estrellas y hacia el porvenir.

Francisco STRUCK

81. "Hitler," article from
Timón 16 (8 June 1940).

The reader might object that, despite the similarities between their two projects, Vasconcelos and Hitler were very different men. One was the father of modern Mexican education, who built schools, launched literacy campaigns, and sponsored the muralist movement; the other was a megalomaniac dictator who brought civilization to the brink of collapse. Isn't it unreasonable to compare these two men simply on the basis of a shared obsession with building stadiums?

But Vasconcelos was not simply an altruistic pedagogue or a loving patron of Mexican culture; he also had a tyrannical side that tends to be sidestepped in most official accounts of his life and deeds. He had an unquenchable thirst for power: he ran for president in 1929, and when he lost the highly contested election, he called on Mexicans to launch a civil war (this from a man who associated revolutions with barbarism!).[43] He was also a proponent of ethnic cleansing: after the failure of his presidential campaign, he left for exile in Europe, where, during a trip to Constantinople, he urged Greek nationalists to burn down Turkish neighborhoods.[44]

Even more alarming was Vasoncelos's conduct during World War II. In 1940 he edited the journal *Timón*, a right-wing publication financed by the German embassy in Mexico City and the Reich's Ministry of Propaganda. Its pages were full of vit-

riolic anti-Semitism, and it ran laudatory spreads on Hitler, Mussolini, and Franco.[45] (See, for example, the feature article on Hitler published in *Timón* 16, reproduced in figure 81.) Reading through Vasconcelos's articles in *Timón,* one sees clearly how his lifelong obsession with race and spirit – ideals that seem quite noble and utopian in *La raza cósmica* – was remarkably similar to Hitler's discourse on *Blut* and *Volk.*

Consider the following sampler of hate-filled texts that appeared in *Timón.* Here is an excerpt from an article on Jewish emigration to Mexico: "We cannot allow an extraordinarily generous country such as ours to be turned into a cesspool filled with the human detritus expelled by civilized nations."[46] On Hitler's policies toward the Jews: "Germany's Führer, a visionary and a man of action, did not doubt or hesitate when he repeated the courageous gesture of Ferdinand and Isabella [by expelling the Jews]."[47] On the expected outcome of the war: "To tell Mexicans that Germany will win the war and to take advantage of this outcome is not pro-German propaganda: it is educating our countrymen."[48] And finally, here is Vasconcelos, in a signed editorial, writing about his heroes: "Hitler is destined to liberate his people. . . . Hitler and Mussolini have much to teach us, we Latin American peoples who live in oppression."[49]

Writing about Vasconcelos's pro-Nazi propaganda, José Joaquín Blanco observes that most critics have dealt with his disturbing fascist turn by advancing "the theory of the two Vasconcelos": the view that the Vasconcelos of the 1920s – minister of education, doer of good deeds, patron of Mexican culture – should be considered a different person from the post-1929 raving lunatic. It is as if everything he did during the war should be dismissed as the delusions of a madman. But Blanco aptly notes that we can already discern the beginnings of fascist ideology in the minister's writings and deeds of the 1920s. "There are many common threads linking the two Vasconcelos," he writes; "the same beliefs that were considered progressive when voiced by the Ministry of Education became chilling when uttered by an Axis sympathizer: race, nationhood, cultural messianism, the superman cult, an idealization of the past that equates it with utopia."[50] And, we might add, an obsession with building stadiums and staging mass ornaments.

The National Stadium is evidence that the fascist ideology of the later Vasconcelos already informed his much-revered cultural program for the Ministry of Education. The stadium was a monument to race and nationhood – two ideals that Vasconcelos would later invoke in his support of right-wing dictators – and a stage for spectacles

glorifying the Latin American "spirit." The National Stadium was the culmination of Vasconcelos's cultural and educational reforms as well as the earliest manifestation of his fascist tendencies.

One can only imagine the disastrous turn that Mexican history could have taken had Vasconcelos become president in 1929 and gained unlimited power to further the megalomaniac vision represented by the National Stadium. If he had been in a position to systematically carry out the program described in *La raza cósmica* – and to build not only the National Stadium but the entire city of Universópolis – the world might have seen one more example of a utopian program that culminated in a dystopic outcome. Frédéric Rouvillois's conclusion about the seemingly inevitable link between utopias and totalitarianism clearly applies to Vasconcelos's plans: it appears, he writes, "as if utopia were nothing more than the premonition of totalitarianism and totalitarianism the tragic execution of the utopian dream."[51] And so does Czeslaw Milosz's belief that it is ultimately utopian treatises like *La raza cósmica* that serve to justify the most inhuman acts: "Innumerable millions of human beings were killed in this century in the name of utopia, either progressive or reactionary, and there were always writers who provided convincing justifications for massacre."[52] One such

writer, as the *Timón* articles demonstrate, was José Vasconcelos.

But why were stadiums – and the National Stadium in particular – the perfect medium for the propagation of fascist ideology? Writing in 1936, the year of the Nazi Olympics, Walter Benjamin argued that stadium events and party rallies are perfect vehicles for the "aesthetization of politics," a dangerous operation in which the masses are blinded to the real-life consequences of their leaders' actions. In stadium events, spectators think not rationally but aesthetically about politics: instead of questioning the behavior of their leaders or the viability of their political program, the masses abandon themselves to the aesthetic enjoyment of parades, rallies, and meaningless ornaments. "An aestheticizing of political life," Benjamin concluded, "is the logical outcome of fascism."[55]

The National Stadium continued to be a catalyst for the aesthetization of Mexican politics even after Vasconcelos's departure from the Ministry of Education. For almost two decades, presidential inaugurations, visits by foreign dignitaries, even minor ministerial events were celebrated in the stadium with ceremonies featuring parades, acrobatic displays, and other mass ornaments. Like the fascist ceremonies that were unfolding on the other side of the Atlantic, these events replaced

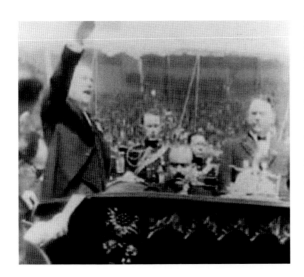

critical thinking with aesthetic enjoyment. And though Mexico never plunged into full-fledged fascism, figure 82 illustrates the extent to which Mexican political spectacle resembled fascist events. Though the photograph seems to depict a man giving a Nazi salute, this is in fact a picture of President Emilio Portes Gil saluting the cheering crowds during his inauguration at the National Stadium in 1928. Portes Gil was one of the puppets through whom Plutarco Elías Calles, in a typically fascist disregard for electoral laws, continued to rule the country behind the scenes until 1934. During Portes Gil's installation ceremony, the thousands of spectators were probably thinking

not about Calles's Machiavellian designs but about the elaborate mass ornaments being performed before their eyes.

Conclusion

We have thus seen how stadiogenic events exhibited three distinct characteristics that set them apart from other types of performances: they were staged by and for the masses, they featured human ornaments, and they were vehicles for the propagation of fascist ideology (most notably by facilitating the aesthetization of political events).

The National Stadium makes an appropriate coda to our discussion of technological artifacts, since its history was so closely intertwined with the artifacts and figures discussed in this book: Rivera painted murals for its entrance, Modotti photographed it, Kyn Taniya represented it in a poem, and Jara built a cement replica in Jalapa. Its inaugural ceremony and other important events were broadcast by wireless and thus form part of "the madness of radio" that seized Mexican audiences. The National Stadium was also the most eloquent example of how easily the utopian ambitions of post-revolutionary governments could devolve into dystopian nightmares: the stadium and its glorification of race and human ornaments

82. The inauguration of Emilio Portes Gil at the National Stadium, Mexico City, 1928. Cineteca Nacional, Mexico City.

Stadiums

225

represent the dark side of the generalized enthusiasm that greeted Vasconcelos's idealistic plans for a new society.

Stadiums have much in common with the other four artifacts we have discussed in this book, especially with photography, as Benjamin makes clear in his "Work of Art" essay. "In mass sporting events," he writes, "the masses come face to face with themselves. This process, whose significance need not be emphasized, is closely bound up with the development of reproduction and recording technologies."[54]

Benjamin singles out two important parallels between stadiums and "reproduction and recording technologies" like radio or photography. First of all, both stadiums and new media are mass phenomena, inventions designed to disseminate information to tens or hundreds of thousands of recipients; thus stadiums, like photography and film, constitute a form of mass media. Second, stadiums, like the other artifacts discussed in this book, owe their existence to the rise of technologies of reproduction: the scale of stadium events is too great to be grasped by the naked eye and thus presupposes the existence of a mechanical extension of the eye. "Mass movements," explains Benjamin, "are more clearly apprehended by the camera than by the eye. A bird's-eye view best captures assemblies of hundreds of thousands."[55]

As in the case of skyscrapers, radio towers, and other constructions of modernity, stadium events are designed for the camera (and especially for the oblique perspectives we discussed in chapter 1). Kracauer reaches a similar conclusion when he compares mass ornaments to "aerial photography of landscapes and cities."[56] Stadiums – like cameras, typewriters, radio, and cement – are thus a by-product of the age of mechanical reproducibility, a link that explains why photographers and filmmakers from Modotti to Riefenstahl proved to be such enthusiastic admirers of stadiums.

TEPITO IN THE EARLY MORNING

"Baltimore, in the early morning, is the best image to sum up the unconscious."

Jacques Lacan (1966)

In the early morning, traffic comes to a halt as the streets of Tepito, the working-class district of Mexico City, are turned into a gigantic open-air market. Every inch of every street is taken up by ambulant peddlers forming a maze of makeshift stands — bright blue tarpaulins laid on the ground and decorated with carefully arranged displays of various wares. Crowds of urban types — soldiers, Indian women wearing long black braids, schoolgirls in tight orange t-shirts — squeeze through the vendors, indifferent to the calls of *merolicos:* "¿Qué va a llevar?" "Pásele, pásele pásele," " Productos de caaalidad ofreeece a la venta, treees por cinco peeesos," "Ándele güero, ándele chatita."

But this is no ordinary market of arts and crafts: neither Oaxacan pottery nor woven rugs are to be found in this labyrinth of commodities. Instead, peddlers offer another type of wares, more popular with the crowds. One stand specializes in television sets: remote-controlled, programmable color televisions, all tuned to the same local program and stacked ten-high on a bright plastic tarp. Across the street, another vendor has arranged a dozen cellular phones to form a cross on a blue cloth spread out on the sidewalk. Next to them, a young couple inspects a Whirlpool refrigerator, an enormous contraption that towers over the squat vendor. Other stalls offer bootleg videotapes of the new Salma Hayek film, wireless drills, transparent plastic telephones, stolen car stereos, "woqui toquis," overhauled car engines, plain-paper fax machines, satellite dishes, vacuum cleaners, computer disks, short-wave radios, and talking clocks. To run their gadgets, merchants hook up flimsy wires to the power lines towering above them, forming a web of cords that obscures the facades of dilapidated colonial palaces. Peddlers too poor to afford a stand crisscross the streets with tiny gadgets – musical key chains, battery-operated toys, calculator watches – hanging from their fingers, like decorations suspended from the branches of a Christmas tree.

But not all in Tepito revolves around technological gadgets. On street corners, women sell handmade sweets – amaranth-seed *alegrías* and *fruta cubierta* – from wicker baskets; construction workers swarm around a giant vat of boiling stew where a cook dishes out plates of entrail-laden *menudo;* and tiny, barefoot children run among the stands, stretching out their empty palms to apathetic pedestrians. There seems to be no logic to the bizarre juxtapositions found in the streets of Tepito, where office workers in suits and ties rub shoulders with peasants in straw hats, where semi-nude, feather-clad New Age dancers stage Aztec rituals before the gates of Latin America's oldest and grandest cathedral. Tepito, in the early morning, is a tangled web of cultural contradictions.

Tepito in the early morning might not be – as Baltimore was for Jacques Lacan – "the best image to sum up the unconscious," but it does provide a provocative vantage point for reflecting on the evolution of discourse networks from the period covered in this study to the early years of the twenty-first century. The car stereos and cellular phones peddled daily on the streets of Tepito are every bit as technological as the cameras, typewriters, and radios analyzed in this study, yet their repercussions in the cultural sphere could not be more different. During the first two decades of the twentieth century, technological artifacts exerted

a powerful fascination on writers and artists: radios and cameras were not merely perceived as useful and efficient machines, but were hailed as marvelous harbingers of a new era, as messengers of a technological revolution that would radically improve every aspect of human experience. In contrast, the countless gadgets and flashy appliances sold daily at Tepito lack any symbolic power. They are banal commodities, destined to be bought and sold – alongside taco stands and *comida corrida* restaurants – like fruits, vegetables, or other entirely unremarkable goods in a market.

But what exactly are these symbolic powers, so prominent in early technologies and so conspicuously absent in today's gadgets? Among the marvelous attributes possessed by the technological artifacts examined in this study, none was more important than their connection to utopian thought. Cameras, typewriters, radios, stadiums, and other concrete constructions inspired artists and writers to imagine technological utopias: brave new worlds where machines and industrial processes would lead Mexico – and the world – into a golden future.

The thinker who most clearly expressed the vision of a technological utopia was José Vasconcelos. As we saw in chapter 5, Vasconcelos imagined Universópolis, the future capital of the cosmic race, as a city dominated by technology: technicians and engineers, he tells us, will command the turbines and dams to power the development of Latin America. Vasconcelos believed that technology would not only lead Latin America into an age of prosperity, economic development, and industrial superiority but would also lead the nations of the cosmic race into the ultimate utopia: the "aesthetic period," an age of unsurpassable bliss and spiritual plenitude which represented the pinnacle of civilization, and which Vasconcelos described as the closest earthly approximation to the Kingdom of God. All of these hopes and utopian aspirations materialized in the National Stadium, which was to be the first building of Universópolis.

In contrast to Vasconcelos's Universópolis, a space firmly rooted in Latin American traditions and geography, Diego Rivera's technological utopia was located in the United States. Since his first murals in San Francisco, the painter saw Mexico's northern neighbor as the land where machines were bringing about the liberation of humankind from "drudgery and suffering." But Rivera's Detroit mural also shows us that utopian thought cannot do justice to the contradictions that characterize reality: as we saw in the introduction, the portrait of harmony depicted in *Detroit Industry* could not be further removed

from the harsh conditions that the city's auto workers experienced in 1932.

In order to depict his technological utopia, Rivera turned a blind eye not only to the real Detroit but also to the reality of life in Mexico during the 1930s. In all his celebratory depictions of industries, factories, and machines, the viewer will be hard pressed to find a single reference to the contradictions and unevenness that characterized postrevolutionary efforts to modernize the country. Far from welcoming technology as a mechanical savior, as Rivera predicted, Mexicans received the artifacts of modernity with mixed feelings – an attitude that reflects the historical differences that set Mexico apart from the industrialized countries that created these inventions. To the band of illiterate revolutionaries in Azuela's *Los de abajo*, the typewriter was not a wondrous invention that would revolutionize the writing of literature, but a useless curiosity that soon became an oppressive burden.

In contrast to Vasconcelos and Rivera, Tina Modotti did not envision a new utopian world, but her photographs nevertheless reveal a vision shaped by technological utopianism. Her work celebrates all that was modern in Mexico, from oil tanks and telephone wires to the buildings constructed by the postrevolutionary government. As we saw in chapter 1, Modotti's technological enthusiasm led her to celebrate projects that would seem entirely antithetical to her radical politics. We can clearly understand why she would photograph political scenes, such as workers reading a communist paper, a May Day celebration, or an allegory of the revolution as in *Sickle, Bandolier, Guitar* (1927). But why would a radical activist create an aestheticized homage to Vasconcelos's National Stadium, a temple to protofascist views predicated on race and spirit? At least in this case, Modotti fell into the same trap as Rivera: her technological utopianism blinded her to the political implications of the modern projects she celebrated.

While Vasconcelos began building a Latin American utopia and Rivera depicted a fictional utopia, the poets Kyn Taniya and Manuel Maples Arce believed that radio would eventually lead to a global utopia. As we saw in chapter 3, Kyn Taniya – like Rudolf Arnheim and other radio theorists of the twenties and thirties – celebrated the radio's power to eliminate distance, borders, and national differences. With the advent of wireless communication, all nations would be united in a tightly knit radiophonic community, a utopian ambition symbolized by the image – found so often in avant-garde poetry – of a night sky crisscrossed by invisible radio waves carrying everything from jazz concerts to private love messages. These transmis-

sions from around the world were available to listeners everywhere "for the price of one dollar," and wireless technology promised to make the global utopia accessible to anyone, anywhere.

Whereas the Estridentistas imagined a wireless, immaterial utopia on the night sky, Federico Sánchez Fogarty envisioned a solid, indestructible cement utopia here on the ground. Overtaken by a missionary zeal, the Mexican publicist preached the coming of an "age of cement" and sought to convert architects and engineers to the wonders of concrete, the most "mechanized" and modern of building materials. In the pages of *Cemento,* Sánchez Fogarty published countless technical articles detailing the procedures to build cement houses, cement roads, cement factories, cement garden furniture, and even cement swimming pools[1]—an entirely new world, "eternal" and "indestructible." But cement was utopian not only because of its strength and endurance as a building material: it also emerged as a symbolic antidote to the evils of the Mexican Revolution—a magical binder to repair the social fabric and counteract the tensions and divisions that had led to the outbreak of civil war.

Like radio, cement was antithetical to Mexican nationalism. In contrast to the nationalist revival that emerged in the early 1920s, the cement architecture favored by Sánchez Fogarty down-played the national context in favor of an international style. Functionalist cement buildings looked the same whether they were built in Paris, Mexico City, or Chicago, and the new style was to liberate architecture from the tyranny of national particularities, inserting cement buildings into an international aesthetics of modernity. Entering a cement building had the same effect as tuning a radio: one was suddenly transported into a modern, cosmopolitan world that had been made possible by technology. Like radio, cement promised an international cosmopolitanism that would eventually dissolve all national boundaries.

The technological utopias imagined by these figures—Rivera, the Estridentistas, Sánchez Fogarty, and Vasconcelos—had one aspect in common: they were located not in Mexico but *elsewhere.* Vasconcelos placed Universópolis, the capital of the cosmic race, in a remote area of Brazil, near the Falls of Iguazú; Rivera situated his worker's paradise in Detroit; the Estridentistas projected their dream of a global utopia onto an imaginary night sky brimming with dematerialized radio waves; and Sánchez Fogarty promoted a cement utopia whose buildings, though grounded on Mexican soil, belonged to the international style of functionalist architecture.

And why are these technological utopias invariably located outside Mexico? Perhaps because

the technological reality in Mexico during the 1920s and 1930s was far from utopian. The country had embraced modern technologies like radio and cement architecture, but development had been uneven and haphazard: late-model Fords shared Parisian-style boulevards with donkey-drawn carts, functionalist cement structures shared city blocks with eighteenth-century baroque churches, and radio receivers played jazz music while mariachis continued to sing revolutionary *corridos*. Modernity had arrived in Mexico, but it did not replace the premodern past; it merely coexisted with it, and life in the capital became a paradoxical juxtaposition of ultramodern artifacts and old-fashioned rituals, of cosmopolitan ambitions and nationalistic tendencies, just like Tepito in the early morning. When Mexican thinkers imagined a modern utopia, they were drawn to the ideal of a coherent, orderly, and uniformly developed world – a space whose congruity was diametrically opposed to the anarchic jumble of historical periods found in Mexico City.

The discourse networks considered in this book were utopian in more than one way: writers and artists not only imagined that technological artifacts would eventually lead to a more developed world, but they also believed that technology would revolutionize aesthetic practices. Among these figures, the most progressive thinkers were not satisfied with representing technology but sought to explore the potential inherent in the new mechanical media by inventing new strategies of representation as modern and as innovative as the machines they emulated.

As we saw in chapter 1, Tina Modotti was the first photographer in Mexico to view photography as a radically new form of aesthetic representation. Unlike pictorialist photographers who sought to establish a continuity between painting and their craft, Modotti deployed techniques such as close-ups, sharp focus, and oblique perspectives that could only be achieved with a mechanical instrument like the camera. While pictorialists made photos that looked like paintings, Modotti created images that insist on photography's status as an innovative technology of visual representation.

While Tina Modotti explored the impact of technology on visual representation, typewriting authors from Maples Arce to Mário de Andrade sought to create a new form of mechanogenic writing. Like other avant-garde writers, Maples Arce believed that technology, besides transforming daily life, would also revolutionize techniques of writing. A work like Andrade's "Máquina de escriver" not only celebrates the typewriter, but it does so through experimental techniques. In this poem, as in Modotti's photograph of Julio Antonio

Mella's typewriter, the technique of representation is attuned to the subject of representation.

Among the new inventions of the twentieth century, radio was the most successful in inspiring a new discourse network. In order to replicate the experience of listening to a wireless receiver, Kyn Taniya does away with most poetic conventions – rhyme, meter, punctuation, and even spacing – and he creates a language capable of transmitting the acoustic bombardment of disparate voices and musical styles experienced while tuning a radio. The result is a radically new poetic form that is as technologically advanced in the realm of literature as the wireless is in the realm of machines. Like Modotti and Andrade, Kyn Taniya sought a correspondence between the subject matter and the technique of representation: he writes radiogenic poetry to emulate radio.

But technology's impact on discourse networks went beyond literature and art. In the same way that mechanical processes transformed visual and textual representation, the advent of reinforced concrete – "the most mechanized of materials," as Sánchez Fogarty called it – revolutionized architecture. Whereas previous construction techniques were based on the need to pile stone upon stone or brick upon brick, cement allowed the creation of vast, seamless monolithic structures like the Jalapa Stadium. These and other innovations made possible by concrete construction were made explicit in functionalist architecture, a movement that successfully propagated a radically new "aesthetics of cement."

The ambition to create utopias proved more successful in the imaginary register than in real life. Universópolis was never built, but textual and pictorial utopias proliferated in the 1920s and 1930s. And the repercussions of these utopian experiments were often felt beyond the realm of aesthetics, with art and literature demonstrating their power to alter the course of history. The Estridentistas – inspired by their vision of radio as a harbinger of linguistic revolution – were actively involved in and ultimately helped shape the history of radio broadcast in Mexico. And the powerful textual and pictorial representations of cement as a social glue that circulated in the 1920s inspired architects and engineers to use the new building technology, an impulse that in one case – Jara's cement ship – led to historically disastrous but symbolically fascinating results. Because of their ability to extend their influence outside the realm of aesthetic creation, these experiments were truly utopian.

Modotti, Andrade, Kyn Taniya, and Sánchez Fogarty were extremely progressive in their utopian quest for an aesthetic revolution modeled on Mexico's postrevolutionary technological revolution.

Not all advocates of technology favored such a radical transformation of aesthetic practices, and interest in technology as a subject matter did not always coincide with an ambition to modernize aesthetic practices. Many representations of technology, including pictorialist photography and the murals of Diego Rivera, are paradoxical and ambivalent: either they embrace modern subject matter while rejecting modern techniques of representation, or, conversely, they uphold novel techniques – like photography – while privileging traditional themes. Thus, in *Detroit Industry*, Diego Rivera celebrated the modern machinery of the Ford automotive factories using the most untechnological of media, fresco painting. Pictorialist photographers used the camera – a technologically advanced medium – to represent untechnological village scenes, rural landscapes, and revolutionary melees. And Vasconcelos used modern materials to construct the most unmodern of buildings, a stadium inspired by the traditions of ancient Greece. In all of these projects, we find a paradoxical disjunction between the medium and the subject of representation: these works are haunted by a missed encounter with modernity.

If we now return to Tepito and its peddlers of gadgets, we can see how greatly modernity and its cultural repercussions have changed since the early decades of the twentieth century. Above all,

technological artifacts have ceased to inspire utopian projects. In the 1920s and 1930s, artists and writers embraced radios and typewriters as powerful symbols of progress, as instruments for the construction of a future world that would be technically developed, economically prosperous, and aesthetically innovative. But as we can see on the streets of Tepito, the propagation of technology did not fulfill its utopian promises. Though technological artifacts are now ubiquitous – everyone owns radios, televisions, VCRs, personal computers – they have failed to mitigate the social evils that Vasconcelos denounced in the 1920s: poverty is still rampant, economic development is still uneven, politicians are still closer to caudillos than to philosophers, and Mexico still lags behind its powerful Anglo-Saxon neighbor. And the paradoxical jumble of modernity and tradition that led artists and writers to imagine thoroughly modernized utopias has only become more acute: in the streets of Tepito, late-model cars share the streets with wooden carts; taco stands obstruct the entrances of computer stores; policemen stand under broken traffic lights, using white gloves and whistles to direct traffic. Technology has created not a utopia but a dystopia: a dysfunctional society haunted by many of the same specters of the postrevolutionary years.

Not only has technology failed to produce the economic utopia envisioned by Vasconcelos, but more significantly it has also lost its association with collective betterment, an ideal inherent in all utopian visions. Unlike cement stadiums and radios, with all their promise of a new world, today's technological artifacts are merely ordinary commodities for personal consumption. Perhaps the loss of social ideals in the technological realm is another example of the "passing of mass utopia," to use Susan Buck-Morss's term for the demise of collective ideals that characterizes our post–cold war age.[2]

But the most striking difference between today's machines and the technological artifacts examined in this study has to do with representation. As we saw, in the 1920s and 1930s, cameras and stadiums, typewriters and radios, cement and industrial plants produced a new discourse network: they inspired murals and photographs, poems and novels, cultural journals and even artistic competitions. New media had a powerful impact on art and literature. What is sorely missing in today's technological world is an interest in exploring and experimenting with the new technologies' potential to transform the possibilities of representation. Today, Tepito lacks a symbolic dimension. At a time when daily life in Mexico is increasingly dominated by machines and computers, contemporary writers and artists seem uninterested in exploring the relation between technology and representation. Millions of Mexicans are connected to the Internet, yet there are no novels exploring the impact of the World Wide Web on writing; in Tepito, Mexican and foreign tourists snap digital pictures with electronic cameras, yet no mainstream photographers have considered the revolutionary impact of digitization on the medium. Technology has ceased to spark the imagination not only of artists and writers but of ordinary people. Even the most remarkable and marvelous of inventions – the new wireless technology known as "Wi-Fi" – lack the power to inspire wonder: no one asks how these gadgets might allow us to write or to use language in a new way, how they might produce a new "wireless imagination." We have become accustomed to using machines we do not understand, and their Byzantine workings no longer elicit our curiosity or awaken our imagination.

Technology, it appears, has lost its symbolic powers. In the first decades of the twentieth century, cameras, typewriters, radios, cement, and stadiums were transformed into powerful symbols, into striking metaphors of power, progress, unity, and collective bliss. Like all tropes, these technological metaphors became vehicles through which a culture – postrevolutionary Mexico – expressed

its fears and desires, contemplated its past, and reflected on its future. But today, to quote the title of a surrealist work from the 1920s, there is no more play. Technology is no longer deployed as a metaphor, but merely circulated as a commodity, and our culture – unlike the world of Modotti, Andrade, Kyn Taniya, Sánchez Fogerty, and Vasconcelos – has been deprived of the pleasures of symbolic play.

Notes

Introduction: Media and Modernity in Mexico

1. Quoted in Linda Bank Downs, *Diego Rivera: The Detroit Industry Murals* (New York: W. W. Norton, 1999), 34.

2. Diego Rivera with Gladys March, *My Art, My Life* (New York: Dover Publications, 1991), 111–112.

3. Manuel Gutiérrez Nájera, "El movimiento literario en México," in *Obras,* vol. 1 (Mexico City: Universidad Nacional Autónoma de México, 1959), 191–192. All translations are mine, unless noted otherwise.

4. Octavio Paz, *Cuadrivio: Darío, López Velarde, Pessoa, Cernuda* (Mexico City: Joaquín Mortiz, 1965), 20.

5. Patrick Marnham, *Dreaming with His Eyes Open: A Life of Diego Rivera* (New York: Knopf, 1998), 170.

6. Walter Benjamin, "The Work of Art in the Age of Its Technological Reproducibility (Third Version)," in *Selected Writings,* vol. 4, ed. Howard Eiland and Michael W. Jennings (Cambridge: Harvard University Press, 2003), 257.

7. Quoted in Jorge Schwartz, *Las vanguardias latinoamericanas: textos programáticos y críticos* (Madrid: Cátedra, 1991), 45. Although Vallejo was writing about poetry, his argument applies to other art forms.

8. László Moholy-Nagy's *Von Material zu Architektur* was translated as *The New Vision* (New York: Brewer, Warren & Putnam, 1932); Aleksandr Rodchenko, "The Paths of Modern Photography," in Christopher Phillips, ed., *Photography in the Modern Era: European Documents and Critical Writings 1913–1940* (New York: Metropolitan Museum of Art/Aperture, 1989), 262; David

Alfaro Siqueiros, "A Transcendental Photographic Work: The Weston-Modotti Exhibition," in Amy Conger and Beaumont Newhall, eds., *Edward Weston Omnibus: A Critical Anthology* (Salt Lake City: Peregrine Smith Books, 1984), 19–20.

9. Albert Renger-Patzsch, "Photography and Art," in Phillips, *Photography in the Modern Era*, 143.

10. Rodchenko, "The Paths of Modern Photography," 258–259.

11. Ibid.

12. Quoted in Sybil Moholy-Nagy, *Moholy-Nagy: Experiment in Totality* (Cambridge: MIT Press, 1969), 12.

13. Downs, *The Detroit Industry Murals*, 60–61.

14. Ibid., 11, 143, 145. See also Terry Smith, *Making the Modern: Industry, Art, and Design in America* (Chicago: University of Chicago Press, 1993), 93–140.

15. Downs, *The Detroit Industry Murals*, 144.

16. Ibid., 145.

17. Rosalind E. Krauss, *The Originality of the Avant-Garde and Other Modernist Myths* (Cambridge: MIT Press, 1985), 204–211.

18. Downs, *The Detroit Industry Murals*, 146.

19. Desmond Rochfort, *The Murals of Diego Rivera* (London: Journeyman, 1987), 67.

20. Rivera, *My Art, My Life*, 122.

21. Smith, *Making the Modern*, 210–213. See also Max Kozloff, "Diego Rivera Frescoes of Modern Industry at the Detroit Institute of Arts," *Artforum* (November 1973): 58–63; Laurance P. Hurlburt, *The Mexican Muralists in the United States* (Albuquerque: University of New Mexico Press, 1989), 148; David Craven, *Diego Rivera as Epic Modernist* (New York: G. K. Hall, 1997), 143–145.

22. Friedrich A. Kittler, *Gramophone, Film, Typewriter* (Stanford: Stanford University Press, 1999), xxix.

23. Quoted in Friedrich A. Kittler, *Discourse Networks 1800/1900* (Stanford: Stanford University Press, 1990), 196.

24. Theodor W. Adorno, "The Curves of the Needle," in Adorno, *Essays on Music*, ed. Richard Leppert (Berkeley: University of California Press, 2002), 271–287.

25. Kittler, *Gramophone, Film, Typewriter*, 14.

26. Ibid., xxx.

27. Carleton Beals, *Mexican Maze* (Philadelphia: J. B. Lippincott, 1931), 152.

28. Carlos Chávez, *Toward a New Music: Music and Electricity* (New York: Norton, 1937).

29. Beatriz Colomina, *Privacy and Publicity: Modern Architecture as Mass Media* (Cambridge: MIT Press, 1994), 15, 73.

1 Cameras

1. Tina Modotti, unpublished letter to Manuel Álvarez Bravo, March 25, 1931, collection of Colette Álvarez Bravo Urbajtel.

2. Tina Modotti, "Photos als Waffe de RH-Agitation," *MOPR* 7, no. 3 (March 1932): 10–11. Translated as "Photography as Weapon" in *History of Photography* 18, no. 3 (Autumn 1994): 286.

3. Tina Modotti, "On Photography," *Mexican Folkways* 5 (October-December 1929): 196.

4. Snapshot (pseud.), "Conversaciones sobre el arte en fotografía," *El Universal Ilustrado* 503 (December 30, 1926): 8.

5. Ibid.

6. Alfred Stieglitz, "Pictorial Photography," in Alan Trachtenberg, ed., *Classic Essays on Photography* (New Haven: Leete's Island Books, 1980), 117–118.

7. Ibid., 116.

8. Ibid., 122.

9. Ibid., 119.

10. Silva's photographs appeared in the following issues of *El Universal Ilustrado:* no. 395 (December 4, 1924): 25; no. 541 (September 21, 1927): 21; no. 583 (July 12, 1928): 15; and his obituary appears in no. 674 (April 10, 1930): 10.

11. "Un retrato de Silva en 10 minutos," *El Universal Ilustrado* 395 (December 4, 1924): 25, 53.

12. Walter Benjamin, "Little History of Photography," in *Selected Writings,* vol. 2, ed. Michael W. Jennings, Howard Eiland, et al. (Cambridge: Harvard University Press, 1995), 515, 517.

13. Diego Rivera, "Edward Weston and Tina Modotti," *Mexican Folkways* 2, no. 1 (April-May 1926): 16.

14. David Alfaro Siqueiros, "A Transcendental Photographic Work: The Weston-Modotti Exhibition," in Amy Conger and Beaumont Newhall, eds., *Edward Weston Omnibus: A Critical Anthology* (Salt Lake City: Peregrine Smith Books, 1984), 19.

15. Ibid., 19–20.

16. Ibid., 20.

17. Modotti, "On Photography," 196.

18. Tina Modotti, letter to Edward Weston, September 18, 1928, in Amy Stark, ed., *The Letters from Tina Modotti to Edward Weston* (Tucson: Center for Creative Photography, 1986), 56.

19. Edward Weston, *Daybooks of Edward Weston,* vol. 1, ed. Nancy Newhall (New York: Aperture, 1973), 99.

20. Ibid., 21.

21. Aleksandr Rodchenko, "The Path of Modern Photography," in Christopher Phillips, ed., *Photography in the Modern Era: European Documents and Critical Writings 1913–1940* (New York: Metropolitan Museum of Art/Aperture, 1989), 256.

22. Ibid., 258.

23. Ibid.

24. Ibid., 258–259.

25. Ibid., 259.

26. There is a second example of this dizzying naming and renaming of images: *Woman with Flag* (1928). *New Masses* published it with the title "Mexican Miner's Wife Picketing before a Mine in Jalisco," but a year later the Soviet journal *Puti Mopra* [17 (1929)] and Germany's *AIZ* [17 (1931)] identified it as "Woman with Red Flag" and "Woman with a Black Anarco-Syndicalist Flag." See Christiane Barckhausen-Canale, *Verdad y leyenda de Tina Modotti* (Havana: Casa de las Américas, 1989), 239.

27. Carleton Beals, "Tina Modotti," *Creative Art* 4, no. 11 (February 1929): l.

28. Walter Benjamin, "The Work of Art in the Age of Its Technological Reproducibility (Third Version)," in *Selected Writings*, vol. 4, ed. Howard Eiland and Michael W. Jennings (Cambridge: Harvard University Press, 2003), 258.

29. In German the text reads, "Wird die Beschriftung nicht zum wesentlichen Bestandteil der Aufnahme werden?" Walter Benjamin, "Kleine Geschichte der Photographie," in Benjamin, *Gesammelte Schriften* (Frankfurt: Suhrkamp Verlag, 1972–1981), 2: 385.

30. Walter Benjamin, "A Small History of Photography," in *One-Way Street and Other Writings*, trans. Edmund Jephcott and Kingsley Shorter (London: New Left Books, 1979), 256. Jephcott and Shorter translate the German term *Beschriftung* as "caption," but Eiland and Jennings render it as "inscription." See Benjamin, "Little History of Photography," in *Selected Writings*, vol. 2, ed. Michael W. Jennings, Howard Eiland, et al. (Cambridge: Harvard University Press, 1999), 527.

31. Eduardo Cadava, *Words of Light: Theses on the Photography of History* (Princeton: Princeton University Press, 1997), 20.

32. Leah Ollman, *Camera as Weapon: Worker Photography between the Wars* (San Diego: Museum of Photographic Arts, 1991), 25.

33. Ibid., 22–24.

34. Modotti, "Photography as Weapon," 289.

35. Ibid.

36. Denis Hollier, "Surrealist Precipitates: Shadows Don't Cast Shadows," *October* 69 (Summer 1994): 115.

37. Rosalind E. Krauss, *The Originality of the Avant-Garde and Other Modernist Myths* (Cambridge: MIT Press, 1985), 204.

38. Ibid., 211.

39. Charles Sanders Peirce, "Theory of Signs," in *Philosophical Writings of Peirce*, ed. Justus Buchler (New York: Dover, 1955), 114.

2 Typewriters

1. Friedrich A. Kittler, *Discourse Networks 1800/1900* (Stanford: Stanford University Press, 1990), 193.

2. Richard Current, *The Typewriter and the Men Who Made It* (Urbana: University of Illinois Press, 1954), 71.

3. Martin Stingelin, "Comments on a Ball: Nietzsche's Play on the Typewriter," in Hans Ulrich Gumbrech and K. Ludwig Pfeiffer, eds., *Materialities of Communication* (Stanford: Stanford University Press, 1994), 21.

4. Theodora Bosanquet, *Henry James at Work* (London: Hogarth Press, 1924), 3.

5. Martin Heidegger, *Parmenides*, trans. André Schuwer and Richard Rojcewicz (Bloomington: Indiana University Press, 1992), 80–81.

6. Manuel Gutiérrez Nájera, "El movimiento literario en México," in *Obras*, vol. 1 (Mexico City: Universidad Nacional Autónoma de México, 1959), 191–192.

7. Mariano Azuela, *Los de abajo*, in *Obras completas* (Mexico City: Fondo de Cultura Económica, 1976), 1, 363. Trans. as *The Underdogs*, in *Two Novels of the Mexican Revolution: The Trials of a Respectable Family and The Underdogs*, trans. Frances Kellam Hendricks and Beatrice Berler (San Antonio: Trinity University Press, 1963), 206–207; translation modified.

8. Mariano Azuela, *Sin amor,* in *Obras completas,* 1: 261.

9. Mariano Azuela, "*Mala yerba* y *Sin amor,*" in *Obras completas,* 3: 1054 ff.

10. Azuela, *Sin amor,* 1: 307.

11. Mariano Azuela, *Los de abajo,* 3: 1080–1081.

12. Stanley L. Robe, *Azuela and the Mexican Underdogs* (Berkeley: University of California Press, 1979), 68.

13. Francisco Monterde, *Mariano Azuela y la crítica mexicana* (Mexico City: Secretaría de Educación Pública, 1973), 323.

14. Frank T. Masi, *The Typewriter Legend* (Secaucus, N.J.: Matsushita Electric Corporation of America, 1985), 110.

15. Mariano Azuela, *La luciérnaga,* in *Obras completas,* 1: 594. Emphasis mine.

16. Masi, *Typewriter Legend,* 61.

17. Michael H. Adler, *The Writing Machine* (London: George Allen & Unwin, 1973), 322. On the history of the Oliver typewriter, see also Paul Lippman, *American Typewriters: A Collector's Encyclopedia* (Hoboken: Original & Copy, 1992), 140–145; and Bruce Bliven, *The Wonderful Writing Machine* (New York: Random House, 1954), 108.

18. Friedrich A. Kittler, *Gramophone, Film, Typewriter* (Stanford: Stanford University Press, 1999), 221.

19. Mariano Azuela, *Grandes novelistas,* in *Obras completas,* 3: 814.

20. Azuela, *El novelista y su ambiente [2]* in *Obras completas,* 3: 1120. Azuela's attacks against the Contemporáneos place him in the same camp with reactionary critics like Ermilo Abreu Gómez, who denounced modern narrative techniques as foreign imports. He called the Contemporáneos' engagement with modernist narrative a "European norm" that distanced them from the "reality of the Mexican race" and from the "tragedy" of its history. Ermilo Abreu Gómez, *Clásicos, románticos, modernos* (Mexico City: Ediciones Botas, 1934), 217.

21. Azuela's relationship with modern writers was full of scenes of misrecognition. In 1924 the Estridentistas considered him a kindred spirit (even though Azuela had no interest in futurism or in the myriad machines that inspired their movement), and they published the first widely circulated edition of *Los de abajo.* And despite the repugnance with which Azuela wrote about Gide and other "degenerate" homosexual writers, he published several texts in *Contemporáneos,* a journal run by the very writers he later censored as "effeminate" and "degenerate." (In "El afeminamiento de la literatura Mexicana," Jiménez Rueda considers naturalist narrative, like Azuela's *Los de abajo,* as "masculine," and he dismisses modernist literary experiments as "effeminate." See Julio Jimémez Rueda, "El afeminamiento de la literatura mexicana," *El Universal,* 21 December 1924.)

22. Azuela, *El novelista,* 3: 1112–1113.

23. Azuela claims to have tried his hand at these modern writing techniques, pointing to three novels (*La malhora, El desquite,* and *La luciérnaga*) as the products of his flirtation with modern writing. He concludes that later on he felt "ashamed" about these modernist experiments (ibid., 3: 1118).

24. "Mi amiga la credulidad" was published in 1918 in the New York paper *El Gráfico* 2, no. 5, 492. On the history of this text, see Abreu Gómez, *Clásicos, románticos, modernos,* 281 ff.

25. Bosanquet, *Henry James at Work,* 7.

26. Martín Luis Guzmán, "Mi amiga la credulidad," in *Obras completas de Martín Luis Guzmán* (Mexico City: Compañía General de Ediciones, 1961), 131.

27. Ibid.

28. Coincidentally, the Hammond, a nineteenth-century typewriter, had a keyboard modeled after a piano and actually looked like one. Richard Current writes, "The inventor described the touch on his machine as legato, on the others as *staccato*. 'The Hammond's keys,' it was said, 'may be worked more nearly like those of a piano, the fingers resting on more than one key at a time, and no misadjustment occurring'" (*The Typewriter and the Men Who Made It*, 106). This early typewriter could not compete with streamlined machines like the Remington, and was long discontinued by the time Guzmán wrote his text.

29. Kittler, *Gramophone, Film, Typewriter*, 191.

30. Kittler describes the Underwood's success: "None of the models prior to the Underwood's great innovation of 1897 allowed immediate visual control over the output. In order to read the typed text, one had to lift shutters on the Remington model" (*Gramophone, Film, Typewriter*, 203).

31. Masi, *Typewriter Legend*, 82.

32. Lippman, *American Typewriters*, 214.

33. Masi, *Typewriter Legend*, 82.

34. Frank Masi stresses the Remington's unsuccessful imitation of the Underwood's technical wonders: "Having joined the 20th century 20 years late, the Remington management evidently considered it prudent to underplay the [Remington] No. 10's adoption of a comb segment and knifeblade type-bar, the standard since the Underwood" (*Typewriter Legend*, 83). See also Lippman, *American Typewriters*, 157ff.

35. On Satie's *Parade*, see Roger Shattuck, *The Banquet Years: The Origins of the Avant-Garde in France, 1885 to World War I* (New York: Vintage, 1968), 151ff.

36. Guzmán, "Mi amiga la credulidad," 133.

37. Martín Luis Guzmán, "Acerca del fonógrafo," in *Obras completas de Martín Luis Guzmán*, 137.

38. Kittler, *Gramophone, Film, Typewriter*, xxviii, 14.

39. "The Express Wagons of Mexico City," *Remington Notes* 1, no. 2 (November 1907): 1–2.

40. *Typewriter Topics* 28, no. 2 (June 1914): 116.

41. Manuel Maples Arce, "Actual No. 1," in Jorge Schwarz, *Las vanguardias latinoamericanas: textos programáticos y críticos* (Madrid: Cátedra, 1991), 163.

42. Ibid., 163–164.

43. Mário de Andrade, "Máquina de escrever," in *Poesias completas*, vol. 2 of *Obras completas de Mário de Andrade* (São Paolo: Livraria Martins Editôra, 1966), 70.

44. Quoted in Marjorie Perloff, *The Futurist Moment: Avant-Garde, Avant Guerre, and the Language of Rupture* (Chicago: University of Chicago Press, 1986), 39.

45. Kittler, *Discourse Networks,* 194–195.

46. Heidegger, *Parmenides,* 80–81.

47. Ibid., 81.

48. Andrade, "Máquina de escrever," 70.

49. Ibid., 71.

50. Flora Süssekind, *Cinematograph of Words: Literature, Technique, and Modernization in Brazil* (Stanford: Stanford University Press, 1997), 106.

51. See the discussion of radiographic and radiogenic writing in chapter 3.

52. Süssekind, *Cinematograph of Words,* 105.

53. Pedro Salinas, "Underwood Girls," in Salinas, *Aventura poética (antología),* ed. David L. Stixrude (Madrid: Cátedra, 1980), 102–103.

54. Andrade, "Máquina de escrever," 71.

55. I thank my colleague Jussara Quadros for her generosity in cracking the enigma of the "lagrima" and the "ponto fora de lugar."

56. Mário de Andrade, "Advertência: *Losango cáqui,*" in *Poesias completas,* 67.

57. Marcos Antonio de Moraes, ed., *Correspondência Mário de Andrade & Manuel Bandeira* (São Paulo: Universidade de São Paulo, 2000), 210. I thank my colleague Pedro Meira Monteiro for bringing this correspondence to my attention.

58. Ibid., 201.

59. Quoted in Kittler, *Discourse Networks,* 196.

60. In the 1920s there were only two portable typewriters: the Remington and the Underwood. We can see that the arrangement of the Underwood's keys matches the shape of those in Modotti's photo. The Remington's ribbon reel is concealed under the cover, but the Underwood's is entirely visible, as Modotti's photograph shows. The main clue comes from the disposition of the type bars: in the Remington they are concealed behind an enclosure, while in the Underwood they are visible, as we see in Modotti's photograph.

61. Bliven, *Wonderful Writing Machine,* 120–121.

62. Critics often refer to *La técnica* as a photograph of typewriter keys; Sarah Lowe, for example, compares it to a 1927 Ralph Steiner close-up of typewriter keys. However, this description is only partially accurate since Modotti's photograph includes many other typewriter components, as well as text. Sarah Lowe, *Tina Modotti Photographs* (New York: Harry N. Abrams, 1995), 312.

63. Masi, *Typewriter Legend,* 110.

64. André Breton, *Manifeste du surréalisme,* in *Oeuvres complètes* (Paris: Gallimard, 1988), 328. Emphasis mine.

65. Ibid., 341.

66. Quoted in Lowe, *Tina Modotti Photographs,* 151, n. 236.

67. Leon Trotsky, *Literature and Revolution* (New York: International Publishers, 1925), 253. The Russian word *tekhnika* can mean "engineering," "technics," or "technology," but also – like the Greek *techne* – "technique" and even "art."

68. Ibid., 236. Elsewhere in *Literature and Revolution*, Trotsky gives another example of how art can be given "purposeful form" by technology. He points to the Eiffel Tower, emphasizing that the construction was a failure when it was first built because, despite its impressive proportions, it lacked a purpose. This great fault was corrected when the tower was transformed into a radio antenna: "If the tower had been built from the very beginning as a radio station . . . it probably would have attained a higher rationality of form, and so therefore a higher perfection of art." Trotsky, *Literature and Revolution*, 247.

5 Radio

1. Rudolf Arnheim, *Radio* (London: Faber and Faber, 1936), 13–14.

2. Stephen Kern, *The Culture of Time and Space 1880–1918* (Cambridge: Harvard University Press, 1983), 275.

3. F. T. Marinetti, "Futurist Sensibility and Wireless Imagination," in Marinetti, *Selected Poems and Related Prose*, ed. Luce Marinetti (New Haven: Yale University Press, 2002), 87.

4. Velimir Khlebnikov, "Radio of the Future," in Khlebnikov, *Snake Train: Poetry and Prose*, ed. Gary Kern (Ann Arbor: Ardis, 1976), 234.

5. Manuel Maples Arce, "T.S.H.: El poema de la radiofonía," *El Universal Ilustrado* 308 (April 5, 1923): 19.

6. Felipe Gálvez, "Cincuenta años nos contemplan desde las antenas radiofónicas," *Comunidad* 46 (December 1973): 736.

7. Carlos Noriega Hope, "Notas del director," *El Universal Ilustrado* 308 (April 5 1923): 11.

8. Alfonso Reyes, "La radio, instrumento de la paideia," *Todo*, January 21, 1945. Reprinted in Gloria Fuentes, *La radiodifusión* (Mexico City: Secretaría de Comunicaciones y Transportes, 1987), 187–190.

9. "Solemnemente fue inaugurada anoche la estación radiofónica de El Mundo," *El Mundo*, August 15, 1923, 1.

10. Benedict Anderson, *Imagined Communities: Reflections on the Origin and Spread of Nationalism* (London: Verso, 1983).

11. Gálvez, "Cincuenta años," 733.

12. Maples Arce, "TSH," 19.

13. César Vallejo, "Poesía nueva," in *Favorables París Poema* (1926), rpt. in Jorge Schwarz, *Las vanguardias latinoamericanas: Textos programáticos y críticos* (Madrid: Cátedra, 1991), 45.

14. Octavio Paz, "Poema circulatorio (para la desorientación general)," in Paz, *Obra poética* (Barcelona: Sex Barral, 1990), 620–622.

15. Marjorie Perloff, *The Futurist Moment* (Chicago: University of Chicago Press, 1986), 205–213.

16. Guillaume Apollinaire, *Correspondance avec son frère et sa mère*, ed. Gilbert Boudar and Michel Décaudin (Paris: Librairie José Corti, 1987), 125, 127.

17. Ibid., 140, 139.

18. Pierre-Marcel Adéma and Michel Décaudin, eds., *Album Apollinaire* (Paris: Gallimard, 1971), 186.

19. Apollinaire, *Correspondance*, 142.

20. Blaise Cendrars, "Ocean Letter," in Cendrars, *Complete Poems*, trans. Ron Padgett (Berkeley: University of California Press, 1992), 150.

21. Apollinaire was so taken by this conjunction that in 1916 he wrote a story, "Le roi Lune," about a fantastic radio apparatus that could broadcast live sounds from around the world, including Mexico. At the touch of a key the machine reproduces "the violent prayers rising before a crucifix in Mexico City." Apollinaire, "Le roi Lune," in Apollinaire, *Le poète assassiné* (Paris: Gallimard, 1979), 147.

22. Marinetti, "Futurist Sensibility and Wireless Imagination," 87.

23. Maples Arce, "Actual No. 1," in Schwartz, *Las vanguardias*, 270.

24. Ignotus (pseud.), "La locura del radio," *El Universal Ilustrado* 263 (May 18, 1922): 29.

25. *El Universal*, June 17, 1923, 1:1.

26. Quoted in Perloff, *The Futurist Moment*, 225.

27. *El Universal*, June 17, 1923, 1:9.

28. *El Universal*, June 17, 1923, 2:8.

29. Roald Amundsen and Lincoln Ellsworth, *First Crossing of the Polar Sea* (New York: George H. Doran, 1927), 230.

30. Roald Amundsen and Lincoln Ellsworth, *Air Pioneering in the Arctic: The Two Polar Flights of Roald Amundsen and Lincoln Ellsworth* (New York: National Americana Society, 1929), 80.

31. Ibid., 86.

32. Ibid., 95.

33. Ibid.

34. Ibid., 103.

35. *Excélsior*, June 6, 1926, 1.

36. Jorge Mejía Prieto, *Historia de la radio y la televisión en México* (Mexico City: Octavio Colmenares Editor, 1972), 34. This episode is repeated verbatim in Gloria Fuentes, *La radiodifusión* (Mexico City: Secretaría de Comunicaciones y Transportes, 1987), 71, and is also mentioned in Fernando Mejía Barquera, *La industria de la radio y la televisión*, vol. 1 (Mexico City: Fundación Manuel Buendía A.C., 1989), 26.

37. *Excélsior*, June 18, 1926, 8.

38. *Excélsior*, June 25, 1926, 8.

39. "Amundsen y Byrd hacen elogios de *Excélsior*," *Excélsior*, July 4, 1926, 1.

40. *Sesión solemne en homenaje al ilustre explorador de los polos Roald Amundsen* (Mexico City: Sociedad Mexicana de Geografía y Estadística, 1928), 135.

41. André Coeuroy, *Panorama de la radio* (Paris: Éditions Kra, 1930), 224.

42. Ibid.

43. Denis Hollier, "The Death of Paper: A Radio Play," *October* 78 (Fall 1996): 10–11.

44. Ibid., 11.

45. Salvador Novo, "Radioconferencia sobre el radio," in Novo, *Toda la prosa* (Mexico City: Empresas Editoriales, 1964), 23.

46. Ibid.

47. Ibid.

48. Ibid.

49. Ignotus, "La locura del radio," 32.

50. Coeuroy, *Panorama de la radio,* 224.

51. Kyn Taniya, "IU IIIUUU IU," in Kyn Taniya [Luis Quintanilla], *Radio: Poema inalámbrico en trece mensajes* (Mexico City: Editorial Cultura, 1924), n/p.

52. Esther Allen, unpublished translation of "IU IIIUUU IU," 2003.

53. Arnheim, *Radio,* 13–14.

54. Georges Duhamel, *In Defence of Letters* (New York: Greystone Press, 1939), 30, 35.

4 Cement

1. Beatriz Colomina, *Privacy and Publicity: Modern Architecture as Mass Media* (Cambridge: MIT Press, 1994), 73.

2. Federico Sánchez Fogarty, "El polvo mágico," *Cemento* 21 (January 1928): 30.

3. A second, more widely distributed edition of *Cemento* was published in 1929 by Editorial Cenit in Madrid. More editions followed in Latin America: 1932 and 1934 (Santiago: El Esfuerzo), and 1958 (Mexico City: Editora Nacional).

4. Luis Fernández Cifuentes, *Teoría y mercado de la novela en España: Del 98 a la República* (Madrid: Gredos, 1982), 305–306.

5. Baltasar Dromundo, "Libros, arte de la semana," *El Universal Ilustrado* 676 (April 24, 1930): 127. Frances Toor, unpublished letter to Joseph Freeman, March 9, 1933, Hoover Institution Archives, Joseph Freeman Collection, box 38, folder 45.

6. Fyodor Vasilievich Gladkov, *Cement,* trans. A S. Arthur and C. Ashleigh (New York: International Publishers, 1929), 13.

7. Ibid., 17, 14, 64.

8. Ibid., 65. This chapter title only appears in the Spanish translation of the novel (see note 14).

9. Ibid., 309, 311.

10. Ibid., 76.

11. Katerina Clark, *The Soviet Novel: History as Ritual* (Chicago: University of Chicago Press, 1981), 72, 78.

12. Quoted in Clark, *The Soviet Novel,* 72.

13. Ibid., 75.

14. Fyodor Vasilievich Gladkov, *Cemento,* trans. José Viana (Madrid: Editorial Cenit, 1929), 93.

15. "La casa de concreto tiene la fortaleza de El Palacio de Hierro. El Palacio de Hierro es un palacio de concreto," *El Universal Ilustrado* 433 (August 27, 1925): 9.

16. Federico Sánchez Fogarty, "El concreto es eterno," *Cemento* 21 (January 1928): 7.

17. Enrique X. de Anda Alanís, *La arquitectura de la Revolución mexicana: Corrientes y estilos de la década de los veinte* (Mexico City: Universidad Nacional Autónoma de México, 1990), 50–51.

18. Sánchez Fogarty, "El polvo mágico," 31.

19. Onderdonk (pseud.), "Cenicienta," *Cemento* 30 (July 1929): 19.

20. Federico Sánchez Fogarty, "Tópicos Generales," *Cemento* 19 (November 1926): 25.

21. Raúl Arredondo, "Las posibilidades del concreto," *Cemento* 25 (August 1928): 28–29.

22. Martí Casanovas, "Pastelería y arquitectura," *¡30-30!* 3 (1928): 8.

23. Federico Sánchez Fogarty, *Medio siglo de cemento en México* (Mexico City: Cámara Nacional del Cemento, 1951), 34.

24. OZY [Federico Sánchez Fogarty], "Qué es el concreto," *Cemento* 10–11 (November 1925).

25. C. A. Monroe, "Desafío," translated into Spanish by Derisanty [Federico Sánchez Fogarty], *Cemento* 24 (July 1928): 6.

26. Federico Sánchez Fogarty, "Fue un éxito el concurso artístico de 'La Tolteca,'" *Nuestro México* 2 (March 1932): 138.

27. The exhibit was held at the Teatro Nacional (now the Palace of Fine Arts) from December 5 to 15, 1931. The show was reviewed in *Tolteca* 21 (January 1932), and some of the works were reproduced in *Excelsior*'s photography section.

28. On the competition, see James Oles, "La nueva fotografía y Cementos Tolteca: Una alianza utópica," *Mexicana: Fotografía moderna en México, 1923–1940* (Valencia: IVAM, 1998).

29. Álvarez Bravo received six hundred pesos, which he used to buy a new camera. Susan Kismaric, unpublished interview with Manuel Álvarez Bravo, January 7, 1996, archives, Museum of Modern Art, New York.

30. For a detailed description of the processes involved in the manufacture of cement, see Sánchez Fogarty's "El polvo mágico."

31. Amédée Ozenfant and Edouard Jeanneret, *La Peinture moderne* (Paris: G. Crès, 1927), 66, 69.

32. Federico Sánchez Fogarty, "¿Por qué este primer premio?" *Tolteca* 21 (January 1932): 294.

33. Anita Brenner, *Your Mexican Holiday: A Modern Guide* (1932; New York: Putnam, 1935), 53.

34. Sánchez Fogarty, *Medio siglo de cemento en México*, 22.

35. My discussion of cult value and use value follows Denis Hollier's essay "The Use Value of the Impossible," in which he examines the Documents group's call for an exhibition space that would not strip objects of their use value. In Denis Hollier, *Absent without Leave: French Literature under the Threat of War* (Cambridge: Harvard University Press, 1997).

36. Karl Marx, *Capital: A Critique of Political Economy* (New York: Modern Library, 1996), 42.

37. Walter Benjamin, "The Work of Art in the Age of Its Technological Reproducibility (Third Version)," in Benjamin, *Selected Writings*, vol. 4, ed. Howard Eiland and Michael W. Jennings (Cambridge: Harvard University Press, 2003), 258–260.

38. Hollier, "Use Value," 128–129.

39. "El Sr. Presidente Inauguró ayer el estadio de Jalapa," *Excélsior,* September 21, 1925.

40. Quoted in Jorge Piño Sandoval, "Iniciación de las grandes obras en el puerto de Veracruz," *Excélsior,* December 21, 1942, 1.

41. On Piño Sandoval, see Baltasar Dromundo, *Rescate del tiempo* (Mexico City: Imprenta Madero, 1980), 154.

42. Jorge Piño Sandoval, "Perfílase colosal fraude en las obras del Puerto de Veracruz," *Excélsior,* January 23, 1944, 1.

43. Jorge Piño Sandoval, "Desenfreno administrativo en la obras de Veracruz," *Excélsior,* February 11, 1944, 1.

44. Ibid.

45. Concha de Villareal, "Hay despilfarro por impericia en la Marina," *Excélsior,* January 23, 1944, 1.

46. Piño Sandoval, "Desenfreno administrativo en la obras de Veracruz," 1.

47. "Of all the freak engineering feats with which the U. S. tried to bridge the Atlantic in World War I," *Time* reported, "none was more freakish than its concrete ship." "Floating Stones," *Time* (November 24, 1941): 95–96.

48. Carlos Zapata Vela, *Conversaciones con Heriberto Jara* (Mexico City: Costa Amic, 1992), 132.

49. Kendall E. Bailes, *Technology and Society under Lenin and Stalin: Origins of the Soviet Technical Intelligentsia, 1917–1941* (Princeton: Princeton University Press, 1978), 399–400.

5 Stadiums

1. Hans Ulrich Gumbrecht, *Lob des Sports* (Frankfurt: Suhrkamp Verlag, 2005), 88. See also David Gilman Romano, *Athletics and Mathematics in Archaic Corinth: The Origins of the Greek Stadion* (Philadelphia: American Philosophical Society, 1993), 6.

2. In 1921 the population of Mexico City was 906,000. INEGI, *IV Censo de Población y vivienda* (Mexico City: Instituto Nacional de Estadística, Geografía e Informática).

3. José Vasconcelos, *El desastre*, in Vasconcelos, *Memorias,* vol. 2 (Mexico City: Fondo de Cultura Económica, 1982), 248–250.

4. Ibid., 249.

5. Valerie Fraser, *Building the New World: Studies in the Modern Architecture of Latin America, 1930–1960* (London: Verso, 2000), 29.

6. José Vasconcelos, "El teatro al aire libre de la Universidad Nacional," *El Universal Ilustrado* 250 (February 16, 1922): 23.

7. Vasconcelos, *El desastre,* 251.

8. Secretaría de Educación Pública, *El Estadio Nacional: XXV aniversario* (Mexico City: Secretaría de Educación Pública, 1949), n/p.

9. Juan Galindo, "El enredo ocasionado por la intervención de manos en el Estadio Nacional," *Excélsior,* April 27, 1924, 3, 7.

10. Vasconcelos, *El desastre,* 253.

11. José Vasconcelos, *La raza cósmica*, in *Obras completas,* vol. 2 (Mexico City: Libreros Mexicanos Unidos, 1957), 926.

12. Ibid., p. 940.

13. José Vasconcelos, *Indología*, in *Obras completas,* 2:1293.

14. Ibid., 1299–1301.

15. Vasconcelos, *La raza cósmica*, 936.

16. Ibid., 926.

17. Vasconcelos, *Indología*, 1288.

18. Fraser, *Building the New World*, 24.

19. José Vasconcelos, *Discursos 1920–1950* (Mexico City: Ediciones Botas, 1950), 115.

20. Vasconcelos, *Indología*, 1269.

21. Vasconcelos, "El teatro al aire libre," 23.

22. Vasconcelos, *El desastre*, 252.

23. A detailed chronicle of the inauguration of the National Stadium appears in the following articles: "Un poema de sol, de color, de ritmo y de entusiasmo, fue la inauguración del gran Estadio Nacional, a la que concurrieron ayer no menos de sesenta mil personas" (*Excélsior*, May 6, 1924, 2:1); "Con un grandioso festival se inauguró ayer el Estadio Nacional" (*El Universal*, May 6, 1924, 2:1). Vasconcelos describes the inauguration in his memoirs (El *desastre*, 252), as well as in *Indología*, 1269 ff.

24. Kyn Taniya [Luis Quintanilla], "Estadio," *El Universal Ilustrado* 494 (28 October 1926): 40.

25. Irene Matthews, *Nellie Campobello: La centaura del Norte* (Mexico: Cal y Arena, 1997), 73.

26. Siegfried Kracauer, *The Mass Ornament: Weimar Essays*, trans. Thomas Y. Levin (Cambridge: Harvard University Press, 1995), 75.

27. Ibid., 77, 75.

28. Ibid., 75.

29. Ibid., 77.

30. Kyn Taniya, "Estadio."

31. Kracauer, *The Mass Ornament*, 78.

32. Ibid., 85.

33. Elias Canetti, *Crowds and Power*, trans. Carol Stewart (New York: Farrar, Straus and Giroux, 1984).

34. Richard D. Mandell, *The Nazi Olympics* (Urbana: University of Illinois Press, 1987), 38.

35. Albert Speer, *Inside the Third Reich*, trans. Richard and Clara Winston (New York: Simon and Schuster, 1970), 80.

36. Ibid., 68.

37. Ibid., 68, 70, 69.

38. Antonio E. Méndez Vigatá, "Politics and Architectural Language," in Edward R. Burian, ed., *Modernity and the Architecture of Mexico* (Austin: University of Texas Press, 1997), 69.

39. Vasconcelos, *El desastre*, 248–249.

40. Speer, *Inside the Third Reich*, 68.

41. Vasconcelos, *El desastre*, 253.

42. Ibid.

43. José Vasconcelos, *El proconsulado,* in Vasconcelos, *Memorias,* 2: 892.

44. Vasconcelos, *El desastre,* 436.

45. Itzhak Bar-Lewaw, *La revista "Timón" y José Vasconcelos* (Mexico City: Edimex, 1971).

46. "Hay que hacer limpieza," *Timón* 8 (13 April 1940): 44.

47. "Judaísmo vs. catolicismo: 15 millones contra 2,000 millones," *Timón* 12 (11 May 1940): 34.

48. José Vasconcelos, editorial, *Timón* 15 (1 June 1940): 5.

49. José Vasconcelos, "La inteligencia se impone," *Timón* 16 (8 June 1940): 9.

50. José Joaquín Blanco, *Se llamaba Vasconcelos* (Mexico City: Fondo de Cultura Económica, 1977), 171–172.

51. Frédéric Rouvillois, "Utopia and Totalitarianism," in Roland Schaer et al., *Utopia: The Search for the Ideal Society in the Western World* (New York: New York Public Library, 2000), 316.

52. Quoted in Raymond H. Anderson, "Czeslaw Milosz, Poet and Novelist Who Wrote of Modern Cruelties, Dies at 93," *New York Times,* August 15, 2004, 41.

53. Walter Benjamin, "The Work of Art in the Age of Its Technological Reproducibility (Third Version)," in *Selected Writings,* vol. 4, ed. Howard Eiland and Michael W. Jennings (Cambridge: Harvard University Press, 2003), 269.

54. Ibid., 262, n. 47.

55. Ibid.

56. Kracauer, *The Mass Ornament,* 77.

Epilogue: Tepito in the Early Morning

1. "Piscinas de natación de concreto armado," *Cemento* 38 (November 1930): 5–20.

2. Susan Buck-Morss, *Dreamworld and Catastrophe: The Passing of Mass Utopia in East and West* (Cambridge: MIT Press, 2000), ix–x.

Bibliography

Abreu Gómez, Ermilo. *Clásicos, románticos, modernos.* Mexico City: Ediciones Botas, 1934.

Adéma, Pierre-Marcel, and Michel Décaudin, eds. *Album Apollinaire.* Paris: Gallimard, 1971.

Adler, Michael H. *The Writing Machine.* London: George Allen & Unwin, 1973.

Adorno, Theodor W. *Essays on Music.* Ed. Richard Leppert. Berkeley: University of California Press, 2002.

Alba de la Canal, Rafael. "La exposición nacional de fotografía." *¡30-30!* 3 (1928).

Amundsen, Roald, and Lincoln Ellsworth. *First Crossing of the Polar Sea.* New York: George H. Doran, 1927.

Amundsen, Roald, and Lincoln Ellsworth. *Air Pioneering in the Arctic: The Two Polar Flights of Roald Amundsen and Lincoln Ellsworth.* New York: National Americana Society, 1929.

Anderson, Benedict. *Imagined Communities: Reflections on the Origin and Spread of Nationalism.* London: Verso, 1983.

Andrade, Mario de. *Poesias completas.* Vol. 2 of *Obras completas de Mário de Andrade.* São Paolo: Livraria Martins Editôra, 1966.

Bibliography

Apollinaire, Guillaume. *Correspondance avec son frère et sa mère*. Ed. Gilbert Boudar and Michel Décaudin. Paris: Librairie José Corti, 1987.

Apollinaire, Guillaume. *Oeuvres poétiques*. Paris: Gallimard, 1965.

Apollinaire, Guillaume. *Le poète assassiné*. Paris: Gallimard, 1979.

Arnheim, Rudolf. *Radio*. London: Faber and Faber, 1936.

Azuela, Mariano. *Obras completas*. 3 vols. Mexico City: Fondo de Cultura Económica, 1976.

Azuela, Mariano. *Two Novels of the Mexican Revolution: The Trials of a Respectable Family and The Underdogs*. Trans. Frances Kellam Hendricks and Beatrice Berler. San Antonio: Trinity University Press, 1963.

Baciu, Stefan. *Estridentismo, estridentistas*. Veracruz: Instituto Veracruzano de cultura, 1995.

Baciu, Stefan. "Estridentismo, medio siglo después. Entrevista a List Arzubide." *La palabra y el hombre* 47 (July-September 1968): 49–55.

Baciu, Stefan. "Estridentismo mexicano y modernismo brasileño: Vasos comunicantes." In *Estridentismo: memoria y valoración*. Mexico City: Secretaría de Educación Pública, 1983. 33–38.

Baciu, Stefan. "Los estridentistas de Jalapa." *La palabra y el hombre* 47 (July-September 1968): 9–15.

Baciu, Stefan. "Un estridentista silencioso rinde cuentas." *La palabra y el hombre* (October-December 1981): 140–146.

Bailes, Kendall E. *Technology and Society under Lenin and Stalin: Origins of the Soviet Technical Intelligentsia, 1917–1941*. Princeton: Princeton University Press, 1978.

Bar-Lewaw, Itzhak, ed. *La revista "Timón" y José Vasconcelos*. Mexico City: Edimex, 1971.

Barckhausen-Canale, Christiane. *Verdad y leyenda de Tina Modotti*. Havana: Casa de las Américas, 1989.

Beals, Carleton. *Mexican Maze*. Philadelphia: J. B. Lippincott , 1931.

Beals, Carleton. "Tina Modotti." *Creative Art* 4, no. 11 (February 1929), xlvii–li.

Beeching, Wilfred A. *Century of the Typewriter*. New York: St. Martin's Press, 1974.

Benjamin, Walter. *One-Way Street, and Other Writings*. Intro. Susan Sontag. Trans. Edmund Jephcott and Kingsley Shorter. London: New Left Books, 1979.

Benjamin, Walter. *Selected Writings*. 4 vols. Ed. Howard Eiland, Michael W. Jennings, et al. Cambridge: Harvard University Press, 1996–2003.

Blanco, José Joaquín. *Se llamaba Vasconcelos*. Mexico City: Fondo de Cultura Económica, 1977.

Bliven, Bruce Jr. *The Wonderful Writing Machine*. New York: Random House, 1954.

Bosanquet, Theodora. *Henry James at Work*. London: Hogarth Press, 1924.

Brecht, Bertolt. "The Radio as an Apparatus of Communication." In *Brecht on Theatre: 1918–1932*. Ed. John Willet. New York: Hill and Wang, 1964. 51–53.

Brehme, Hugo. *México pintoresco*. Mexico City: Fotografía artísitica Hugo Brehme, 1923.

Brehme, Hugo. *México: Una nación persistente. Hugo Brehme: Fotografías*. Mexico City: INBA, 1995

Brenner, Anita. *Your Mexican Holiday: A Modern Guide*. New York: Putnam, 1935.

Breton, André. *Oeuvres complètes*. Paris: Gallimard, 1988.

Buck-Morss, Susan. *Dreamworld and Catastrophe: The Passing of Mass Utopia in East and West*. Cambridge: MIT Press, 2000.

Burian, Edward R., ed. *Modernity and the Architecture of Mexico*. Austin: University of Texas Press, 1997.

Cadava, Eduardo. *Words of Light: Theses on the Photography of History*. Princeton: Princeton University Press, 1997.

Cendrars, Blaise. *Complete Poems*. Trans. Ron Padgett. Berkeley: University of California Press, 1992.

Chávez, Carlos. *Toward a New Music: Music and Electricity*. New York: W. W. Norton, 1937.

Clark, Katerina. *The Soviet Novel: History as Ritual*. Chicago: University of Chicago Press, 1981.

Coeuroy, André. *Panorama de la radio*. Paris: Éditions Kra, 1930.

Colomina, Beatriz. *Privacy and Publicity: Modern Architecture as Mass Media*. Cambridge: MIT Press, 1994.

Conger, Amy. "Tina Modotti: A Methodology, a Proposal, and a Love Letter." In *Tina Modotti, una vita nella storia: atti del convegno internazionale di studi*. Udine: Comitato Tina Modotti, 1995.

Conger, Amy, and Beaumont Newhall, eds. *Edward Weston Omnibus: A Critical Anthology*. Salt Lake City: Peregrine Smith Books, 1984.

Current, Richard. *The Typewriter and the Men Who Made It*. Urbana: University of Illinois Press, 1954.

De Anda Alanís, Enrique X. *La arquitectura de la Revolución mexicana: Corrientes y estilos de la década de los veinte*. Mexico City: Universidad Nacional Autónoma de México, 1990.

Downs, Linda Bank. *Diego Rivera: The Detroit Industry Murals*. New York: W. W. Norton, 1999.

Bibliography

Dromundo, Baltasar. *Rescate del tiempo.* Mexico City, 1980.

Duhamel, Georges. *In Defence of Letters.* 1937. Trans E. F. Bozman. New York: Greystone Press, 1939.

Fernández Cifuentes, Luis. *Teoría y mercado de la novela en España: Del 98 a la República.* Madrid: Gredos, 1982.

Franco, Jean. *Plotting Women: Gender and Representation in Mexico.* New York: Columbia University Press, 1989.

Fraser, Valerie. *Building the New World: Studies in the Modern Architecture of Latin America, 1930–1960.* London: Verso, 2000.

Fuentes, Gloria. *La radiodifusión.* Mexico City: Secretaría de Comunicaciones y Transportes, 1987.

Gálvez, Felipe. "Cincuenta años nos contemplan desde las antenas radiofónicas." *Comunidad* 46 (December 1973): 733–742.

Gastélum, Bernardo J. *Palabras del Dr. Bernardo J. Gastélum en la inauguración de la estación de radio de la Secretaría de Educación Pública C.Y.E.* [. . .]. Mexico City: Editorial Cultura, 1924.

Gladkov, Fyodor. *Cement.* Trans. A. S. Arthur and C. Ashleigh. New York: International Publishers, 1929.

Gladkov, Fyodor. *Cemento.* Trans. José Viana. Madrid: Editorial Cenit, 1929.

Gumbrecht, Hans Ulrich. *Lob des Sports.* Frankfurt: Suhrkamp Verlag, 2005.

Gutiérrez Nájera, Manuel. *Obras.* Mexico City: Universidad Nacional Autónoma de México, 1959.

Guzmán, Martín Luis. *Obras completas.* Mexico City: Compañía General de Ediciones, 1961.

Heidegger, Martin. *Parmenides.* Trans. André Schuwer and Richard Rojcewicz. Bloomington: Indiana University Press, 1992.

Herf, Jeffrey. *Reactionary Modernism: Technology, Culture, and Politics in Weimar and the Third Reich.* New York: Cambridge University Press, 1984.

Hollier, Denis. *Absent without Leave: French Literature under the Threat of War.* Cambridge: Harvard University Press, 1997.

Hollier, Denis. "The Death of Paper: A Radio Play." *October* 78 (Fall 1996): 3–20.

Hollier, Denis. "Surrealist Precipitates: Shadows Don't Cast Shadows." *October* 69 (Summer 1994): 111–132.

Huidobro, Vicente. *Tour Eiffel.* Madrid, 1918.

Huth, Arno. *La radiodiffusion: Puissance mondiale.* Paris: Gallimard, 1937.

Jitrik, Noé. "El estridentismo y la obra de Manuel Maples Arce." *Literatura mexicana* 4, no. 1 (1993): 27–63.

Kern, Stephen. *The Culture of Time and Space 1880–1918.* Cambridge: Harvard University Press, 1983.

Khlebnikov, Velimir. *Snake Train: Poetry and Prose.* Ed. Gary Kern. Ann Arbor: Ardis, 1976.

Kittler, Friedrich A. *Discourse Networks 1800/1900.* Stanford: Stanford University Press, 1990.

Kittler, Friedrich A. *Gramophone, Film, Typewriter.* Stanford: Stanford University Press, 1999.

Koch, Howard. *The Panic Broadcast: Portrait of an Event.* Boston: Little, Brown, 1970.

Kracauer, Siegfried. *The Mass Ornament: Weimar Essays.* Trans. Thomas Y. Levin. Cambridge: Harvard University Press, 1995.

Krauss, Rosalind E. *The Originality of the Avant-Garde and Other Modernist Myths.* Cambridge: MIT Press, 1985.

Krauze, Enrique, et al. *La reconstrucción económica 1924–1928: Historia de la revolución mexicana.* Vol 10. Mexico City: El Colegio de México, 1977.

Kyn Taniya [Luis Quintanilla]. *Radio: Poema inalámbrico en trece mensajes.* Mexico City: Editorial Cultura, 1924.

Lippman, Paul. *American Typewriters: A Collector's Encyclopedia.* Hoboken: Original & Copy, 1992.

List Arzubide, Germán. *El movimiento estridentista.* Jalapa: Ediciones de Horizonte, 1927.

Lowe, Sarah. *Tina Modotti Photographs.* New York: Harry N. Abrams, 1995.

Mandell, Richard D. *The Nazi Olympics.* Urbana: University of Illinois Press, 1987.

Maples Arce, Manuel. *A la orilla de este río.* Madrid: Plenitud, 1964.

Maples Arce, Manuel. *Soberana juventud.* Madrid: Plenitud, 1967.

Maples Arce, Manuel. *Urbe: Super-poema bolchevique en cinco cantos.* Mexico City: Botas, 1924; reprinted in Schneider, 427–438.

Marinetti, F. T. *I manifesti del futurismo. Prima serie.* Firenze: Edizioni di Lacerba, 1914.

Marinetti, F. T. *Selected Poems and Related Prose.* Ed. Luce Marinetti. New Haven: Yale University Press, 2002.

Marinetti, F. T. *Teoria e invenzione futurista.* Milano: Mondadori, 1996.

Markov, Vladimir. *Russian Futurism: A History.* Berkeley: University of California, 1968.

Marnham, Patrick. *Dreaming with His Eyes Open: A Life of Diego Rivera.* New York: Knopf, 1998.

Masi, Frank T. *The Typewriter Legend.* Secaucus: Matsushita Electric Corporation of America, 1985.

Matthews, Irene. *Nellie Campobello: La centaura del Norte.* Mexico City: Cal y Arena, 1997.

Mejía Barquera, Fernando. *La industria de la radio y la televisión.* Vol. 1. Mexico City: Fundación Manuel Buendía A.C., 1989.

Bibliography Mejía Prieto, Jorge. *Historia de la radio y la televisión en México*. Mexico City: Colmenares, 1972.

Méndez Vigatá, Antonio E. "Politics and Architectural Language." In Burian, 61–90.

Meyer, Jean A., et al. *Estado y sociedad con Calles*. Vol. 11 of *Historia de la Revolución mexicana*. Mexico City: El Colegio de México, 1977.

Meyer, Lorenzo, et al. *Los inicios de la institucionalización*. Vol. 12 of *Historia de la Revolución mexicana*. Mexico City: El Colegio de México, 1978.

Modotti, Tina. "On Photography." *Mexican Folkways* 5 (October-December 1929).

Modotti, Tina. "Photography as Weapon." 1932. Reprinted in *History of Photography* 18, no. 3 (Autumn 1994): 289.

Moholy-Nagy, László. *Painting, Photography, Film*. Trans. Janet Seligman. London: Lund Humphries, 1969.

Moholy-Nagy, Sibyl. *Moholy-Nagy: Experiment in Totality*. Cambridge: MIT Press, 1969.

Monterde, Francisco, ed. *Mariano Azuela y la crítica mexicana: Estudios, artículos y reseñas*. Mexico City: Secretaría de Educación Pública, 1973.

Moraes, Marcos Antonio de, ed. *Correspondência Mário de Andrade & Manuel Bandeira*. São Paulo: Universidade de São Paulo, 2000.

Novo, Salvador. "Meditaciones sobre el radio." In Novo, *Toda la prosa*. Mexico City: Empresas Editoriales, 1964.

Novo, Salvador. "Radioconferencia sobre el radio." *Antena* 2 (August 1924): 10; reprinted in *El Universal Ilustrado* 399 (January 1, 1925): 4–5; anthologized in Novo, *Toda la prosa*.

Novo, Salvador. "Radio News, 1938." *La vida en México en el periodo presidencial de Lázaro Cárdenas*. Mexico City: CONACULTA, 1994. 166–176.

Oles, James. "La nueva fotografía y Cementos Tolteca: Una alianza utópica." *Mexicana: Fotografía moderna en México, 1923–1940*. Valencia: IVAM, 1998.

Ollman, Leah. *Camera as Weapon: Worker Photography between the Wars*. San Diego: Museum of Photographic Arts, 1991.

Osorio, Nelson. "El estridentismo mexicano y la vanguardia literaria latinoamericana." *Estridentismo: Memoria y valoración*. Mexico City: SEP/80-FCE, 1983. 49–61.

Osorio, Nelson. *El futurismo y la vanguardia literaria en América Latina*. Caracas: Centro de Estudios Latinoamericanos Rómulo Gallegos, 1982.

Ozenfant, Amédée, and Edouard Jeanneret. *La peinture moderne*. Paris: G. Crès, 1927.

Paz, Octavio. "Antevíspera: Taller." In *Generaciones y semblanzas*. Vol. 4 of Paz, *Obras completas*. Mexico City: Fondo de Cultura Económica, 1994. 94–120.

Paz, Octavio. *Cuadrivio: Darío, López Velarde, Pessoa, Cernuda*. Mexico City: Joaquín Mortiz, 1965.

Paz, Octavio. *Obra poética*. Barcelona: Seix Barral, 1990.

Paz, Octavio, ed. *Poesía en movimiento*. Mexico City: Siglo xxi, 1966.

Paz, Octavio. "Seis vistas de la poesía mexicana." In *Generaciones y semblanzas*. Vol. 4 of *Obras completas*. Mexico City: Fondo de Cultura Económica, 1994. 15–93

Peirce, Charles Sanders. *Philosophical Writings of Peirce*. Ed. Justus Buchler. New York: Dover, 1955.

Perloff, Marjorie. *The Futurist Moment: Avant-Garde, Avant Guerre, and the Language of Rupture*. Chicago: University of Chicago Press, 1986.

Phillips, Christopher, ed. *Photography in the Modern Era: European Documents and Critical Writings 1913–1940*. New York: Metropolitan Museum of Art/Aperture, 1989.

Renger-Patzsch, Albert. "Aims." 1927. In Phillips, 104–105.

Renger-Patzsch, Albert. "Photography and Art." 1929. In Phillips, 142–144.

Rivera, Diego. "Edward Weston and Tina Modotti." *Mexican Folkways* 2, no. 1 (April–May 1926): 16–17.

Rivera, Diego, with Gladys March. *My Art, My Life*. New York: Dover, 1991

Robe, Stanley L. *Azuela and the Mexican Underdogs*. Berkeley: University of California Press, 1979.

Rochfort, Desmond. *The Murals of Diego Rivera*. London: Journeyman, 1987.

Rodchenko, Aleksandr. "A Caution." 1928. In Phillips, 264–266

Rodchenko, Aleksandr. "The Paths of Modern Photography." 1928. In Phillips, 256–263.

Romano, David Gilman. *Athletics and Mathematics in Ancient Corinth: The Origins of the Greek Stadion*. Philadelphia: American Philosophical Society, 1993.

Rouvillois, Frédéric. "Utopia and Totalitarianism." In Roland Schaer et al., eds. *Utopia: The Search for the Ideal Society in the Western World*. New York: New York Public Library; Oxford University Press, 2000. 316–331.

Saborit, Antonio. *Una mujer sin país: Las cartas de Tina Modotti a Edward Weston, 1921–1931*. Mexico City: Cal y Arena, 1992.

Bibliography

Salinas, Pedro. *Aventura poética (antología)*. Ed. David L. Stixrude. Madrid: Cátedra, 1980.

Salvat Papasseit, Joan. *Poemes en ondes hertzianes*. 1919. Reprinted in *Poesies*. Barcelona: Ariel, 1978.

Sánchez Fogarty, Federico. *Medio siglo de cemento en México*. Mexico City: Cámara Nacional del Cemento, 1951.

Schneider, Luis Mario. *El estridentismo o una literatura de la estrategia*. Mexico City: CONACULTA, 1997.

Schwartz, Jorge, ed. *Las vanguardias latinoamericanas: Textos programáticos y críticos*. Madrid: Cátedra, 1991.

Secretaría de Educación Pública, *El Estadio Nacional: XXV aniversario*. Mexico City: Secretaría de Educación Pública, 1949.

Seifert, Jaroslav. *Na vlnách TSF*. Prague: Nakl. V. Petra, 1925.

Shattuck, Roger. *The Banquet Years: The Origins of the Avant-Garde in France, 1885 to World War I*. New York: Vintage, 1968.

Siqueiros, David Alfaro. "A Transcendental Photographic Work: The Weston-Modotti Exhibition." Reprinted in Conger and Newhall, 19–20.

Smith, Terry. *Making the Modern: Industry, Art, and Design in America*. Chicago: University of Chicago Press, 1993.

Sociedad Mexicana de Geografía y Estadística. *Sesión solemne en homenaje al ilustre explorador de los polos Roald Amundsen*. Mexico City: Sociedad Mexicana de Geografía y Estadística, 1928.

Speer, Albert. *Inside the Third Reich*. Trans. Richard and Clara Winston. New York: Simon and Schuster, 1970.

Stieglitz, Alfred. "Pictorialist Photography." In Trachtenberg, 115–123.

Stingelin, Martin. "Comments on a Ball: Nietzsche's Play on the Typewriter." In Hans Ulrich Gumbrecht and K. Ludwig Pfeiffer, eds. *Materialities of Communication*. Stanford: Stanford University Press, 1994.

Süssekind, Flora. *Cinematograph of Words: Literature, Technique, and Modernization in Brazil*. Stanford: Stanford University Press, 1997.

Trachtenberg, Alan, ed. *Classic Essays on Photography*. New Haven: Leete's Island Books, 1980.

Trotsky, Leon. *Literature and Revolution*. New York: International Publishers, 1925.

Vasconcelos, José. *Discursos 1920–1950*. Mexico City: Ediciones Botas, 1950.

Vasconcelos, José. *Memorias*, vol. 2: *El desastre, El proconsulado*. Mexico City: Fondo de Cultura Económica, 1982.

Vasconcelos, José. *Obras completas*. Mexico City: Libreros Mexicanos Unidos, 1957.

Weston, Edward. *Daybooks of Edward Weston*. Ed. Nancy Newhall. Millerton, N.Y.: Aperture, 1973.

Wolfe, Bertram D. *The Fabulous Life of Diego Rivera.* New York: Stein and Day, 1963.

Wollen, Peter, and Laura Mulvey, eds. *Frida Kahlo and Tina Modotti.* London: Whitechapel Art Gallery, 1982.

Wymer, Norman. *From Marconi to Telstar: The Story of Radio.* London: Longmans, 1966.

Zapata Vela, Carlos. *Conversaciones con Heriberto Jara.* Mexico City: Costa Amic, 1992.

Index

Page numbers in boldface refer to illustrations.

Abreu Gómez, Ermilo, 241 (n. 20)

Adorno, Theodor W., 8, 20

AIZ (Arbeiter-Illustrierte Zeitung), 59

Alemán, Miguel, 205

Allegory of California (Rivera), 6

Alva de la Canal, Ramón, **124**

Álvarez Bravo, Lola, 187

Álvarez Bravo, Manuel, 20, 46, 187–191

 Instrumental, 188–190, **189**

 Tríptico Cemento–2, 187–191

Amundsen, Roald, 148–156

Anderson, Benedict, 126

Andrade, Mário de, 92–97, 99–103, 109–110, 114, 141, 232, 233

 Losango caqui, 93, 101–102

 "Máquina de escrever," 93–97, 99–102, 103, 109–110, 115, 141

Antena, 125, **147**

A orillas del Hudson (Guzmán), 81

Apollinaire, Guillaume, 121, 132–141, 161

 "Lettre-Océan," 132–141, 161

Armco Steel (Weston), 49

Arnheim, Rudolf, 26, 119, 163, 230

 Radio, 163

Arsenal, The (Rivera), 6

Assembling for a Demonstration (Rodchenko), 53

At the Telephone (Rodchenko), 53

Automatic writing (Breton), 109–110

Azcárraga, Raúl, 142

Azuela, Mariano, 23, 25, 69–80, 90, 93, 97, 102–103, 114–115, 241 (nn. 20–23)

 Los de abajo, 25, 69–76, 90, 241 (n. 21)

 Sin amor, 72–74

Balzac, Honoré de, 79

Banco Nacional de México, 181, **182**

Beals, Carleton, 22, 57

Beethoven, Ludwig van, 82, 86, 93

Benjamin, Walter, 8, 10, 19, 42, 57–59, 60, 61–62, 65, 123, 192, 224, 226

 "The Work of Art in the Age of Its Technological Reproducibility," 8, 57, 191–192, 226

BIFUR, 56

Blanco, José Joaquín, 223–224

Bliven, Bruce, 104

Bolaños Cacho, Fernando, 128, **129, 212**

Bosanquet, Theodora, 81

Brecht, Bertolt, 59, 123

Brehme, Hugo, 31, 42–44, 46, 47–48, 50, 62, 64. *See also* Pictorialist photography

 Hombre con sombrero, **42,** 47–48, 50, 62

 México pintoresco, 42

Brenner, Anita, 190

 Your Mexican Holiday: A Modern Guide, 190

Breton, André, 108–110, 134

 Manifesto of Surrealism, 109–110

Buck-Morss, Susan, 235

Buen Tono, El, 123, 143–148, 152–156, 158

Building, Mexico City (Modotti), 48–49, **49**

Cadava, Eduardo, 57

Calles, Plutarco Elías, 22, 25, 26, 108, 112, 170, 193–194, 205, 225

Campesinos Reading "El Machete" (Modotti), 50, **51,** 53, 57

Campobello, Nellie, 214

 30-30, 214

Canetti, Elias, 217

Capital (Marx), 191

Cárdenas, Lázaro, 205

Carpentier, Alejo, 169

Carrillo, Rafael, 42

Caruso, Enrico, 82

Casa del Radio, La, 142

Cement (Gladkov), 27, 174–179, 191, 197

Cemento, 27, 172–175, 177, 179–186, **182, 184, 186**

Cementos Tolteca, 23, 186–188, 190

Cendrars, Blaise, 79, 94, 121, 140, 147

Cervecería Moctezuma, 142, **143**

Cézanne, Paul, 46

Chafirete, El, 5

Chávez, Carlos, 23

Chopin, Frederic, 86, 92

"Circulatory Poem (for the Disorientation of All)" (Paz), 134

Clark, Katerina, 176

Coeuroy, André, 26, 156–157, 160–161

 Panorama de la radio, 157

Colomina, Beatriz, 26, 170

Colonia Condesa, 23

Colonia Roma, 181, 203

Comité para propagar el uso del cemento Portland (Committee to Propagate the Use of Portland Cement), 171–172, **175, 178**

Communist Party (Mexican), 175, 194

Contemporáneos, 79–80, 124–125, 241 (nn. 20–21)

Creative Art, 56

Crumpled Tinfoil (Modotti), **19,** 19–20

Cult value (Benjamin), 8, 191–193, 197–198

Current, Richard, 242 (n. 28)

CYB (El Buen Tono radio station), 123–125, 158

CYE (Ministry of Education radio station), 125–126

De Anda Alanís, Enrique X., 177

"Death of Paper, The," 157–158

Decena trágica, 135–138. *See also* Mexican Revolution

Defense of Letters (Duhamel), 164

De Forest, Lee, 130

Delaunay, Robert, 135

Detroit, 2, 11, 13–15

Detroit Industry (Rivera), 2–4, 8–9, 11–18, **14, 17, 18,** 42–43, 229–230, 234

Detroit Institute of Arts, 2

Díaz, Porfirio, 4, 22, 77–78, 88, 90, 135

Discourse Networks 1800/1900 (Kittler), 18

Downs, Linda Bank, 12

Dream of Arcadia, A (Litvak), 18

Dromundo, Baltasar, 175

Duchamp, Marcel, 101

 Underwood, 101

Duhamel, Georges, 65, 164–165

 Defense of Letters, 164

Duque Job, El. *See* Gutiérrez Nájera, Manuel

Écriture automatique. See Automatic writing

Edison, Thomas, 128

Edward Weston with a Camera (Modotti), 34–37, **35**

Eiffel Tower, 119, 135

Eliot, T. S., 68, 79

 The Waste Land, 68

"Estadio" (Quintanilla), 211–212, **212,** 216

Estadio Nacional 25, 27–28, 49, 202–215, **217,** 221–222, 224–226, 229

Estridentistas, 8, 26, 91–93, 94, 123–124, 126, 144, **146,** 146–147, 185, 193, 231, 233, 241 (n. 21). *See also* Maples Arce, Manuel; Quintanilla, Luis

Fascism, 216–218, 221, 223–225

Ford, Edsel, 2, 11

Ford, Henry, 2, 15

Ford Motor Company, 2, 15, 23. *See also* River Rouge

Fraser, Valerie, 204, 208

Functionalist architecture, 27, 186, 189–191

Galli-Curci, Amelita, 82–83

García, Rafael, 42, 46

Garduño, Antonio, 46

Gastélum, Bernardo, 126

Gladkov, Fyodor, 27, 174–179, 191, 197

 Cement, 27, 174–179, 191, 197

González Camarena, Jorge, **186,** 187

Gramophone, Film, Typewriter (Kittler), 18, 20

Gropius, Walter, 172

Gumbrecht, Hans Ulrich, 19, 202

Gutiérrez Nájera, Manuel, 4–5, 69, 76, 198. *See also Modernismo*

Guzmán, Martín Luis, 25, 80–88, 92, 93, 96, 97, 102–103, 114–115, 125

 A orillas del Hudson, 81

 "Mi amiga la credulidad," 26, 81–83, 86

Hammond typewriter, 242 (n. 28)

Heidegger, Martin, 68, 94–95, 101, 107

Herf, Jeffrey, 28

Hertz, Heinrich, 119, 128

Historia de la radio y la televisión en México (Mejía Prieto), 154

Hitler, Adolf, 217–223

Hollier, Denis, 60, 158, 193, 247 (n. 35)

Hombre con sombrero (Brehme), **42,** 47–48, 50, 62

Horizonte, 56. *See also* Estridentistas

Huerta, Victoriano, 135

Huidobro, Vicente, 121, 135

Hurlburt, Laurance P., 16

Iliad, 82

Imaginazione senza fili. See Wireless imagination

Indexicality, 13, 42, 45, 60–62, 64, 99, 108

Indología (Vasconcelos), 207–209

Instrumental (Álvarez Bravo), 188, **189**

International Red Aid, 64

Irradiador, 49, 124, **146,** 146–147. *See also* Estridentistas

"IU IIIUUU IU" (Quintanilla), 162–167

Jalapa Stadium, **183–184,** 192, 193–194, 202, 205–207

James, Henry, 68, 81, 83, 87

 The Sacred Fount, 83

Jara, Heriberto, 183, 193–198, 206

Jiménez, Agustín, 20, 187

Jiménez Rueda, Julio, 241 (n. 21)

Jolas, Eugène, 56

Kahlo, Wilhelm, 31

KDKA (Pittsburgh radio station), 120

Kern, Stephen, 119

Khlebnikov, Velimir, 121

 "Radio of the Future," 121

Kittler, Friedrich, 18–19, 20, 21, 23–24, 68, 79, 83, 87, 94, 170

 Discourse Networks 1800/1900, 18

 Gramophone, Film, Typewriter, 18, 20

Kodak Mexicana, 32–34, 38

Kostrowitzky, Albert de, 135–140

Kozloff, Max, 16

Kracauer, Siegfried, 65, 215–216, 226

Krauss, Rosalind E., 60, 61

Kyn Taniya. *See* Quintanilla, Luis

Labor 2 (Modotti), 48

Lacan, Jacques, 227

Landau, Paul, 68, 79

Larrea Celayeta, Juan, 121

 "TSH," 121

Le Corbusier, 172, 188, 205

 La peinture moderne, 188

"Lettre-Océan" (Apollinaire), 132–141, 161

Lissitzky, El, 103

List Arzubide, Germán, 124

 El movimiento Estridentista, 124, **144**

Literature and Revolution (Trotsky), 110–111, 114

Litvak, Lily, 18

 A Dream of Arcadia, 18

Losango caqui (Andrade), 93, 101–102

Los de abajo (Azuela), 25, 69–76, 90, 241 (n. 21)

Lunacharsky, Anatoly, 176

Machado, Gerardo, 114

Machine in the Garden, The (Marx), 18

Madero, Francisco, 72, 78, 135

Making of a Fresco Showing the Construction of a City, The (Rivera), 6

Man at the Crossroads Looking with Hope and High Vision to the Choosing of a New and Better Future (Rivera), 6, 9

"Manifesto of Estridentismo" (Maples Arce), 5, 91–92

"Manifesto of Futurism" (Marinetti), 92

Manifesto of Surrealism (Breton), 109–110

Mantel, Ricardo, 42, 46

Maples Arce, Manuel, 5, 23, 26, 91–93, 97, 114, 123, 126–133, 140–141, 156–158, 193, 230, 232

"Actual No. 1: Manifesto of Estridentismo," 5, 91–92

"TSH," 123, 126–133, 140, 146, 156–157

"Máquina de escrever" (Andrade), 93–97, 99–102, 103, 109–110, 114, 141

March, Otto, 217

Marconi, Guglielmo, 119–120, 128

Marinetti, Filippo Tommaso, 26, 82, 91, 121–122, 135, 140–141, 165

"Manifesto of Futurism," 92

Zang Tumb Tuuum, 121–122, 135

Márquez, Luis, 42

Marx, Karl, 191

Capital, 191

Marx, Leo, 18

The Machine in the Garden, 18

Masi, Frank, 242 (n. 34)

Mass ornament (Kracauer), 215–221, 225–226

Mejía Prieto, Jorge, 152, 154

Historia de la radio y la televisión en México, 154

Mella, Julio Antonio, 62, 104, 114

Méndez Vigatá, Antonio, 221

Mexican Folkways, 56

Mexican Revolution, 6, 22, 25, 31, 64, 69–72, 74, 78, 88, 90, 91, 135–140, 208, 214

México pintoresco (Brehme), 42

"Mi amiga la credulidad" (Guzmán), 26, 81–83, 86, 93

Milosz, Czeslaw, 224

Ministry of Education. *See* Secretaría de Educación Pública

Ministry of Health. *See* Secretaría de Salud

Modernismo, 4–5, 22, 68–69, 76

Modotti, Tina, 5, 19–20, 23, 24–25, 32, 34–37, 44–65, 104–115, 212–214, 230, 232, 233

Building, Mexico City, 48–49, **49**

Campesinos Reading "El Machete," 50, **51**, 53, 57

Crumpled Tinfoil, 19, **21**

Edward Weston with a Camera, 34–37, **35**

Labor 2, 48

"On Photography," 45

"Photography as Weapon," 36

Stadium, Mexico City, 48, **52**, 53, 212–214

Tank No. 1, 47, 57, **58**, 60, 61, 62, 64

La técnica, 48, 57, 62–64, **63**, 104–108, 110–115

Telegraph Wires, **55**

Telephone Wires, Mexico, 47–48, **48**, 50, 54–55

Worker Reading "El Machete," 57, 61

Workers' Parade, 50, **51**, 53, 56–57, 59, 61

Moholy-Nagy, László, 1

Monroe, C. A., 185–186

Montenegro, Roberto, **161**, 161–162

Monterde García Icazbalceta, Francisco, 124–125

Movimiento Estridentista, El (List Arzubide), 124, **144**

Multifamiliar Presidente Juárez, 205

Mundo, El, 125

Munzenberger, Willi, 59

Museum of Technology (Mexico City), 192–193

Mussolini, Benito, 217, 223

Nashville, Parthenon, 181, **182**

National Stadium. *See* Estadio Nacional

New Masses (New York), 22, 56, 65

New York City, 81, 86

Nietzsche, Friedrich, 20, 68, 103

Norge, **149,** 149–150

Noriega Hope, Carlos, 123, 124, 126

North Pole, 148–150, 152–154

Novo, Salvador, 5, 125, 158–160. *See also* Contemporáneos

 "Radio-conferencia sobre el radio," 125, 158–160

Nuremberg, stadium, 218–222

Obregón, Álvaro, 21, 22, 25, 26, 108, 112, 141, 156, 170, 203, 204,
 208

Obregón Santacilia, Carlos, 49

O'Gorman, Juan, 23, 187

Oliver, Thomas, 77

Oliver typewriters, 69–80, 81, 88

 Oliver Typewriter Co., 90

Ollman, Leah, 59

Olympia (Riefenstahl), 218, **219–220**

Olympic games, 202, 217–218

"On Photography" (Modotti), 45

Ortíz Rubio, Pascual, 205

Ozenfant, Amédée, 188

 La peinture moderne, 188

Pani, Mario, 205

Panorama de la radio (Coeuroy), 157

Panteón de La Piedad, 203

Parade (Satie), 85–86

Paso del Norte, El, 74–75

Paz, Octavio, 5, 134, 135

 "Circulatory Poem (for the Disorientation of All)," 134

Peinture moderne, La (Le Corbusier and Ozenfant), 188

Peirce, Charles Sanders, 60–61

 "Theory of Signs," 60–61

Perloff, Marjorie, 134

"Photography as Weapon" (Modotti), 36

Pictorialist photography, 32, 38–47, 50, 54, 62, 64, 87. *See also*
 Brehme, Hugo; Silva, Gustavo

"Pictorial Photography" (Stieglitz), 38

Piño Sandoval, Jorge, 194–196

"Polvo mágico, El" (Sánchez Fogarty), 169, 172–174, 179, 185

Porfiriato, 4, 21, 31, 77–79, 88, 90, 136, 172

Portes Gil, Emilio, 205, **225**

Pound, Ezra, 123

Prío Socarrás, Carlos, 205

Pugibet, Ernest, 143, 144

Quintanilla, Luis (Kyn Taniya), 5, 23, 26, 124, 161–167, 211–212,
 216, 230–231, 233

 "Estadio," 211–212, **212,** 216

 "IU IIIUUU IU," 162–167

 Radio: Poema inalámbrico en trece mensajes, 124, 161–162, 166,
 167

Radio (Arnheim), 163

"Radio-conferencia sobre el radio" (Novo), 125, 158 160

Radiogenic literature (Coeuroy), 26, 157–161

"Radio of the Future" (Khlebnikov), 121

Radiophonic literature (Coeuroy), 157

Radio: Poema inalámbrico en trece mensajes (Quintanilla), 124, 161–162, 166, **167**

Radiotelegraphy, 119–120, 138–140, **139**

Raza cósmica, La (Vasconcelos), 5, 23, 28, 207–209, 212, 223, 224

Rebolledo, Miguel, 194–196

Reece, Jane, 46

Remington, E., and Sons, 83–84

Remington typewriters, 68, 81–90, 93–95, 99–101, 103

 Remington Noiseless, 84, **85**

 Remington Notes, 88–90

 Remington Typewriter Company, 88–90

Renger-Patzsch, Albert, 10, 188

Revista de Revistas, 46, 152

Reyes, Alfonso, 125

Riefenstahl, Leni, 218

 Olympia, 218, **219–220**

Rivera, Diego, 2–4, 5–18, 19–20, 28, 42–43, 49, 65, 204, 229–230, 231, 234

 Allegory of California, 6

 The Arsenal, 6

 Detroit Industry, 2–4, 8–9, 11–18, **14, 17, 18,** 42–43, 229–230, 234

 The Making of a Fresco Showing the Construction of a City, 6

 Man at the Crossroads Looking with Hope and High Vision to the Choosing of a New and Better Future, 6, 9

 River Rouge, Ford plant, 2, 11–15

Rochfort, Desmond, 15

Rodchenko, Aleksandr, 10, 11, 50, 53–54, 188

 Assembling for a Demonstration, 53

 At the Telephone, 53

 Steps, **53**

Rolland, Modesto C., 183

Rouvillois, Frédéric, 224

Russian Revolution, 6, 175, 179

Ruttman, Walter, 123

Sacred Fount, The (James), 83

Salinas, Pedro, 97–99, 131

 "Underwood Girls," 97–99, 131

Salvat-Papasseit, Joan, 121, 131

Sánchez Fogarty, Federico, 27, 169, 172–181, 184–187, 190–191, 193, 197, 231, 233

 "El polvo mágico" 169, 172–174, 179, 185

Satie, Erik, 85

 Parade, 85

Secretaría de Educación Pública, 7, 125–126, 203. *See also* Vasconcelos, José

Secretaría de Marina, 193–196. *See also* Jara, Heriberto

Secretaría de Salud, 22, 25, 48–49

Seifert, Jaroslav, 123, 131

Sheeler, Charles, 11–13, 20

Silva, Gustavo, 39–44, 47, 64. *See also* Pictorialist photography

Sin amor (Azuela), 72–74

Sink (Weston), 107

Siqueiros, David Alfaro, 10, 43–45, 50, 55

Smarth (photographer), 42, 46

Smith, Terry, 16

Snapshot (pseudonym), 37–38

Soirées de Paris, Les, 133

Speer, Albert, 218–221

Stadiogenic events, 210, 214–218, 224–226

Stadium, Mexico City (Modotti), 48, **52,** 53, 212–214

Stalin, Joseph, 196–197

Steiner, Ralph, 103

Typewriter Keys, 103

Steps (Rodchenko), **53**

Stettler, W. J., **14,** 15

Stieglitz, Alfred, 38–39

"Pictorial Photography," 38

Süssekind, Flora, 97

Tamayo, Rufino, 187

Tank No. 1 (Modotti), 47, 57, **58,** 60, 61, 62, 64

Taylorization, 101, 106, 147, 216

Técnica, La (Modotti), 48, 57, 62–64, **63,** 104–108, 110–115

Tejeda, Carlos, 187

Telegraph Wires (Modotti), **55**

Telephone Wires, Mexico (Modotti), 47–48, **48,** 50, 54–55

Tepito (Mexico City), 227–229, 234

"Theory of Signs" (Peirce), 60–61

30–30 (Campobello), 214

Timón, **222,** 222–223

Tina Modotti and Miguel Covarrubias (Weston), 34–37, **55**

Toilet (Weston), 107

Tolteca, 27, 172, 177, 187, 190–191

Tolteca Cement Co., 23, 186–188, 190

Toor, Frances, 175

Torres Bodet, Jaime, 5

Torso (Weston), 47

Transition, 56

Tríptico Cemento–2 (Álvarez Bravo), 187–191

Trotsky, Leon, 8, 110–113, 115

Literature and Revolution, 110–111, 114

Truman, Harry S., 205

"TSH" (Larrea Celayeta), 121

"TSH" (Maples Arce), 123, 126–133, 140, 156–157

Turnbull, Roberto, 46

Twain, Mark, 68

Typewriter Keys (Steiner), 104

Typewriter Topics, 90

Underwood (Duchamp), 102

"Underwood Girls" (Salinas), 97–99, 131

Underwood typewriters, 81, 84, 97–99, 104–108, 112, 114

 Underwood Portable Typewriter, 104–106

Universal, El, 142, 147–148, 210, **211**

Universal Ilustrado, El, 22, 32, **33, 34,** 39–42, 123, 126, 128, **129,** 142, **143,** 152, **153, 160, 178, 212**

Universópolis (Vasconcelos), 27, 208, 209, 229, 231

Valentiner, William, 2

Vallejo, César, 8, 131, 165

Vasconcelos, José, 5, 7, 23, 27–28, 65, 125, 203–217, 221–224, 229, 231, 234

Indología, 207–209

La raza cósmica, 5, 23, 28, 207–209, 212, 223, 224

Veracruz, 183, 193–196, 205

Villagrán García, José, 203

Villaurrutia, Xavier, 5, 125. *See also* Contemporáneos

Waste Land, The (Eliot), 68

Welles, Orson, 123

Weston, Edward, 32, 34–37, 44–50, 107

Armco Steel, 50

Sink, 107

Tina Modotti and Miguel Covarrubias, 34–37, **35**

Toilet, 107

Torso, 47

Wireless imagination (Marinetti), 26, 121

Wireless telegraph. *See* Radiotelegraphy

Worker Reading "El Machete" (Modotti), 57, 61

Workers' Parade (Modotti), 50, **51,** 53, 56–57, 59, 61

"Work of Art in the Age of Its Technological Reproducibility, The" (Benjamin), 8, 57, 191–192, 226

XEB (El Buen Tono radio station), 154

Your Mexican Holiday: A Modern Guide (Brenner), 190

Zang Tumb Tuuum (Marinetti), 121–122, 135

Zola, Émile, 79